MENTAL HEALTH FROM A GENDER PERSPECTIVE

MENTAL HEALTH FROM A GENDER PERSPECTIVE

EDITED BY

Bhargavi V. Davar

First published in 2001 by

Sage Publications India Pvt Ltd
M-32 Market, Greater Kailash-I
New Delhi 110 048

Sage Publications Inc Sage Publications Ltd
2455 Teller Road 6 Bonhill Street
Thousand Oaks, California 91320 London EC2A 4PU

Published by Tejeshwar Singh for Sage Publications India Pvt Ltd, typeset by Line Arts, Pondicherry and printed at Chaman Enterprises, Delhi.

Library of Congress Cataloging-in-Publication Data

Mental health from a gender perspective/edited by
Bhargavi V. Davar.
p. cm.
Includes bibliographical references and index.
1. Women—Mental Health—India. I. Davar, Bhargavi V. 1962–
RC451.5.I5 M46 616.89′0082′0954—dc21 2000 06 061547

Second Printing 2001

ISBN: 0–7619–9470–7 (US-hb) 81–7036–960–3 (India-hb)

SAGE PUBLICATIONS
New Delhi . . . Thousand Oaks . . . London

First published in 2001 by

Sage Publications India Pvt Ltd
M-32 Market, Greater Kailash-I
New Delhi 110 048

Sage Publications Inc
2455 Teller Road
Thousand Oaks, California 91320

Sage Publications Ltd
6 Bonhill Street
London EC2A 4PU

Published by Tejeshwar Singh for Sage Publications India Pvt Ltd, typeset by Deo Gratis Systems, Chennai and printed at Chaman Enterprises, Delhi.

Library of Congress Cataloging-in-Publication Data

Mental health from a gender perspective/edited by Bhargavi V. Davar.
 p. cm.
 Includes bibliographical references and index.
 1. Women—Mental Health—India. I. Davar, Bhargavi V., 1962–
 RC451.5. I5 M465 616.89'0082'0954—dc21 2000 00-059156

Second Printing 2003 2285 4002

ISBN: 0-7619-9477-7 (US-Hb) 81-7036-955-X (India-Hb)

Sage Production Team: Shweta Vachani, Radha Dev Raj and Santosh Rawat

CONTENTS

List of Tables 8
List of Figures 9
Acknowledgements 10

INTRODUCTION 11

 I Gender and Mental Health: Inter-disciplinary
 Perspectives 13
 Bhargavi V. Davar
 II Mental Health of Indian Women:
 A Field Experience 34
 Ajita Chakraborty
 III Gender Issues in Mental Health:
 A Clinical Psychology Perspective 61
 Anisha Shah
 IV From the Personal to the Collective:
 Psychological/Feminist Issues of
 Women's Mental Health 82
 U. Vindhya
 V Further Considerations on Women and
 Mental Health 99
 Sasheej Hegde

THE BODY, REPRODUCTION AND MENTAL HEALTH 121

 VI The Interface between Psychiatry and
 Women's Reproductive Health 123
 Prabha S. Chandra

VII Gynaecological Morbidity and Common
 Mental Disorders in Low-income Urban
 Women in Mumbai 138
 Surinder K.P. Jaswal
VIII The Female Body as the Battleground
 of Meaning 155
 Janet Chawla and Sarah Pinto
 IX The Female Body of Possession:
 A Feminist Perspective on Rural Tamil
 Women's Experiences 181
 Kalpana Ram

VIOLENCE AND MENTAL HEALTH 217

 X The Unsafe Nest: Analysing and Treating
 the Roots and Reaches of Marital Violence 219
 Rajalakshmi Sriram and Sudipta Mukherjee
 XI Self-disclosure in Child Sexual Abuse:
 Content Analysis of Written Narratives
 of Disclosure 248
 L. Kavitha Vijayalakshmi and Shekhar Seshadri
XII Child Sexual Abuse and Social Factors
 Preventing Disclosure: Adolescent Girls'
 Narratives 262
 Rinchin and Shubhada Maitra
XIII Sexual Violence and Mental Health:
 Confronting the Paradox of the
 'Guilty' Victim 277
 Kavita Panjabi
XIV Inscribing Madness: Another Reading of
 the Yellow Wallpaper and *the Bell Jar* 296
 Jayasree Kalathil

WOMEN, SOCIETY AND MENTAL ILLNESS 311

 XV The Lay and Medical Diagnoses of Psychiatric
 Disorder and the Normative Construction
 of Femininity 313
 Renu Addlakha
XVI Women and the Law on Unsoundness of Mind 334
 Amita Dhanda

XVII The Media and Women's Mental Health 370
 Ammu Joseph

References 390
About the Editor and Contributors 414
Index 419

LIST OF TABLES

2.1 Neurotic complaints and probable diagnosis 44

2.2 Correlation between work and distress 49

2.3 Family roles, economic status and neuroses 51

7.1 Frequency of common mental disorders 147

7.2 Summary of findings on gynaecological morbidity and common mental disorders in respondents 151

10.1 A profile of batterers and victims: A congregation of views 224

10.2 Nature of effects and persons affected by marital violence 234

12.1 Myths about CSA 274

16.1 Relevance of unsoundness of mind in various legal contexts 337

16.2 Unsoundness of mind as affecting the capacity to marry 356

16.3 Unsoundness of mind as a ground for divorce 357

LIST OF FIGURES

6.1 A model for pelvic pain 135
10.1 Causative factors in marital violence:
 An overview 230
10.2 Marital Violence: Approaches to intervention 240
11.1 Disclosure model 257

ACKNOWLEDGEMENTS

This book is based on a national seminar on Indian women and their mental health in 1996. The project was supported with funding from Hivos, Bangalore (Indian regional office) and the Indian Council of Social Science Research, New Delhi. The seminar was organised by Anveshi, Research Centre on Women's Studies, Hyderabad.

Introduction

Introduction

I

GENDER AND MENTAL HEALTH: INTER-DISCIPLINARY PERSPECTIVES

Bhargavi V. Davar

CONTEXTUALISING THE BOOK

The concept of 'gender and mental health' became audible in many professional and feminist circles by the year 1995. Many discussions and meetings took place on the subject. We were very much in the thick of these discussions at Anveshi (Research Centre for Women's Studies, Hyderabad), and were beginning to see 'mental health' in almost all women's issues. The idea for a national seminar on Indian women and their mental health was also discussed.

At the seminar, which had a large participation, it was immediately obvious that there would be major differences between different interest groups and the first few sessions were very heated. Some of us who were feminists could not take what we thought was the 'talking-down' attitude of the professionals and some professionals found feminist communications intolerable. Other concerned intellectuals, who were neither feminists nor professionals, were critical of the evident hostilities. As organisers, and as women who had had so much time to thaw out and autopsy ideas and practices about mental illness at Anveshi, we were quick to index a fault or a naivete. Almost every discipline was represented at the seminar and the strong presence of feminist, health and user groups from all over the country strengthened the critical edge of the discussions. We admired some professionals for their perseverance in taking a staunchly gender

perspective within the masculine milieu of psychiatric practice. Gender bias seemed so obvious in some of the other professional presentations that we were amazed at the ethical complacency. We were all in all absorbed by the complexity of the mental health discourse, moved both by the professionals' daunting work as well as the feminists' ire against mainstream practice. The seminar was an intense emotional experience, and as the following papers show, fundamental differences remain. But the book is the result of remembering those emotions and conceptualising those differences, even though it has been very long in the making.

This book is as much about difference as it is about sameness. We cannot over-emphasise this. The book shows that even to pose the problem simply as that between feminists and professionals, between the mainstream and the radical, between professional and consumer, etc., can be misleading. In the process of co-ordinating this work and making the links with other initiatives elsewhere, many layers of sameness and difference among the participants and contestants became obvious. There were differences and identity problems between psychiatrists, psychologists and other community workers; they were homogenous only at a distance. Nor were feminists a homogenous lot, differing in positions and emphases about women's 'empowerment'. Diagnosed friends had problems with both therapy as well as feminism. It was difficult to make sense of all this.

A few of us did, sometimes strenuously and rather severely, mark out our differences from other professional and women's groups' initiatives. The urgency over the subject was necessary. But we also disdained hasty professional efforts to articulate 'policy recommendations' to the government; or, equally, 'feminist alternatives'. As feminists, we weren't sure about the implications of accepting mental illness as part of reality, as an 'objective' truth about women's lives. So much about diagnoses and psychiatric labelling needed deconstruction from the gender perspective. The sociological, ethnographic and feminist bases required for planning programmes and agendas on women and mental health were missing. Systematic feminist scrutiny of documented psychiatric materials was scarce, confounding any planning efforts. We

objected to the way the professionals were treating the issue of gender and mental health, through 'gender sensitisation' programmes. As if a new digit had to be simply added on to a changed (electronic) telephone number! Professionals who talked a lot about 'culture' and 'community' had no idea about the rich feminist sociological and ethnographic work in this area. There also seemed to be something wrong in holding that all moral questions relating to mentally ill women had to be answered only by the professionals, and not by feminists. Some of us were both feminist and diagnosed and we strongly felt that the limits of academic feminism must be extended in the interests of diagnosed women. Our interest in acting as advocacy or support groups for mentally distressed women was filled with unresolved dilemmas and quandaries. We thought that we could not take our own feminist perspective for granted and that we must self-consciously re-negotiate this from the standpoint of those women who were brought within the psychiatric regime. The activist-academician divide was very prominent in these differences, and some of us took the side of thinking over doing.

Through these discussions, some of us (Davar, 1999; Vindhya and Jayasree, in this book) could not fully accept that it was enough to treat madness as protest. Being engaged in feminist political activity did not always 'cure' our 'madness', our distressing thoughts, emotions and anxieties. There seemed to be an experiential reality to madness that needed to be addressed in its own terms. During an episode of depression, for example, we were more likely to be engulfed by the intense realities of our own psyche than by societal problems. Within the feminist movement, diagnosed friends who were thus 'absent' were sorely missed. However, the diagnostic manuals, the psychiatric jargon and clinical protocols did little to enlighten us. Clinicians were not particularly forthcoming about what exactly it was that they were doing through the clinics. From shared group experiences, we knew that mental hospitals were not friendly to women and that ECT (electroconvulsive therapy) could be given to 'cure' naxalism! It was not surprising that we thought of the clinics often as mechanisms of social control. Mediating perspectives had to be evolved which negotiated Indian feminism, the gender

politics of Indian society and the mental health services, altogether. If Indian feminism, with its strong left ideology, showed us that the personal was the political, it needed to still show us how the political could be therapeutic, in terms of specific ideas and intervention practices. A richly nuanced discourse was awaiting formulation by feminists and others interested in women's body/mind experiences.

Indian feminism itself is a story of mental resilience, and mental health was always a subtext (Shatrugna, 1999). Our work in critically addressing the mental health discourse would not have been possible without feminism, without feminist spaces and without those feminists who presented themselves with supreme mental power. Within these feminist spaces, our rage and our emotions were not 'outlawed', but were seen as legitimate anger against oppressive, sometimes life-threatening situations. Here, no one was going to tell us that we were preoccupied with our bodies, our aches and pains, and our emotions. Many of us who entered feminist groups, broken and demoralised, read, wrote and shared new stories about ourselves and about other women; learnt new methods of re-constructing our emotional and embodied lives; and made empowering networks with other women. As Susie Tharu writes,[1] the rich history of feminist writings, such as Mahasweta Devi's *Bayen*, Ismat Chugtai's *Tehri Lakhir*, much of Triveni's writings including the award-winning *Sharapanjara*, and many other stories of the *Naye Kahani* period of the 60s and 70s, 'count as evidence of a body of critical work which reinterprets madness in a feminist mode'. Jayasree and Panjabi, in this book, also write about the self–empowering aspects of women's writings and feminist protest. Feminism preserved all of women's lives,

[1] References to Susie Tharu are from personal communications shared in the process of her review of my introduction to this book. I also thank Sasheej Hegde and the anonymous Sage reviewer for commenting on earlier versions of this introduction. The basis for this chapter are the many discussions at Anveshi, at the National Seminar and at various other feminist and advocacy forums. I thank the paper contributors, the discussants and participants at the Seminar for the engaging and enduring dialogue through the whole editorial process.

emotions and experiences as legitimate and valid, thereby making psychiatric labelling redundant, reductionistic and objectionable.

There is a powerful sense in which the feminist movement itself might be viewed as one in which women's experience is shifted from the domain of the pathological to that of the political. At the level of the personal, autonomous women's groups functioned very importantly as therapeutic contexts.... What we have been doing is devising strategies, on the ground, in specific contexts...in the absence of meaningful shared knowledge or practices [Tharu, personal communication].

Veena Shatrugna writes, in re-tracing the history of Indian feminism from the present context of concerns about women's mental health:

In India it is perhaps the feminist activism of the last twenty years that has come closest to understanding mental health. Women in such groups were neither prescriptive nor did they patronise, instead they challenged social institutions and other cultural and political structures which have a direct bearing on women's day-to-day lives, and in all probability play an important role in the mental well-being of women.... [T]here was excitement in the air as women shared experiences about themselves, their families, their lives and encounters. The growth of women's confidence and self-esteem knew no bounds as they challenged established theories about law, work, justice, equality and medicine. . . . The women's movement helped avert many breakdowns [Shatrugna, 1999: 15–16].

At the same time, established professionals—some of them represented in this book—were giving a conceptual and intervention basis to women and mental health in their own work. They were doing this without having to call themselves 'feminist', or having to directly discourse in terms of 'gender'.

They were often working in unsupportive institutional environments, where women's issues were not taken very seriously. Getting recognition, peer acceptance or other support for their work from their departments and institutions was often a struggle. Outspoken women in these professions, especially psychiatry, were patronised, humoured, but they often missed that important assignment, project or editorship; were regularly *not* invited for the 'very important' professional meetings; or if their nuisance value was considered to be of a high index, were labelled as somewhat cranky and eventually isolated. Effecting curricular, policy, ethical or ideological changes within this context was impossible. As Chakraborty says in her introduction, sexism existed in the professions—invisible and unquestioned. In a professional milieu where it is widely accepted that the total number of a professional's academic publications determines the quality of his or her interventions—which is an entirely different matter altogether—some of these professionals sensitive in general to intervention, and in particular to gender issues, were going to be marginalised as subversive, unco-operative, non-productive, of slow intelligence, and deluded about service priorities! We need not call these professionals 'feminist' to appreciate their recognition that the mental health discourse requires interrogation from the point of view of women. Not that all the conceptual nuances of gender were fully comprehended, but gender was as much an enduring sub-text in their work as mental health was in feminism.

This book, then, may be described as an effort to foreground these sub-texts and understand the politics of the mental health discourse from a gender perspective. An editorial suggestion made while starting this work was that the professional writers should excavate their own work for insights on 'gender', and that the feminist writers should do the same for insights on 'mental health'! In a sense, then, this book is the presentation of ideas and positions already in circulation as effective and meaningful practices. What is new about the book is perhaps its manner of making academic 'disclosures' possible between the different disciplinary and ideological players.

STRUCTURING THE BOOK. REALISM AND ANTI-REALISM

The book is in four parts. The papers in Part I, following this chapter, review the domain of women and mental health: who are the interested parties and what are their contributions and their limitations. Parts II and III thematise mental health issues pertaining to the body, sexuality, reproduction and violence against women. Part IV examines the multiple interphases between gender, diagnoses and society in the hospital psychiatric wards, the courts and the media.

There is epistemological movement in each part of the book. This movement is the basis for the organisation of the chapters. The papers are organised in terms of their sameness and/or difference regarding scientific epistemologies. The locations range from realist positions about the validity and objectivity of science to critical, anti-science, anti-realist, phenomenological, hermeneutic or deconstructionist positions. The realism vs. anti-realism debate is a debate in the philosophy of science about the nature of 'objects' that are referred to by any science as natural or social. This debate relates to the issue of whether scientific constructs (such as 'depression', for example) refer to something really out there, existing outside the language in which it is formulated, or whether the referent is internal to the theory, simply a matter of scientific habit and custom or a stipulation of norms by the scientific community. Nearly half of the contributors to the book, broadly speaking, adopt a realism about mental health and illness. They hold the view that mental illness is 'natural'. It is a nameable item which exists in the natural order of the world. Truths about these items can be identified and quantified through the diagnostic and explanatory paradigms of the mental and behavioural sciences. 'Depression *is* there' or 'She *is* depressed' are existential statements, where it is assumed that the construct 'depression' is an existing item in the world which can be adequately captured through, let's say, the Beck's inventory, a well known scale for measuring depression (or a chemical/hormonal assay or a life events' inventory): The Beck's (or other) inventory measures the real thing and has actual potential for intervening

with human reality, and the tool is not simply a product of the scientific imagination. For the scientific realists, scientific activity and clinical conduct are rational—and more often than not, moral—behaviours of human beings. Sometimes, such behaviours may not be sensitive to women and so the theories and methodologies must be 'adjusted' to include gender-related aspects too. No fundamental overhauling of systems or questioning of values is thought to be necessary. Gender evaluations must be included along with the other internal, logical, methodological, and normative evaluations and protocols of the sciences and the service systems. For the realists, science is a universal, liberal, democratic tool and the connection between science, societal oppression and marginalisation of people is not an essential, but an accidental one.

The anti-realists do seriously concede the reality of mental distress experiences. But they often doubt that a scientific language adequately represents these experiences. 'Mental illness' is a grey area, and in defining it, science, cultural history, community norms and behaviours, cultural morality, gender morality, group conformity and an individual's social position are all powerfully operative. The concepts of mental illness, given by the *Diagnostic and Statistical Manual* (DSM), for example, are a mix of all this, and 'pure' and 'proper' science or pure epistemology is a fantasised ideal. Therefore, 'adjustment' attempts by scientists may not be really profound or valid, and alternatives to science, and the scientific method, have to be articulated. Feminism or community psychiatry are some examples of alternatives. The esotericism and artificiality of scientific practice have to be negotiated by opening up community- and women-friendly interventions using, if possible, the ordinary language, existing belief systems and women's psycho-social experiences.

It must perhaps be added, in order to demystify some commonly held opinions, that scientific realism may be upheld not only by the mental and behavioural scientists, and therapists, but also by feminists (e.g., Davar, 1999; Sriram and Mukherjee, and Vindhya, in this book). The mental health professionals may, equally, (e.g., Chakraborty, Vijayalakshmi and Seshadri, in this book) choose the phenomenological

approach to understanding human behaviour. There are a variety of epistemological positions within feminism, the social sciences and the mental and behavioural sciences; and what divides beliefs and opinions between the professionals and the feminists is not always the type of epistemology espoused. Hegde's paper in the book is a critical self-reflection on this book itself—about the possibilities and limitations of realist positions for a philosophy of social science in general, and for the emergent discourse on women and mental health in particular. The collection of essays in this book gives an idea of how the contributors have negotiated their own disciplines in resolving the epistemological tensions of science vs. culture, nature vs. nurture, truth vs. narrative, individual vs. community, fact vs. experience, man vs. woman, etc., in addressing the women and mental health domain.

Realist and anti-realist epistemologies can have different implications for therapy. These differences can be further accentuated by whether the therapy is feminist or not. Realism about human behaviour stresses the sameness of individuals over differences. The universal aspects of being human is privileged over the particular and it is argued that over and beyond contextual differences, there is something common to all human beings. These common aspects may be biological, but equally, they may also be behavioural, cognitive, psycho-social, etc. For example, a scientific realist would hold that the range of emotions available for human expression is not infinite. As Shah argues in this book, 'where social learning principles are relevant for therapy, the attempt is still to minimise the importance of gender differences'. The realist therapies—behavioural, cognitive, existentialist, or systems models—are often rationalist. They emphasise and reinforce the logical, conscious, analytical, representational, linguistic and verbal aspects of human behaviour. Interventions are in terms of the universal and de-contextualised individual/woman presenting in the clinic, rather than in terms of subjectivities embedded in cultures or collectives. Some mental experiences regularly found in mental distress are taken to be common to all men and women, whatever the gender or community background. Intervention for the realists will focus on these common aspects.

Feminist realism also proposes its variety of intervention (as in Davar, 1999; Vindhya, in this book). For these realists, the material and social world is gendered and inequality is a real index of women's social position. There is something common and universal in the socio-political situation of all women, which is what brings them to the clinic in the first place. For example, issues such as job opportunities, wages, problems of domesticity, sexuality, reproduction and violence are common to women across the world. Feminist intervention involves targeting, not just the individual woman through the clinic, but also the structural framework through political activity. Feminist activism has existing, real, rational, logical and manipulable targets—changing health indices, demanding service structures, making legal changes, etc.—which must be effected through goal-oriented and scientifically conceived political agency. Feminist therapy which works within the scope of scientific realism is not opposed to rationality. In fact, it only objects to the fact that mainstream psychology and psychiatry have made theoretical and intervention formulations as if only men are rational and as if women can only be insane. Women are rational too, and deserve an equal share in all the outputs and benefits of the rational systems and structures that are available to the men, such as the sciences, the laws, etc. Feminist therapy however argues, contrary to the professionals who hold a scientific perspective, that interventionists are necessarily also agents of social and structural change. The connotations attached to 'intervention' in both these cases are obviously different in terms of the range of behaviours that an interventionist is allowed to enact as part of 'her job'. Thus, for example, while the orthodox clinical psychologist may, using intensive therapy, work with and alter the interpersonal variables as they present themselves within the space of the clinic, a feminist counselling centre may offer some supportive therapy, along with a diverse range of other referral and networking services, to deal with the social and medico-legal aspects.

Anti-realism stresses people- and community-centred methods of intervention. It rejects dichotomous thinking (mind/body; reason/emotion) as scientistic, individualistic and reductionistic. There is emphasis on culture, embodi-

ment and emotions, rather than on science, truths and ob-
jectivity. Rationality is an important aspect of human
experience, but does not comprise all of it. Speaking, or the
verbal linguistic aspects which therapy often emphasises, is
only one manner of being-in-the-world. A lot of social be-
haviours spill over from the rational and the linguistic domain
into other more diffuse domains. Anti-realism emphasises
the more diffuse, contextual, tacit, textured, creative, pre-
verbal, unconscious and inarticulate realms of personal,
interpersonal, cultural and socio-political experiences. The
subjects here are seen as creative, embodied and emotional
selves who act unconsciously, sometimes subversively, to
survive social oppression. A community is not just a sum
total of human beings, their individual mentalities and their
manners of verbal expression. Communities, when they
perform as a whole, for example, in orchestrating posses-
sion, show the complex interaction between individual and
context, mind and body, speech and self-expression, reason
and emotion, man and woman.

Anti-realist feminists, even while they agree to a communi-
tarian philosophy, are self-conscious of the problems of overly
emphasising the role of the community in a woman's—social
and mental—life, because of the evident patriarchies and
chauvinism of the Indian communities. As Panjabi, in this
book, observes:

> An emphasis on her [a woman's] ethnic or communal
> identity...could prove to be either fruitless in the context
> of patriarchal communities, or dangerous in terms of in-
> tensifying strife between communities.

Therefore, within feminist perspectives, anti-realism is also
theorised to be counter-patriarchal. They suggest how one
may model care for women through the community by coun-
tering those structural and ideological aspects that oppress
women within those communities. A feminist group, for
example, may be seen as a type of community model, as
Vindhya suggests. A feminist group fills the need for a spe-
cial discourse critically relating gender and the community,

and the need for special therapeutic enclaves for women. In doing so, feminist groups build community intervention on the basis of gender difference. As Panjabi argues in this book:

> [T]herapy that is founded on the function of normalising ... deflects the possibility of a genuine healing based on women's reason and values, and their sense of morality, which might be different from the men's.

The feminist papers by Kalathil, Panjabi, Chawla and Pinto, and Ram describe the therapeutic effectiveness of social behaviours of women who are rooted within community life. The anti-realist, anti-science, feminist papers in this book see intervention in political terms, and feminist resistance to oppression, whether open or indirect, is argued to be an important intervention strategy contributing to women's mental health.

Here, I am using 'realist' and 'anti-realist' as neutrally as I possibly can, and only as an axis for allotting each of the papers its place in the book. It would be cliched to privilege in a general way either realism or anti-realism. The standards for such evaluations require further feminist, methodological or other normative analyses. The papers argue in their own interest for their particular perspective, and this introduction need not pre-empt those arguments. As such, this book only offers a vista of positions about women and mental health, without suggesting some overall feminist or clinical preferences.

Realism and anti-realism are both equally legitimate linguistic habits of addressing a particular universe of discourse, here, women and mental health. Issues about theoretical rigour, type and specificity of intervention, clear norms of use and abuse, and strategies for empowerment, can be equally formulated through both types of habit. Let it be said that 'facts' on women and mental health; how they can be clinically used for women's mental health needs; how policy and services must be negotiated with... have emerged from the realist models, and also by asking the question, in Hegde's words, 'what is the specific reality of mental health?' However, as Hegde cautions:

[T]o speak, as the book seeks to do, about the complex-
ities surrounding mental health and their implications for
a gendering of mental health policy may seem to miss the
point. There is indeed an analogous preparation that the
essays in the book are meant to inculcate, namely, just
what it means to be concerned with prescriptive notions
of mental illness [personal communication].

The second and more foundational question for Hegde is
'just what is known [or being willed] when something is posit-
ed as mental health?' What is it about insanity that makes it
the business of the sciences and the courts? The anti-realist
positions thus place themselves on the margins of realism,
and question the axiomatic—factual and moral—basis of the
discourse on women's mental health. Or, as Panjabi says in
this book:

> [W]e need to examine why there is a *selective* subjugation
> of non-reason by Reason. We need to investigate how and
> why certain aspects of non-reason are assigned to the cat-
> egory of abnormality of madness, while others are not.

The 'meanings' that mental distress experiences have for the
women who are operating in diverse socio-cultural, commu-
nity and linguistic contexts, and the way that lunacy is con-
structed through the courts, the hospitals and in the media,
are discussed in the papers. These papers address mental
illness as a category of social discourse, as a discursive item
deployed in social negotiations, and not just as a matter of
diagnostic classification or as a matter of policy. By empha-
sising the cultural, personal, communicative, even literary
nature of distress experiences, and of female subjectivities,
the papers force us to listen to the multiplicity of women's
'voices'. In doing so, they interrogate, and also recreate, the
ordinary languages required to deal with subjective distress
in everyday social situations: How do women talk about, dis-
play or enact their own distress? How does this drama,
display and enactment help? These papers are all about the
personal, interpersonal, cultural, experiential and institu-
tional meanings of being labelled mentally ill rather than

about the facts of being so. The epistemological variety, and the many implications for interventions will, I hope, become evident through the book's unfolding.

A PREVIEW OF THE BOOK

The following four papers in the introduction are overviews of the domain of women and mental health. Chakraborty's paper following this chapter is a candid account of a senior female psychiatrist fiercely unwilling to toe the colonial, 'medical expert' line in the history of Indian psychiatry. Her paper questions psychiatric diagnoses on grounds that the cultural, social and colonial bases of the practices are not fully acknowledged or accounted for. There can be no final answer to the question as to when ordinary distress becomes mental illness. While resigning herself to the use of available diagnostics in presenting the outcomes of her prevalence study in Calcutta—the only one in India which had the women's question as a 'hidden agenda'—Chakraborty concludes that the issues involved in women's mental health may be more psychological than psychiatric.

Continuing the deconstruction, Shah argues that turning to psychological theories may have its problems, for such theories are not always gender-sensitive. There can be no generalised response to the question whether women are the same as men, and so emphasising sameness, as psychologists do, or complete difference, as some feminists are wont to do, are both biases. Shah, however, maintains an ideological loyalty to her discipline in maintaining a gender-neutral and value-free clinical stance that is not directly supportive of social change. However, Shah does not rule out the incidental outcome that the therapeutic process may socio-politically empower the woman by changing certain aspects of her self/psychological experience. For example, if while in therapy, a woman is enabled to learn some cognitive skills in dealing with the violence in her marital relationship, this may be socially empowering for her as well. The fact that the clinician is not taking the role of a political,

feminist or a paralegal activist in her case is not of great consequence.

Focusing more directly on the individualism of psychology and its contrast with the political collectivism of feminist activity, Vindhya suggests the necessity of integration. Having a feminist interest in these disciplines, she questions scientific ideas and practices through which women in therapy have been re-victimised. Positions of clinical value-neutrality, especially in contexts of treating women surviving in violent situations, may only re-establish the gender status quo, vindicating male aggression and chauvinism in relationships. While value-neutrality may be acceptable in certain therapy situations, the clinician must be prepared, in other more problematic contexts, to make the networks necessary for reconstructing the individual pathology as a political problem. Vindhya's paper makes the shift from seeing disease as an individual problem to seeing it in terms of the structural aspects of the community. In integrating feminist networks within a clinical perspective, she also extends intervention from the clinic to the community.

Hegde's interest is in the logical and conceptual basis of the discourse on women and mental health. The writers preceding Hegde are all responding to the contents of the mental and behavioural sciences: facts, data, diagnostics, clinical and feminist strategies, thus espousing realisms of sorts. Hegde urges an evaluation of realism itself, as the axiomatic basis of medico-psychological practice. He laments the unself-consciously realist basis of most available feminist and advocacy literature on women and health/mental health; they have been notoriously unimaginative by not raising questions about the possibility of the formation of a discourse on women and mental health. Both Vindhya and Hegde share concerns about the overall invisibility of women and mental health in the literature. Vindhya explains this by referring to the ideological and collectivist goals of feminism, which contradict the individualist goals of psychiatry. Not concerned with feminism, or for that matter with gender, Hegde explains the invisibility as the result of an overall axiomatic disregard for anything other than what is categorical, quantifiable and observable, in other words, what is considered real. Together,

the papers in Part I lay out the emerging domain of women and mental health, while also critically engaging with the boundaries of that domain.

Part II thematises concerns linking the body, sexuality, fertility and reproduction with women's mental health. Through this section, we sense the movement from seeing the body as a biological product to seeing it as a cultural phenomenon, thus moving from shades of biological determinism to possibilities of unique female self-expression and autonomy within often oppressive social contexts. Prabha Chandra's chapter gives a broadly bio-psycho-social perspective, with the stress falling on bio-medicine and the life cycle approach. The bio-medical approach views the body organically, as a set of systems finely regulated by psycho-biological circuits. I believe that knowing about our bodies as brains or as a system of well regulated chemicals is an important perspective, and cannot be easily rejected in the context of mental health. The misdiagnosis of medical problems in female psychiatric clients is only recently being understood (Klonoff and Landrine, 1997). The significance of medical problems, such as infections, sepsis, or endocrine problems in women's mental distress experiences is evident from Prabha's chapter and, following this, Jaswal's. In this book, we will miss contributions from neuro-psychological and other bio-medical perspectives which would have been important additions to the book.

Jaswal's paper, from a social psychiatric perspective, is also concerned about reproduction and common mental distress. However, she examines this issue from a community and public health perspective, linking mental health with macro-developmental issues such as growing urbanisation, poverty, unemployment, changing family structures, etc. The epidemiological and public health perspectives in mental health are becoming increasingly vital in mental health planning (Levin et al., 1998)—especially in the context of global turbulences in economies, shifting political contexts, development politics and the consequent effects of poverty, unemployment, displacement and violence (Desjarlais et al., 1995; Good, 1996). The public health perspective is also enforced upon communities as the welfare states all over

the world downsize or withdraw supports to health work, letting private interests and voluntary community initiatives to take over.

Chawla and Pinto, and Kalpana Ram, subvert the realist paradigm which sees the mind/body as an item that can be mapped as functions of real indices (symptom inventories, hormonal levels, self-reporting questionnaires, development indices, etc.) Responding to Chandra's appeal for experiential accounts of female reproductive experiences, these writers present a cultural hermeneutics of the female body. The mind/body is a 'lived symbol' of shared meanings, values and associations, enacted through dance, song and ritual. Feminist ethnographies highlight the fact that mainstream medicine and even the more liberal cross-cultural psychiatry—as in Obeysekere—have not found it important to integrate women's, and other subaltern voices, in understanding mental health, thus offering only master narratives, maintaining privileged social positions. Feminism, ethno-medicine and anthropology counter the patriarchal hegemonies of both tradition and modern bio-medicine, setting the possibilities of agency, self-experience and expression not only within the lives of women, but also within communities which are oppressed by the existing caste and religious hierarchies.

For Chawla and Pinto, the pregnancy and childbirth rituals, central to the lives of subaltern women, subvert the 'pollution' ideology prevalent in Sanskritic traditions and reinforced by Western bio-medicine. Extending Chawla's own earlier work on the *dais,* the paper discusses three subaltern 'scripts' related to birthing: the Jaunpuris' *Matri Masaan ki puja;* the Irulas' *puja* to *Coopa Ma* and the song to the Sapto Mayas by the Charmars. In these rituals, the woman is brought within but also transcends the cultural significance attached to blood, tissue, fluids and secretions unique to the female experience of sexuality and fertility. Ram contests cross-cultural psychiatric attempts to see possession as 'orgasmic'. This view reduces female sexuality and the complexity of women's relationships to their own bodies to genitality. Writing against the rationalism and objectivism of science in general, and against psychoanalytic accounts of female

embodied behaviours in particular, Ram's hermeneutic account records the 'multiple voices' of possessed women.

The feminist ethnographies examine the role of the customary and habitual in women's everyday lives. The social meaning of woman's body is contested and regulated by various knowledge interests. However her embodiment—and her rootedness in a sisterhood—is, as Ram says, 'in excess of the dominant discourses'. Together Chawla and Pinto, and Ram, stress that women are not just objects on which things are done—as in general medicine or psychiatry—nor are they unambiguously victims of tradition and patriarchy, but are creative agents clearing cultural space for themselves, however little, to legitimately experience their own embodiment.

Part III of the book links themes relating to violence (against women), mental health and self-disclosure. As in the earlier sections, the movement is from detached, objective behavioural accounts, to engaged, phenomenological accounts. The section moves from setting up the violated woman as a 'victim' of violence to eventually hearing her own voice and detecting her agency, however minimal, in protesting even the more severe experiences of personal violations. Sriram and Mukherjee are concerned with the scientific—cognitive, behavioural and developmental—aspects of domestic violence against women. Vijayalakshmi and Seshadri, Rinchin and Shubhada Maitra, and Panjabi are all concerned with personal narratives of distress in the context of violence, with self-disclosure, the process of resistance and personal overcoming. Together these chapters landscape the complexity of structures and ideas in formulating interventions for victims of violence. They are all, in different degrees, concerned with both formulating gender-sensitive clinical interventions and with feminist, community-based interventions.

Violence in intimate contexts is maintained by the woman's silence. The papers on childhood sexual abuse by Vijayalakshmi and Seshadri, and Rinchin and Maitra emphasise the value of self-disclosure in intervention. Panjabi argues that women condemned to the realm of the private through experiences of violence, break that silence and emerge into the public sphere by self-disclosure. In doing so, they show resistance and transform from being the guilty victims that society

expects them to be, into political agents, and their disclosures become forms of public protest. The papers reiterate the claim made by Vijayalakshmi and Seshadri in the context of intervention for childhood sexual abuse, that self-disclosures are therapeutic and socially empowering. 'Disclosure' is a many-valenced construct. There is something personal as well as political in what it connotes. Disclosure is a process by which a private grievance is given a public voice, through the clinic, through community networks or through women's collectives. Disclosure also alludes to the affective, sensuous and embodied aspects of human negotiations, that is, to drama, art, song and play.

Kalathil, following the papers on violence, continues the theme of women's self-disclosures, and highlights the empowering and therapeutic nature of autobiographies. In women's songs, poems and diaries, there is the possibility of having oneself as the ideal, listening 'Other'. This enhances the avenues for self-scrutiny as well as self-affirmation. Perhaps, it was similar for Plath and Gilman—whom Kalathil discusses—that what they looked for in their therapists and did not find, they found in their own writings. Diagnosed women, such as Plath, often experience psychiatry as violent and under these circumstances, writing for oneself is therapeutic. But writing, since it involves resourcing the publicness of language, is also a means of relocating the private within the public and of using the public discourse to enable the private. Even writing for oneself is writing for the listening 'Other' in oneself.

From the position of Part III, we can connect back with the feminist ethnographies of Part II as being accounts of women's self-disclosures. Even though they are all feminists, Chawla and Pinto, and Ram's themes are somewhat different from Panjabi's and Kalathil's. The latter two show their women to be agentive by an open rendering of their situation and their distress experiences. Writing, as in autobiographies, is supremely rational behaviour. The protagonists in Panjabi's narratives are also political actors, openly explicating—if not confronting—their social situation. The ethnographic accounts, however, argue that women's agency is not necessarily at stake when distress is expressed through

symbolic and embodied means. The agents in the ethno-graphic accounts empower themselves by extracting self-constructed meanings from the prevailing community discourses. Their form of 'protest' is to defuse the power embedded in the language of these discourses by taking control over the passage of meanings between women.

Part IV of the book shows that personal narratives do not always remain just stories of 'pure' and intimate self-experience. They often become transformed by social and institutionalised meanings. I have heard many depressed women refer to themselves as 'manipulative' and 'craving attention'; I could not accept such 'stories'. Women's narratives may carry the colour of presiding hegemonic discourses. This is why feminists are sometimes discriminatory, if not fully suspicious, about 'women's stories'. As Ram writes in this book: '[W]omen's narratives about their own experience, even in moments of heightened agency, are shaped and structured by the discourses generated by dominant groups.' The institutions within which the women's narratives are sited (the health care system; the system of justice; the other social systems such as workplace, community, school, etc.) estrange the stories from the storyteller by adding their own meanings. For example, it is well known from feminist experience that doctors who treat women exhibit a wide range of insensitivities in dealing with women's narratives of distress, leaving them helpless, powerless and with the feeling that 'they will not understand'. Any analysis of narratives must be politically sensitive to the incursions of such institutionalised meanings and practices. While the feminist papers explore the self-experiential ground of subjective distress, and themes linking female subjectivity, embodiment and making space for women's stories, the papers in Part IV analyse the discursive interphase between social institutions (the court, the hospital and the media) and women's mental lives. They highlight how women's narratives are appropriated to serve institutional and patriarchal interests.

In this book, Amita Dhanda extends her own earlier work on mental health legislation (reviewed in Dhanda, 2000) to problems about adjudication. Dhanda examines narratives of personal distress, which appear in the courts through

petitions filed against women on the charge of insanity. The interpretive lag between the social, judicial readings of these narratives and the personal distress narratives of the women petitioned for insanity is highlighted. While earlier, Dhanda has argued for broad-based changes in the Mental Health Act (1987), in this paper, she makes an appeal for a total recasting of the MHA from a minimalist into a maximalist law. Yet another instance of the social, institutional mis-understanding of women's distress narratives is noticed by Renu Addlakha in a general hospital psychiatric ward. Pushpa's 'schizo-affective disorder' is systematically misread by her husband and the family. While not deconstructing the validity of the diagnosis, Addlakha's paper on the 'Lay and medical diagnoses' raises questions about the social rationality for incarceration, which is deeply coloured by stereotypes about being a woman. Ammu Joseph's paper on 'The media and mental health' covers how the media projects women's mental health as coming 'Free' with a range of household appliances. Women's mental health and distress are seen to have a market value as the media cashes in on seductive images of the liberated, beautiful, modern—and sometimes working—woman vis-a-vis a harried housewife to hard sell a range of products, both of domestic commerce and of entertainment. The papers in the concluding part highlight the destructive stereotypes that operate in the so-cial domain about the mental health of women.

II

MENTAL HEALTH OF INDIAN WOMEN: A FIELD EXPERIENCE[1]

Ajita Chakraborty

THE PROBLEMS OF DIAGNOSIS

The heyday for psychiatry and mental health was the post-war period. It had seemed in those optimistic welfare days that all social ills were remediable, an unfulfilled promise. Eventually, only accusations piled up that these disciplines were the eurocentric, pseudo-scientific, racist and sexist tools of a repressive society. Anti-psychiatry, which aimed to demolish the subjects altogether, petered out after having made some impact. The adoption of a wider approach subsequently came about, as found in the latest diagnostic manuals such as the *International Classification of Diseases* (*ICD*-10, 1992) and the *Diagnostic and Statistic Manual* (*DSM*-IV, 1994). Cultural variations of expression, perception and experience have now found their place in these manuals. The blanket term 'disorder' has eliminated the difference between sickness and health as well. The pillar of psychiatric classification, psychosis, however, remains at the core. The present multi-axial approach of the *DSM*-IV does take care of aetiology. Cause and effect, if indeed they are so, remain embedded in

[1] An earlier version of this paper was presented at the National Seminar on Indian Women and their Mental Health, organised by Anveshi, Research Centre for Women's Studies, Hyderabad, 23–24 February 1996. I express my deep gratitude to my friends and ex-students who helped or worked in all my projects without any personal gain.

the diagnostic categories. But the wider approach notwithstanding, research in psychiatry has firmly turned towards the biological. This trend does not augur well for the future. Promises of great advances in the drug treatment of mental disorders have not solved any of the fundamental problems of psychiatry. The revised classifications read as if the non-medical dimensions have been fully taken care of, which is far from the truth.

As a social psychiatrist, I find it difficult to delineate precise disease entities amidst a diffused social substrate. Differences of gender, class and culture make the presentations of personal difficulties also different. The malign influence of poverty or women's social conditions on their mental health can no longer be denied. It is now recognised that the outcome of many psychiatric ailments depends on socio-economic structures and the social milieu. It would have helped if psychometric tests—there is almost an industry behind them—were foolproof, but they are not. The women's question has made us aware that biological, developmental and social variables are not independent. Between distress and disease there is a threshold area, not just a thin line. A large grey area around people's lives exists, where they try to cope with adverse or stressful situations. Distressed people usually resist being labelled sick because of the sense of failure that the label entails.[2] Psychiatrists would like to keep this grey area under mental health separate from psychiatry. I contend that this would not only be impossible, but also unjust. A dichotomy of important or major, and unimportant or minor areas of disorder will reappear.

Medicine rests on hierarchies, and research and treatment facilities these days target only major disorders. Psychosis, particularly schizophrenia, is of foremost importance, not only because it causes maximum disability, but it is still a challenge to medicine. In the entirety of the psychiatric spectrum, psychoses occupy only a small proportion, but they claim all social interventions, research and medical

[2] Such self-stigmatising attitudes are 'modern', and do not exist in societies where health is a collective, and not an individual responsibility.

attention.[3] Doubtful, un-named or uncategorised conditions are ignored. Discrimination against women is more than likely because of this prioritisation. It is advocated that our mental health policy should give primacy to what is more prevalent in the community, and to the group which is the most vulnerable (Davar, 1995a). However, moral consideration is one thing and what it means in actual terms is another.

Thresholds, labelling and categorisation naturally lead to diagnosis. The controversies about psychiatric diagnoses exist because these are based solely on clinical observations and interpretations usually unsubstantiated by objective tests. Human behaviour however is never static and all-encompassing frameworks become shaky in no time. For example, earlier, in Europe, demonic possession was the usual explanation for the phenomenon of double personality and churches used to exorcise the afflicted quite solemnly. In colonised countries, spirit possessions were (and still are) common, but manifested in different ways. Western psychiatrists did not consider these as psychiatric, but as expressions of backwardness and superstition. Presently, there is quite an epidemic of double and multiple personalities in the USA. The derisive diagnosis of hysteria would have been applied to such phenomena earlier but not any longer. The new classifications recognise these conditions as bonafide 'illnesses'. Even the society grants these sick persons the most quaint recognition. The courts allow, if need be, each personality her own lawyer! The role of power and deprivation, the cultural provision of self-expression or self-representation of women, the symbolic nature of external agents (realistic or spiritualistic) and unconscious dynamics are all said to contribute to the genesis of these disorders.

Multiple personality disorder (MPD) highlights the problem of placing an obviously social phenomenon in the proper

[3] In recent years, depressions have taken the central position in the West. Discarding the major/minor dichotomies has brought medical attention to bear on the somewhat 'unimportant' or 'minor', non-psychotic/neurotic types of depression, now considered the 'common' mental disorders. Unqualified depression (*ICD*–10 still has 23 types) is the commonest mental disorder now.

context. As an individual-based disease category, it remains at best a footnote in general psychiatric text or only as a minor condition. The phenomenon of possession however deserves a more cautious consideration. The *ICD*-10 is quite emphatic, rightly so, on the point that listing personality disorders together with trance and possession states should be avoided. Possession can be very similar to short acute psychosis and it is my belief that the course that psychoses take in our culture, where even classic schizophrenias carry 'good prognosis', is somehow related to the way these behaviours are seen, evaluated and dealt with. It will be a medical disaster if possession states are also transformed to become something 'severe' and 'inexorcisable'! This is a distinct possibility with the present medicalisation of the concept.

The examples are cited to illustrate not only the shifting bases of the so-called mental disorders, but also their relative social ambience. A rigid categorical approach to the subject at the present time may create a false picture, particularly in India, where even observational data are lacking. However, human beings always seem to think in terms of categories, which is useful and necessary (Davar and Bhat, 1995). Our cognitive processes would be too chaotic without anchoring devices. A medical diagnosis tells us what a disease is, how it happened, and what is to be done. However, these concepts have to evolve experientially; those evolved in one culture cannot be copied blindly by another. Therefore, to the question, 'At what point does misery, unhappiness and distress become a disease, a category?', there can never be an absolute answer.

OUTLINING A STUDY IN CALCUTTA

Desjarlais et al. (1995) have cited my index of neuroses (Chakraborty, 1990) as an indication of subjective distress and not of disorder or disease. My study was obscured because, to begin with, it had an anti-medical bias. The use of non-standard, non-technical terms, and an old-fashioned

methodology—the only one possible under the circumstances—gave it a deceptively simplistic look. I may add that my ideas were formed in an atmosphere of racial bias. Sexism was there as well, but it was hardly objected to. My aggrieved attitude persists because Indian psychiatry has not yet deconstructed its colonial past. Debunking and devaluing traditional knowledge within colonial countries also undermines faith in one's own worth, experiences, perceptions and cognition (Nandy, 1983). For medicine in India, perhaps psychiatry has been the worst sufferer. I do believe that human beings suffer severely, often irremediably, from the sickness of their minds, where only doctors can be healers. However, a certain degree of anti-psychiatry was inevitable, given the climate within which the subject was practised.

The field survey of Calcutta and its environs during 1978–80, with its 10 million population, had a sample size of 13,335, the largest mental health survey in the world at the time. The basic premise of the study was that it is vital to know what does exist a priori in the community as subjective distress. Knowledge of folk concepts, indigenous effective knowledge or practice is necessary before using any specially devised methodology. Hence, attempts were made in the study to find out (a) how people expressed their psychological difficulties; (b) who would they identify as 'mad'; (c) what are the types of behaviour people would label as abnormal; and (d) how far did psychiatric thinking of the day elide with grassroots' perception of mental illness. All expressions were recorded verbatim. The study culminated with interpretations at least by one source only, that is the author. This was achieved by avoiding the use of medical terms. The approach reflected a conceptual understanding of phenomenology, more specifically what Spinelli (1989) would call critical hermeneutics. But there was no other way out of semantic difficulties. Diagnostic terms corresponding to common psychiatric understanding have been used. In the final analysis, more was gained heuristically by this non-conventional approach than was lost due to the omission of my work in the available lists of surveys conducted in psychiatric journals.

All the differences over the diagnostics and the methodology notwithstanding, the results of the Calcutta survey did

not differ significantly from those of the other surveys except for the rates for neuroses. So much for sophistication in measurements! Based on the experiences gained from the survey, neuroses in women were studied in depth by Sandel (1982; 1990) using standard instruments and protocols, as well as those devised by us. Sandel's studies confirmed the findings of the larger survey. What we found in Calcutta was indeed a valid indicator of mental health within the psychiatric meaning of the term. The broad-based methods also encompassed various features of behaviour, which had their very local flavour.

It was known that the mental hospital data in India was biased because far fewer women were being admitted there for varied social reasons. But out-patients' rates were freely quoted. Varma et al. (1992) note the higher attendance and rates for males in north Indian clinics in contrast to the higher rates for females in field investigations. They explain this with the sexist interpretation of 'better utilisation of facilities by the males', as if the fault of the non-utilisation of services lies with females. However, determining the extent of illness in females is also difficult in the community surveys, for women are often not allowed to talk to strangers, particularly males. For our survey, women were interviewed only in the afternoon—when the men were away—and by female investigators.

Epidemiological studies to determine the number of cases in the population at risk are extremely difficult and expensive. So, at any time, a high level of unrecognised or 'hidden illnesses' may be present in the community. A WHO (Ustun and Sartorius, 1995) study of hidden psychiatric illnesses among people attending primary health care centres found that 10 to 50 per cent of the attendees (in different countries) were in need of psychiatric help. In our country, many such people consult *vaids*, local healers, homeopaths and astrologers. We have no knowledge of the extent of the problems covered by these helpers; The National Institute of Mental Health and Neurosciences (NIMHANS) of Bangalore was part of the WHO study and they found a figure of 23 per cent (which was also the international average). The study noted a preponderance of females among such psychiatric patients.

The cases were mainly depression, anxiety and alcohol addiction. It is important to remember, however, that primary health care (PHC) attendees, like clinic patients, are also a special group, not truly representative of the population. Their attendance is determined by several factors quite external to their illness.

The data being presented in the following section are all drawn from our field survey. Comparisons are made only with the urban studies—which had large, properly drawn samples—as rural studies in India are difficult to assess. Davar (1995a) has compiled all the psychiatric epidemiological data in India. She has regrouped much of the data to highlight the gender differences, but the result is not very satisfactory, as she herself points out. Our Calcutta study was not professedly targeted towards women but the women's question was almost a hidden agenda.

Demographic distribution of the sample (13,335 persons) tallied in major respects with the 1971 Census figures. There was near parity in the sex ratio among children and in the over-60 age group. There were fewer females in all the intervening years, the grossest discrepancy in the ratio being 21 per cent in the age group of 46–59 years. Some difference could have been caused by the absence of the wives of the migrant labourers. The sizeable difference, however, leaves no doubt that the missing women were part of the 100 million women in the world who are missing (Sen, 1990).

THE EXTENT OF SEVERE MENTAL DISORDER

Except for mental retardation, the severe bio-genetically caused conditions did not show much gender difference. The overall rates for severe mental retardation were 6/1,000 and for mild retardation, it was 19/1,000 of the child population.[4]

[4] The sex ratios in the child population, as indicated, suggest that female infanticide was not in practise in Calcutta and its surroundings. It perhaps also accounts for the higher rate of severe retardation found in girls. However, the discussions and the data presented must be treated

Mild retardation in girls up to the age of 5 years was almost equal to boys, but it was less in the age group 6–13 years, Epilepsy had an overall rate of 6/1,000 children, which corresponds to that found by the WHO (1978) in the other developing countries. The epilepsy rate in females was lower than in males but it increased after the age of 24 years. The low rates for retardation and epilepsy in India are suspect because of their inconsistency (Desjarlais et al., 1995). Perhaps details of obstetric histories are essential to settle the issue. Maternal factors, harmful to the foetus *in utero* are undoubtedly extremely high in India. The possibility of the defective foetus being easily aborted due to poor antenatal care, lower prevalence of genetically determined conditions, high early mortality, infanticide or benign neglect of the retarded child, particularly the girl child—all these factors existed. However, we found no pointer towards any definite factor. These severe conditions together with conduct disorders and hyperactivity were much lower in girls, a finding in keeping with all other studies in India and in the West.

Severe psychological disorders with strong genetic factors and with poor outcome occur in all communities, more or less to similar extents in both men and women. Biological vulnerabilities probably operate for schizophrenia, but recovery is dependent to a large extent on psycho-social factors (Jablensky et al., 1992). Developing countries have far better prognosis than other countries. The prevalence of psychoses for the whole of Calcutta was 72,400, with a prevalence rate of around 5/1,000. If all closely related diagnostic conditions are also taken into account, then the prevalence rate of

with caution. The havoc female foeticide is creating for demography and the sex ratio is yet to be fully evaluated.

Estimated numbers found in the Calcutta study were 45,000 for severe and 1,32,000 for mild retardation, among the 10 million people of Calcutta. Taken together, these compare well with the number calculated for the whole of India (13 to 16 million), taking the population as 684 million (Prabhu et al., 1985). The prevalence of severe mental retardation is estimated to be two to eight times higher in low income countries. In Western countries, the rate varies from 3–5/1,000 children (Desjarlais et al., 1995).

psychoses comes to 13.2/1,000[5]. We found a higher rate of psychoses in the women (1.06 per cent and 0.49 per cent for the female and male populations respectively). Gross disturbance was more common among males of the age group 14–24 years. Our assumption that the female who is chronically ill will be quiet and manageable at home, and would require minimum custodial care, was however belied.

There were certain types of disordered individuals who never voluntarily sought help nor were brought to the clinic by relatives. Yet they showed disturbance of behaviour designated by us as 'abnormal personality'. Among those with marked paranoid features were mostly women who were usually quiet and asocial, but could be very abusive. The prevalence rates were 8 and 4/1,000 population at risk for abnormal personality and 'paranoid state' respectively. The rates for women peaked at the age group 40–49 years. Paranoia is well-recognised in the community and merits a vernacular term—*sandeho-batik*. It is interesting that anthropologists designate some societies as having a paranoid culture. Belief in the evil eye and witchcraft is widespread in India and the torture and killing of women believed to be witches is also increasingly common. Persecutory beliefs are common among all sections of Bengali society and persecutory symptoms are present in all types of mental disorders (Chakraborty and Bhattacharya, 1985). Murphy (1982) found a historical association between depression and witchcraft—the former appeared with the disappearance of the latter. In the last days of witchcraft in Europe, women had started declaring themselves witches.

Depression coupled with paranoid features is being seen in increasing frequency in my clinic. The symptoms often

[5] This gross figure includes the 'vagrant lunatics', who didn't feature in the sample. Though their total number did not make a difference to the rates, it is important to keep them in mind for future rehabilitation and legislation. The prevalence rate for psychoses in Lucknow was found to be 20.4/1,000 (Sethi et al., 1974); for Ahmedabad, 16.3/1,000 (Shah et al., 1980); and Vellore, 9/1,000 (Verghese et al., 1973). For the sake of interest, the rate of prevalence of psychoses in London was found to be 5.9/1,000 population at risk (Shepherd et al., 1981).

co-exist, or more often, alternate, and they are almost always experienced by young housewives. It is possible that immediately after marriage, young housewives, unable to cope with the rather sudden demands of adjustment and adaptation, feel helplessness, a sense of inadequacy, hopelessness, anger and resentment. These feelings are often overcome with support, or if required, medication; otherwise it may become a life pattern in one or the other mode of paranoia/depression, or both. Some of the housewives cross the threshold and become psychotic, but at what stage and why the resentment and the blaming becomes a delusion is debatable.

Senile psychosis or dementia related to ageing is common enough to merit a vernacular term, *vimroti*. But, because degrees of *vimroti* were not locally recognised, we received only indirect information from the family members about the loss of memory and childish, incongruous behaviours. In addition, such features were more likely to have been reported in the case of uneducated old women than literate men. However, collating other information, a difference between severe and mild disability could be made. The male–female ratio at the age of 60 and over was the same. Severe memory disturbances were found to be 5.3 per cent among the males and 11.2 per cent among the females.

THE EXTENT OF MINOR DISORDERS, PSYCHO-NEUROSES AND DISTRESS[6]

One can say that neurosis is a way of expressing emotional difficulties when the usual ways of resolving them fail. These

[6] I prefer to use the old-fashioned term psycho-neuroses to maintain the ambience of the study as it was done. The term neurosis still carries connotations of the derogatory term 'nerves', as well as, distantly, that of the neurological disorders. Both the terms are going out of psychiatric use and are being replaced by other diagnostic terms. It is interesting that the term 'depression' has begun to substitute all 'mental' terms with the lay public. I have no quarrel with my findings in this section being taken as distress than as rates of disorder or disease. However, as the findings were analysed under certain diagnostic terms, the same are being used.

expressions can be very different in different societies, but there are also great similarities of certain clusters of symptoms. The sense of suffering or distress with the symptoms can be great, but it does not, with some exceptions, make the sufferers lose their touch with reality. Table 2.1 presents the types of complaints made by the respondents in our study. Diagnoses were made as 'probable', as, except for the obsessional states, none of the others were clear-cut, separate entities. The maximum overlap of symptoms was between the anxiety and the depressive complaints, but only the predominant one was given emphasis. For the last category, 'pan neurosis', all types of symptoms were present equally

Table 2.1
Neurotic Complaints and Probable Diagnosis

	No. of Persons (Total N= 9101)	Rate per 1,000 Population at Risk
Major somatic complaints (4–5)	1,226	134.7
Minor somatic complaints (2–3)	1,237	135.9
Sleep disturbances	1,302	143.0
Functional fits and faints (not epilepsy)	179	
Probably hysteria	54	5.9
Complaints of nervousness, tension, restlessness, lack of concentration and worries of recent origin	1,141	
Probably severe anxiety state	95	10.4
Probably anxiety state	167	18.3
Complaints of palpitation, sweating and suffocation; washing and cleaning endlessly; thoughts going round and round; checking all actions frequently; intense fear of falling ill, fainting in the streets, 'mad' people, VD, leprosy, death	487	
Probably obsessional state	78	8.5
Probably phobic state	32	3.5
Complaints of sadness and 'feeling bad' all the time, loss of interest in everything, helplessness and inadequacy	668	
Probably depressive state	363	39.8
Multiple complaints: Pan neurosis	209	22.9

strongly. The major mental disorders described earlier were elicited by questionnaires—Family Report—which were answered by the heads of the families. The minor disorders were obtained by a specially constructed Self Report.

Basic anxiety is a survival mechanism. It is manifested reflexively and instantly in the face of danger, though temporarily. Depression usually results from an enduring anxiety. Depressions, conforming more or less to dysthymic disorder (300.00 of the *DSM*-IV), were far higher in women than in men, particularly at the lower levels. This finding is in keeping with the worldwide trend (Dennerstein et al., 1993).

Sandel's (1982) study examined the problem of whether the depressions we detected belonged to the category of disease or not. She used the standard instrument available at the time—our locally devised ones—and her clinical judgement based on long interviews. Her findings compared well with our larger study. As an answer to Desjarlais' et al.'s (1995) evaluation of our work mentioned earlier, I may say that since the results of the two studies were similar, they 'measured' the same thing. However, whether disease and distress are two sharply different, accurately measurable matters or not, is a question that runs through the present paper.

We consider the disturbed condition of the city to be one of the reasons for the high levels of anxiety and depression. During the period of the survey, Calcutta was going through one of its worst crises. There was a food shortage; youth from downtown Calcutta were engaged in smuggling rice; women were especially worried about the family's next meal.

We did not diagnose somatisation disorders (300.81, *DSM*-IV) or somatoform disorders (F.45, *ICD*-10). We noted the somatic complaints, and when accompanied by psychiatric complaints, these indicated the severity of depression. Western interest in the non-organic somatic complaints came with the large scale immigration of Asians and Africans in the Western countries. At one stage they thought that the somatisers were alexithymic, that is, unable to express themselves in language. In our study (Chakraborty and Sandel, 1985), we have shown that there is no inverse relation between the verbal and the somatic complaints. Those who

somatised much, given the opportunity, verbalised just as much.

For diagnosing 'conversion disorder or hysteria' we recorded only non-epileptic fits. Other forms of conversions had become rare in the city and obsessive compulsive states had become highly prevalent. Hysteria no longer produced the dramatic effect it used to. People had become more knowledgeable about anatomy and illness, and were able to detect the non-serious nature of hysterical manifestations. The exception was hysterical fits, where confusion with epileptic fits was common. These fits were usually found in young girls, precipitated more often than not by trivial incidents. 'Weak nerves' or oversensitivity were often cited by relatives as the 'cause'; the affected were said not to be able to bear bad or sad news. Hysterical manifestations, which often also arise from deep psychic trauma, such as sexual abuse in childhood, were not probed in our study. The rate was about 6/1,000 adults.

Persons undergoing 'possession' would not answer mundane questions of mental distress, even when the episodes were quiescent. We enquired only into the possession by 'good spirits'. Popular belief in the villages has it that possession by evil spirits or '*bhut*' causes madness (Deborah Bhattacharya, 1986). The possessed often acted like oracles; they were respected but not always believed. At the time of our study there was quite an 'epidemic' of these and other types of religious phenomena in the city, affecting 4.6/1,000 adults in our sample. These phenomena have gradually disappeared, suggesting their social origin.

The concept of *suchibai* is very well-known in Bengali society. Purity mania or suchibai, though found among all housewives in varying degrees, particularly affected elderly widows. We found that 17.8/1,000 women were affected by it. The lives of these women were overshadowed by fears of contamination by 'unclean' objects and all their time would be spent in purifying themselves by sprinkling Ganga waters! The compulsive rituals made life difficult for the other family members, who were often completely dominated by the dictates of these women, but the affected persons usually denied that there was anything 'wrong' with them. Some of these

people, who either agreed to the compulsions or whose be-
haviour had reached an extreme degree were diagnosed under
psycho-neuroses as being in an 'obsessional state' (also see
Chakraborty and Banerji, 1975).

All the aforementioned disorders were significantly higher
in women, except abnormal personality (or schizotypal dis-
order, *ICD*-10) which was higher in men. Overall, 22.5/1,000
women were affected compared to 9.26/1,000 men.

SOME IMPORTANT CORRELATES OF COMMON DISORDERS IN WOMEN

Age

Young women were less afflicted by psychoses than young
men. The rates of neuroses increased with age for both men
and women, but the latter had a much higher rate. In women,
there was a sharp rise in neuroses in the age group 25–39
years from the previous age group of 14–24 years, and a rise
of 8 per cent compared to a 4 per cent increase in the next
age group of 40–49 years. The sex difference in prevalence
was highest in the 40–49 age group. In the 25–39 group,
stresses conceivably related to marriage, responsibilities,
adjustments with in-laws, childbirth and other problems spe-
cific to women were operative. In the 40–49 age group, which
I consider the most vulnerable for women, several stressors
were operating. Economic pressures were particularly
stronger here, as the majority of the distressed women were
from the lowest economic strata.

Marital Status

The distribution of marital status in our total sample showed
a glaring feature of social inequity. The number of widows
was disproportionately high, the reason probably being that
Indian men marry much younger women. Moreover, a second
marriage after the first wife's death is customary for men
but almost precluded for Indian women. Taking all disor-
ders together and working out a ratio of the observed to the

expected number of affected persons, the following was found: Single women had less illness (F:M–81 per cent: 108 per cent); in married women, the ratio was almost equal; but in widows it was much higher (F:M–122 per cent: 99.9 per cent). The analysis was standardised for age.

Economic Status

The association of the disorders with economic status was not clear with further diagnostic and gender disaggregation. Statistical significance was reached only when the whole sample was considered together. Some isolated groups, particularly the 40–49 age group, showed strong correlation. On the whole, it appeared that for women, psychoses were somewhat higher in the middle and the upper strata, whereas neuroses were more common in the lower strata. Of the two culture–based conditions, the possession states were absent in the upper strata, but the *suchibai* was higher in the upper caste, upper class elderly women, many of whom were uneducated.

A strong association was found between the lowest economic class, the level of distress and the location. Comparing the poorest living in Calcutta with those living outside the city, it was found that those living outside had much higher rates of distress (the upper class did not show this difference). The suburban areas of Calcutta were under greater stress as this population comprised mainly Bangladeshi refugees. The old Calcutta refugees who came after Partition, in comparison, were more integrated with the mainstream. A 'culture of poverty' (Finney, 1970) did not seem to be present in Calcutta at the time. It was reasonable to assume that poverty per se did not cause illness, but rather the social and other factors associated with or leading to poverty.

Women's Occupation

The lower social classes are always found to be associated with poor mental health. The types of employment are also important in this respect. The health surveys have typically found higher reported illness among housewives than among

employed women (Nathanson, 1980). According to Brown and Harris (1978), unemployment is a potent factor in the onset of depressive illness. For women, employment or unemployment per se is not of significance as compared to the social class related to the occupation. The comparison of the distress levels of housewives with women in employment and in 'other' types or work, is represented in Table 2.2.

Table 2.2
Correlation Between Work and Distress

Occupation	Number	In Percentage	Per cent Affected
Housewives	2,905	71.9	17.1
Employed women	420	10.3	16.4
Unclassifiable* or unemployed	215	5.3	20.9

* Unclassifiable work includes prostitution, beggary, paper bag making, rag picking, and such. Except for some prostitutes, most of these women lived with their families. Women living alone were studied separately.

The high levels of distress among the poorest may be thought to be unremarkable since they suffered high stress with little support from their families. However, our method helped us detect a very vulnerable section among the poor women: the domestic servants, who were the most distressed group. They comprised 2.57 per cent of all occupation groups. Nearly 50 per cent of these were 'part-time', who lived with their families in the slums close to their place of work. The other 50 per cent 'lived in' with their employers. Eighty women in this category were taken out of the sample at the time of the computation because their status could not be fixed. They neither belonged to the family nor did they live alone. Forty-four per cent of these women had high levels of neurotic complaints, much higher than the average rate. Most of them had families in the villages, who often depended on their earnings; often they were separated from their husbands or were deserted. In spite of the better clothes and better food, they were overworked and exploited. Even when they were claimed to be 'almost a family member', their future was never under consideration.

There was a close correlation between economic class and occupational status. Accordingly, psychoses in women were slightly higher in the middle and the higher classes. This finding raised the question whether psychotic women from poorer homes had drifted away or got 'lost'. We had inquired into the 'disappearances' from the family and found some men had become *sadhus*. However, it is possible that the migrant labourers had driven out their 'mad wives' and had suppressed the fact. In jails or in the custody for the 'vagrant lunatics', the number of women were higher. So, this factor perhaps was operative, but was not probably very large in number, going by impressions and other evidence.

Education

The association between education and mental disorders was very strong. For neurosis, it is quite striking that the higher the level of education, the lower the rate of distress than average for women.

Family Roles, Dependency and Neuroses

The joint family system is a hallowed institution in India, much lauded by Indian psychiatrists as most of the studies had shown good mental health in such families. Such 'good' effects, however, may be quite mechanically imparted by the very design of structuring the Indian family. The Calcutta study had an innovative approach to the study of the families. (see Chakraborty, 1990, for a detailed discussion). The premise was that it will reveal more about the elderly, but what we found was more about the vulnerability of a certain group of women.

The families were defined as follows (modified from Conklin, 1968): *Nuclear* (a single, earning member living with spouse and children); *Extended* (the above, with one or more non-earning adults or dependent members living together); *Joint* (two or more adult earning members, other than the husband and the wife, sharing family expenses, irrespective of the other dependent adults); *Unitary* (a single person living on her/his own or in an institution). A severity scale for the

neurotic complaints were later constructed for the family study. It is indicated in Table 2.3 by '+' signs. No diagnoses of neuroses were made for this purpose. The table summarises the findings relating to family roles, economic dependency and neuroses. The heads of the families were the senior-most earning members, usually male, who were always independent (so were the wives or husbands of the head). Non-earning adults were dependent, while earners were independent.

As we have seen earlier, 10–14 per cent of all the women in the different groups had neurotic symptoms. In Table 2.3, all in the 'independent' category fall approximately in that range, except 'mothers'. It is understandable that as heads of families (mostly widows or with infirm husbands), stresses will be great for these women. However, why the other categories such as 'head's wife' or 'head's mother', even when independent, should also be so stressed is not very clear. Dependency as 'head's mother' produced higher rates but not that remarkably. The only conjecture that can be made is that the 'demands' on the mothers, both emotionally and physically, were very great in Bengali families. It is to be noted that the head's daughters or sisters with independent means were less affected, a finding that is in keeping with what has been found among the younger and the single women.

Table 2.3
Family Roles, Economic Status and Neuroses

Roles	Affected (In %)			
	Independent	Severity	Dependent	Severity
Female head	35.2	+++++	–	–
Male head's wife	21.5	+++	–	–
Head's son's wife	10.3	++	–	–
Head's daughter	8.7	++	23.8	++++
Head's mother	25.5	+++	28.9	+++
Head's aunt	–	–	18.1	++
Head's brother's wife	13.5	+++	41.6	++++
Head's sister	12.9	++	15.0	+++
Head's mother-in-law	–	–	50.0	++++
Head's distant relative	14.5	+++	17.6	++++

Several other relations like grandmothers, brothers' daughters and like wise were found to be too few in number, hence excluded from the table.

The most important observation of the study was that dependent women, in whatever role, had very high levels of distress. The roles in this context seem to provide an extra dimension. Dependent mothers-in-law of the heads perhaps had a terrible sense of shame, for social norms anywhere in India disapprove of mothers visiting their sons-in-law, leave alone living there as a dependent. Unmarried dependent daughters may also have the guilt of being burdens. There is no apparent reason why brothers' wives should be so stressed. Their rates of distress were considerably higher than that of the dependent aunts, sisters or even distant relatives. One has to ask whether matters of rights and property were also operating in their case. Perhaps they could not accept their dependent situation, whereas the others were more reconciled to their fate. The study strongly underscores that economic dependency is a potent source for mental ill health in women. The dependent women were not only afflicted in greater number but their sense of suffering was also more acute.

The women in the nuclear families, though independent, were not any happier than those in the joint families, their sense of loneliness and hopelessness were also very great. In contrast, the women who were actually living alone, or in hostels or institutions, did not score any higher than the average women. Joint families are widely presumed to be good for mental health (Sethi et al., 1974; Verghese et al., 1973). The percentage of the dependent members found in the extended families was 40.4 per cent compared to 58.2 per cent in joint families. Since joint families turned up fewer sick persons, in spite of harbouring a high number of vulnerable persons, we have to conclude that this family system does have a protective function. However, it was my impression that joint families often kept their cohesion by extruding the sick member, for example, sending the sick aunt back to the village home (Chakraborty, 1990). In Calcutta, many families consisting of several brothers often lived in the same ancestral house but had separate kitchens. Sandel (1982) found some interesting features in such families. Whether the different members considered themselves as one family or not—often there were bitter quarrels among

the brothers—close proximity of elders was strongly desired by the young housewives. The emotional dependency of Indians on their elders is graphically described by Sandel:

> Middle and lower status respondents from nuclear families most commonly reported feelings of anxiety at the lack of an older person in the house. Older women seemed to provide a sense of reassurance and act as confidantes and advisers to younger wives, since very few even in the upper 'liberated' classes saw marriage and the husband as providing support of this sort. This is so common as to be part of the culturally determined set of expressions of the roles within a marriage rather than a manifestation of poor marital relationships. That the older family members fulfil this role in a joint family, is seen in the statements of both women and men, often well into their late middle age of feeling bereft at the death of father, mother or older sibling [Sandel, 1990: 105].

The causal effects of life events on the psychiatric disorders have been noted by various authors (Brown and Harris, 1978). Sandel (1982) studied the life events and the difficulties (sustained effects of events) in a field study of neuroses in 200 Bengali women. The cases of neuroses found among them were compared to the cases attending the psychiatric clinic of a postgraduate institute. In her study, formalised schedules and ratings were applied to cover

> ten areas of experience including personal health, bereavements, separations as well as enquiries about stresses relating to children and the family Emphasis was placed on certain features which were expected to affect women in particular—family: employment outside the home with reference to prejudice or discrimination against working women, and the extent of conflict between traditional mores and modern roles; interpersonal relations within the family with special attention to the delegation of authority and responsibility; conflicts between traditional and modern attitude to marriage, dowry and intercaste unions; conflicts pertaining to child-rearing and motherhood (Sandel, 1990: 157).

A special feature in drawing up her schedule was the spontaneous information provided by the patients linking their illness to events. These were also obtained from the old case records of the clinic and from the data sheets of the Mental Health Survey (CMDA, 1983). It was presumed that the personal stresses or the stresses within the family will be expressed as psychological distress and symptoms, an assumption which was belied. The associations between the stressors and the symptoms were not that strong. Sandel's study suggests that while discussing mental ill health, we should look not only for vulnerabilities and stresses but also for coping mechanisms and protective factors.

Coping is said to be culturally learnt (Murphy, 1982). The various and diverse modes of allaying anxieties and coping with them are built into the traditional cultures. These include pujas, rituals, talking to elders, going to pilgrimages. Social support exists in traditional cultures in various diffuse ways, which is now disappearing because of social change, leaving women more vulnerable. Basically, coping implies acceptance, adjustments and compromises, while holding on to one's own affirmed role and identity. There is in coping a sense of active and passive resistance, a battle without hostility. In domestic settings it comes to mean acceptance of moral injunctions and demands of self–sacrifice. However, some inborn capacity to withstand physical anxiety seems to be necessary. Sandel (1990) found that individual predisposition has a significant role in producing case level severity. Intensity, severity and personality factors were stronger in her clinic cases, whereas events and difficulties were less. However, women's vulnerabilities without a thorough examination of the social structures are suspect these days.

CROSS-CULTURAL PSYCHIATRY AND MENTAL DISORDER

Certain features of mental ill health in women in terms of conventional psychiatric disorders, based on the Calcutta study, have been outlined above. The cross-cultural psychiatrists, even with much effort, have not been able to initiate

an interdisciplinary discourse. My attempts to find local idioms and concepts during the field study revealed nothing more than what we already knew. The disappearance of indigenous ideas—barring general health matters to some extent—are rather widespread in India. It is, therefore, correct to say that mental disturbances take certain forms irrespective of terms or models. In certain situations, through the complex interaction of internal and external stresses, a person reaches a state when she exhibits out-of-the-way behaviour which is usually disapproved of by all societies everywhere. However strange her behaviour might appear, she has a limited range to choose from. There can be the broadly similar schizophrenic pattern or a loss of vitality of the self/ego or depression (Scharfetter, 1995), as well as the less virulent forms of psychoses and other strange behaviour and moods, which find parallel in different cultures. Unusual and socially disapproved, they are, all the same, recognised, named and explained variously in different cultures. Some of them can be seen as culturally sanctioned stress-containing mechanisms. Among such forms are the paranoid and obsessional states. The high prevalence of paranoid manifestation with the ambience of paranoid beliefs and ideation, and high rates of obsessional states, were noted in Bengali culture. Bengali culture has always been permeated by unending rituals, festivals and community pujas. Pollution rules, closely related to the idea of the sacred, are almost ubiquitous among Hindu Bengalis. We found that 96 per cent of the Bengali families observed some pollution rules (Chakraborty, 1990). It seems that culturally known phenomena that occur insidiously are considered to belong within the spectrum of social norms. Acceptance renders them innocuous, explaining the high rates of the above two conditions.

Possessions and hysteria had always been and still are synonymous with women. The 'cause' for hysteria is usually sought within the person's self or in her immediate family environment. Possession, because of the involvement of an 'outside agency', is also being studied for its personal dynamics. There had been reports of 'epidemics' of possession where, many women in a village in the vicinity of a target

case became afflicted, suggesting that imitation, suggestion and conscious choice precipitating unconscious mechanisms were operating. Such studies have revealed the complex interplay of gender, power and personal significance. Wide public manifestation of possession and other dissociative states may possibly have genesis other than that played out within the family and the village.

The Calcutta 'epidemic' was a little different, for the disorders were scattered throughout the city. Large numbers were affected, a majority of them being women, but there were also some men. Through the 60s to the 80s, Calcutta experienced a socially deep disturbance, where, in addition to anxiety, uncertainty and a charged political atmosphere, there were also waves of religious cults—such as the Cargo Cult (Chakraborty, 1971)—which swept through the city. An openly religious wave started later, what with the hippies arriving in hordes in Calcutta at about this time. When this wave of religious fervour died down, so did the possession phenomena. In another strange episode in Calcutta, in the late 80s, the operators in the telephones departments started getting 'shocks' through their headphones, resulting in fits and unconsciousness lasting for minutes to hours, and for some, days and months. The instruments were not faulty, but at the time, there was fear of a massive retrenchment due to the conversion of the telephone system to automatic transmission. This phenomenon affected only women[7].

It is seen that massive dissociative[8] phenomena can be provoked by socially generated tensions, anxieties and fears.

[7] Men are not immune to such 'mass hysteria'. The phenomenon of *koro*—the fear that the penis is shrinking and disappearing—occurred in a massive epidemic form in north Bengal and Assam in the early 80s. Some cases of breast shrinking panic were also present (Dutta, Phukan and Das, 1982).

[8] Dissociation of consciousness is a concept introduced by P. Janet: 'dissociation' or disaggregation of consciousness was essentially a failure of integration of different elements of consciousness producing either a disturbed or restricted sense of personal identity or a restriction of conscious awareness to certain themes of immediate emotional importance in a setting in which memories of past personal events were often inaccessible (Kendell, 1983: 235).

In such situations, the possession state seems to occur in the dissociated consciousness and not in embodied femininity, as discussed in Kalpana Ram's study (in this book). Ram refutes the 'deprivation' theory, but it deserves some merit: The exclusion of women from the public realm and the male control of power render her insignificant and useless. Some deprived women (and also socially lower level men) harbouring a sense of personal injustice which they have silently tolerated, or being of a more assertive and aggrieved personality, possibly find these socially approved religious 'outlets'— to be let out from the confines of the body and a restrictive society—'heaven sent'! Our cases of possession were all invariably identified as *Thakur-bhar* (possession by a deity) and, to the afflicted as well as to their relatives, it was a 'gift of power'. '*Thakur* had given her *sakti*', they would say, leaving the gender of the deity unclear. In the case of the women telephone operators, it was natural for them to think that they were the most expendable group. High powered technical jobs, as automation signifies, were 'naturally' not for the women.

Evoking choice or rational action to explain 'irrational' and unconscious phenomena remain problematic, as Ram argues. A certain level of dissociation of the self from full self-consciousness is quite commonplace. We do that all the time when faced with unpleasant situations or with great physical discomfort, but its dysfunctional nature may be admitted. The growth of self-psychology provided a different understanding of the dissociative phenomena, suggesting that it is not only the split or the dissociation of consciousness, but also the creation of a whole new self. In earlier understandings, the self, ego (in varying senses), the mind, or the consciousness had no solid existence. They 'existed' in the void as a 'text' (Kirmayer, 1992). Recently, however, the body has been placed firmly on the centre stage. The women's question is inseparable from these developments in the social sciences which have foregrounded the body.

Women in the West are constructing their body in a definitive fashion, in keeping with their individualistic culture. Their bodies are within well-defined boundaries with distinct personalities. From the general body-oriented ambience of

the West, the phenomenon of the ever new creation of the body/self, of rebirth and transformations, is being labelled sickness and has become socially ridiculous. Dissociative phenomena, without deserving labelling, may be seen as protest by the woman against the bio-politics of the body (Scheper-Hughes and Lock, 1987) that had gone on for so long. Having no power or control over her body, she had lived perforce in a disembodied state, her femininity constructed around that split. The only way that she could undo it all was to construct a fully embodied self, with a 'matching' personality.

Indian selves, and perhaps all eastern selves, are usually unindividuated and remain within the family and the kinship (Hsu, 1985; Roland, 1988). At a philosophical level (Bharti, 1985), the body, in Indian thought, is only a coarse (*sthula*) part of the self/mind (*jiva/atman*). Its boundaries are basically permeable (Hoch, 1993). Not only can the great sages—and also the lesser deities—come and go from their bodies at will, they can also take an ordinary mortal self out and return it back to the body. So, on the one hand, not being in one's body (disembodiment) is not so incredible for an Indian; on the other hand, in the social context, she finds herself only in other bodies. In spite of a repressive patriarchy, Indian women do not suffer from a primary disembodiment. A great many Bengali women remain in a kind of dissociated state quite habitually, resulting in both being-in-the-body and not-being-there-at-all, that is, both somatisation (taking all the anxiety in the body) and dissociation (as if nothing is happening or it's happening to somebody else!) exist simultaneously. For the Bengali women, a disembodied existence is a sustainable state. This state is a means of coping. Disembodiment does not make her unfeeling; her habitual body feels all the joys and the sorrows, except, that her coping device is always ready at hand. However, she pays a price for it. It is inefficient; at moments of crisis, it may fail; it prevents growth and a fully embodied living. It must also be noted that I do not consider somatisation as a definite category of disease. 'Somatisation may be studied as a cognitive style, a sociosomatic language, a negotiative strategy and a basic way of being in the world' (Lee, 1996: 26). For a

communication to concretise into a statement of distress, or a symptom, or a cry for help, a social context is required. Somatisation became a psychiatric category because the Westerners did not have this kind of language for expressing distress, nor the social context where distress could be enacted. Hardly any such 'cases' are seen among the white males (*DSM*-IV, 1994), and so it has become a 'third world' disease, 'alexithymia', etc.

Dissociation may be seen as the pathway for both dysfunction as well as coping. Paris (1996: 63) discusses Kirmayer's recent argument that dissociation is better understood as a process than a discrete group of disorders (also see Merskey, 1992). Depression may also be understood in a somewhat similar fashion, if one follows Littlewood (1994). Several dimensions of commonly experienced mood or affect, anxiety, misery, unhappiness, indifference, resentment, inadequacy, hopelessness, anger and such, admittedly often without any apparent or conscious cause, fluctuate and interchange considerably over time. Any pattern of mood depends on the immediate or the larger social context; the permissibility of expression, and the possibilities of redress. To force them all into one container and to label it as 'depression' is a mistake. Lower class, poorly educated women react to adversities more often with 'drained out' feelings of hopelessness because they have the least power or the possibilities of changing anything. As to the question whether the women cause the depression or whether depression happens, Littlewood writes: 'Each "it" is rather different sort of thing, disease process (or intruding spirit) versus duplicitous masquerade' (Littlewood, 1994: 16). Further, the question can be seen 'dualistically' through a 'cause-effect naturalistic mode of thought;' it can also be seen 'personalistically' through a 'motivated action of agents', he concludes: '[N]either can be demonstrated as completely true, nor false; we always live with the two options' (Littlewood, 1994: 17). The answer to the question why women suffer from mental ill health in such numbers must also be sought in the way patriarchal societies make meaning and define reality for women. It is the women who are forced to adjust to a time-warped, fast changing, competitive world without any means of controlling

it. I do not think that all mentally disordered women are rebels or protesters, yet, in a great many ways they do protest and defy the male controlled orderly world. Then again, they also try to find order within that world by punishing themselves and declaring themselves 'witches' and 'sinners'. Overall, I agree with the authors who hold that women cannot be taken as passive victims of oppression. They resist, make space for themselves and wield considerable power and control in their micro-worlds (M. Bhattacharya, 1989/1990; Lerner, 1979; A. Sen, 1987). The analysis of women's situations at different times and in different cultural ambience are important and necessary. Understanding how women construct their selves also reveals the stresses they encounter. The processes and issues involved are more *psychological* and less *psychiatric*.

III

GENDER ISSUES IN MENTAL HEALTH: A CLINICAL PSYCHOLOGY PERSPECTIVE[1]

Anisha Shah

This chapter approaches gender issues through a matrix of perspectives available to the field of clinical psychology. I present this more as on overview of the theoretical developments and research-related issues over the last two decades or so, and not as a comprehensive review of the field. This is done with the hope that it makes the field and the professionals in it aware of the challenges emerging from gender issues. The stability of the theoretical constructs is an issue before all academicians. However, every profession's identity undergoes changes with time. I bring to you that new face of clinical psychology which is being painted by the various professionals whose work is being mentioned here. Maybe, many will find this identity more promising, and maybe it will open new windows for more interdisciplinary activities.

In the historical development of this area, Chesler's *Women and Madness* (1972) stands out as an excellent commentary on its status in the 60s and 70s. She speaks as a feminist, a psychological researcher, a theoretician and a clinician in the book. Most of the issues addressed by her are still of contemporary relevance in the feminist psychology literature. It has also provoked research on gender bias in mental health. The classic study by Broverman et al. (1970) has also had a similar effect. They highlighted how the abstract

[1] An earlier version of this paper was presented at the National Seminar on Indian Women and their Mental Health, 23 and 24 February 1996, Anveshi, Research Centre for Women's Studies, Hyderabad.

notion of health tends to be more influenced by masculine stereotypic characteristics than by the less valued feminine stereotypic characteristics. The study concluded that healthy women must accept a less desirable and a less healthy pattern about mental health than a mature adult. This turned out to be a controversial conclusion and the subsequent literature reviews agree on some points: Research that demonstrates gender bias is often based on anecdotal or political material and not on sound research; crucial findings should not be concerned with the attitudinal characteristics of therapists, but the effect of those attitudes on interventions and outcomes; to understand these relationships between gender, therapist's attitude, diagnosis, prognosis, the psychopathology assessed, and the goals of therapy, gender may have to be examined in interaction with a number of moderator variables (Stricker and Shafran, 1983).

Nevertheless, a vast research database has been created over the last two decades that addresses gender issues in the psychiatric setting and in the practice of psychotherapy. Simultaneously, new theoretical formulations are being offered, though the material in this area is comparatively less. It is also a fact that currently there is hardly any literature from India that addresses these issues directly. Yet, I find that the Western literature is thought provoking and touches those dimensions of the field of clinical psychology which might be universally acceptable. That is why I have not hesitated to use the international literature in two-thirds of my paper. The emphasis here is on the elements that get activated when women present with psychiatric illnesses in the clinic.

However, there are a few points that I would like to make here as caution against the use of 'mental illness' as an index of the mental health of any group. Simply dealing with disturbed behaviour, its aetiology and treatment is not sufficient to reveal all aspects of mental health. The definition of mental health can be very wide and cover all that promotes the absence of pathology, or it can be narrowed down to only those aspects of human behaviour that approximate the qualities of an ideal human being. These issues will have to be addressed in the women's mental health agenda too,

though these are not reviewed in this presentation. The following sections address: (*a*) the link between gender and the psychological frameworks that are utilised in the clinical setting in order to comprehend pathology in women, as well as the gender-sensitivity they lend to various intervention strategies; (*b*) depression in the Indian context; (*c*) the magnitude of psychological gender differences and its relevance for the clinical setting; and (*d*) the research guidelines to encourage non-sexist research in psychology and clinical psychology in order to allow the emergence of more gender-sensitive theoretical formations.

GENDER IN PSYCHOLOGICAL THEORIES AND THERAPIES

The psychological theories utilised in the clinical setting are: psycho-dynamic theories, cognitive theories, behaviour theories, humanistic–existential theories and family systems theory. Psychological theories embody gender in one way or the other. Hare-Mustin (1987) categorises these into theories that exaggerate gender differences and those that minimise gender differences, i.e., demonstrating alpha bias or beta bias respectively. In an alpha bias, 'male' and 'female' are viewed as different and opposite, and thus, having mutually exclusive qualities. The author proposes that this view is present in both the Western and the Eastern philosophies. A beta bias occurs in ignoring the differences between men and women even when they exist.

According to Hare-Mustin's (1987) view, alpha bias is most readily seen in the psycho-dynamic theories and therapies. This is evident in the Freudian view of holding male anatomy and masculinity as the standard and femininity and female anatomy as the deviation. The Jungian concepts of 'anima' and 'animus' place the masculine and the feminine in opposition. Erikson holds that the female identity is predicated on an inner space which harbours a biological, psychological and ethical commitment to take care of human infancy. The male identity is associated with outer space which involves intrusiveness, excitement and mobility.

Psycho-dynamic theories have originated from psycho-analytic movements. Psycho-analytic theories have been criticised for using a pervasive double standard of mental health: men should be active, women passive; men should dominate and women be dominated; men are strongly influenced by their work, women are not. These gender-related patterns were presumed to be natural and desired (Murray, 1983). These conceptualisations have had a widespread effect on the current practice of psycho-dynamic therapies.

Hare-Mustin and Marecek (1988) hold the following views of the recent developments in psycho-dynamic theories. The feminist psycho-dynamic theories of Chodorow (1974) and Gilligan (1982) emphasise women's special nature and the richness of their inner experience. This has contributed to a movement that celebrates the special qualities of women. Chodorow's work is based on the object relations theories and sees the girl's identity as based on similarity and attachment to the mother, and the boy's identity as based on separateness and independence. These are theorised to give rise to the broad-ranging gender differences in personality structures and the psychic needs in adulthood. Thus, this view proposes a basic gender difference rather than holding the social structure to be responsible for gender differences. Gilligan (1982) proposes that the female identity develops from connections and relationships and that female morality is based on an ethics of care. Gilligan, however, views these differences in a positive light.

According to Hare-Mustin and Marecek (1988), beta bias is less prominent in psychological theories. I, however, propose that many of the therapies originating from cognitive theories, behaviour theories and humanistic–existential theories have beta bias. These appear to be relatively gender neutral. The therapies originating from these set up goals that do not take gender into consideration. To that extent, these are gender fair approaches.

The cognitive and behaviour therapies aim to groom men and women in certain patterns of behaviour and thought. The social context is largely ignored for its differential impact on male and female behaviour. It is presumed that certain types of behaviour will elicit the same reactions regardless

of the sex of the person. The principles of learning and con-
ditioning are important for understanding behaviour; how-
ever, the goals of these therapies do not differ in content for
men and women. Social skills training, assertiveness training,
correcting irrational beliefs, all have uniform applicability
across gender. Where social learning principles are relevant
for therapy, the attempt is still to minimise the importance
of gender differences.

The therapies originating from humanistic-existential
movements attempt to view persons as human beings deal-
ing with certain realities. The search for meaning and self-
actualisation is important for all individuals. The realities of
men and women are not that different. Thus, these therapies
aim for such patterns for all individuals and they also seem
to be minimising gender differences. To that extent, gender
neutrality is reflected in these approaches that could be
termed as beta bias rather than alpha bias.

According to Hare-Mustin (1987), theories that represent
male and female roles or traits as counterparts also exhibit
beta bias. Bem's theory of androgyny (Bem, 1975; Bem,
Martyna and Watson, 1976) views a balanced or healthy
personality as an integration of masculine and feminine quali-
ties. A therapeutic aim towards such a personality can en-
courage a gender-neutral therapeutic process. A theory of
psychological androgyny implies that counterparts have sym-
metry and equivalence, and it obscures the differences based
on power and social value. Hare-Mustin and Marecek (1988)
see beta bias in the systems approach to family therapy that
is based on systems and structural theories of Haley and
Minuchin. According to them, there are four primary areas
along which hierarchies are established in all societies: class,
race, gender and age. Within families, class and race are
usually constant, but gender and age vary. Family systems
theory is seen as disregarding gender and viewing genera-
tion as the central organising principle. Thus, it ignores the
fact that though the mother and father may belong to the
same generation, they do not necessarily hold comparable
power and resources in the family. Further, Hare-Mustin
(1987) points out that women's depression is often associated
with mindless and unappreciated routines of housework. The

permeability of boundaries between work and family is in opposite directions for men and women: That is, women are evaluated negatively as workers, but men can take work home or use family time to recuperate from occupational stress. Some research findings on family are not assimilated in family therapy, such as: It is fathers more than mothers who teach gender stereotypes to both boys and girls; children grow up to expect their fathers to be absent, but freely express their anger at their mothers for being absent; and the formulations of dominant mother/ineffectual father in every serious psychological disorder is often made by ignoring the responsibilities assigned to women in the family.

In general, Hare-Mustin and Marecek (1988) consider alpha bias in theories as masking the inequality between men and women, as well as the conflict between them. In their view, theories that construe rationality as an essential male quality and relatedness as an essential female quality conceal the social origins of these, particularly the gender-related inequalities and power differences. Women's concern with relationships may be a need to please others which arises due to lack of power. The feminist psycho-dynamic theories are underplaying the influences of economic conditions and social role conditioning.

In viewing men and women with mutually exclusive traits, certain errors occur, for example, one ignores how child-rearing in women also reflects achievement, and how nurturing involves power over those in one's care. However, alpha bias theories have also asserted certain feminine qualities positively. A focus on women's special qualities has led to a criticism of the cultural values of aggression, self-interest and individualism. In theories with beta bias, postulating zero difference between men and women ignores women's special needs and the distribution of power and resources between women and men.

Feminist therapy has come into the picture wherein the therapist should act as an agent of social change, increase the woman's awareness of socio-political pressures, support her legitimate anger, encourage respect for herself and other women, help her to recognise her choices, and change the context of her life (Hare-Mustin, 1983). Similarly, family and

marital therapy is addressing gender norms and contradictions created by gender polarity, and attempting to incorporate a gender-sensitive systemic view of families (Sheinberg and Penn, 1991; Storm, 1991). Experiential exercises involving learning about gender from one's own family, or origin, culture and gendered interactions in professional life, as well as gender questions for clients, have been developed (Roberts, 1991).

When dealing with a female patient, the psychological theory that the clinician uses to comprehend her problem will largely determine the gender-sensitivity that the treatment will demonstrate. The current debate about whether the sex role stereotypes that the clinician/therapist holds influences the treatment choices is still unresolved. In general, any form of stereotype in the clinician/therapist's behaviour with a patient is detrimental to the patient's recovery (Stricker and Shafran, 1983). To that extent findings about the therapist's attitudes and stereotypes need to be made use of in the course of supervision of therapy. So far, research has not conclusively demonstrated differential treatment of men and women by therapists (Murray, 1983). In planning therapy goals, the therapist may not very easily be seen as an agent of social control or of social change. Only in practice, can the therapist assess an individual's capacity for change and determine whether social change is possible through her. However, the therapist cannot make social change a primary agenda. The therapist has to work through the patient's needs for conformity and acceptance, and the conflicts of these with her growth-oriented needs.

The theoretical orientations that influence the therapy process, thus, determine how gender emerges in therapy. The choice of these orientations with a woman client will be determined by many factors, not necessarily related to the client being a woman. These are, the clinician's preferences in psychological theory, the training in different approaches, the mastery over varying therapeutic techniques, an awareness of new approaches that emerge with a changing social context, as well as the client's illness-related factors.

However, in general, one does see that some of these therapy approaches are used less often than the others, e.g.,

existential-humanistic approaches are practised less often, though they have established usefulness of certain con- cepts—empathy, warmth, unconditional positive regard—in therapeutic relationships across all orientations. This may again be a function of the trainability in certain approaches being better than others. Under all these approaches dis- cussed above, the extent to which gender-based power re- distribution or resource redistribution can be achieved with therapy is limited. It appears most feasible in the family and marital therapies, as here, a system of family members is directly available to facilitate change. In individual psycho- therapies, it can be explored, but actual change would still be a function of the woman's social reality and her capacity to demand changes, which itself calls for strengths in the personality. Thus, the search continues for more gender- sensitive intervention strategies.

DEPRESSION

Women's mental health can be addressed through various perspectives. Mental health professionals are examining it through issues like physical and sexual violence, stress and coping patterns, and reproductive functions. Many are un- ravelling it through the distribution of various psychiatric illnesses in men and women. In clinical practice, it is often the presentation of symptoms and the diagnosis that influ- ences the clinician/therapist to decide on a certain line of management. In my clinical practice, I have found many of these psycho-social issues emerging when dealing with de- pression. Thus, this section reviews the current status of these issues in relation to gender.

The relationship between depression and gender has gained prominence in international literature since the 70s. Reviews suggest that for the past 30 years women all over the world have experienced depression twice as frequently as men (Culbertson, 1997). In the West, it is also the most prevalent women's health problem (Dennerstein, Astbury and Morse, 1993). Reviews of epidemiological studies in India

also suggest its prominence in the Indian women (Davar, 1995a, Kapur and Shah, 1992, Nandi, 1988). In the inter-national literature, the explanations for this come from bio-logical factors, social effects of life stress and the lack of social support.

Psychological models explain depression through many conceptualisations, such as:

1. Under certain circumstances, people behave in a manner where their behaviour is reinforced; but when circumstances change too drastically, it results in a loss of behaviour, i.e., depression.
2. Inability to discover the characteristics of the envir-onment due to: (*a*) a limited view of the world; (*b*) a 'lousy' view of the world; and (*c*) an unchanging view of the world.
3. A repression of behaviour that was punished, that in turn prevents positive reinforcements.
4. Depression as an adaptive function for: (*a*) social com-munication; (*b*) physiological arousal; (*c*) subjective awareness; (*d*) psychodynamic defense/protection for the ego.
5. A 'depressive personality' characterised by: (*a*) a de-pendency on a dominant other; (*b*) a fear of autono-mous gratification; (*c*) an establishment of a bargaining relationship, by seeking nurturance from the dominant other, for denying oneself an autonomous satisfaction; (*d*) an inability to alter the environment (Friedman and Katz, 1974).

Other theoretical explanations offered are: restrictions placed on female sexual expression, power and personal free-dom; conflict over the role of child-rearer and the need for self-development; women's concerns with relationships; learned helplessness and explanatory styles in women, along with more helplessness training, received by them over a lifetime (Nolen-Hoeksema, 1987).

The most important contribution towards understanding the social origins of depression has come from the work of

Brown and Harris (1978). They view depression as a central link between many kinds of problems—those that lead to depression and those that follow it. The four vulnerability factors identified in this research are: early loss of the mother (before 11 years), the lack of a confiding relationship, the presence of three or more children under fourteen, and the lack of employment. The causality between self-esteem and the four vulnerability factors could work either way, according to Brown and Harris (1978): E.g., women low on mastery may choose not to work outside home, or fail to restrict family size; a low self-esteem may make them accept an unsatisfying marriage for fear of not finding anyone more suitable. The authors suggest that depression can be best understood in terms of the contribution of the current environment relative to the other influences. The vulnerability factors may be evident for many women, but the current environment with new role identities and opportunities to find new sources of positive value can lessen the risk to depression. They also propose that the vulnerability factors and provoking agents are interchangeable in terms of the production of depression.

The role of interpersonal relationships in the aetiology of depression in the Western literature has shown that marital discord and depression are associated. Beach and O'Leary (1986) found a 50 per cent overlap in the samples selected with marital problems and the samples selected with depression. They suggest that as couples become increasingly discordant, their relationship becomes more negative and they start making negative judgements about each other. If individuals have low self-esteem and strong dependency needs, the negative thoughts and feelings about the self and the relationship generalise rapidly to other areas, precipitating a depressive episode.

While the research is still young and definite conclusions are not emerging yet, many studies have found evidence of gender effects in the relation between marital distress and depression. Barnet and Gotlib (1988) report a longitudinal study on male and female patients and their spouses. Both the groups had lower marital satisfaction compared to the normal subjects. However, following recovery, the couples

with depressed wives reported no significant improvement in marital satisfaction whereas couples with depressed husbands reported significant improvement. Other studies have pointed out important clues: Wives' depression scores correlate with husbands' marital adjustment scores; in discordant couples, wife's depressive behaviour suppresses husbands' aggressive behaviour. Research from marital therapies also encourages us to examine the potential effectiveness of marital therapy in the treatment of depressed patients.

Research on interpersonal relationships has demonstrated quite effectively their potential to create positive mental health as well as cause anxiety, anger and depression. Interpersonal conflicts, and problems of self-disclosure and intimacy may result in poor self-esteem due to comparisons, enmeshment, loss of autonomy and a fear of abandonment. In India, research on this area has been going on over the last almost three decades but the number of studies are few and the number of variables examined very large. However, some of the findings can be shared here to stimulate further conceptualisation and research, though this is not aimed at a comprehensive review of all Indian research in the field. Ansari (1969) reported that incidence of depression is more in married females than others. Bagadia et al. (1973) conducted a prospective study in a general hospital setting and they found high incidence of depression in the widowed, the divorced and the separated groups. While some research studies on cognitive distortions and depression are reported, their findings do not emphasise any gender-related pattern. Harsh (1989) has examined depression in women in relation to lifestyles and sex role orientations.

However, when one approaches the area from the other perspective of interpersonal relationships and depression, some research studies address gender issues partially. Most of the research has focused on marital disharmony in neurotics, in which depressed men and women often form one of the larger subgroups. Thus, one can extrapolate further from these findings. A review of seven research projects carried out in the Department of Clinical Psychology, NIMHANS, over the last two decades (Shah, 1997, unpublished observations) shows certain patterns:

1. Marital quality can be comprehended through the following dimensions: understanding, rejection, satisfaction, affection, despair, decision-making, discontent, dissolution-potential, dominance, self-disclosure, trust, and role-functioning (Shah, 1995).
2. Poor marital quality is associated with the presence of depression and family pathology. Further, there is some evidence suggesting that wives experience a poorer marital relationship compared to husbands.

I would like to present three of these researches in detail as they offer certain insights on gender issues. In an extensive study on the predictors of marital discord (Mayamma and Sathyavathi, 1985, 1988a, 1988b), marital disharmony in neurotics was predicted by—a disturbed communication, affectional discrepancy, presence of an only child or no children, frequent conflicts, and less education. Marital harmony in normal couples was predicted by—a healthy communication; relatively more affection given; less marital role strain; the family life cycle stage, where the eldest child is over 6 years of age; less domination by the husband; more egalitarianism; and less affectional discrepancy. Thus, a further examination of these factors in depressed women may help in narrowing down the factors. Therapeutic experience suggests that examining affectional expression, role expectations and strain, dominance/submission patterns in marriage, may help identify and understand gender differences in depression.

In a research on relationship attributions and marital quality in couples with depressed wives (Gaonkar, 1995), some interesting findings are reported. The non-clinical couples' responses showed evidence pointing to the possibility of gender differences in males and females on relationship attributions of the relationship-related positive and negative events. The husbands showed a tendency to attribute problems in marriage to personality factors in the wives, and wives showed a tendency towards self-blame. Gaur (1996) studied the same variables in women with depression, and women with a psychiatrically ill child and referred for family interventions. The finding showed many similarities in both the groups:

1. Both the groups of women were similar on the level of depression rated.
2. The marital quality was poor, with lower satisfaction with marriage and a high dissolution-potential. Both had problems with role-functioning, poor self-disclosure and trust. The depressed women had significantly poorer trust in their spouses compared to the other group.
3. Further, 60 per cent of the depressed women had disengaged from their families, suggesting a poor family cohesion.

Future research on this topic may need to specifically examine the gender-specific relationship needs and its link to depression versus the other emotional disturbances. Basic research for understanding the relationship structure existing in our culture can also help document where men and women differ. Apart from interpersonal relationships, research also needs to identify the other vulnerability factors for depression. Literature review, as well as therapeutic work with the depressed women and their families suggest certain hypotheses that could form the focus for future research:

1. The loss, or the threat of loss of a current relationship like marriage may often be sufficient to cause depression in the absence of past influences because it often implies the loss of any intimate, heterosexual relationship in future. This seems to be linked to society's marginalisation of separated women.
2. A married woman may have a confiding relationship with any member of the family and this intimacy may be more than the intimacy shared with the husband. This may be a very common protective factor where a marital relationship may be low on intimacy.
3. The lack of employment may not be an important vulnerability factor, rather other sources of self-esteem, like a sense of achievement, the self-image, the significant other's responses to one's behaviour and the status and power given in social relationships, may be crucial.

4. The relationship between employment and depression may be much more complex and may depend on the social class, the reason for employment, the family members' attitudes towards working women and the social support available for carrying out dual roles.

From this narrowing of gender issues in a specific condition, I would like to move on to a broader review of psychological gender differences, and then end the chapter by thinking about research guidelines.

THE MAGNITUDE OF PSYCHOLOGICAL GENDER DIFFERENCES

Throughout this century, research in psychology has been examining the sexes. In fact, sex has been one of the core socio-demographic variables for which most research findings in this field are being documented. This holds true across the various disciplines of psychology—cognitive psychology, social psychology, personality psychology, and experimental psychology. However, systematic efforts to draw conclusions on gender differences started only in the 70s (Eagly, 1995). The genders have been compared on a variety of psychological variables. Psychological constructs are constantly being refined in the ongoing research and the current status of these constructs often influences the clinicians. Quite often, when dealing with the female patients, the theoretical constructs from the disciplines of personality and social psychology research are likely to find a place in the formulation of psycho-pathology. These would often also be used to examine the response to certain types of interventions. Keeping this relevance in mind, this section looks at the magnitude of psychological gender differences examined over the years. Some of the concepts that have received attention from this angle can be broadly categorised into:

1. *Specific functions*: spatial ability, mathematical reasoning ability, intelligence, motor activity and cognitive abilities.

2. *Interpersonal behaviours*: verbal abilities, self-disclosure, influenceability, social behaviour, helping behaviour, leadership styles, aggressive behaviour, empathy, non-verbal behaviour (smiling, gazing, and touching) and group performances in task groups.
3. *Personality*: personality development, competence, achievement motivation, emotionality, self-fulfilling prophecy, positive well-being, life satisfaction and happiness.
4. *Sexual behaviour*: sexual preferences, selection of mates, sexual strategies, sexual stimulation, romantic attractions and sexual orientation (Lott, 1985).

In the last two decades there have been various meta-analytic studies that have attempted to answer whether the gender differences really exist on these factors. There is very little consensus about gender differences on the whole (Buss, 1995; Eagly, 1995; Marecek, 1995). Reviews two decades back were able to agree only on a few factors: sexes were seen to differ in intellectual abilities (verbal, quantitative and spatial abilities) and on aggression. Evidence on some of the other aspects of social behaviour was found to be inconclusive. Also many classes of human behaviour were not significantly different for the two sexes, despite the cultural stereotypes existing in a widespread way.

Currently, the review suggests that there are certain sex differences that seem to be established and they require attention in planning intervention with men and women. Eagly (1995) finds that more substantial sex differences in favour of men are on visuo-spatial ability, whereas differences favour women on verbal fluency. Research on most general categories of behaviour shows large differences in some studies, smaller differences in most studies, and a few studies yield a reversal of the typical direction of difference. Hyde and Plant's (1995) review finds these patterns in the areas of moral reasoning, non-verbal behaviour, patterns of interpersonal touching, and other interpersonal behaviour, e.g., men interrupt women more often. The proposed differences in cognitive abilities, mathematical ability and verbal ability have not found consistent validation in research.

Interestingly, Hyde and Plant (1995) find that amongst all the factors examined for gender differences, 25 per cent show close to zero effect size, 10 per cent of the factors show large effect size and only 3 per cent exceed 1 standard deviation. This finding, that 25 per cent of factors examined for gender difference have close to zero effect size, is significant, as in the other psychological variables examined, meta-analyses have shown up to 6 per cent of the factors showing close to zero effect size. This suggests that there are many small gender differences, and only a few large gender differences.

Hare-Mustin and Marecek (1988) point out that research that focuses on mean differences tends to produce one conclusion, whereas focus on a range and overlap of distribution may produce another conclusion. Questions like what constitutes a difference compared to a similarity, how much difference makes a difference, etc., need to be addressed. A meta-analysis of cognitive differences, sex differences and mathematical achievement have shown that male–female differences are not as universal, as dramatic and as enduring as has been asserted (Deaux, 1984). However, Eagly (1995) concludes that a synthesis of sex-related differences in social behaviour and personality has made psychologists reach a general agreement that there is evidence of differences from these meta-analyses.

In the application of this knowledge to the clinical setting, perhaps the following two points can be kept in mind:

1. The use of these differences, in understanding the psycho-pathology or as contributing to the aetiology of mental disorders in men and women, should be done with caution. If it has to be done due to the relevance of certain types of sex differences in psycho-pathology, then therapists must keep in mind the social origins of these differences. Using them in aetiology theories can create the wrong impression of the universal and enduring nature of these differences.
2. Eagly (1995) proposes that the way in which the psychologists understand the causes of these gender differences can have a great impact on planning intervention strategies. For example, suppose gender dif-

ferences in spatial ability are seen as arising out of experience, girls and women can be given more equal access to experiences that train them in high spatial ability. If women require a differential cue system for negotiating spatial tasks, it can be used to create more gender-informed programmes for training women in such tasks. Similar kinds of application can be attempted in the clinical setting: for example, neuro-psychological rehabilitation programmes for male and female head injury patients can attempt to build gender-informed programmes based on cognitive ability differences in men and women.

The available information on gender differences in social behaviour and personality can be used in the clinical setting to provide more gender-sensitive cues to the clients in the course of establishing the therapeutic relationship, rather than allowing it to influence the goals of therapy.

RESEARCH AND GENDER

Research guidelines for the behavioural scientists emphasise the principles of objectivity and neutrality in the researcher. The research must examine the dependent and independent variables by controlling all other factors. The context of research is presumed to be a controlled environment that allows for an unbiased data collection that lends itself to interpretation. These principles of the scientific research methodology have evolved from the research in the pure sciences, and they govern the research on human behaviour too. It is important to re-examine these for two reasons:

1. In the research on mental health, these same principles are accepted and utilised. Thus, gender biases that have been affecting the research issues in other fields are likely to affect the research in the field of mental health too.

2. While handling the mental health issues related to mental illness—the aetiologic theories, the manifestation of symptoms and intervention strategies—the research findings from non-clinical settings are often utilised. These include the psychological research in laboratory settings that addresses specific attributes and abilities, and the research from social psychology that examines social-interactional variables. Thus, the clinical psychologist needs to be aware of gender-related issues in research coming from these branches of psychology before applying them in the clinical set-up.

A committee composed of representatives from the Board of Scientific Affairs, Board of Social and Ethical Responsibility for Psychology and Women in Psychology has drawn the following guidelines for question formulation and research methods (Denmark, Russo, Frieze and Sechzer, 1988):

Question Formulation

1. Gender stereotypes associated with the topic can bias question formulation and research outcomes, e.g., leadership styles should not be congruent with dominance and aggression; instead a range of leadership styles should be included with emphasis on egalitarian relationships, negotiation and conflict resolution.
2. New theories must be generated when existing theories are not able to provide satisfactory explanations, e.g., the use of 'masochism' in battered women is not able to explain when and why battered women leave or don't leave the abusive situation.
3. Gender bias must be avoided in categorising some topics as basic research (e.g., aggression in boys and impact of media) and others as specialised research (e.g., psychological correlates of pregnancy and menopause).
4. Questions based on previous research must review the biases in the selection of research participants

and methodologies, e.g., aggressive stimuli's link to sexual arousal is true only for males.

Research Methods

Both sexes must be incorporated into the research. If only one sex is used then the researcher must justify it. Unanticipated gender differences in the previous research have often led to female participants being dropped from the analysis. For example, the achievement behaviour studies did not use females for many years, as in the initial studies they did not behave in the expected way. The sex of everyone in the research team who is in contact with the subjects must be specified as their potential interaction can cause unexplained variance. For example, helping behaviour is seen more in men when a female (researcher) needs help. The measures selected must be controlled for gender-related content. The researcher must avoid using labels with negative connotations to describe behaviours that do not fit traditional gender or sex roles. For asserting gender differences, the other major explanatory factors must be controlled. The researchers must report non-hypothesised gender differences accurately. The tests of significance must be done to assert gender differences. The researcher's conclusions should not be arbitrarily formulated to suggest innate biological sex differences, as many may be functions of socialised gender differences like culture and previous experience—for example, nurturing behaviour in mothers. The researchers must keep the following considerations in mind while planning research on gender (Lott, 1985):

1. To establish differences and similarities, the same methodologies need to be used across studies, with men and women.
2. To increase the validity of research findings on gender, multiple methods must be used.
3. The researchers must not assume that employed men and unemployed women are representative of their groups.

4. It is obvious from the social psychology research that
 the same person may behave differently in different
 situations. Thus, to understand gender, multiple con-
 texts must be used (e.g., aggression, influenceability
 and self-confidence in women vary with context). Thus,
 the researchers must remember that in society, men
 and women are differentially distributed across situ-
 ations. The use of exploratory and qualitative method-
 ologies can help minimise the researcher's imposed
 definitions of situations.
5. The variability within gender also needs to be under-
 stood.
6. It would be incorrect to assume that the mental health
 for women is necessarily related to fulfilling the dictates
 of the gender stereotype.
7. Topics specific to women's lives are not researched
 adequately. For example, housework, sexual harass-
 ment, sexual assault, psychological aspects of child-
 birth and motherhood need to be understood through
 research so that women can be helped to understand
 as well as shape their attitudes towards these situ-
 ations.

To eliminate gender bias in research, McHugh, Koeske and
Frieze (1986) suggest that the respondents themselves must
be encouraged to participate in formulation of goals and
hypothesis so that research control and bias is less. The
researchers seeking an explanation for sex-related behav-
iour must consider all possible explanations: biological (gen-
etic, hormonal, or physiological), socio-cultural (familial,
peer, economic) and situational (immediate cues operative
in the context). Meta-analysis in reviews should examine
convergence and divergence across studies and consider his-
torical factors and gender-related role changes that make
certain previously established findings irrelevant in the
current setting. The writers also suggest that researchers who
wish to test gender-related differences routinely should be
more cautious about gender bias in theory, sample, context
and research methods. Further, the method of comparing
male and female samples when their age is similar cannot

ensure that the life activities or priorities of the two gender are comparable. For example, it has been found that men are most involved in their careers at 30 whereas women do so at 40. Similarly parenting style difference in the father and mother may be a function of the relative ages of the father and the mother. Researchers must also examine positive consequences of gender behaviours that deviate from the traditional gender role. To conclude, I would like to quote McHugh et al.: 'Bias occurs because it represents accumulated experience of being a member of a particular group. . . . It is most difficult for a scientist to become disengaged from everyday shared assumptions about the nature of reality and to generate alternative testable conceptualisation of reality', (McHugh et al., 1986: 879). However, this is what the scientist has to do in the field of gender and psychology. The issues discussed above become more weighty when seen from the clinician's perspective. The clinician's perspective can sharpen further if he/she uses Lott's (1985) reminder that society devalues women but not evenly or homogeneously.

From the Personal to the Collective: Psychological/Feminist Issues of Women's Mental Health

U. Vindhya

By and large, women's health has been viewed in terms of their reproductive health or in terms of the impact of the work they do on their health. And yet, more women than men the world over are said to suffer from mental disorders. Although the stresses and strains women undergo in the course of marriage, child-raising and other reproduction-related events have been highlighted by activists and researchers, issues like—do women have specific mental disorders? what are the conditions that foster mental illness? what kind of intervention and prevention approaches can be adopted? can mental health in fact be a part of the agenda of women's groups?—have not received much attention. This 'marginalisation' of women's mental health issues by the women's movement is understandable for two reasons.

First, the women's movement in our country, over the past two decades or so, has had to deal with an enormously wide range of issues and problems that are largely consequences and effects of societal oppression of women. Issues of survival—for land, for work and wages, for protection of environment—have for the most part dominated the concerns of the women's movement in the past few years. In addition, issues like—sexual and family violence, harassment and discrimination in places of work and working conditions, inequities in services like literacy and health care and examining and challenging the various ways the state,

through its legal system, operates, either to promote the status quo or to oppose changes favourable to women—are a few examples of the interventions and initiatives of the women's movement. Mental illness does not figure on the agenda because it is viewed as a manifestation of an individual problem, not directly related to societal oppression, and not common to all women.

Even though the women's groups in the country are not unified by a single feminist perspective, the basic underlying thread is a forward-looking ideology calling for action and change, while the bodies of knowledge/disciplines central to mental health—psychology and psychiatry—have a conservative ideology calling for adjustment and continuity. Thus, while the women's movement, grounded in the feminist framework, is committed to political activity and collective change, psychology, rooted in individual experience and behaviour, looks for individual solutions and individual change, which is why, perhaps, feminism and psychology have been held to be incompatible.

Second, traditional notions of mental illness are based mostly on the medical model that looks for underlying pathology to cure by its specialised treatment. The psychological model too encourages the notion that mental illness, incomprehensible in lay terms, is a domain best left to the specialist, be it a psychologist or a psychiatrist, and is beyond the purview of the women's organisations.

The present paper makes a modest attempt to elaborate on the contradictions and tensions between the feminist and the psychological points of view on women's mental health and concludes by discussing how the feminist critique of mainstream psychology need not lead to an irrevocable breach with psychology. Rather, the critique can be utilised for a more sensitive understanding of both, individual women and women's mental health issues by women's groups.

MENTAL ILLNESS AS AN INDIVIDUAL PROBLEM

Essentially, psychology as a science of the individual, is rooted in individual experience and behaviour. At the turn of the

last century, when Western psychology declared itself to be independent (from philosophy) and to be a rigorous experimental science, it indicated that it was committed to the objective, positivist paradigm of the natural sciences. Modern psychology's insistence on objectivity has led psychologists to claim that theirs is a value-free, ethically neutral science. There is also a reluctance and resistance on the part of psychologists to elaborate on the role of values in their discipline. To be fair to psychologists, this belief in the value-neutrality of their science is but a part of the widespread belief in the possibility of an objective social science, free of ideology that has informed the undergirding rationale for the post-war modernisation perspective in social science (Alvin, 1990).

But the power of psychology's claim to value-neutrality lies in the ideological function that such a notion conveys. It predisposes the public to accept psychology's assertions uncritically and to regard them as apolitical truisms rather than as socio-historically conditioned statements. By promoting thus a depoliticised image of psychological findings, the image has in fact served to promulgate the reigning ideology of the status quo. Thus the 'objective' descriptions of behaviour, in effect, become prescriptions of what is desirable. And our definition of 'desirable' is generally in conformity with that of the ideological apparatuses of society whose major function is to bring about a successful socialisation (Sarason, 1981). In the guise of value-neutral research, psychology has in fact propagated values like individualism (Spence, 1985), male supremacy (Nahem, 1981), political conformity (Jacoby, 1975) and the glorification of technology in solving human problems (Woolfolk and Richardson, 1984), thereby reinforcing the ideology of liberal humanism.

However, in no other area than in mental health, perhaps, do we witness the ideological, value-laden assumptions that are built in into definitions of normality and abnormality. In the garb of value-free definitions of mental health, psychology has actively promoted dominant assumptions about what society is like and what it means to be normal. Traditional psychology has for the most part, presumed that the masculine male and the feminine female are the models of 'healthy' development (Bem, cited in Vaughter, 1976).

Psychology's construction of women's mental illness is based on dominant stereotypes regarding what is appropriate or inappropriate for women's behaviour. Thus, if women deviated from socially prescribed notions of 'feminine' behaviour, they were liable to be labelled as 'disturbed' and 'sick'. The influential work of Chesler (1972) and the much quoted study of Broverman et al. (1970) showed that there are double standards in evaluating the mental health of men and women. In what has been termed as the Catch 22 of women's mental health, both conformity and nonconformity to the feminine role are liable to generate definitions of psychological ill health. As Chesler (1972) has argued, women who conform totally to the feminine role, if and when they are hospitalised, are likely to be treated for 'predominantly female behaviours', such as depression, suicide attempts, anxiety neurosis or paranoia, while those who reject or are ambivalent about their female role could be hospitalised for 'less female behaviour', such as schizophrenia or lesbianism.

We do not know how far this holds good for our society, although we do have evidence that women in our society suffer more from neurotic disorders which have a psychosocial origin, rather than from severe disorders which have an organic or bio-genetic origin (Davar, 1995a). We can also be more certain that ambivalence or rejection of feminine qualities associated with 'good wifely and good motherly' behaviour is problematic for women (Addlakha, in this book). Dissatisfaction with traditional expectations of femininity in our society is perhaps considered to be more 'deviant'. A common 'symptom' expressed by the accompanying male escorts of women brought in for psychiatric treatment is that 'she does not do any housework, just sits around'.

Psychology in fact lends 'scientific' support to the dominant view of women being judged severely and even of being labelled as sick if they do not fulfil the obligations of a good wife and mother. As Caplan and Hall-McCorquodale (1985) showed, clinical studies of pathological behaviour involve extensive mother-blaming for a number of disorders and difficulties. Mothers have been and continue to be implicated in psycho-pathologies ranging from arson to incontinence, drug abuse and bad dreams. The label of the

'schizophrenogenic mother' was a common explanation of schizophrenia till the recent acceptance of a more interactive bio-psycho-social cause of the disorder.

Victim-Blaming and Violence Against Women

A related variant of this framework is victim-blaming. A basic assumption on which many psychological explanations are constructed—the acontextual view of the individual—leads to attribution of unfavourable experiences in a person's life to faulty mechanisms within herself or himself. An extensive lexicon of person-blaming concepts abound in psychological research. The universality of victim-blaming is not without its sexist and racist assumptions. In a context like violence against women, victims of violence must contend with a culture which would rather stress on women's responsibility for provocation of sexual and physical assault. The affirmation and validation necessary to recover from the trauma are unlikely to take place when victim-blaming becomes a tool to endorse and justify male dominance and power, and induce guilt and anxiety in women. In addition, as Walker (1989) points out, women victims of violence cannot understand neutrality. Their heightened sense of danger and the realistic need for safety leads them to categorise those who wish to study/help them as either 'with' or 'against' them.

A peculiar situation arises, however, in the context of domestic violence where both victim-blaming and a search for psycho-pathology in the (male) offender absolve the perpetrator of responsibility and deny justice and rights to the woman victim. Western psychological research has sought to understand domestic violence through examination of characteristics of individual men and women. The focus of such research (e.g., Roy, 1977) has been on personality traits or the presence of some psycho-pathology as causing the violence. For instance, abusive men have been characterised as passive-dependent, infantile or as lacking in impulse control, while women who have been at the receiving end of such violence have been labelled as masochistic, paranoid or depressed. Feminist critiques have highlighted how psychological explanations can be differentially applied to

men and women (Bograd, 1988). In general, trait theories tend to excuse the abusive man through reference to alcohol abuse or poor childhood histories. In contrast, battered women are implicated for the abuse since many psychological theories suggest that they need or tolerate the abuse. Women are seen as creating their own victimisation. For instance, Lion (1977: 127) speaks of the battered woman's 'provocation' and states that 'the victim may evoke violence in a vulnerable person'. Faulk (1977: 121) refers to battered women as 'querulous and demanding'. It is also not uncommon to find violence against wives being treated as a phenomenon no worse than women's verbal aggressiveness. For example, Deschner (1984:19) draws a parallel between a man's physical violence and what she refers to as a 'woman's verbal persecutions (nagging)'. By thus equating nagging with violence, the intensity and consequences of physical assault are trivialised.

The notion, pervasive in the literature—that the man loses control, that the violence lies outside of the realm of choice and that battering occurs during brief irrational episodes—constructs, as Ptacek (1988:152) points out

a contemporary profile of the batterer as one who is not necessarily *sick*, but who is rather just *temporarily insane*. Seen from this perspective, the batterer is not abnormal enough to be considered a psychopath and not responsible enough to be considered a criminal.

But this notion of loss of control is in fact contradicted by the violent men's own testimonies. As Ptacek (1988) reports from his work with batterers, the men claim that their violence is beyond rational control, but they also simultaneously acknowledge that the violence is deliberate and warranted. And most importantly, through an emphasis on psycho-pathology, most psychological explanations ignore the question of power. They are unable to explain why allegedly out of control and pathological husbands beat up their wives and not, say, their bosses, or why they contain their rage until they are in the privacy of their homes. While victim-blaming thus abounds in psychological research on

domestic violence, the responsibility of the man as well as that of the patriarchal social context which sanctions the use of power and violence are glossed over.

In an overview of research priorities for women's mental health, Russo (1990) draws attention to other traditional biases towards focusing on the perpetrators of violence against women, rather than on the effects of violence on its victims. The task of assessing the mental health impact of violence becomes all the more arduous when one has to reckon with the finding that women's victimisation is more likely to be committed by family and friends than by strangers (Koss, 1990). The contribution of histories of violence to several disorders in women ranging from major depression to post-traumatic stress disorder is neglected, although several community sample surveys have found a strong relationship between a history of violent victimisation and certain mental disorders (cited in Koss, 1990). In India, we cannot perhaps even imagine the gravity of the problem since even estimates of the extent of violence are not extensive or comprehensive (see Sriram and Mukherjee in this book). Neither do we have systematic accounts of the role that violent histories play in the aetiology of mental disorders in women.

Medicalisation of Reproduction-related Events

The medicalisation and psychologising (which in turn is dependent on the medical model) of women's experiences like pregnancy, menstruation and menopause have had far-reaching consequences, creating a series of paradoxes. Reismann (1983: 16) points out:

> As women have tried to free themselves from the control that biological processes have had over their lives, they simultaneously have strengthened the control of a biomedical view of their experience. As women visit doctors and get symptom relief, the social causes of their problems get ignored. As doctors acknowledge women's experience and treat their problems medically, problems are stripped of their political content.

The medicalisation of menstruation, for instance, reinforces the idea that women are controlled by biology in general and their reproductive systems in particular. As Reismann argues, this has been used to legitimate the exclusion of women from positions of power because of supposed emotional instability and irrationality due to raging hormonal imbalances. The fact that Premenstrual Syndrome (*PMS*) is a diagnostic category, to be treated and controlled, deflects attention from social aetiology. Rather than looking at the circumstances of women's lives that may make them irritable, depressed or angry, their strong feelings are dismissed. The contradiction, as Reismann points out, lies in the fact that 'the label of PMS allows women to be angry and say what's on their minds at a certain time each month, while at the same time it invalidates the content of their protest' (Reismann, 1983: 11). Furthermore, feminists have maintained that the discovery/ invention of PMS and the rush to establish it as a diagnostic entity were bankrolled by pharmaceutical firms that were eager to market new drugs to 'cure' it (Parlee, 1979).

Like menstruation, women's weight and the psychiatric diagnostic categories of anorexia nervosa and bulimia too are present-day examples of the relationship between the social norms for femininity and medical social control. As Conrad and Schneider (1980) note, the potential for medicalisation, in fact, increases as science discovers the subtle physiological correlates of human behaviour. In particular, as we know more about women's physiology and the complex bio-chemical components that are related to experiences like menstruation, pregnancy, weight gain and so on, the issue will be how to acknowledge this knowledge without allowing these human experiences to be distorted by scientific understanding. To 'demedicalise' is not to deny the biological components of experience or to turn our backs to discoveries and treatments that may ease pain and suffering. Rather, as Reismann maintains, demedicalisation is to 'alter the ownership, production and use of scientific knowledge' (Reismann, 1983: 16). In fact, the predominance of women diagnosed with affective disorders underscores the importance of investigating the relationship of depression to reproduction-related events, social roles, and life

circumstances of women (Russo, 1990). The psycho-social nature of women's health problems emphasises the need to go beyond narrow bio-medical approaches and build a more comprehensive knowledge base.

COLLECTIVE CHANGE AND PERSONAL CHANGE

It follows from psychology's conception of mental illness as an individual problem that it would seek individual solutions as well. These solutions, evolved from the clinical, therapeutic tradition, are considered scientific and objective. Questioning the politics of inequity and the social causes of psychological suffering, and advocating collective change are held to be incompatible with scientific goals of individual change. Perhaps such a notion derives from the polarisation of science as objective and value-neutral, and politics as subjective and partisan (Kitzinger, 1990). On the other hand, much of the critical literature on psychology's conception of mental illness of women has been motivated by feminist theory, which treats illness as a consequence of women's position in society, which is shaped by the sexual division of labour and patriarchal power. In one of the first formulations of the social construction of gender, Weisstein, pointing to where women stood in relation to psychology, said 'Psychology has nothing to say about what women are really like, what they need and what they want, essentially because psychology does not know' (Weisstein, 1970: 268). Psychology's commitment to the experimental method has in fact served to obscure the connections between individual experience and social institutions and structures. Feminists accuse psychology and psychiatry of pathologising women, of attributing problems to the woman herself rather than viewing her illness as a product of the social and political context which oppresses her (Ussher, 1990). As Henley (1985) remarks rather sardonically, the psychology of women has in fact to contend with a psychology against women.

Psychology relies on an individualistic interpretation of the world and understands distress in terms of dysfunction.

The immediate and natural response then of psychology to distress is to try and correct this dysfunctional process. Although it does acknowledge the 'forces of society', psychology asserts that these are not within its control and thus are not open to enquiry by psychologists. There is nothing wrong with this kind of logic if it is limited to areas where distress is seen as a direct result of misperception of the real world. However, as feminist psychologists have pointed out:

> It increasingly seemed to us that misperceptions of this nature were rarely as simple as this and although psychology could (sometimes) alter this, it could also clearly further cause distress by failing to see the forces by which such misperceptions were set up, experienced and interpreted. The result of this focus thus views the distressed individual as in some sense faulty, and thus, culpable. This sense of fault is easily equated with blame and increases feelings of inadequacy and guilt in most of us. If we then acknowledge why it suits society (while avoiding a functionalist analysis) to perpetuate such feelings, we come nearer, we believe, to understand why psychology is structured as it is, and how . . . women get the worst possible deal from this (Adcock and Newbigging, 1990: 173).

It is not as if the feminist perspective completely denies or dismisses the validity or importance of psychological explanations in understanding women's mental health. Instead, feminists seek to connect our psychological analyses with an understanding of the patriarchal social context, of the unequal distribution of power, and of the socially structured and culturally maintained patterns of man/woman relations and in what manner they contribute to problems of psychological health for women.

Current research, both in the West and in our country, indicates that it is not just women who figure more prominently in neurotic disorders, but rather that it is married women who experience more emotional distress than single, widowed, or divorced women (Gove, 1972). In a further study, Gove and Tudor (1973) confirmed the argument that married, housebound women are more likely to experience mental

illness than unmarried women. An explanation of this difference is that the married unemployed woman is often confined to the restricted domain of the household, where her self-image and social prestige are perhaps not significant when compared to that of the working woman. In addition, the Gove and Tudor (1973) study also found that married women are more likely to have problems of mental illness than married men. However, the results were opposite in the case of unmarried persons. Within each of the unmarried status—single, divorced or widowed—more studies found men to have higher rates of mental illness (Gove and Tudor, 1973: 828). In short, this means that marriage is more advantageous for men in minimising stress than it is for women. Suicide, in fact, is reported to be more prevalent for single than for married men (Turner, 1989). While marriage seems to work better for men, perhaps because their emotional worries are 'laundered and processed' by their wives, the same cannot be said for women. Busy taking care of the emotional needs of the others, women seem to be left with their own dependency needs unfulfilled. The results of sociological research (Gove and Geerken, 1977) show that the most vulnerable, from the point of view of mental illness, is the unemployed housewife.

Let us take depression, for instance, which not only affects a majority of women but more women than men are reported to suffer from this condition. The feelings of powerlessness, frustration, inadequacy, guilt and loneliness that combine as depression cannot be understood if we look at it only in terms of the woman's psychological characteristics, as a deficiency or inability to cope. It certainly seems probable that women are more likely to undergo experiences which generate those feelings, which is why women still tend to occupy the subordinate position in relationships with men. It is again women who are more likely to be inhibited from forming strong social bonds outside marital relationships, developing other interests or pursuing occupational achievements outside the home. Self-esteem which often acts as a buffer for depression is also problematic for women. Self-esteem is said to derive from (*a*) positive experiences of mastery or engagement in an important activity and (*b*) from

involvement in intimate and satisfying relationships (Sniderman, 1983). Women have limited opportunities for experiences of mastery, and work is not central to their self-definition. Even if family relationships are crucial to their self-definition, they may not bolster their self-esteem, either because these relationships are not egalitarian or because the family roles of wife and mother are dubbed as natural and hence do not call for any special pride or distinctiveness.

When things go wrong in the home, women are more vulnerable because they have fewer options. The discrepancy between the average earnings of men and women, and the economic and social insecurities suffered by women also lead to feelings of depression. The social origins of depression, the impact of stressful life events, and the complex relationships between gender, social roles and mental health are by now well documented in sociological literature (Brown and Harris, 1978). While Shah (in this book) has emphasised the psychosocial aspects of depression, I want to highlight here the importance of a social buffer—such as a close friend—to minimise the impact of these structural and psychological forces. Where there is no buffer and a woman finds herself experiencing extreme social isolation, there depressive psychoses are likely to develop (Brown and Harris, 1978).

The presence of social support has been identified as a key variable in moderating the effects of threatening life events which push the individual towards mental distress. The range of social relations available to an individual provides a mechanism whereby the burden of emotional stress can be relieved and the objective sources of stress managed in a collective fashion. This pull of social relations has been referred to as the fund of sociability which is composed of intimacy, the network of common concerns, the ability to develop supportive social relations, the confirmation of one's own prestige and the feeling of alliance with others who provide a supportive base (Turner, 1989: 78).

Fortunately for us, community support in the form of kin, friends, acquaintances, co-workers and the neighbourhood can still be counted upon to act as a form of buffer against threatening life events. The extent of an individual's and, in particular, a woman's social network is consequently

important in protecting her from both external threat and stress.

Women's Organisations and Mental Health

In this context, first, instead of leaving the woman to locate her distress in terms of her own psycho-pathology, women's groups can provide a milieu which will make visible the connection between private suffering and social causes. Second, if we are able to demystify the 'specialised' treatment of mental illness, we will perhaps be able to see more clearly that the treatment method at its simplest involves trust, talk and understanding. The collective sharing of personal experiences of women's oppression is in any case an existing and valuable aspect of the functioning of women's groups. Why should this sharing be only with respect to direct and explicit instances of oppression like, for instance, rape or wife-beating? Cannot this sharing include understanding of each other's needs? The 'symptoms' can then be understood not as indicators of illness but 'struggles to preserve or express some deeply needed aspect of personal integrity . . .' (Miller, 1976: 381).

Understanding these needs means seeing the problems from the woman's point of view. Walker (1989) in her research with battered women used eight-hour face-to-face interview schedules that turned out to be a critical factor in obtaining reliable and valid data. Walker claims that the victims needed the time to perceive the interviewers as interested in them in order to be able to talk about the experience of violence they had gone through. In this connection, what else could be more relevant than a women's collective that can validate the reality of the woman's perception and support change, rather than adjustment? Rather than traditional therapy in a neutral and detached setting, a women's group can in fact reformat constellations of emotions and behaviours from the woman's point of view. For example, in contrast to dominant views of battered women as helpless victims or as provocative women who ask for it, and instead of viewing the woman's

personality as a pre-existing contributory factor to the abuse, the supportive structure of a women's collective can provide the space to examine these situations as the consequences of repeated brutalisation and potentially life-threatening violence. Even a question like 'Why do women stay in a violent relationship?', as in conventional research and therapy situations, in a subtle way blames the woman for her own victimisation. On the other hand, a question like what social factors constrain the woman from leaving can be examined within the supportive atmosphere of a women's group.

Admittedly, feminist critiques contend that there can be no meeting ground between the feminist and psychological points of view because they say that psychology only attempts to relocate the political in the psycho-pathology of the personal. Through seeking individual solutions for women's distress, feminist critics point out that the impact of psychology on feminism can only lead to the depoliticisation of feminism (Wilkinson, 1990). And yet, while feminist—and radical psychiatric as well—arguments provide explanations for why many women are distressed in terms of their roles and position in society, avoiding biological-reductionist explanations, these may be of little help to the individual woman who feels that she is depressed. There are many women who need direct and immediate help that cannot be provided merely by a theoretical analysis of mental illness as a consequence of social oppression.

Furthermore, mental distress can be at various levels, ranging from those connected to material deprivation and poverty to interpersonal relationships, and to existential issues or life choices. Calling for restructuring of social arrangements alone will not bring an end to women's misery. Although this may appear as insignificant in the face of the enormously wide canvas of women's unhappiness, women's groups can certainly provide space for building strong support networks, by recognising and valuing women's competencies rather than pointing to their weaknesses as deficiencies to be overcome and by insisting that personal change is as equally important as social change.

By doing so, a women's group need not be accused of depoliticising and exchanging political ideals for therapeutic

ones. By seeing, understanding and making connections between our psychological state and the structural position of women, women's collectives can make this point that individual change and collective change can take place simultaneously. Thus, even as we struggle with our 'inferiority complexes', our 'conditioning', our 'phobias' and our 'sex roles', the struggle need not be a lonely, isolated one, but a collective one.

If we agree that women's problems are more due to distress than caused by illness alone, the ambience of care and support that a women's group can create can be rewarding for not only women seeking help from the group but also for the group members. Women working in a group on a variety of issues for a number of people can get numbed in the role of 'listener and provider' with possible effects of burnout. The stress of having to constantly listen with sympathy, her own concerns often suppressed for the sake of 'larger causes and others' problems', may at times thwart the individual member's own dependency needs. In this context, I would like to mention a recent experience of mine when a woman activist working with a local group came to me reporting feelings of depression. In the course of my counselling sessions with her, she told me that there were several others in the group who went through 'bouts of depression' and who would benefit if I could talk to them as well. What followed was a series of informal group sessions where I witnessed an outpouring of anxieties, depressive feelings, resentment against fellow members as well as their own families, exhaustion and fatigue of having to deal with 'some issue or the other' all the time, desire to lead a 'normal life' but rebelling at the same time against the idea of a status quo existence. Most of the women were from the middle class, in their twenties and thirties, were either students or employed as teachers, clerks, sales assistants and in such other occupations. The pressure of leading unconventional lives, antagonising families and neighbours by 'unfeminine behaviour' and taking up 'unpopular causes', the implicitly held notion that 'private suffering' is secondary to the larger interests of 'public causes', the burnout effects of having to listen with depressing regularity to stories of violence, in the middle

class milieu of a small city, the hurt and humiliation were evidently telling on the psychological well-being of the members themselves. As the sessions progressed, the members recognised that it was not 'cure' that was being aimed at, rather, the breathing space the sessions provided for the activists to ventilate their own depressions and anxieties gave them the insight and clarity not only about their own needs and motives and about each other, but also about how their own lives were positioned vis-à-vis a society which alienates, hurts, and at the same time enables them to lead lives with a sense of purpose. My interaction with this group was facilitated partly because all the members knew me not simply as a professional psychologist, but also as a fellow activist. It would be worthwhile for women's groups to reflect on the necessity of having mental health issues on their agenda and the value of networking with either individual counsellors/psychiatrists who are sensitive to these issues or with a professional group if there is any such group in their city or town. I am not prescribing a weekly session with a counsellor as a boosting shot for women's organisations but only pointing to the usefulness of interacting with mental health professionals to underscore the responsibility women's groups owe to maintaining their own psychological well-being.

In a powerfully evocative piece on the dynamics of violence and sexuality, Geetha (1996), drawing on her experience of working with a women's centre, illustrates how the group provides a support structure for the women in their attempts to counter the violence, in their legal battles and in the various and often difficult tasks of survival. The women who came to the centre for help ranged from domestic helpers, construction workers, petty vendors in the working sections of the population, to middle class and upper caste women. Geetha says,

> The space of the centre grants these various women an identity that is different from what they usually ascribe to themselves. Our conversations and modes of being and working together have created this community of women, who, above all, feel hurt, punished and humiliated for being women and wives. They constantly seek to translate

their concerns into a language that allows each woman [to] grasp the specificity of her problem, but yet enables her to recognise her hurt in the pain another woman has endured and survived (Geetha, 1996: 2).

It is this very 'community of women' that a women's organisation can strengthen and nurture. Despite the current emphasis on recognition of the diversity among women and the difference in their experience of oppression, it does not rule out a potential identity between women. This concept of identity rests on the idea that women share similar experiences: an external situation of economic oppression, legal discrimination and so on; and an internal response of a feeling of inadequacy and a sense of narrow horizons. Thus, despite the lack of political unity, a shared response to shared experience could be put forward as the basis for a communality of feeling between women.

Psychology can add to a feminist analysis in research and offer individual women in distress an alternative to the medical model. Indeed, the feminist account of the social construction of gender fits with the understanding of women's mental health problems, that they are mostly caused by psycho-social factors. The feminist insistence on the importance of context, though at odds with mainstream psychology's focus on the individual, has in fact led to changing definitions of psychological knowledge produced by feminist practice. Psychology as a reflexive discipline, created by people about people, is founded on a bedrock of 'scientific explanation' that is laden with ideological assumptions, most of which are part of the taken for granted currency of the dominant culture. Acknowledgement of psychology as a social practice need not however detract from its value in understanding and providing insight into the distress of individual women or men. A women's collective with a feminist approach to the social causes of women's oppression can offer the space, structure and nurturance for bringing about both personal and collective change.

V

FURTHER CONSIDERATIONS ON WOMEN AND MENTAL HEALTH[1]

Sasheej Hegde

If the true is what is grounded, then the ground is not *true*, nor yet false.

—Wittgenstein, 1969: # 205.

People may ask why I've allowed myself to get involved in this—why I've agreed to ask these questions. . . . But, in the end, I've become rather irritated by an attitude which for a long time was mine, too, and which I no longer subscribe to, which consists in saying: our problem is to denounce and to criticize; let them get on with their legislation and their reforms. That doesn't seem to me the right attitude.

—Foucault, 1988: 209.

In putting together this set of remarks, I hope to be able to give some indication of the remarkable range of questions that the subject on hand, namely, women and mental health, could help yield. My own institutional location has been

[1] These remarks issue from my participation in the national seminar on Women and Mental Health organized by Anveshi, Research Centre for Women's Studies, Hyderabad (23–24 February 1996). I am grateful to Bhargavi Davar for the invitation; indeed as she would aver, I have remained an insistent collaborator to her volume's project ever since. Hopefully, she will come to locate and place in perspective this contribution. The paper remains largely exploratory, and is geared chiefly towards a specialized audience. I hope to have a more integral version in the future. Seemanthini Niranjana read through the draft.

neither women's studies nor psychology, not psychiatry either, but the discipline of sociology (although what I make of the discipline can amount to a dissolution of its very problematic). I make this qualification out of respect for my other contributors, not all of whom share (nor indeed need share) my concerns. And yet, in making the claims that I will, I think there is much that they need to be made aware of. Our questions here are not aimed at, say, protecting psychiatric practice against some new attack, nor even to cast the slightest doubt upon the importance, the necessity and legitimacy of a policy on mental health. At best, we are here interested in some logical and conceptual protocols that obtain within the moment and the injunction to study women and *mental* health, the latter especially. As diverse as this orientation may be in its explicit aims and in its qualities—meaning the level of reflection at which it may be situated—the issue that I would like to formulate concerns largely the axiomatic into which, and in terms of which, the problem of medico-psychological practice in general is delivered. Our forays here ought also serve as an index of how much remains to be said about women and *mental* health, and of our attitudes towards law, psychiatry and medicine in particular.

The chapter is broadly divided into two parts, not entirely unrelated of course, but each with its own moment of precipitation and/or urgency; my final part is an altogether brief coda drawing on some impulses governing the essay as a whole.[2] In the first part, I am concerned to pursue some implications of a *methodological* sort, working basically through some available documentation on the problem of women and (mental) health. In the second, I am concerned to effect a more determinate hold on the problem, shifting to a more *substantial* (read, theoretical and/or moral) register,

[2] This partly explains the structure of my essay, as indeed the *style* in which it is delivered. It has happened that I have been taken as capable of (and even culpable of) self-satisfaction; but at the same time, it is my conviction that all thought must combine analytic argument with a sensitive appreciation of the details of actual human perplexities. This, of necessity, has led me to be self-consciously concerned with the problem of finding an appropriate *style* for theorizing.

and devolving particularly upon the subject of mental health practice. In either case, I have not felt compelled to scan the entirety of the field and/or traverse the full range of questions; and, wheresoever I do invoke a more historical context, it is again mediated through an imperative to effect a contemporary delimitation of the problem.

A KIND OF METHODOLOGICAL DETOUR

I

Questions of women and health in India have been pursued in a recent volume edited by Das Gupta et al. (1995). This is a timely and welcome contribution to the debate, a debate which has engaged mainly with adverse health outcomes for women. It would be inappropriate to review this volume here, but I would like to draw attention to a feature obtaining on its very surface. Although structured to take a 'holistic view' of the issues of women's health, the volume almost totally avoids the question of women's *mental* health. Also, what is perhaps more poignant, even where the analysis bears upon phenomena that could lend themselves to informed conjectures about the state of women's mental health, the contributors seem indifferent to such a prospect altogether. Is this feature—ought one to say, anomaly—significant? What can it be taken to mean?

The suggestion may not be entirely felicitous, but I am deploying it all the same in order to roughly mark out a line of thought.[3] Indeed, the problem can obtain in a particularly

[3] It is another question of course whether this is the most plausible line of thought that can be marked out. But do consider, for instance, Wittgenstein's remark:

> Can't an assertoric sentence, which was capable of functioning as an hypothesis, also be used as a foundation for research and action? I.e., can't it simply be isolated from doubt, though not according to any explicit rule? It simply gets assumed as a truism, never called in question, perhaps not even formulated (Wittgenstein 1969: # 87).

stark form if it were to be maintained (*a*) that 'health'/'well-being', cannot, and need not, be informed by indices of a psychological (read, mentalistic/affective) sort; that ultimately 'meanings' are not in the head, but in the world; and (*b*) that in addressing the world—any set of adverse circumstances—only the sources and precise points of vulnerability, and risk attaching to those circumstances can or need engage policy and research; and indeed, that testability or evidential support—in short, parametric co-ordination—is what all the fuss need be about. (The inference, I suppose, is obvious: the Das Gupta et al. volume is claiming precisely so, or at least that the treatment which it accords of the phenomena of women and health are appropriable in this light.) There is nevertheless a singularity and a reductiveness in holding precisely thus—I mean not the inference, but the claims (*a*) and (*b*). It is evidence above all of how deep *realist* assumptions about meaning and truth lie in our thinking about health and/or well-being. But the issue goes further, and as I shall go on to state, in the specific case of women and *mental* health at least, it is the space of medico-psychological practice that would have to be plumbed in order to get a determinate hold on the problem.

II

The avowal with which we concluded the foregoing section engages the section on 'Resiting the Problem' of our chapter. But if we are to develop towards this outline, then we ought to begin by specifying what being realist about meaning and truth can entail? If by this is meant 'the idea that a statement has meaning if, and only if, it has truth conditions, where "truth conditions" are understood in accordance with a correspondence conception of truth' (Skorupski, 1979: 166), we may not get too far. When this standpoint however is

Something of the order of this understanding underlies our gesture here, as well as serving up the point from which this paper has been written. See also note 6, and the overture anchoring the I section of the subheading titled 'Resiting the Problem' below.

combined with another sort of realism, according to which (if Skorupski is to be our guide again) 'theoretical science . . . is neither reducible to statements about observable goings-on, nor to be treated as a heuristic instrument, but is to be understood as offering an account of the unobservable constitution of reality' (ibid.), then perhaps we could weave some considerations which are relevant for the present purposes. But first, some possible objections.[4] It would seem that we are using the words 'meaning' and 'truth' more confidently, in a tidier, more rigid and holistic way, than one should dare try; and that, far from obtaining within the same analytical field, there are differences between them, across them. For one, to use the word 'meaning' does not (and need not) automatically raise the problems of knowledge and truth. Also, that 'meaning' concerns belief and/or the generation of belief, and that this could in part be explained in terms of some causal antecedents, need not have any implication as to a belief's truth-value.

The only way in which one could meet with these objections is by typically considering cases of what is to be realist about health, and about women's *mental* health in particular. We have done so, even if somewhat perfunctorily, with reference to a paradigm case of *women's* health. Let me now turn to a consideration of another case, that of women's *mental* health. It should be discernible that the polarities *women's* health and women's *mental* health delimit a definite field in which to guarantee a certain knowledge about states of affairs, but that need not concern us here. To recall what we posited at the very outset: at best, we are here interested in some logical and conceptual protocols that obtain within the moment and

[4] The considerations that follow in the rest of the paragraph bear the brunt of the exchange between the philosopher John Skorupski and the anthropologist Mary Douglas in the volume edited by Brown (1979). To explicate them would presuppose reading the complicated tangle of ideas presented both in the philosophy of science and the philosophy of mind. Significantly, the part enclosing the exchange is titled 'Relativism in Social Anthropology', which only makes our task of explication that much more difficult. But for a traversal of the 'realism' question, see my review essay (1994).

the injunction to study women and *mental* health, the latter especially.

III

In a secondary analysis of the epidemiological data on mental health, drawn largely from community surveys, Davar (1995a) poses in stark terms the issue of women's *mental* health. The conclusions of her study are two-fold: one, that mental illness is far more frequent in women than in men—a prevalence often obscured in the literature based on hospital samples; and two, that gender difference also exists in the *type* of mental illness exhibited, that is to say, while women predominate in the *common* mental illness category, the prevalence of illness is homogeneous across gender in the *severe* mental illness category. This classification of mental illness into those of the 'severe' type and those of the 'common' type, Davar avers, is well-established in the literature,[5] and adds that some gender-sensitive implications follow from the distinction:

> This distinction has profoundly influenced the mental health programme in the country with a distinct bias of policy being in favour of severe mental disorders. It is well known that the common mental disorders are more frequent in the community and that the percentage of population being severely ill is only one percent. The alleged justification is that the severely mentally ill suffer more, but this [is] questionable if "suffering" is understood to include the social aspects of mental illness also. This is

[5] Elaborating this distinction, Davar notes:

Disorders such as schizophrenia, depressive psychoses, mania, epilepsy, mental retardation, and organic brain disorders are usually treated as severe mental disorders. Neurotic disorders, major depression, hysterias, obsessive-compulsive disorders, anxieties and phobias, somatisation disorders are classified as being common mental disorders. The clinical picture between these two categories of disorders varies remarkably (1995a: 2881).

particularly pertinent in the case of women where psycho-social distress is very high, sometimes high enough to lead to social isolation, violence and self-destruction. This suffering cannot be measured, evaluated nor treated with the same clinical standards of the severe mental disorders (Davar, 1995a: 2881).

I have quoted this passage at some length, for it bears testimony to the realist concepts (in the sense noted in the previous two sections—I and II) structuring perceptions of the mental health issue; it also enables me to formulate some questions vis-à-vis Davar's proposals. Note, yet again, here, the weaving together of schemes of truth and meaning into a near holistic bundle capable of producing the truth about women *and* mental illness.

IV

Davar's argument is avowedly seeking after the ground(s) of women's mental health, and towards this end, appears to be running together two different contexts in which questions of justification might be raised. On the one hand, there is the context where, as in her case, it is a question of establishing what is the case—that is to say, positing what is the problem, identifying its characteristics and so on; thus, the information she provides about the occurrence of mental illness among Indian women, about the gender differences in the expressions, course, prevalence and cause of mental illness. On the other hand, there is the context of what I shall term, for want of a better expression, 'determination', the imperative, that is, of not only ascertaining what is the case, but also what can (or needs to) be done about it—in short, of *altering* it. In Davar's case, this takes the form of a search for a model of explanation that would foreground the issue of gender in mental health. She thinks that putting the matter in these terms is necessary, not only because, as she affirms, the national mental health policy is based on 'cost-effectiveness rather than community need in its prioritization of the severe mental disorders' (Davar, 1995a), thereby revealing the gender

politics of mental health, but also because, as she believes, a proper aetiology is imperative if we are to bring about desirable outcomes. Davar's preference is for a 'psycho-social' aetiology, both as a model that 'best explains the greater prevalence of common, specifically neurotic and depressive illnesses among women' (ibid.: 2882 and *passim* for details) and as a guide to action.

There is evidently a difficulty here, in that this (or any) search for grounds can turn out to be an elusive one. Thus, for instance, Wittgenstein:

> The difficult thing here is not to dig down to the ground; no, it is to recognise the ground that lies before us as the ground.
> For the ground keeps on giving us the illusory image of a greater depth, and when we seek to reach this, we keep on finding ourselves on the old level (Wittgenstein, 1967: VI # 31).

Note our point—not that Davar is mistaken, rather that the kind of theoretical demand that her argument translates into cannot be met. In short, the problem needs to be relocated. Wittgenstein however further observes: 'Our disease is one of wanting to explain' (ibid.). Now, this is surely not a conclusion that Davar—nor, for that matter, we—would be interested to endorse. Indeed, her point, especially as it bears upon our problem, may be reformulated thus: we can, we ought all be realists; only, what is needed is a correct epistemology, an appropriate model of 'observation' and/or justification. The problem here is taken to be less what we must want to know about women *and* mental health, than how most adequately to think about it. The aim of the analysis is one of how we can establish the truth conditions of a given state of affairs (in Davar's case, mental illness among Indian women), while refusing to recognise a reality as it is in itself, beyond all theoretical projection (or capacity to gain knowledge of it).

The reality of *women's* mental health is being posited from within this field, and concerns the concepts necessary to

give a consistent description of it.[6] The insertion of a gender element into this positing is an attempt, really, to force renewed attention upon a description, even to render that description more adequate than it would otherwise be. Besides, note that this positing need not always entail a focus coming to be upon the space of the 'mental'—for, as we saw in section I there can be an indifference about the prospect altogether. In other words, the realist edifice of a theorising about health can make for forms of attention that *either* issue from a recognition of the mode 'mental' (in which case, the concern would be to inscribe a wider reference for health) *or* deflect from that circumstance (the space of the 'mental') altogether. Davar of course is interested to effect the former, to include within 'health' a focus not only (as in the case of women's health) on reproductive health or even child mortality, life expectancy, widowhood—the contents, say, of the Das Gupta et al. volume—but also on women's *mental* health (or, again, indices of a psycho-social sort).

RESITING THE PROBLEM

I

The positions recounted above may have their uses but I wonder whether their limits are being properly heeded. To seek what is logically required of a focus on *women's* health and/or women's *mental* health is not quite the same as suggesting that these foci ought involve a scaffolding of facts. Besides, it seems impossible to pick up on a theme unless one also shared its evaluative interest. Indeed, if I might affirm *contra* Davar, *contra* the perspectives consolidated in

6 Note how this avoids the question of *what we should* say—not in the sense of establishing the truth conditions of a discourse, but clarifying the evaluative perspective in which a certain discourse/description has its point. Apropos the contexts we are concerned to traverse here (namely, women *and* mental health, the latter especially), this would entail, first of all, specifying the space of practice—the space, in our case, of medico-psychological practice in general. See also the overture anchoring section I of the subheading titled 'Resiting the Problem' below.

the Das Gupta et al. volume, there is dislocation—and consequently, the possibility of a resiting—not only as a result of some perceived empirical inadequacy, but also as a result of something inscribed in the very logic of a problem. Perhaps we ought to begin by relocating the problem itself, not least by devolving upon the subject of mental health practice (henceforth medico-psychological practice), as well as by placing in perspective our attitudes towards law, medicine and psychiatry in particular. I shall do so here by picking up on a theme traceable to Foucault's work, although constricting his circumstance somewhat. The problem, note, is now theoretical and/or moral and not strictly (or only) methodological.[7]

Foucault is above all concerned to assert the point that the development of a scientific concept of madness could not be separated from a history of 'social ethics', and that what the supposedly scientific psychology of the nineteenth century had attempted to establish as truth, the delimitation of the 'normal', was in fact only the discursive consecration of practices for establishing the juridical incapacity of an individual.[8] For as his biographer, Miller observed, Foucault went on to subsequently distinguish 'mental illness' from 'madness', which met and were confounded from the 17th Century on, the former would enter a technical field

[7] It can and need be asserted that the concerns of this and the ensuing sections, though not directly engaging the problem of gender, are not criticisable on this count. Surely there is more to gender than enclosing a reference to, or about, women. The reader will also recall that we have moved into this space, following an initial (even if somewhat methodological) delimitation broaching specifically the themes of women and mental health. See also our final coda for another affirmation.

[8] I am broaching here, above all, the central thesis of his Madness and Civilization (1965). However, I am particularly struck by this little piece of 'statistic' that Canguilhem alludes to in an essay that I shall draw on later in the text. Foucault's Folie et deraison: Histoire de la folie a l'age classique was first published in France in 1961, itself a by-product of his doctoral manuscript running into 943 type-written pages, plus 40 pages of documenting appendices and bibliography. A much abridged version of this book was published in 1964, and was translated into English by Richard Howard under the title Madness and Civilization: A History of Insanity in the Age of Reason (1965). The inference, I suppose, is obvious.

while the latter would persist and thrive in a new kinship with literature, far away from pathology. Indeed, as the distinguished historian of science, Canguilhem, adjudicating Foucault's thesis and uneasy about the role left for science and modern medicine in the latter's account, remarked: 'But the entire Enlightenment experience of madness cannot be summarised nor even symbolised by the practice of internment. Mr. Foucault cannot ignore that madness has always been, to some extent, an object of medical care' (Canguilhem, 1995: 279).[9] The 'impasses' of his concept of madness and the difficulties into which his project lead him (see especially Derrida, 1978 and Taylor, 1986) must not however blind us to the fact that Foucault himself remained sensitive to the quality of his avowals and the uses to which they were (or could be) put.[10]

Surely, it cannot be our intention here to provide systematic commentary on Foucaults' work; only placing in perspective a disintrication being effected in and by this work, and devolving upon the space of medico-psychological practice. In an essay published after Foucault's death, Canguilhem has this to say: 'In Foucault's thesis (that which went to make *Histoire de la folie*) it is madness that is primarily at issue, not mental illness; it is exclusion, internment and discipline, that is primarily at issue, not asylum, assistance and care'. And adds, in deference to Foucault of course, a remark full of resonances and lessons for us: 'It is from a *power of relegation* and not from a *knowledge of identification* that medico-psychological practice proceeds by way of a practice of internment-assistance' (Canguilhem, 1995: 284, my italics). It is this latter formulation that shall concern

[9] Note, my reference to Canguilhem here (and in the sections to follow) draw on three short essays—one a report, really, adjudicating Foucault's thesis—by him, written at different intervals. These have been put together in a recent issue of *Critical Inquiry* (1995: pp. 277–289). All the relevant mentions in this paper are from this issue.

[10] One is here directed to the dialogue 'Confinement, Psychiatry, Prison' reproduced in his 1988 volume of writings/interviews. In this conversation, Foucault remains the anchoring orientation. I will have an occasion to allude to this dialogue later on in Part 2 of the section titled 'Resiting the Problem'.

us, but will perforce attempt to turn this idea inside out. I don't mean to imply for a minute that either Canguilhem or Foucault are mistaken; rather, that there is a crucial disintrication taking place here, which has consequences for the ways in which we approach psychiatry and/or thematise its links with law and medicine in particular. The acute historical sensibility of Canguilhem, as indeed, one might assert, Foucault's, could not fail to pick up on this. We shouldn't either. Let me set up a further passage before coming to grips with our questions.

II

In setting upon this problem, it may help to distinguish the theme 'what is the specific reality of mental health?' from the issue: 'Just what is known (or being willed) when something is posited as health and/or mental health?' Many anachronistic readings of psychiatry, of medico-psychological practice turn on the inability to recognise what is at stake in this division/distinction as well as the compulsions behind reiterating it.[11] One might even say that this division/distinction is a kind of analogue of the point that was noted earlier (in the previous section), that Foucault remained elusive on the diagnoses of madness as a type of disease. But even here there are complexities involved—for, as his biographer notes, Foucault went on subsequently to distinguish 'mental illness' from 'madness', calling them 'two different configurations, which met and were confounded with each other from the seventeenth century on', and adding that while the former 'will undoubtedly enter an increasingly well-controlled technical field', the latter (now properly inflected into the philosophical problem of madness and of unreason) would continue to persist and thrive in a new kinship with literature, 'far away from pathology' (the citations here, as indeed our point, are from Miller, 1994: 104). A crucial accent,

[11] Anachronistic readings of psychiatry, of medico-psychological practice? I have in mind here the claims of Thomas Szasz, R.D. Laing, David Cooper and others, the strains particularly of anti-psychiatry and psychiatric imperialism. See Moore (1984, especially Part 2) for a discussion. The ensuing section may also be further suggestive.

however, has been displaced, something that Canguilhem (1995) picks on in the context of the remark cited above, that in Foucault '[i]t is from a power of relegation and not from a knowledge of identification that medicopsychological practice proceeds by way of a practice of internment-assistance.' I am suspending for the moment an elucidation of the disintrication involved here, being concerned more, in this section, with a determination of its locus. Particularly, I am interested to clarify the two axes that Canguilhem vide Foucault constitutes as the fount of medico-psychological practice, namely, 'a power of relegation' and 'a knowledge of identification'. What do they issue from? What are they meant to inscribe? Let us return to our division/distinction.

Strictly speaking, the poles instituted in and by it are not separable and/or mutually exclusive. There is indeed, in every ability, to craft a further consideration upon the specific realities of mental health, a thought that issues from—or, more properly, inflects into—the subject of 'just what is known (or being willed) when something is posited as health and/or mental health?' One need only refer the conversation reproduced in Foucault's *Politics, Philosophy, Culture* (1988) in order to bolster this inference. Although reigning large over a variety of topics/agendas, the discussants (Foucault included) consistently articulate the question of mental health practice—that the thing to be worked at is 'a possibility of defining practice' which would 'actually obtain therapeutic results . . . without the setting up of a type of medical power, and a type of relationship to the body and a type of authoritarianism' (Foucault, 1988:193–196 and *passim*). Besides, we may also consider here the point Canguilhem makes with reference to Foucault:

> [P]erhaps he suspected, without being able to prognosti-cate, that to reduce the power of the psychologist to a technique for the control of normality, that is to say, of precariously tolerable deviations, was to open the door to the critics of contemporary medicine (Canguilhem, 1995: 285).

But note the accent being placed on our division/distinction—the nub on which it is being made to turn—the issue, most

concisely, of '*diagnostic realism*'.[12] It seems to be that this is the locus from which the two axes of medico-psychological practice are being recouped as it were. And, what is more, the disintrication being effected in and by Foucault's work, off the space of medico-psychological practice generally, must be addressed from within this possibility.

In what follows, I shall venture a further prognosis, while placing in perspective the disintrication involved.

III

In a recent effort to query psychiatry's and psycho-pathology's framing of the problem of multiple personality disorders (MPD), the historian of science, Hacking (1995) has argued that it is necessary to identify three questions about the diagnostic reality of this disorder: (a) In virtue of what behaviours (or symptoms) does a person exhibit MPD? (b) What events or processes explain the onset of, and variability in, the disorder? and (c) What functions within psychiatric medicine does a diagnosis of MPD serve? That is, why is it medically useful to have the diagnostic category MPD? According to him, the first two questions presuppose both the utility of the diagnostic category, and that the contrast between being in the category and being out of it is clinically available or verifiable. For Hacking, it is the last question that is the most basic, and, accordingly, he takes as his aim the task of identifying and assessing the medical utility of the category. However, a quite different problem of diagnostic realism is being raised by us here, in this paper.

To ask 'is mental disorder a *real* disorder?', and to answer that it is so—or even to examine, as Hacking does, what 'real' means when applied to the disorder—is common enough. But this does not of itself explain why (or how) this must be so. Granted that Hacking's concern is to query the diagnostic utility of a category, even to argue, as he does,

[12] Note the variation wrought on our theme of realism above (in Part 1)—but issuing more internally, something given to the very logic of the space of medico-psychological practice. The section to follow has further discussion.

that the category MPD is methodologically and politically vacuous. Nevertheless, the axis from which these remarks are determined is, I would think, the content and orientation of medico-psychological practice in general. Pithily, the question to ask is this: what is it about medico-psychological practice that enables it to undertake (or offer) the diagnoses that it does?[13]

Perforce, this is the problem, subsumable under the rubric diagnostic realism, that Canguilhem is concerned to assert vide Foucault, vide the two axes of medico-psychological practice in general (namely, 'power of relegation; and 'knowledge of identification'). Broadly, these two axes constitute, as it were, *the tools*—of perception, of analysis and de-coding—of medico-psychological practice in general; as well as serving up, from within the practice itself, the possibility of defining why (or how) the 'real' comes to mean what it does when applied to a disorder. There is nevertheless a disintrication involved here, which Canguilhem picks on in the context of Foucault's work as a whole: that in Foucault's *oeuvre*, even as the two axes are postulated, it is from a 'power of relegation' and not from a 'knowledge of identification' that medico-psychological practice is held to proceed. The question is, again: what is one to make of it? How much theoretical weight can it be given?

IV

In highlighting the disintrication in Foucault, off the space of medico-psychological practice in general, what are we (or, for that matter, Canguilhem) concerned to assert as a whole? As is his wont, Canguilhem credits Foucault with the insight that the latter obliged him 'to recognise the historical existence of a medical power that was equivocal' (Canguilhem,

[13] In fairness to Hacking (1995), it need be stated that his critique of MPD does lend itself to this question, although slanting the problem in the direction of an applied ethics. Hacking's main worry seems to be about diagnostic and therein therapeutic incompetence: that a state which requires medical assistance may be seriously misdiagnosed and mistreated since its category (MPD) is methodologically and politically vacuous.

1995: 288). But it seems to me that this recognition does not sufficiently capture the force behind his remarks identifying the two axes of medico-psychological practice. For, as we have seen in the sections preceding this one (and especially in the previous one), Foucault/Canguilhem are concerned to effect a modulation on the problem of diagnostic realism, and doing so above all by devolving upon the space of medico-psychological practice. Apropos this modulation/devolution, it can be claimed that the disintrication in Foucault has been to substitute one axis for another—'relegation' for 'identification'—thereby picking out as his guiding thread the theme of internment as a whole. But as Canguilhem has noted, in his report adjudicating Foucault's thesis:

> If internment resulted from an administrative decision that hardly ever relied on medical expertise, it remained that *juridical* problems of interdiction, which did not cover those of internment, required the medical definition of criteria whose elaboration anticipated the subsequent analysis of psychopathology;

And then, the telling point off Foucault: 'In the prehistory of psychiatry, the subject of law is more important than the mentally deficient or sick man' (Canguilhem, 1995: 279).

We have here, within the locus of these remarks, passages in and out of Foucault, ways of straddling the interface between law, medicine and psychiatry in particular, as well as inflecting our problem of a disintrication in the body of medico-psychological practice in a specific direction.

It is important to take note of what Canguilhem is asserting here vis-à-vis Foucault—that even as madness had always been, to some extent, an object of medical care, 'this medical care never enjoyed autonomy', accepting as it did 'its modes of classification from the domain of law,' and that the advent of positivist psychiatry in the first half of the nineteenth century—before the Freudian moment—'express[es] more an evolution in the practical attitude of reason regarding madness than a conceptual revolution'. In short: that madness, before becoming 'a theoretical object of medical judgement' had to be constituted as an 'object of ethical behaviour', and

that this yields a perspective on the question of law, medicine and psychiatry; while also 'calling into question the origins and scientific status of psychology' (Canguilhem, 1995: 279–80). And yet, as so often happens with historical condensations of this sort, Canguilhem vide Foucault fails to pick out and to follow what could have been, at least in the present context, a deeply reasonant theme, namely; 'what is it about diagnoses of disease which can make these the proper business of the courts?'. Or, what comes to the same thing: 'how is one to cast about for *partly* prescriptive notions of mental health/illness?' Mark the question, demanding something more than just an explication of the legal concept of insanity, but issuing off a recognition of the space of medico-psychological practice generally.[14] The disintrication highlighted above, it need be affirmed, must attach itself to this possibility.

V

An answer could be sought in a reading of the provisions of the mental health law, which, in the context of India at least—if we were to take the word of a recognised authority on the subject, Dhanda—would have to do with the possibility of relevant capacitaton/incapacitation. Dhanda is particularly forthright on the point that 'there is no provision in the Mental Health Act [of 1987] to the effect that diagnosis arrived at in the mental health setting will not be used in any legal context requiring a determination of mental capacity'. And adds:

A disclaimer on these lines is especially necessary considering that the Mental Health Act has expansively defined a mentally ill person as 'a person in need of care and treatment by reason of any mental disorder other than mental retardation' (Dhanda, 1995: 359).

[14] And besides, aren't we—or shouldn't we—in picking on the theme of *women* and mental health, also concerned to negotiate the space of this question? But see the considerations to follow, as indeed our all-too-brief summation in Part 3.

But even here, there can (and there ought to be) other leads to follow as well.

It is certainly not the case that the content and orientation of a medico-psychological practice cannot have implications for ourselves—for our ideas of agency, personhood and choice. Nor ought we, by that token, to be concerned with effecting a non-institutional focus for the practice in general.[15] Is not Davar, in revealing the contours of mental illness among Indian women, casting about after a theme deeply resonant of our thrust, after all? It is a moot question, however, whether these perceptions/mediations are issuing from a clear understanding of what is involved. In particular, they fail to give due recognition to the processes involved in instituting a certain conceptual boundary, and the rest of the thinking and acting that can flow from that construction. Mental illness, the diagnoses of disease, well-being, the precise metric determining these, and so on, are in a sense descriptively available; but no sooner than when it is asked, of these demarcations, 'what kind of mental illness and/or well-being?', or again, more properly, our question, 'what is it about diagnoses of disease which can make these the proper business of the courts?', there is effected, it seems to me, a dislocation in the very annunciation of a problem.[16] Mental illness, well-being, the diagnoses of disease and so on come to be grafted onto the theme of their *identification*. (And, what is more, as we have been affirming in the course of the foregoing pages, the framework from which to determine this are the schemes *internal* to a practice.)

The upshot is a problem which would strike one as overly rationalist, but which still remains full of resonances and lessons.

[15] Kakar (1982) seems a plausible place from which to begin such a disquisition. See also (Kakar, 1997). We shall, in the section to follow, be concerned, yet, to effect a formulation off him.

[16] Cf. again the overture anchoring Part I of the section titled 'Resiting the Problem' above.

VI

It seems to me useful to work with an idea of mental health as a certain sort of standing in the '*space of reasons*'.[17] The concern is a familiar dialectic—of what happens to this space when the self, which is held to *embody* it, undergoes a certain deformation. In the case of mental illness, the deformation is an internalisation of the space of reasons, a withdrawal of it from the external world. Now, it has been fairly customary in the literature to formulate this internalisation as the bedrock of a historical modernity issuing from the seventeenth century.[18] But, if Kakar were to be our guide, one may constitute this internalisation as the core of a 'psychological modernity', which 'although strongly associated with post-Enlightenment, is nevertheless not identical with it'. Kakar (1997) writes:

> The core of psychological modernity is internalisation rather than externalisation Experientially, this internalisation is a recognition that one is possessed of a mind in all its complexity. It is the acknowledgement, however vague, unwilling or conflicted, of a subjectivity that fates one to episodic suffering through some of its ideas and feeling . . . simultaneously with the knowledge, at some level of awareness, that the mind can help in containing

[17] The 'space of reasons'—the expression is derived from Wilfrid Sellars, who, however, formulates it in a preeminently knowledge context: 'In characterizing an episode or a state as that of *knowing*, we are not giving an empirical description of that episode or state; we are placing it in the logical space of reasons, of justifying and being able to justify what one says' (Sellars, 1963: 169). See also McDowell (1994) for a recent application of this idea. In constricting our terms somewhat, I am suspending a consideration of the questions of how one is initiated into culture, of how one moves in the space of reasons, the deformations that (can) result and so on. Nonetheless, it cannot be that the world is the only thing that one can blame for what has gone wrong.

[18] The *locus classicus* here is of course Taylor (1989). See also the exchange between him and Susan James in Tully (1994: 214–219). The disintrication idea that our paper has called attention to is partly derived from this source, but has been deployed to bolster other conclusions.

and processing disturbed thoughts—as indeed can the family and the group as well (Kakar,1997: 51).

I have cited this passage at some length for reasons that will soon become apparent—but what is going on? It would seem that we have drifted away from the themes anchoring Part 2, and especially sections IV and V. Let me therefore reiterate. Without trying a full treatment, I shall mention only a way of framing the problem.

The interest of the foregoing paragraph consists less in the problem that it can help animate—namely, in the case of Kakar, the question of the cross-cultural validity of psycho-analysis, and, unto this question, to assert that '[p]sychoanalysis is [-] eminently possible with persons who do not share the modern Western version of psychological modernity but subscribe instead to their own traditional concept of individuation' (Kakar, 1997: 59)—than in the intersection that it seems to point, between the body/mind and discourse. Such an intersection has the effect both of structuring our perceptions of mental illness as well as of positioning the body/mind within it. More importantly, it seems to me to effect a modulation upon the space of our question concluding the previous section, i.e., section V.

Consider, yet again, Kakar. Illustrating from his own clinical practice in India, he observes the 'biggest error [consists] in making a sharp dichotomy between a [certain] cultural view of the interpersonal and transpersonal nature of man and a modern "Western" view of man's individual and instinctual nature'; and adds that '[a]lthough suggestive and fruitful for cultural understanding, the individual/relational differences should not be overemphasised' (Kakar, 1997: 52).[19] Now, this seems a remarkably fecund suggestion to make—an act

[19] I have modified somewhat the terms of the quote, mediating a more generalised and yet culturally sensitive reference for it. In the original, these remarks follow a vignette from a case history involving a *Hindu* patient.

[20] But is this thesis not relativist? And besides doesn't Kakar's psychoanalytic register inscribe emphases far removed from psychiatry and psychology (indeed from the spaces of medico-psychological practice generally)? I am afraid I cannot take up these questions here.

coming to be individuated by its appropriate description.[20] One explication, for our purposes, would be that the courts may have to seek after more structure than just the medico-psychological practice's verdict of 'identification'. And where, or if, this is not entirely possible or forthcoming—to condense, the legislative and adjudicative context of courts can imply constraints that are at once operational and structural—to seek after a reordering of *the tools* (in the sense noted in section III) of medico-psychological practice in general. This would not only have the advantage of taking note of the 'contradiction of purposes' that derive from an unrestricted transfer of psychiatric diagnoses to a legal context (for this see generally Dhanda, 1995); what is more, the search for definitionally constitutive views of mental illness is not hereby discarded. The disintrication factor alluded to in the foregoing sections, though not quantifiable, must be addressed in the evaluation of the chances in which we—legal practitioners, medical experts, policy planners and normative theorists— are engaged.

A FINAL CODA, AS IF IN CONCLUSION

To be sure, the idea inspiring this chapter has not been gender but the space of mental health, glossed here to the space of medico-psychological practice in general. In addressing this space, I think, we have always overlooked a vital mechanism that contributes to its internal dynamic—the axes of what we, following Canguilhem/Foucault, have termed a 'power of relegation' and a 'knowledge of identification'. The burden of this paper has been to institute a focus on the latter, and away from the former. This relocation, to be sure, gives considerable leverage to clinical practice, even shifting the axis of power from the patient to the medical practitioner. But, as if to displace this emphasis, our concern was also to mediate another reference for it, which, while issuing off the space of practice generally (vide the diagnoses of disease), was also concerned with placing in perspective our attitudes towards law, medicine and psychiatry in particular.

To suppose, then, that these problematisations constitute a retreat from the specific injunction to study women and mental health is to miss the significance of the fact that implicating gender, in this present context, is also to search after or give voice to partly prescriptive notions of mental illness. Indeed, towards the end, we were concerned to effect some specific considerations in the sections concluding Part 2.

And again, if I might venture a final suggestion: there is in all this, in the considerations that we have brought forward in these pages, a much larger question of what needs to be, and what can be, restructured in the light of, to use the philosopher–theorist Bernard Williams' words, a 'reflective and non-mythical understanding of our ethical practices' (Williams, 1985: 194). Specifically, one can take the moment and the injunction to study women and mental health as an opinion about what morality demands—and no argument can be decisive of that question which does not include premises or assumptions about what morality is for. The imperative is where to begin; and as we have tried to formulate here, it must begin with a consideration of the frameworks *internal* to a practice (in our case, medico-psychological practice).

Note the ideal inspiring this effort, invoking health/mental as at once a kind of *logical* demand and a brute (historical?) fact.

The Body, Reproduction and Mental Health

VI

THE INTERFACE BETWEEN PSYCHIATRY AND WOMEN'S REPRODUCTIVE HEALTH

Prabha S. Chandra

There is probably no other area in medicine which is fraught with so many emotional issues as reproductive health. For women, issues such as fertility, pregnancy, abortion and contraception have been areas of concern and debate. The reproductive health framework goes beyond the narrow confines of maternal and child health and family planning, to encompass all aspects of human sexuality, and adopts a life cycle approach (Ford Foundation, 1994).

It is important to recognise and describe psychiatric and psychological syndromes linked to reproductive function in women. There is an under-recognition of these conditions by health professionals and a tendency to label some of these, based on cultural expectations, as 'normal'.

.Three main forms of mental health problems have been linked to reproductive function:

1. Those related to physiological changes such as menstrual cycle, pregnancy and menopause.
2. Complications of surgeries/procedures/gynaecological pathology.
3. Pre-existing psychiatric problems and reproductive health.

Though the link between the emotional lives of women and reproductive health has long been recognised, there are very few studies and research projects that have addressed this issue directly, specially in the Indian context. Investigations

in this field have been confronted with the problems which relate to the ways in which people have viewed mental health and reproductive issues. Trivialising, medicalising and psychologising have been some of the ways of viewing these problems. Trivialising undermines the seriousness of the condition, while medicalising all the problems takes a very narrow perspective and ignores the cultural and social perspective in which a problem occurs. Psychologising any condition completely also has its drawbacks and may not acknowledge the benefits that recent advances in drug therapy have to offer women. Workers in this area have only recently acknowledged the value of understanding medical and psycho-social issues in an interactive manner.

In this chapter, I have made an attempt to describe the associations of mental and reproductive health, using a life cycle approach to view it in a bio-psycho-social perspective. Reproductive health is a large canvas and to be more focused and to describe the complex interplay of biological, hormonal and psycho-social factors, the chapter focuses on four major areas—the post-partum period, menopause, psychiatric issues in relation to the menstrual cycle and gynaecological somatisation.

POST-PARTUM PSYCHIATRIC PROBLEMS

The post-partum period is often associated with psychiatric disturbance and can be a harbinger of future chronic mental illness. Three types of disorders are seen: Post-partum blues, depression and psychosis. Post-partum blues is a fairly common condition, characterised by anxiety, gloominess and irritability. It occurs on the fifth to the seventh day post-partum and is usually self-remitting. However, in some women it may lead to more severe mental illness.

Post-partum depression is a more serious condition, occurring in 12–15 per cent of women and is the result of several biological and psycho-social factors. It has been found to occur more in those with a family history of depression. Biological factors that have been implicated are: a sudden

drop in oestrogen and progesterone levels, presence of hypo-thyroidism and neurotransmitter changes in the brain linked to the hormonal changes (Brockington and Cox-Roper, 1988; Cox, 1988). In addition, poor marital support has been strongly linked to depression (Cox, 1983).

Post-partum psychosis is a more serious form of mental illness and is the least common. Both schizophrenia and affective disorders can occur and the women may often need hospitalisation. Recurrence rates of post-partum psychosis range from 30 per cent in subsequent post-partum periods to 50 per cent in non-post-partum periods. An episode of post-partum psychosis in a large number of women acts as a trigger for subsequent psychotic episodes (Dean and Kendell, 1981). One of the findings causing concern has however been the poor levels of 'case finding'. Post-partum depression very often remains a hidden problem (Bagedahl-Strindlund and Monsen-Borjesson, 1996) and nearly two-thirds of the mothers with depression are not diagnosed, leading to under-treatment.

Several intervention methods are now being tried to pre-vent post-partum psychiatric morbidity (Cox, A.D., 1993; Elliot, Sanjack and Leverton, 1988). In a novel programme in the U.K. called *Befriending Young Mothers*, volunteers help women to care for their babies and 'listen' to the women's problems and worries (Cox, A.D., 1993). This acts as a method of support and networking. Women who are vulnerable to developing depression or psychosis (i.e., those with a past history or family history of illness) can be protected by drugs that prevent the rapid hormonal changes during the post-partum period (Gitlin and Pasnau, 1989). The strong associ-ation between marital functioning and post-partum depression also lends itself to intervention programmes that encourage husband participation in child birth and infant care.

Although there remains uncertainty regarding the rela-tive contribution of biological and psycho-social causes to post-partum psychiatric disorder ('PPP illness'), it is obvious that the clinical entity is deeply embedded within the socio-cultural content. This influences its labelling and treatment as well as help seeking. An isolated mother/infant dyad from whatever cultural background is at risk (Cox, 1983, 1988;

Brockington, 1996; Kumar and Brockington, 1988). In India, most studies have been epidemiological and clinical in nature and have not studied the impact of various social and cultural factors on post-partum psychiatric morbidity (Agarwal, Bhatia and Malik, 1990; Gautam, Nijhawan and Gehlot, 1982; Yogananda, 1997). Most studies have however found more morbidity among primipara, younger women and those with female new-borns. It has also been found that women with post-partum psychiatric problems in the Indian context often have associated medical problems, infections and neurological conditions. Marital life has been assessed in one study and certain areas of marital functioning such as role functioning, self disclosure and trust have been found to be impaired.

There is obviously a need for more vigorous biological and more qualitative, experiential studies. It is only when we hear the 'hidden voices' of women with PPP and their subjective feelings regarding motherhood, parenting and support are examined that the last word in PPP can be said.

THE MENSTRUAL CYCLE AND PSYCHIATRIC PROBLEMS

Pre-menstrual Psychiatric Syndromes

Nearly 100 symptoms have been described under the rubric of pre-menstrual changes and syndrome. Some of these are more common than the others. According to Dalton (1964, 1977), there are few body tissues that may not be affected by menstrual variations. Usually, women with pre-menstrual distress have more than one symptom and not infrequently have clusters of symptoms relating to various aspects of psychological and physical functioning. The definition of pre-menstrual changes is based mainly on the timing of the symptoms, i.e., occurring cyclically during the pre-menstrual period and returning to baseline shortly after the beginning of flow. The length of the pre-menstrual phase itself varies and ranges from one day to the entire luteal phase, though most workers use a period of 3–5 days for defining PMS. An operational definition of pre-menstrual changes is given:

Symptoms are considered pre-menstrual changes if there is a cyclic recurrence in intensity of the symptom measured from the second week of the menstrual cycle compared to the peak intensity of the symptom during the late luteal phase (1–7 days) prior to the onset of menses.

Symptoms and Subsyndromes in the PMS

Different groups of workers have described varying degrees of prevalence of these symptoms. Reports describe depression (85 per cent), irritability (80 per cent), mood swings and anxiety (60 per cent) in women with PMS. These figures are indicative of a high percentage of mood disturbances (Clare, 1985; Dennerstein, Morse and Vamavides, 1988). The second most commonly occurring group of symptoms is somatic in nature and its prevalence varies from 40–60 per cent. Cognitive symptoms have been described in 40 per cent women, with symptoms indicating water retention in 60 per cent. Among 400 normal women studied in Bangalore, the prevalence of abdominal pain was the highest (51 per cent), followed by irritability (39 per cent), lethargy (37 per cent) and mood swings (23 per cent). Thirteen per cent of the women reported the symptoms as being disabling and interfering with their work (Chandra and Chaturvedi, 1989).

Positive Symptoms. Though the usual manifestation of PMS is in the form of distress, a number of women also report an improvement in one or more areas of functioning. Nearly 15–40 per cent of women report increased well-being, improved energy and better efficiency with an improvement in libido. In some women there is an overall improvement in functioning, while in others positive symptoms co-exist with more distressful ones. In a majority of women the changes in the pre-menstruum are bi-directional and include both positive and negative changes (Chaturvedi, Chandra and Issac, 1993).

Pre-menstrual Subsyndromes. A number of factor-analytic and cluster-analytic studies carried out on PMS and pre-menstrual changes have revealed the existence of discrete

typological categories. The commonly reported factors are related to mood, which consist of a depressive factor and a well-being factor. In addition, most workers have described factors which indicate vegetative and somatic symptoms. The fourth commonly described group of symptoms is related to water retention.

Halbreich et al. (1982) reported that it is easier to discuss syndromes in women with mild to moderate degrees of pre-menstrual changes rather than in the more severe cases. In the latter group there probably occurs an overlap of several syndromes with one of them predominating. They have also described clusters of pre-menstrual changes which are subtyped based on symptoms. The following subtypes have been described:

1. Full depressive syndrome, which is further subdivided into:
 a) Atypical depressive, which clusters items of increased sleep, appetite and decreased energy.
 b) Hostile depressive, which has symptoms of violence, anger outbursts, spitefulness and irritability.
 c) Anxious agitated depressive, which consists of manifestations of anxiety, agitation and bitterness.
 d) Withdrawn depressive cluster, for loneliness, decreased activity and energy.
2. Organic mental syndrome, which is characterised by poor motor co-ordination, clumsiness, forgetfulness, concentration difficulties and confusion.
3. Impulsive syndrome, which includes women who show violence, lack of self control, impulsive behaviour and outbursts of irritability.
4. Water retention syndrome, which consists of breast pain or swelling, decreased urination, weight gain, abdominal bloating and signs of water retention such as puffiness of face and pedal oedema.
5. General discomfort syndrome, which includes complaints of headaches or migraines, backaches, joint and muscle pains and abdominal discomfort.

6. Increased well-being syndrome, which includes features such as increased enjoyment, excitement, well-being, improved efficiency and bursts of energy.

The importance of subtyping is both for management and determining possible aetiology. Other authors have also recognised the importance of subtyping and recognising 'bipolar' features in PMS.

Concurrent Morbidity

A variety of factors emphasise the relationship between menstrual cycle-related mood disorders and affective disorders in general. These are (*a*) a high prevalence of PMS in patients with major affective disorder; (*b*) the association of major affective disorders with periods of reproductive endocrine change; and (*c*) the possible role of recurrent menstrual-related mood disorders in the aetiopathology of major affective disorder.

A number of studies have tried to establish whether the co-occurrence of psychiatric disorders and PMS is more than a coincidence. Four studies have shown a much higher prevalence of affective disorders in women with PMS than the general population. Fifty-seven to hundred per cent of women with PMS had a lifetime diagnosis of major depressive disorder (Halbreich et al. 1982). Other disorders like schizophrenia and mania have not been found to be associated with PMS more than expected in the general population. Follow-up studies have shown a prevalence of 11–18 per cent of affective disorder in college women with PMS.

The periodic psychosis of puberty was one of the first entities to be described among syndromes that occurred *de novo* in association with the menstrual period and remitted with the onset of menses. Repeated psychotic episodes occurring in the pre-menstrual phase, which are usually described as being 'atypical', have been reported. In addition to psychosis, syndromes such as bulimia and panic disorder occurring only in the pre-menstruum have also been reported.

Cultural Issues in PMS

Any attempt at viewing an 'illness' or syndrome in a cultural perspective has to take into account the attitudes and beliefs related to the syndrome and the nature of help seeking sought for the conditions. Help seeking, in its turn, is to a large extent influenced by a society's explanatory model for that illness and may not even present to another form of healing or medicine. This has been amply demonstrated in conditions such as neurasthenia, possession and the 'semen loss syndrome'. Was it possible that the lack of reports of PMS from non-Western cultures was a result of varying help seeking patterns, wherein women with pre-menstrual distress do not attend gynaecology or medical clinics dealing with Western medicine, instead choose to seek help from traditional healers? Was PMS a 'hidden popular illness' that was being overlooked by investigators because of different patterns of help seeking?

To examine this issue 780 women from rural and urban areas were assessed for pre-menstrual distress. It was found that nearly 87 per cent had mild distress while 8 per cent experienced moderate to severe distress. Using diagnostic criteria 10 per cent of the women were found to have PMS. Based on these findings, 74 women with different help seeking problems were interviewed using the explanatory model approach with regard to possible aetiologies of pre-menstrual distress and its perception as a clinical syndrome needing treatment (Chandra and Chaturvedi, 1995). Forty-eight per cent of women experienced positive feelings at menarche, 50 per cent performed menarcheal rituals and 44 per cent had a positive attitude towards them. Only 8 per cent felt that pre-menstrual distress had a biological basis. Interestingly, the women with and without pre-menstrual distress differed from each other in some respects. The differences related mainly to attributional patterns (causation) of distress and menarcheal experiences. More women who experienced distress considered 'bad blood' accumulating in the body prior to periods as being a cause for their problems. This was considered as a self-remitting state which became

normal once 'bad blood' was expelled and was, according to the women, a necessary cyclical phenomenon.

Menarcheal experience was another factor where significant differences were observed. Women with no distress had more positive feelings at menarche. These findings appear to suggest that positive experiences at menarche influence the perception of pre-menstrual and menstrual experience. The evidence of occurrence of pre-menstrual distressful symptoms in this group of Indian women raises several questions based on the fact that none of them reported these symptoms spontaneously and were not seeking help (or had at any time sought help) for these distressful symptoms.

One of the possibilities is that the women did not consider these as 'medical' problems and hence did not feel the need to seek help. This is evident from the fact that only a small number of women felt that the aetiology of these symptoms was biological; majority of them considered the absence of rituals, inadequate diet and bad blood as the causative agents. The importance of menarcheal experiences in the Indian culture seems to form a major cornerstone in the perception and experience of subsequent menstrual experience.

'Accumulation of bad blood', which when removed from the body, 'leaves the body cleansed'—was another reason given for pre-menstrual symptoms. The menstrual period was seen as a healthy, necessary phenomenon to keep the body clean, and pre-menstrual symptoms occurred because of the 'bad blood' collecting prior to the period. The explanatory models offered by most women were based on non-medical models and all the causal agents implicated were of a nature that could be either modified on one's own (such as rest) where non-modifiable any longer (inadequate rituals, poor diet during menarche), were part of a 'natural, rhythmic' process (accumulation of bad blood). These might be the possible reasons why women did not seek help for their problems.

Extrapolating from this finding it appears that women do not consider pre-menstrual distress as an 'illness' and hence, do not seek help. The observation that only two women were aware of the syndrome as a clinical entity reaffirms the view that it is not considered an 'illness' but as a 'problem' which has its roots at menarche and is modified by rest and diet.

That PMS is a 'Western culture bound syndrome' may hence, not be completely true. A number of other conditions, e.g., possessions are not identified in certain cultures as 'illness'— they are supposed to be variations of behaviour and no medical help is sought, reaffirming the paradigm that it is the nature of the explanatory model which causes individuals to perceive a condition as an 'illness'.

PSYCHIATRIC PROBLEMS RELATED TO GYNAECOLOGICAL PATHOLOGY

Pelvic surgical procedures of any form have been reported to cause increased psychiatric morbidity. Depression and a post-hysterectomy syndrome characterised by headaches, insomnia and tiredness have also been reported. However, recent literature using vigorous methodology reveals this problem only in women with pre-existing psycho-pathology (Dennerstein and Pepperell, 1989; Martin et al., 1980). There is also evidence to indicate a high prevalence of depression among those with pelvic pain, menstrual irregularities and gynaecological cancers. Another important gynaecological pathology that has important mental health implications is infertility. Infertility in any culture imposes severe emotional stress on women. High rates of depression, anxiety and suicidal ideation have been reported in this group. Societal and cultural values hold women responsible for procreation and a failure to bear children is seen as a sign of weakness. Studies in India have reported high rates of mental heath problems, marital disharmony and social ostracism. Despite the new 'high tech' reproductive culture, few facilities are available to handle the emotional needs of such women and their spouses (Chandra et al., 1991).

MENTAL HEALTH AND MENOPAUSE

Several physical symptoms have been described in menopause that are related to decrease in levels of oestrogen.

These are mainly in the form of flushing, bone pains and vasomotor symptoms. Though it is well known that physical symptoms occur frequently in the peri-menopausal period, the status of the psychological syndrome of menopause is far from clear. The following psychological symptoms have been reported in the climacteric: depression (20–30 per cent), anxiety (15–20 per cent), sexual dysfunction (10 per cent) and difficulties in concentration (5–8 per cent) (Dennerstein, Burrows and Hyman, 1979; Hunter, Battersby and Whitehead, 1986; Pearce, Hawton and Blake, 1995). Most of the data is from menopause clinics, though general population studies contradict assertions that menopause has a negative effect on mental health.

Several cross cultural variations in the perception of menopause have also been noted with Western women showing a higher incidence of depression (Pearce, Hawton and Blake, 1995). This has been accounted for by negative attitudes towards ageing and menopause in cultures where higher psychiatric morbidity has been reported. Studies done in the Melbourne Women's Mid-life Health project have indicated that menopause does not directly influence well-being. Mental health of women in the climacteric appears to be related more to social factors, pre-morbid functioning and physical health, than to the menopausal status. Several factors might contribute to increased psychiatric morbidity at menopause including life events such as death, poor physical health, altered roles, retirement or a poor marital relationship.

Though in most cases, menopause may not directly cause psychological problems, a small minority do have the problems which were described earlier. Surgical menopause has been linked to a higher incidence of psychiatric morbidity compared to natural menopause.

Hormone Replacement Therapy and the Menopause

The role of HRT (Hormone replacement therapy) in relieving symptoms of the menopause has been fairly well-established. For the problems related to menopause, HRT is beneficial in the relief from vasomotor symptoms, prevention of

osteoporosis and prevention of cardiovascular disease. However, similar conclusions cannot be drawn regarding the beneficial effects of HRT on psychological symptoms. The only situation in which HRT has a definite role in ameliorating psychological symptoms are in surgical menopause (i.e., following a hysterectomy with bilateral oopherectomy or in primary ovarian failure). In surgical menopause, HRT appears to have a two pronged approach. First, it causes a 'domino effect', i.e., it improves well-being by ameliorating physical distress. More importantly, however, it improves sleep, cognitive and sexual functioning and has a definite beneficial effect on mood (Hunter, Battersby and Whitehead, 1986).

It is very important that the condition of a peri-menopausal woman with psychological distress be assessed in detail. Factors that need to be considered are psychological and social attitudes towards ageing, and other family- and role-related issues. Apart from that, a detailed physical evaluation is mandatory. With the current state of knowledge, considerable caution must be exercised when using HRT for psychological symptoms alone in natural menopause. However, women with degenerative disorders, cardiovascular diseases and psychiatric problems in the context of surgical menopause should not be denied the possibility of trying HRT.

GYNAECOLOGICAL SOMATISATION

Several clinical conditions in gynaecological practice are known to have social and psychological associations. Among these, the commonest and probably the least adequately understood are chronic pelvic pain and leucorrhoea. Chronic pelvic pain (CPP) is defined as a general symptom of persistent pain—of at least several months duration—located in the pelvis. It can be a major problem for those afflicted because of the associated distress, and for health services because of the large numbers of patients presenting with it (Harrop-Griffiths, Katon and Walker, 1988). In 1978, over 10,000 laproscopies were carried out in the U.K. to investigate

unexplained pelvic pains (Chamberlain and Brown, 1978). In at least two-thirds of the women with CPP, there is no obvious identifiable pathology. The most important theory explaining pelvic pain has been that of the pelvic congestion syndrome. Several psychologial factors including 'the meaning of pain', sexual abuse and depression have been linked to CPP. Figure 6.1 offers a possible explanation for CPP by attempting to link psychological factors, attitudes towards pain, illness behaviour and help seeking patterns to pelvic congestion and pelvic blood flow.

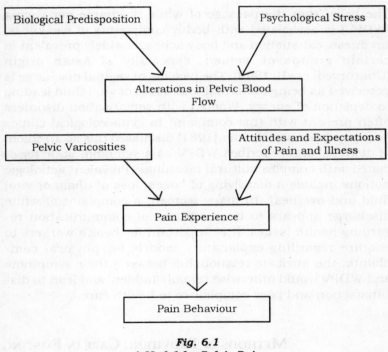

Fig. 6.1
A Model for Pelvic Pain

The importance of this syndrome lies in the fact that women with CPP often go through several surgical procedures for pain relief, and psycho-social factors that might

contribute to the pain are often ignored. Studies done in India (Agarwal et al., 1996) have also noted that women with CPP have higher rates of depression and somatisation than normal. Most workers have emphasised the need for detection and appropriate treatment rather than medicalising the condition completely (Agarwal et al., 1996; Fry, Crisp and Beard, 1997; Harrop-Griffiths, Katon and Walker, 1988).

NON-PATHOLOGICAL VAGINAL DISCHARGE

The belief that the passage of white discharge per vagina (WDPV) is associated with bodily complaints of weakness, tiredness, exhaustion and body aches, is widely prevalent in certain groups of women, especially of Asian origin (Chaturvedi et al., 1993). The passing of vaginal discharge is perceived as being abnormal and a loss of vital fluid leading to depletion of energy. Women with somatisation disorders often present with this complaint to gynaecological clinics or to psychiatrists. Nichter (1981) discussed this as an 'idiom of distress' and described WDPV as a symptom state associated with complex cultural meanings. Prevalent aetiologic notions include a dissolving of bones, loss of *dhatu* or vital fluid and overheat. In many women, a complaint of white discharge appears to be a medium of communication regarding health issues. It is important for health workers to enquire regarding explanatory models for physical complaints; the intricate relationship between their symptoms and WDPV would otherwise remain 'hidden' and lead to dissatisfaction and poor compliance to health care.

METHODS OF PROVIDING CARE IN EXISTING HEALTH SETTINGS

Most women may not seek advice for mental health issues unless the problem becomes severe. Women, however, seek frequent help for gynaecological complaints and with advances

in primary health care, most women go through regular ante-natal check-ups. It is important hence, to integrate mental health in the care of pregnant women or those who come to the reproductive health clinics. One of the ways in which morbidity could be reduced is by early assessment and iden-tification of mental health problems. Simple screening meth-ods used by medical and paramedical staff can identify 'at risk' cases and consider appropriate referrals. On the other hand, mental health professionals often ignore reproduc-tive health issues in women with psychiatric problems and we need to increase their sensitivities regarding this issue. The two teams need to work together to provide appropriate care.

Pilowsky (1991) has commented that although women are the major mental health consumers, their special needs have yet to be understood and accounted for in service planning. Reproductive milestones in the form of menarche, pregnancy and menopause are intimately related to mental health. In addition, issues related to reproductive health play an im-portant role in increasing the choices women have in planning their lives and in the control over their health and bodies. Help seeking regarding reproduction-linked mental health issues is related to explanatory models, communication regarding dysfunction and attitudes towards illness. Limited choices and poor accessibility to appropriate information may often lead to poor detection and treatment.

The 'trivialisation' of psychological suffering and inappro-priate 'medicalisation' of natural reproductive milestones alienate women from seeking help from the existing health resources. More in-depth understanding of women's bodies, the link between physical and psychological health, and unbiased treatment models are necessary to create harmony between reproductive and mental health.

Women's subjective experiences are very often lacking in most of the research in the field. In addition to diagnosing dysfunction and treating illness, it is also important to pro-mote positive attitudes in women towards their bodies and regarding choices related to reproductive health.

VII

GYNAECOLOGICAL MORBIDITY AND COMMON MENTAL DISORDERS IN LOW-INCOME URBAN WOMEN IN MUMBAI

Surinder K. P. Jaswal

GYNAECOLOGICAL MORBIDITY

Gynaecological morbidity including Reproductive Tract Infections (RTIs) have started to receive increasing attention at international fora and by international bodies, such as WHO, policy groups and donor agencies. This is probably as a result of increased attention to the association of RTIs with Human immunodeficiency virus (HIV) infection and to high maternal morbidity and mortality associated with sepsis of the reproductive tract (Wasserheit and Holmes, 1992).

McDermott, Bangser, Ngugi and Sandvold (1990), in their review article on infections, presented at the 1991 National Council for International Health (NCIH) Conference in Washington D.C., report that the prevalence of infections in women is extensive, and current knowledge probably reflects only the tip of the iceberg. These infections include a broad range: sexually transmitted diseases (STDs) including HIV and acquired immunodeficiency syndrome (AIDS); overgrowth of endogenous organisms; infections acquired from unsafe abortions and deliveries, female circumcision and unsafe practices during reproductive years, and from endemic diseases such as tuberculosis (TB) and malaria. Their consequences can be severe and life-long, resulting in

not only medically recognised mortality and morbidity but also social ostracism due to either the physical symptoms and signs such as incontinence, painful sexual intercourse, foul-smelling vaginal discharge and skin lesions, or to their social sequelae including divorce due to infertility and the inability to work (Wasserheit and Holmes, 1992). Bhatia and Cleland (1995), Brabin et al. (1995), Cooper et al. (1991a, 1991b), Younis et al. (1992) and Zurayk et al. (1995) also report similar findings from Western and South Africa, and India.

Wasserheit and Holmes (1992) further report that in re-source poor settings around the world, gynaecological morbidities are extremely common and the consequences for health and social well-being of the women (as in the case of subsequent infertility) and their children—due to devel-opment of congenital defects or illness as a result of infection in the mother—are frequent and potentially devastating. They further assert that because of socio-cultural factors and structured barriers to care, both the incidence and the impact of gynaecological sequelae are likely to be particularly great in developing countries. Further demographic changes (rapid urbanisation and population growth) in the developing world have placed an ever greater proportion of these populations at risk for gynaecological morbidity and their sequelae.

As a result of problems in study design, reporting, speci-men collection and laboratory methods, data on the preva-lence of RTIs in the developing world are often difficult to interpret in terms of internal validity and generalisability. Nevertheless, some observations appear consistently. First, that RTIs and related morbidity are common (as high as 15 per cent even in low-risk populations) in almost all of the developing countries in which they have been investigated, even among asymptomatic populations and low-risk indi-viduals such as family planning or ante-natal clinic attenders and adults sampled in population-based studies. Second, in most countries, STD rates are highest among high-risk populations such as commercial sex workers and men in occupations involving extended or recurrent separations from family (truck drivers, migrant workers). Finally, certain infections (chlamydial and bacterial vaginosis) despite their

potential role in upper tract infection, infertility and adverse outcomes of pregnancy remain largely ignored as causes of morbidity in women in developing countries (Wasserheit and Holmes, 1992).

Gynaecological Morbidity in India

A review by Sullivan (1989) of the Indian literature on 'Women's Health Behaviour' demonstrates that studies that have examined morbidity in women, apart from those related to pregnancy and childbirth, are rare. However, through an initiative by the Ford Foundation in the last decade, India has addressed this gap in knowledge by initiating multiple activities to increase the social science research capacity for women's health in India (Bentley et al., 1990).

As a consequence of the Ford initiative and other studies since 1988, research in India (Bang et al., 1989; Bang and Bang, 1994; Bhatia and Cleland, 1995; Bhattacharya, 1991; Chatterjee, 1994; Kannani, 1991; Latha, Shah and Kannani, 1991; Luthra et al., 1992; Mulgaonkar, 1991; Patel, 1994; Shatrugna, Vidyasagar and Sujata, 1993) shows that there is a large reservoir of unmet needs among women (high percentage of gynaecological and related morbidity which are not reported or treated at local health centres), particularly in low-income communities, that are not addressed by current primary health care (PHC) practices and which are bypassed by the various child survival programmes. Also, it is seen that in general, health services for women have been conceived with little regard for their needs, demands and the socio-cultural milieu in which they live, as evidenced in the timings of the government's urban and rural health clinics, the absence of female doctors and the emphasis on family planning.

In India, there is a large absolute number of women potentially in need of reproductive health care; approximately 133 million women are in the reproductive age group. The demographic trends in India have been important indicators of the women's health status. The ratio (933 females: 1,000 males) found in the 1981 National Census is a clear indicator of the higher mortality risk experienced by females. The

average Indian woman has about eight pregnancies and live births while typically four or five of her infants survive. She is estimated to spend 80 per cent of her reproductive years pregnant or lactating. The reproductive morbidity including RTIs and other morbidities exercise an adverse influence on her productive role in society and a detrimental effect on her health profile (Luthra et al., 1992).

Magnitude of Gynaecological Morbidity

Research in developing countries thus indicates that reproductive morbidity and especially RTIs and other gynaecological morbidity conditions are common diseases with profound social and health consequences for women, men and children of developing countries. As one of the world's most neglected problems, these morbidities are related in important ways to girls' and women's basic sexual and reproductive health. Yet, in allocating scarce human and financial health care resources to developing countries, policy makers, programme planners and international donor agencies have generally given low priority to gynaecological and other morbidity conditions in women.

In part, this is because of the mistaken belief that these morbidities (especially RTIs) are not fatal, that they are too expensive and too complicated to treat, and that in most developing countries they affect only small and specialised segments of sexually active adults such as prostitutes. Each of these assumptions can be challenged by a growing body of evidence (Brabin et al., 1995; Dixon-Mueller and Wasserheit, 1991; Gittelsohn, Pelto et al., 1994; Gittelsohn, Bentley et al., 1994; Schmunis, 1993; Zurayk et al., 1995).

Impact of Gynaecological Morbidity on Women

Literature review of community and hospital based data on reproductive health in India in the last decade clearly indicates that the prevalence of gynaecological morbidity amongst low-income women is very high (ranging between 50–72 per cent). However, health seeking behaviour of women indicates that they are unwilling to seek medical treatment of their problems or do not recognise them as health problems at

all. In many cultures women accept vaginal discharge, discomfort during intercourse or even the chronic abdominal pain which accompanies some gynaecological morbidity conditions (especially RTIs) as an inevitable part of their womanhood. These morbidities are to be endured along with other reproductive health problems such as sexual abuse, menstrual difficulties, contraceptive side effects, miscarriages, and potentially life threatening clandestine abortions or still-births (Brabin, 1992; Jaswal, 1995).

Gynaecological morbidity has an additional element of shame and humiliation for women because the women are considered unclean (in most Hindu homes a menstruating woman is perceived as a 'pollutant' or as 'polluted' and is forbidden to touch the water pot or pray to the family deity). The invisibility created by psycho-cultural barriers and taboos associated with reproduction and sexuality are responsible for the belief that gynaecological morbidity should be endured, and create a 'culture of silence' within families and communities that can severely compromise womens' health, both physical and mental. Besides the cultural and social taboos related to gynaecological morbidity, womens' concepts of 'normality' further inhibit them from seeking treatment.

Thus, it is seen that in spite of the increasing attention given by international and national health organisations to the health problems of women, especially to gynaecological and related morbidity conditions in women from low-income groups in developing countries, due to social customs and taboos related to women's health and the status of women in these countries, very few women report morbidity to the allopathic health providers. Moreover, women from low-income urban areas face further hurdles in access to health care as discussed in the following section on impact of urbanisation on women's health.

URBANISATION AND MENTAL HEALTH

This section discusses the effects of migration on underserved populations, urbanisation, and its impact on women's

mental health. Schwab and Schwab (1978) noted greater mental illness under social, especially metropolitan, conditions of instability, turmoil, adversity, corruption and social disintegration. Urbanisation has produced major transformations in Third World societies, which have been particularly critical for women. Women have higher rates of unemployment than men, and urban working-class households headed by women—a growing phenomenon in the Third World (see Tinker and Bramsen, 1977: 37)—have less access to resources and are more dependent on the informal sector of the economy than households with a male partner in residence (see Bolles, 1985). These issues have consequences for women's health, particularly for women's mental health (Alves et al., 1992). The association between urbanisation and mental ill health is now widely acknowledged (Almeido-Filho, Mari and Coutinho, 1995; Cheng et al., 1995; Harpham, 1995). The WHO (1991) has stated that mental health deserves particular attention and action in the 1990s and the twenty-first century because modern trends such as urbanisation are likely to increase the extent of the problem (Alves et al., 1992). Blue and Harpham (1994) emphasise that the World Bank's *World Development Report* (1993) for the first time focuses on health and reports that neuro-psychiatric disorders, particularly depression, account for 5.7 per cent of the total burden of disease for women in the developing world and rank fifth in this respect.

Walters (1993) reports that in a stratified random sample of 356 Canadian women, it was seen that women experienced mental health problems differently depending on their socio-economic status, ethnicity, family structure, the quality of family relationships and the nature of their participation in the labour market. Several studies in developing countries have also suggested associations between the mental ill health (psycho-social distress) of poor women and factors such as migration, marital status and occupation (Blue et al., 1995; Harpham, 1992; Rabelo, Alves and Almeida Souza, 1995; Sugar, Kleinman and Heggenhougen, 1991; Wasserheit and Holmes, 1992).

As Reichenheim and Harpham (1991) note, two specific components are of particular importance in mental health:

(a) Major difficulties such as low-income, poor housing, overcrowding and high parity, lack of security of tenure etc. (Brown, 1979); and

(b) The absence of support provided by social relationships and the internal dynamics of the family group, where lack of intimate ties with spouse is explicit (Henderson, 1980).

Thus, in urban areas, a complex variety of interacting stressors affect the population. Urban communities tend to be anonymous, people often do not know their neighbours as they might in a small town, and extended families are rare. Because of their size, urban communities also tend to be places where formal human services are centred. Cities are also often progressive and somewhat experimental in orientation and thus are able to provide alternatives for the sociological functions that exist in more traditional forms in rural places (Bachrach, 1992). Thus, cities often contain self-help groups and supportive caring networks that are developed specifically for the purpose of assisting people who have special problems and they frequently take over some of the functions that are traditionally associated with family support (Bachrach, 1992). However, the low-income populations do not have access to these supports due to financial (fees for entry), social, political and legal (lack of recognised housing, stigmatisation and political polarisation) barriers.

Urbanisation, it is thus seen, has produced major transformations in developing countries which have been particularly critical for women's health, especially women's mental health. Further, the association between mental ill health of poor women and factors such as migration, marital status and occupation are widely recognised today (Harpham and Blue, 1995).

OUTLINING A STUDY

Methodology

This chapter reports part of the findings of a larger study on low-income urban women's gynaecological and mental health.

The main objective of the study was to understand women's experience of gynaecological morbidity and its association with common mental disorders, and social supports and networks. The study used both quantitative and qualitative methods to collect data on gynaecological morbidity, common mental disorders, and social support and networks. Rapid assessment techniques were used to explore women's emic perspective of gynaecological morbidity, the findings of which are reported elsewhere (Jaswal, 1995).

A total of 660 women were interviewed in three contiguous low-income communities (*zhopadpattis*). Of these thirty-six women were further followed up for in-depth interviews. Inclusion criteria were used to select the women for the study. Women residing in the selected community, ever married, in the reproductive age group of 16–45 years, married for at least two years, not currently pregnant, not menopausal and not post-natal amenorrhoeaic, with no history of severe mental illness were eligible for the study. For the purpose of the study, gynaecological morbidity was operationalised as self-reporting of symptoms (one or more) indicative of reproductive tract infections, menstrual problems, prolapse, infertility, dyspareunia, urinary problems, abortion morbidity and intra-uterine device (IUD) morbidity. Households were selected for the quantitative phase of the study through simple random sampling procedure. Purposive sampling was used to select women for the in-depth interviews based on their willingness to participate and ability to reflect on their experiences. Further, women reporting a variety of gynaecological morbidity, of different ages and from different parts of the community were included for the in-depth studies.

Results and Discussion. Common Mental Disorders

The self-reporting questionnaire–20 (SRQ–20) (WHO, 1994)—Hindi and Marathi versions—was used to assess common mental disorders of all the women who met the eligibility criteria. The SRQ–20 was conceived as a tool for primary health care enabling non-specialised health personnel to identify individuals with mental disorders in community

settings for either follow-up or referral. As Reichenheim and Harpham (1991) quote 'because women are more likely to develop neurotic disorders such as depressive episodes, anxieties, agoraphobias or somatisations (Murphy, 1986; Paltiel, 1987; Weissman and Klerman, 1977) and because anxiety depressive states and psychosomatic disturbances are the most frequent types of mental disorders found in medical practice and in community studies (Climent et al., 1980; Goldberg and Blackwell, 1970; Mari, 1986; Wing, Cooper and Sartorius, 1974) the subject of women's mental health is best studied in the community using a questionnaire which assesses these specific issues' (Reichenheim and Harpham, 1991: 685). Various studies on the measurement of mental health in developing countries have used the SRQ–20 for the diagnosis of minor psychiatric morbidities (common mental disorders). In these studies, the cut-off point between what is normal (non-caseness) and what is abnormal (caseness) is usually based on the sensitivity and specificity figures for that cut-off point. Studies conducted in India in the past have used 7/8, 10/11, and 5/6.

The cut-off point for this study was calculated by reviewing international and Indian literature on the use of the SRQ–20 (Araya, Wynn and Lewis, 1992; Carta et al., 1993; Deshpande, Sundaram and Wig, 1989; Dhadphale, Ellison and Griffin, 1982; Harding et al., 1980; Kortmann and Ten Horn, 1988; Mari and Williams, 1985; Penayo, Kullgren and Caldera, 1990; Salleh, 1990; Sen, 1987), and calculating the specificity and sensitivity of the various cut-off points with the dot matrix and the ROC (relative operating characteristics) analysis. As the difference in specificity between the two cut-off points was not high and though ROC analysis favoured 8/9 as the cut-off point, the above literature review favoured 7/8 as the cut-off point. Hence, it was decided to use 7/8 as the cut-off point for assessing common mental disorders in the current study.

Presence of Common Mental Disorders

On using 7/8 as the cut-off point, 17.9 per cent women in the community reported common mental disorders. Table

Table 7.1
Frequency of Common Mental Disorders

Symptom on SRQ–20	Frequency of 'Yes' Responses (%) N = 660
Frequent headaches	175 (26.5)
Poor appetite	130 (19.7)
Poor sleep	65 (9.8)
Easily frightened	174 (26.4)
Hands shake	91 (13.8)
Feel nervous, tense, worried	250 (37.9)
Poor digestion*	42 (6.4)
Trouble thinking clearly	55 (8.3)
Feel unhappy	212 (32.1)
Cry more than usual	167 (25.3)
Difficulty in enjoying daily activities*	37 (5.6)
Difficulty in making decisions	65 (9.8)
Daily work suffers	69 (10.5)
Unable to play useful role	47 (7.1)
Loss of interest in things	65 (9.8)
Feel like a worthless person*	77 (11.7)
Thoughts of ending life*	41 (6.2)
Feel tired all the time	281 (42.6)
Uneasiness in stomach	127 (19.2)
Tire easily	250 (37.9)

* Missing data = 1 case

7.1 shows the distribution of symptoms on the SRQ–20 when 7/8 was taken as the cut-off score for caseness and non-caseness.

A certain proportion of the women (42.6 per cent) reported feeling tired all the time, followed by 37.9 per cent each who reported feeling nervous, tense and worried and easily tired. When the cut-off point was raised to 8/9, 13.2 per cent of the women reported common mental disorders.

PRESENCE OF GYNAECOLOGICAL MORBIDITY AND ITS ASSOCIATION WITH COMMON MENTAL DISORDERS

In this study, 50.6 per cent of the women reported gynaecological morbidity (i.e., presence of at least one gynaecological

morbidity). Further, 27.5 per cent of these women also reported common mental disorders. This indicates a definite association between gynaecological morbidity and common mental disorders as only 17.9 per cent of the respondents (with and without gynaecological morbidity) had reported common mental disorders in the total survey sample. Reichenheim and Harpham (1991) report a prevalence rate of 36 per cent in low-income women in Brazil. In the U.K., prevalence rates of common mental disorders in the community are reported to be between 10–30 per cent (Stansfeld et al., 1995).

The association between gynaecological morbidity and common mental disorders is quite high, indicating a heavy burden of reported illness (both physical and mental) among poor women. The in-depth interviews with the women threw light on the impact that the presence of gynaecological morbidity had on them. They reported that the gynaecological symptoms had affected their lives in different ways. The effect was felt in three ways—physical, social and psychological.

Physical

The women said that they could not perform household chores at the same pace as they had earlier. They took much longer to cook, clean, wash clothes and fill water from the community taps. Many said that they found it difficult to wake up in the morning and were stiff for an hour or so. Most reported being unable to sit on the ground for long and to also lift heavy things. Many of the women said that they could not walk long distances any more; their limbs felt lifeless and hands and legs got easily cramped. Most women said they had a general feeling of weakness.

Social

The women restricted their social activities such as visiting relatives, friends or going out for entertainment as they tired more easily, or could not walk for long distances, or because they felt dirty (discharge). They also did not want to give an opportunity to relatives and other people to comment on their

'laziness' when they could not help in performing household chores at family functions.

Psychological

The women reported a poor self-image as compared to earlier due to poorer performance in household tasks and inability to perform other tasks (take child to school, or work for wages). Women with white and red discharge reported that they wondered what other women/people thought of them, as they themselves felt 'wet and dirty'. Women who had itching and bad odour with the discharge were also afraid to sit or stand close to other people for fear of giving off a bad odour or to scratch themselves to alleviate the itching. They were reluctant to have intercourse due to the same reasons. They also reported feeling 'low' as they could not perform their share of the household tasks due to physical implications (elaborated above), and instead had to spend money on their treatment (even if spasmodic). They felt that this money could be better spent on the children.

Further, though most of the women 'made light of' or showed disinterest in their reported symptoms, on probing it was learnt that they had hidden fears and beliefs about them. Many women feared that the white, red discharges would lead to cancer. Some women who had itching and a bad odour along with the discharge feared that they had STDs (sexually transmitted diseases).

The following are fears expressed by a 19-year-old woman from north India, educated up to class five, married for two years and as yet childless; a 30-year-old woman from Maharashtra with two children and no formal schooling; a 23-year-old woman from Maharashtra with education in Bihar till class eight and a 34-year-old Buddhist woman educated up to class seven.

- Even I think there must be some illness [hesitated] . . . yes . . . yes I feel like that [that it's 'heat'—the term for STD] but there are no boils. I think now it's less but some day or the other it will happen.

- Who will look after my children if something [cancer] happens to me?
- If it was more I would have fear . . . long silence . . . but it's not.
- If something more happens who will look after me? My children are young.

The fears for all the symptoms were similar. Some women felt that the symptoms would grow/increase over time and the women would eventually die. Most feared contracting cancer or some big (fatal) disease, and eventually become disabled and die. Most women felt that the symptoms were a sign of some disease. 'I fear that some illness must have happened to me.' On the other hand, many women coped by accepting the morbidities (denial) as their lot in life. 'I do not think I have an illness. Women always have white discharge.' One said, 'No fear. I don't think.'

Table 7.2 summarises the association between socio-demographic variables and the two morbidities.

ASSOCIATION BETWEEN MORBIDITY AND SOCIO-DEMOGRAPHIC CHARACTERISTICS OF RESPONDENTS

Age

A significant association is seen between the age of the respondents and psychiatric morbidity. Table 7.2 shows that with increase in age there is a proportional increase in the number of women reporting caseness for common mental disorders. Interestingly, though for gynaecological morbidity the least number of cases were reported by women in the 36–45 years age group, in the case of common mental disorders the largest number of cases were reported by women in the older age group. This indicates that though younger women in the sexually active age group are vulnerable to gynaecologial morbidity, older women are vulnerable to common mental disorders.

Table 7.2
Summary of Findings on Gynaecological Morbidity and Common Mental Disorders in Respondents

Type of Morbidity	Presence of Morbidity
Gynaecological morbidity	• Women reported one to six morbidities each. The presence of gynaecological morbidities were reported by 50.6% women; one was reported by 24.4%, two by 13.5% and three to six morbidities by 12%.
	• Reproductive tract infections, menstrual problems, prolapse and urinary infections (in that order) formed the major proportion of the reported morbidities.
	• Respondents in the 16–35 age group reported 87% of the morbidities; women in the 26–35 age group mainly reported RTIs, menstrual problems, urinary infections and prolapse; and women in the 36–45 age group reported the least number of cases.
Association between gynaecological morbidity and common mental disorders	• The percentage respondents who reported common mental disorders when 7/8 was taken as the cut-off point was 17.9% and 13.2% when the cut-off point was raised to 8/9.
	• Around 27.5% respondents reporting gynaecological morbidity also reported common mental disorders when 7/8 was taken as cut-off point for common mental disorders and 81.6% when the cut-off point was raised to 8/9.
Gynaecological morbidity and common mental disorders and socio-demographic variables	• No association between both morbidities and respondents' and husbands' education, family monthly income, religion and sterilisation history.
	• Gynaecological morbidity was associated with younger women (16–35) and common mental disorders with women in the higher age group (35–45).
	• Unemployment was associated with higher common mental disorders.
	• Presence of a major illness was associated with higher reporting of both morbidities.

Education, Family-income and Sterilisation

On exploring the association between morbidity and respondents' and respondents' husbands' education, no significant association was seen between gynaecological morbidity and common mental disorders and education. There was also no significant association between family income and sterilisation and the two morbidities.

Religion

A significant association was seen between respondents' religion and common mental disorders. Women who were non-Hindus (especially Baudhs—minority group from the home state) reported higher caseness for common mental disorders.

Employment

Though there is no significant association between gynaecological morbidity and respondents' employment, there is a significant association between respondents' employment and common mental disorders. Table 7.2 shows that women who are not employed for wages are more vulnerable to common mental disorders.

Major Illness

A significant association is also seen between gynaecological and common mental disorders and presence of major illness as reported by the respondents. Table 7.2 shows that though the numbers are small, the proportion of women reporting caseness for both gynaecological and common mental disorders is higher for those women reporting a major illness.

Thus, women reported that the presence of gynaecological symptoms affected their physical health (weakness, fatigue, body pain), changed their sense of self-worth and personal dignity (due to inability to perform tasks and feeling 'dirty'), and affected their social mobility (inability to participate in functions/ceremonies).

Results indicate that there is a significant association between women in the higher age group (36–45 years) and common mental disorders. Studies in Argentina, Guyana, Costa Rica and Chile also report that older women in slum/ migrant communities are more susceptible to common mental disorders. Paltiel (1993) reports that lack of friendship, lower income security, weakening of traditional family obligations and caring for older senile relatives and grandchildren may be contributing factors.

As expected, women who were not employed suffered from major illnesses such as kidney problems, lumps in breast etc., and women who were non-Hindus, especially those belonging to minority groups, also reported higher caseness for common mental disorders (Table 7.2). Stansfeld et al. (1995) also report that there is increasing evidence that work-related social support may be a powerful protective factor against common mental disorders. However, only the presence of major illness was associated with gynaecological morbidity. The direction of causation remains ambiguous here as the time of onset of the major illness and gynaecological morbidity and common mental disorders was not explored.

This study reveals that 17.9 per cent of the respondents report common mental disorders. This implies that women in low-income communities have a heavy burden of mental ill health. Harding et al. (1980) report that 15 per cent of all primary care attenders across the world have common mental disorders. It is reported (*World Development Report*, 1993) that there is a growing evidence from both developing and developed countries that the prevalence of common mental disorders (depression and anxiety) among women is higher than that of men. Several studies in developing countries also report that there is a predominance of females among depressives, both in incidence and prevalence studies in institutions as well as community settings (Davar, 1995a; Venkoba Rao, 1994: vi.). This predominance is reported in several epidemiological studies reviewed in Latin-America, Cali, Colombo, Taiwan and Sao Paulo, Brazil (Blue et al., 1995).

This chapter clearly demonstrates the high association between reporting of gynaecological morbidity and common

mental disorders in the community. Women who are unemployed, report a major illness, belong to non-Hindus castes and are older, are also seen to be more vulnerable to common mental disorders. The underlying reasons for women's vulnerability could be due to various explanations: as women are more willing to admit psychological distress, effect of hormones, social class, social roles, status of women, because of integration of feelings of lack of power, and demand overload which causes an overall sense of loss of control (Blue et al., 1995). Whatever the reasons, one fact emerges clearly—that women in urban communities report a fairly high incidence of common mental disorders. This points clearly at the need for integration of mental health services at the primary health care level at both preventive and curative levels with a special focus on the 'neglected half' of the population—the women!

VIII

THE FEMALE BODY AS THE BATTLEGROUND OF MEANING

Janet Chawla and Sarah Pinto[1]

To the extent that feminism itself views the splitting of the self as an index of the fundamental crippling of women in patriarchy, and implicitly posits a unified and continuous self as the aspiration of a feminist sense of subjecthood, we stand the risk which is acute in a country such as India, that of ceasing to be able to apprehend the voices of women who situate their experience within a religious framework. This in turn violates what is equally one of the constitutive features of feminist ethics, which would entail developing the capacity to listen to the voices of women telling of their experiences, however radically differently situated those women might be.

—*Kalpana Ram*

The legacy of representations about the female body has been many-layered and often problematic. On the one hand, the dominant Indian cultural traditions valorise the woman as mother while controlling female sexuality and delimiting powers in socio-political-economic arenas. On the other, globalisation is simultaneously exploiting female bodies as marketing devices and erasing embodied and woman-centered knowledge systems and practice. Herbal medicines, dietary regimens, ritual and other healing modalities are

[1] Credits. Sheba Chachi, Vidya Rao, Sunil Khanna, S.Srinivasan, T. Vijayanendra, Father Gispert, Father Amaldoss, Elinor Gaddon, Poonam Zutshi, Susan Wadley, Anuradha Marwah Roy, Deepti Priya.

being replaced by medicalisation and pharmaceuticals. The female body has been problematised by Western bio-medicine in the name of 'development'. Within this context, it has been difficult to develop feminist theoretical perspectives on the female body.

Within hierarchised social systems individuals are controlled via their bodies. The bodies and body processes of certain individuals are circumscribed within spheres of pollution, avoidance and danger, among others (Comaroff and Comaroff, 1992; Foucault, 1975). This paper will explore the ways in which the flesh-and-blood body is foregrounded in the expression of the *non*-hegemonic belief systems by drawing on data from *dais* (traditional midwives). Although both have made incursions, neither allopathic medical, nor Brahminic ritual praxis have managed to supplant the embodied knowledge and the practice of the *dais* on the subcontinent.

Our interpretation of the *dais'* rite and song examines the dynamics of modes of *'knowing and being'*, that is, the epistemologies and the ontologies, in which the body is not separated from the mind or spirit, and is in fact, honoured. Indian socio-cultural expressions are replete with non-hegemonic examples of the body being utilized as a religio-cultural metaphor. In this paper, we attempt a feminist articulation of the female body's role in the creation of embodied meaning. In the larger sense, 'body' can be defined as that through which all experience is lived, and so we take the perspective that bodies both read and create culture; that body and mind are not separate in the creation of meaning and ideology.

Complex sensibilities of radical non-separation are often approached through the 'firstness' of aesthetic expression. Songs, poems, rituals, and other cultural expressions, mediated via the symbol and the aesthetic, speak eloquently of a central problem of postmodern hermeneutics. Scholars and writers face a dilemma in which one is unable to speak of the body, or even of a bodied spirituality, a 'body-mind-spirit' continuum, or any variation thereof, without radically isolating the body from the continuity of experience. Symbol, image and cultural trope, in which there is no such fragmentation, or less

of one, can be used to address the holism to which we aspire. Such 'alternative' ways of knowing, so designated because they are alternative to the dominant Cartesian rationality of the global cosmopolitan voice, are at the heart of our exploration. Indeed, in the hegemonic gaze of the Western, and the colonial discourse, the mind-body dualism differs significantly from other conceptions of the 'whole' human being. Notions of embodiment encoded in the Hindu-Buddhist epistemology and ontology do not posit the same mind-body dualism as does Cartesian rationality.

Indigenous holisms aside, the gender problems remain—in narrative, icon, sacred text, philosophy and ritual. Religious scriptural orthodoxies have often linked the female body and women to the world, while man has been identified with the spirit. Women are imaged as body-associated, bound to the body, in part, because of the uniquely female ability to bear new life. Likewise, as spirituality has often been viewed as a denial of, or a retreat from, 'the world', world-denial has meant woman-denial, misogyny and the power relations and ideology that we now call patriarchy. Feminist critiques assert that the orthodoxies of the dominant world religions employ hierarchical gender categories. Proscriptive legalist texts, the *Dharmashastras* of Hinduism, and Leviticus of the Judeo-Christian-Islamic traditions, among others, construe the female physiological processes, menstruation and birth, as polluting and anti-thetical to spiritual practice. Ideas of female untouchability and the transfer of ritual pollution are demonstrated by the Gautama's *Dharmashastra*, wherein it is stated that, for men desiring purity, '[t]he rule regarding impurity' should be followed for the birth of a child as for its death. However, 'some declare that it applies to the mother only because she is the immediate cause of that event' (Gautama, 1991, XIV.14–16: 250–251). Vashishta (1991) also noted that the menstrual blood, not found in males, is impure, and the male does not become impure if he does not touch the female (Vashishta, 1991, IV.22: 22). Similarly, in the Chapter 12 of Leviticus from the Old Testament of the Bible, the woman is said to be unclean for seven days if she bears a male child and for two weeks for a female child. She remains 'in the blood of her purifying' and is not to touch

any sacred thing for thirty-three days for a male child, and sixty-six days for a female child. When the prescribed purifying days are over, she brings an offering for the Lord as atonement and 'she shall be clean from the flow of her blood' (12: #6,7). The woman's ritual transgression, then, is the blood associated with the giving of human life.

The religious traditions attempt to circumscribe women's bodies and lives according to specific hegemonic systems of belief. The central problem with these constructions is that the woman has been diminished and de-spiritualised at the height of her bodily powers—her monthly cycles, her capacity to bring forth new life, her reflexive and subjective bodily knowledge. Brahminic and Judaic orthodoxies developed notions of sacrality, ritual purity and sacredotal function which were conceptualised and enacted in opposition to female corporeality and procreativity. In these traditions, women's bodily processes were also imaginatively associated with demonic feminine entities, thus relegating them to certain spheres within a formal hierarchy. Both priestly and bio-medical renderings of the female body are essentially constructed in the male gaze and voice.

We extend a feminist critique of such gendered hierarchies by searching for voices of the embodied spirit-mind—other female identities and knowledges which may subvert or support orthodox views, or do both simultaneously. We turn to these cultural constructs for what can be called 'alternative' epistemologies—ways of knowing which may be shared by both men and women but which are not reflected in the dominant discourse—of the female and the female body. They are 'alternative', not only because they challenge the view that the split between body and spirit is gendered, but perhaps more importantly because they challenge the fundamental separation between the bodily processes and the life of the spirit. Data from the subordinate, low and outcaste sources, voices which arise from spaces outside the orthodoxies, can contribute more liberative paradigms of birth and female corporeality. See Ganesh (1990) who relies heavily on the iconographic sources in this article and Chawla (1993). Women here can be appreciated as both knowers, exercising powers of perception, cognition and valid expression,

and as embodied female beings with menstrual cycles and procreative capacity.

We foreground the midwife and the water source as *entres* into the complex web of epistemologies and meaning-full bodies. In highlighting the many variant, and occasionally conflicting, dynamics of these crucial, but under-valued and under-examined cultural tropes, we challenge the notion that people and societies live out single scripts.

It is within this context that we view the female body as a battleground of meaning. In ritual, image and symbolic patterns, the body is the space in which multiple ontologies, ideologies and spiritualities meet and are acted out. The statement that the body is a battleground of meaning acknowledges the fluidity of embodied voices and discerns that women, individually and in groups, engage in the ongoing processes of embodied and negotiated meanings. We are acknowledging a plurality and interweaving of embodied 'scripts', departing from the notion that the female body, particularly the generative womb, is the battle site of sharply dyadic discourses between the hegemonic and the subaltern, the masculine and the feminine, the modern and the traditional inscriptions.

MIDWIVES, *KUAS* AND EMBODIED WELL-BEING

In developing the topic of embodied knowledge relevant to women's mental and emotional health, we focus on the rites and songs, the cosmology and theology of the *dais*, the women who traditionally handle the female process of childbirth. The *dai* is privy to the 'mysteries' of birth and the culturally interpreted 'facts' of the female physiology. She mediates between the seen and the unseen and the born and the unborn, the one (mother) who becomes two and the community. She is the possessor of embodied knowledge and the practitioner of 'alternative' ontologies, styles of cognition and epistemologies, which she and her clientele incorporate into the female body through the practice and the ritual of childbirth.

Midwives functioned in the pre-Enlightenment Europe and continue to work today in various Third World settings as

ethno-medical practitioners and ritual specialists.[2] In both settings, existing power relations between the dominant and the subordinate knowledge systems privilege the former. Foucault's term 'subjugated knowledges' (1980) applies to the midwives' praxis. He describes subjugated knowledges as 'insufficiently elaborated and naive knowledges located low down on the hierarchy, beneath the required level of cognition or scientificity' (Foucault, 1980a: 82–83). Guha's analysis of women's subaltern knowledge of the body also relates to midwives' ethno-medical and ritual modalities. He writes that 'since women speak here in a language not fully comprehensible to men and conduct themselves by rituals that defy male reasoning' (Guha, 1987: 163), this knowledge is a challenge and dreaded by male authority. Turner (1974) addresses the complex ways that power is negotiated in non-hegemonic epistemologies. He has discussed hierarchied ideologies in India pointing to the various ways in which people of 'lowly status' ritually manipulate symbols of power, using religious devotion to challenge their given stations in life.

The midwife, as with the other subaltern groups, has been credited by her clientele with more knowledge than that granted to her by the colonial discourse and European rationality. The European attempt to eradicate women's knowledges can be located at the historical juncture of waning ecclesiastical powers and the emerging rational scientific medical establishment. Many feminist scholars assert that the European witch burnings were in part patriarchal, rationalist offensives against women-centred midwifery and their healing traditions (Achterberg, 1990; Barstow, 1995; Williams, 1992). In the Indian context, caste identities and customs of ritual purity and pollution have defined and delimited the authority and the influence of traditional midwives. Traditional Indian midwives are experiential guides, ritual specialists and ethno-medical practitioners. In these roles they

[2] Although we use the anthropological and public health term 'ethno-medicine' denoting that 'Other' to Western bio-medicine, we recognise that the dominant, and now cosmopolitan, allopathic medicine has its own ethnic origins and is certainly also 'ethno-medicine'.

draw upon rich religio-cultural knowledge traditions which are experience based, oral and have been passed on informally through apprenticeship with the older, experienced midwives. This apprenticeship system is breaking down as young women prefer higher status and 'modern' employment without the caste stigma attached to being a *dai*.

In the course of researching women's knowledge systems, we have found that the *kua* (the well) and the water source are central to women's lives and rituals. Representations of the water source, the goddess and the demonic feminine can be seen as the vehicles of meaning which may create a bodily base for goddess-centred cultural ideas and women's experience. The 'well' image is a bridge between the body and the cosmos. The poetry and the imagery of the well both illuminate and reflect the microcosm of the female body and the macrocosm of the body of the universe. Beyond the obvious similarities to the womb and yonic iconography, reproductive ritual often involves the idea of the water source, if not the water source itself. The well is not only an icon or an aesthetic; it also has a place within the diagnostic systems of causality. The *kua* can be found in women's expressive, performative culture, and also in the explanatory systems by which pregnancy illness and demon/goddess possession are reckoned.

To better understand how the well and the female body are linked, we turn to notions of embodiment, a trope of recent postmodern and medical-anthropological discourse. These theories provide a window onto the various ways that cultural meaning is read into and through the body, and is negotiated therein. For Bourdieu (1990) the concept of embodiment centres on the notion of praxis, that is, the notion that cultural values and systems of meaning are enacted in the day-to-day movements of the body. If we expand the concept of praxis to involve ways of reckoning the body and of appropriating it, through song, myth and ritual, then we are able to see how systems of meaning, value and ideology are negotiated, contested, created and played out upon the field of the body. The body is, in a sense, a lived symbol.

The concept of embodiment challenges the notion that the body is an essential, objectifiable reality to which culture

is a mere response (or mental/cognitive response). Such an assumption, according to Csordas is the gaze of a scientific rationality which takes for granted that the body is a 'biological substrate' to which all cultural expression reacts (Csordas, 1994: 3). The notion of embodiment challenges the idea that culture is separate from the body and that individual experience is separate from the social reality, likewise challenging the ontological separation of the body from the mind. Important to our concerns, it also blurs the constructed boundaries between the body and ideology and enables us to see how knowledge is embodied and how the body is knowledgeable.

We will examine the ways in which the cultural meanings of the water source are in many ways the cultural meanings of the body, in particular of the female body, in its generative and receptive potentials. We will describe three religio-cultural 'texts' which speak of midwives' and their communities' imaging of female corporeality, procreative energies, and 'alternative' epistemologies.[3]

MATRI MASAAN KI PUJA

In a workshop in Jaunpur, a mountainous area of Uttar Pradesh, with thirty midwives and ten NGO workers, women spoke of their ways of understanding threats to maternal-foetal well-being during pregnancy. Miscarriage is thought

[3] We are grateful to the following people and the NGOs for recognising the importance of midwives in their areas and providing Janet with opportunities to interact with the *dais*: Anuradha Joshi of the Society for the Integrated Development of the Himalayas, Mussoorie, Uttar Pradesh, for organising a workshop in December 1994, with midwives from the mountainous Jaunpur area, a polyandrous, hinduised, tribal locality; SIDH was interested in documenting the practices surrounding pregnancy and birth in their efforts to provide culturally sensitive education and health services; Manjula of the Irula Tribal Women's Welfare Association, who acted as translator for the interview with Nagamma which was done in January 1996, in Chinglepet District, Tamil Nadu. Manjula helped me to contextualise Nagamma's words in terms of Irula and Tamil culture; Viji Srinivasan of Adithi, Patna, Bihar, for organizing a workshop in March 1996, with midwives from villages surrounding Dhanbad, near Patna.

to be caused by an afflicting entity (*bhut* or spirit) whom Jaunpuris call Matri Masaan. Within the conceptualisation of Matri Masaan, a causal linkage is established between the health problems during pregnancy and the water source at the woman's maternal home. It is important to recognise that the different styles of perception and cognition, different ontologies and cosmologies allow for different causal linkages. The symbolic chains of meaning and causation embedded in the figure of Matri Masaan allow Jaunpuris to claim that the pregnant woman experiencing problems was possessed by Matri Masaan when as a girl she was fetching water from its source at her *maike* (natal home). Consequently, the therapeutic ritual involves a puja performed at this water source: spring, river or tap.

> When she's pregnant they know Matri Masaan has affected her if she has nightmares or dreams of eating flesh or of deformed children. She may scream, want too much food or none at all, be always afraid, talk in her sleep, mutter things.

According to the *dais*, the therapeutic ritual, *Matri Masaan ki puja*, involves the pregnant woman, her husband and the male members of his family, along with a Brahmin, walking silently through the mountains. The mother wears a black blanket covering her clothes. At the water source of her maternal home the *pundit* (Brahmin) chants mantras while the pregnant woman performs a puja with seven leaves, *urad dal* (lentil), *chawal* (rice), *haldi* (turmeric), *sindur* (vermilion) and burning *gobar* (cowdung). She throws pieces of *roti* (bread) in the four cardinal directions and removes her *shringar* (adornments)—*kajal*, lipstick, cream, bangles and bindi, leaving them at the site. Rice is sprinkled on her by her *sasural* (marital) kinsmen. The group walks directly back to the *sasural*. After this puja, she is not supposed to go back to visit her *maike* for the duration of the pregnancy.

Any culture's practice of medicine reflects the identity of the social group and is an expression of ethnicity. In Indian traditional systems, well-being is often understood as a balance between opposite, but complementary forces: hot/cold,

male/female, wet/dry, sun/moon, etc. Healing modalities such as herbs, foods, mantras, bathing and rituals involve networks of meaning and are used to realign forces/energies and restituting the balance in the body. Ethno-medicine as the art of restoring a multi-dimensional equilibrium centres the individual within her community and the world.[4]

In the case of the *Matri Masaan ki puja*, the epistemology, the why and how of pregnancy illness reflects a core issue in the lives of many Indian women: the experience of leaving the natal home at the time of marriage, when young women are expected to be absorbed by and adjust to their husband's family. This shift is a disjuncture, a separation of women's lives into two distinct temporal and locational parts and a marking of women as the ones who move. The often traumatic separation and the consequent emotional upheavals are a recurring motif in women's folk songs in north India. Sax (1994), in his essay on the Garhwali goddess Nanda, notes that this goddess is depicted as an 'out-married village daughter' in women's pilgrimage songs and nearly all women 'are moved to tears' by the songs depicting the young bride's departure from her home. Sax points to the parallel between the story of the goddess and the life situations of the local females and states that this compulsory change of residence is the source of some of the most pervasive tensions and anxieties of local peasant women (Sax, 1994: 180).

This anxiety and sadness is particularly germane to the woman 'afflicted' by Matri Masaan. From the *sasural* perspective, when the *bahu* (daughter-in-law) body is doing the work of producing the next generation, expectations are that she be the most aligned with her affinal kin. Thus, the pregnancy illness and the malevolent possession that causes it may signal a trauma of allegiance.[5] But in the context of a young woman's life experience, this metaphysics is collapsed

[4] In this section, we rely on learnings from Dr Sylvia Marcos, a Mexican researcher and ethno-psychologist.

[5] *Matri* means mother and *masaan* is the word used for the cremation ground and the ashen, bone remnants of a dead body. Thus, *matri masaan* also signifies the cosmological realm of death, rebirth and the continuum of life processes.

into her own grief at having been wrenched from the affection-
ate ties of the *maike* village and mother's love. In the case of the
bahu—whose affliction is diagnosed as originating in her natal
home, thus jeopardising her role in her affinal home—such
possession denotes not just an imbalance, but an incorrect
balancing of allegiances. *Matri Masaan ki puja* enacts and at-
tempts a resolution to this disjuncture of women in staunchly
patrilineal and patrilocal societies. By locating the aetiology of
pregnancy disturbance at the disjuncture between *sasural* and
maike; the rite validates the affective and bodily experience of
this conflict and re-negotiates the balance between these com-
peting contexts. The ritual performance also heightens public
awareness of the woman's inner experience of this conflict.

Another provocative aspect of this puja is the woman re-
linquishing signs of the *suhagin* (the chaste wife) status:
bindi, *kajal*, bangles, etc. A psycho-analytic interpretation
would suggest that maternal and erotic identities of women
are juxtaposed and placed in conflict with one another. And
that the young woman must renounce eroticism in embracing
the fertility of motherhood. However, the relevance of this
interpretive model is increasingly questioned. Raheja and
Gold (1996) present data which questions the theoretically
posited split between the maternal and erotic female identi-
ties:

> In these songs there is evidence of an exuberant sexuality,
> a positive valuation of sexual pleasures, and a conjoining
> of eroticism and birth giving that undermine and resist
> that split between sexuality and fertility posited in the
> dominant ideology. In subverting such split images of
> female identity, women are at the same time questioning
> that authoritative discourse of male control over female
> sexuality and female lives (Raheja and Gold, 1996: 27).

We would tentatively interpret that the marks of female sexu-
ality, attractiveness and *suhagin* are not abandoned but
gifted: offered to the geo-mystical Matri Masaan. This gift
allows the *bahu*-mother to partake ontologically in her watery
generativity through accessing a bodily, cosmic energy source
equated with femaleness, signified by the *maike* water source.

This signification, located on maternal ground and invoking the mother-*maike*-water network of imagery, reflects what Diana Eck has called a 'sacramental natural ontology' (quoted in Gyatso, 1989: 45).

The *Matri Masaan ki puja* affirms the woman's experience as it centres on the social, the psychological and the emotional realities of women's lives. The theology (or demonology, for here boundaries are blurred between the goddess and the demon) enacted in this rite attempts the social/psychological task of harmonising and restituting a balance between the *maike* and the *sasural*. But importantly, as the possession illness of pregnancy somatises and voices a central disjuncture in women's lives, the ritual to 'cure' the illness also 'cures' the disjuncture by reasserting a social mandate. The puja places the afflicted individual in a solidly defined context, the *sasural*, attempting to remove her experience of the pain of being betwixt and between. Notions of the rites of passage posit that an individual is first removed from day-to-day routine, placed in a liminal mode in which the ritual takes place, and then re-integrated into society with a new status. So, in *Matri Masaan ki puja*, the woman is removed from her environment, moved to a symbolic space 'betwixt and between' the natal and affinal life (at the *maike* but surrounded by *sasural* kin). In the paradoxical world of ritual, the acknowledgment and sacralisation of *maike* is used to assert the status quo of the *sasural*. The fact that a woman is ritually accompanied to her *maike* by her male *sasural* kin, that is, they with whom she performs the puja, may indicate a reminder that her proper place is in the *sasural*, couched in an acknowledgment of her sadness. The affliction of 'possession' offers a vehicle for validating the emotional ontology—even the very existence—of women's grief; simultaneously providing a means to assuage the somatised grief in a way that asserts the patriarchal structure of society. The affliction which has jeopardised the pregnancy signals the need for a rite of passage, indicating that a woman has not fully made the transition that should have occurred at the time of her marriage. The passage from *maike* to *sasural* requires completion which the *Matri Masaan ki puja* offers.

A mingling of 'alternative' hegemonic and multiple other epistemologies are visible in this ritual; we see both the

assertion of a social hegemony and the acknowledgment of the pain wrought by that hegemony. In the liminal space of the *Matri Masaan ki puja*, the *maike* is acknowledged as a powerful force in women's lives. It is the *maike* of a women's girlhood which, through her body, challenges the husband's line and the well-being of the *sasural* by striking at the heart of its continuation. Perhaps, because of the danger posed by women's association with their own kin, the threat of *maike* to *sasural,* she is forbidden to return for the duration of her pregnancy. The hegemony of patriarchy is asserted but with the presence of a crucial visibility. Rather than simply enforcing the hegemony of the *sasural* by relegating the *maike* a certain time, childhood and space, the puja also acknowledges the potent relevance of the *maike* to the wife's well-being, giving it a scope of meaning that applies to the whole of her life.

A feminist hermeneutics would suggest that the staunchly patrilineal context of the *sasural* may be in some way responsible for the naming of this Matri Masaan as demonic rather than divine. The symbolic and narrative convention of naming matriline as demonic pervades Indian myth and text from the Vedas on (Chakravarty, 1993; Leslie, 1989; O'Flaherty, 1988). Thus, the networks of meanings involved in the goddess–demoness problematic are deeply informed by caste and gender ideologies. One *basti* (community) informant stated:

> We believe that the *dai* picks up the *nau mahena ka narak kund* [the nine month hellish container]. Of course the *kharaye-nal* [the placenta and the umbilical cord] is dirty. What else? The *dai* does the dirty-bad work.

In the contexts of a Dalit midwife (who said 'the *kua* is in your body'), the Shaktic and Puranic texts and praxes, the *yoni-kund*, and by extension, the female sexual and fecund body are sacred theology. The *basti* woman's interview renders the fleshy afterbirth as a demonic container. The womb-well, inscribed as it is by multiple meanings and valuations, is a site in which patriline and caste are invested and challenged.

The female experiential dimension of rite, image and symbol is significant in understanding the theological conflation of goddess and demoness. The Matri Masaan is located literally and

figuratively on the ground of the mother. The puja ascribes the power to ensure maternal and foetal well-being to Matri Masaan, a female symbolic constellation—mother, *maike*, water. Here we return to the female-associated cultural symbol of the water source, and its association with malevolent and benevolent spirits. Networks of meanings are associated with the images of the maternal, generative waters, meanings which are also often rendered as threatening and demonic (Chawla, 1994, 1995). The *churel* in some parts of north India is imaged as the ghost of the woman who has died during pregnancy or childbirth. This malevolent spirit is believed to have a special affinity for water places and is also referred to as *jaljogini*. The *basti* women in Delhi spoke of a post-partum well worship ritual adapted to urban life by being performed at a water tap.

Many ethno-medical systems consider the body porous, permeable and open to cosmic currents and spirit entities. Things, energies, spirits, such as the Jaunpuri Matri Masaan, can enter and leave a person's body. This is not the inner terrain of Western anatomical charts. The internal and the external world are seen to be connected. Each part of the body is analogous with, and connected to, the cosmos. These beliefs and attitudes are blueprints of causality and allow for different healing modalities.

The image of the water source provides a thread linking the female body with the realms of spirit-nature-world through ties of word-play and allegory. The female body is simultaneous with a wider cosmology in a way that is both practical and explanatory, linguistic and symbolic. Parallels between the well and the female body are evident not only in the basic capacity to make immanent the invisible (water, *bhuts*, babies), but also in the way that it is understood to occur, as malevolent spirits are thought to enter the human body through its orifices. Wells and water sources are spaces of opening, spaces through which entities of power transmigrate. They thus mirror the cosmic anatomy of the female body.

In the *Matri Masaan ki puja*, the water source is linked with women's bodies, life cycles and spiritual knowledges. It provides both a way to explain bodily and emotional suffering (and a symbol which conjoins the two) and a systematic

means for the amelioration of that suffering. In many ways the water source is the woman's place, and she and her *sasural* kinsmen go there to acknowledge her reality within a patriarchal system. At this fluid site, her *sasural* kinsmen acknowledge her pain and she ritually and bodily accepts her place within the patrilineal system of out-marriage. It is at the water source that both she, and through her, the social stability have become afflicted, and it is there that both the woman and *sasural* are righted, where both her pain and the *sasural*'s authority are heard.

IRULA RITE HONOURING PLACENTA, EARTH AND *COOPA MA*

We now turn to the voice of an Irula tribal herbalist and midwife, Nagamma.[6] Nagamma was absolutely clear in her assertion that the goddess is present and supports and guides her in her practice of midwifery and herbal healing:

> My mother gave me the confidence to do this work and asked me to put all the burden on our Goddess *Kannyamma* [Virgin Goddess], and that she would help me. The Goddess has been helping me all these years. I have never been under-confident or scared because I know that the Goddess is with me.

Nagamma describes the ritual burial of the afterbirth, the placenta, umbilical cord and membranes which hold the amniotic fluid:

[6] The Irula Women's Tribal Welfare Association had put up a stall at the Congress on Traditional Sciences and Technologies in Madras, Anna Malai University, Madras, 28 December 1995–2 January 1996. There Nagamma examined and diagnosed visitors' complaints, shared her knowledge with the fellow practitioners, displayed and sold her herbal preparations. She seemed to be around 65–70 years old, and like many poor, rural and old women, she did not know her age. Her sense of time did not include such details. She said she was trained by her mother, who had learned from her mother.

We don't throw away the placenta. The mother later buries it near the house. Water from the first bath of the mother and the baby should flow on the ground where the placenta is buried. We bury it near the bathroom so the water from family bathing goes to that place. We put neem leaves and then the bundle of the afterbirth, cover it with earth and put a stone on top and then more neem leaves. On the ninth day when the woman is given a bath, we clean up the place where the afterbirth is buried. On the stone we put saffron and turmeric. We put cooked rice on top of a banana leaf and put it on a winnowing basket. Also a sweet made of rice powder and jaggery. On the other side a *kamakshi velakku* (a sacred lamp) of copper is placed and lit. We put the child on the ground near this.

This ritual is called *Coopa Ma* (garbage mother) because the placenta is buried near the bathroom, near the garbage heap, but not on it. Once done, the members do not come back to this place again. They do this only for the first child, not for the subsequent births. Only when this generation grows up and they have children, will they pray to her again. When they light the camphor the mother will prostrate herself on the ground before the stone and then the baby will be given to her. They pray 'if in the future there is any sickness or trouble . . . anything good or bad . . . even then we will not come here'. Till the ninth day ceremony they will not sweep the floor with a broom, and nobody will walk near that place.

The problem with the desacralisation of women at the height of their procreative powers and with the priestly designation of the female body as a source of pollution has been elaborated on above. The amniotic fluid appears to be the female physiological correlate of the notions of sacred and generative waters. That these waters flow out of women and are worshipped by others in the family/community is crucial, particularly as this fluid and associated organs are ultimately imaged as polluting substances in the Hindu mind. The Irula rite, in contrast, honours the waste, the by-product of the pregnancy; not just the baby, mother or abstract 'nurturing' or fertility goddess, but the flesh and blood products of female bodily generativity. The personification and deification of the afterbirth, the

sacralisation of the ground where it is buried and the water which has bathed family bodies, displays a reverence for human corporeality, especially the female body, a reverence less visibly present in orthodox Hinduism.

The ritual implicitly acknowledges that the life force within itself contains decay, death and dissolution. The placenta which sustained the existence of the child in the womb will now decompose, buried in the earth and moistened by bathwater. The natural forces of generativity and decay are comprehended and ritually enacted as complementary (not conflicting) opposites, both encompassed by notions of the sacred. Irula cosmology and theology, encoded in this rite, are neither blind affirmations of a life force nor patent vilification of female bodily processes. Rather, they span and celebrate the boundaries of embodiment, of human life in all its generation and decay. What is venerated is inclusive of death. The decaying placenta is worshipped in the shrine of the trash heap, consecrated by the sacred fluids of the old bathwater.

In the post-birth worship of Coopa Ma, the signs of embodiment of the mother and baby are venerated. They are revered in their association with waste, which is, likewise, by association, venerated. By turning the placental site into a goddess shrine the body itself become divinised. The garbage heap, marked by the burial of the placenta, exists for a while as a temple. We see the linking of the body and the goddess united by the water from the baths and somehow signified by it.

Baths themselves have ritual meaning and mark the periodicity of female time. According to Nagamma:

> When women have their menstrual time they wash their hair on the third day. When women are pregnant, they have no menses, so they are called *muzhugama irukaradu* [one who remains without a bath]. Yes, she bathes, but she does not take that monthly bath. She is referred to this way throughout pregnancy.

Furthermore, the female body and water are conflated in ritual preparations that cleanse both the impurities of the body and of fate:

Nagamma: As soon as people of the family get to know that she has come of age they separate her from the rest of the people. They either build a small hut outside or make a partition in the house in order to set apart the girl. When she discovers that she has her period she is kept away from people. In the evening she is given a bath by five or seven women of the family or neighbourhood. They take a sieve and pour the water through the sieve over her head. Pouring the water once through one way, then through the other way, then back again through the first way. This is done to remove, wash away the impurities.

Janet: The impurities of the body?

N: The impurities of fate, not of the body. They make her horoscope . . . to see if she's come of age at an auspicious moment or an inauspicious moment. Then they [the girl's family] go to a villager of another community, a priest for the Harijan, *Vallulan*. He is a priest, astrologer and healer. He reads the horoscope of the girl . . . if it is an inauspicious time, then they do the sieve ceremony. This was done for me.

J: I've not heard of this bath on the first day, only on the third day . . . to wash away the impurity of the body. How is this bath understood?

N: You become dirty that's why you take a bath . . . the clothes are given away to the dhobi. She is given a bath on alternate days. On the fifth day given the ceremonial head bath with oil by her aunts, father's sisters. They come to the house with sweets, a new sari and blouse piece. On the ninth or eleventh day outside people are invited and the girl is taken back into the house. The ceremony is called *manjal thanni uthharadu*. On a *thattu* (plate), they put turmeric, water, lime, a blade of grass and a betel leaf on which some camphor is lit. *Aarathi* is done with this around the girl.

In the context of these menstruation rites, we are better able to understand the dynamics of the ritual to Coopa Ma. Here, the notions of impurity and exclusion are at play. But so too are ideas of sacrality and of celebration. These levels of meaning are interwoven and are inseparable. Although the burial of the afterbirth and the homage to Coopa Ma acknowledge that a dangerous power is present and recognised, the family will not

return to this place ritually until the next generation. The female body is not represented here as simply, univalently impure (or pure) or as antithetical to community spiritual practice. Interestingly, there is no demonic feminine here.

Notions of impurity in Nagamma's interview do not carry the same ritually exclusionary overtones found in other contexts. The ways in which pollution/impurity is reckoned by Nagamma bring the female body into the fold of spirituality rather than excluding it. The association of placenta with garbage, in the context of the sacred, suggests that impure things can also be sacred; that impurity or pollution does not indicate a separation from the realm of the sacred. (It could also, of course, be argued that the Coopa Ma ritual placates or modifies the impurity of the placenta. Likewise, the possibility exists that the placenta is more closely associated with the baby, in which case it may say more about the baby's body than about the mother's).

A powerful statement is made about the sacredness of women's bodies in the linking of women and water, even in the midst of the more negative estimations. In the Indian ontologies, water sometimes functions as a symbol of the unity of finity and infinity, of the present/existent and the impermanent. But what of the space in which the water, itself a fundamental symbol of the ultimate, becomes manifest? The water source too is both liminal and paradoxically all-encompassing. It both borders realms and breaks those borders by bringing the substance of life from the inside out, from the invisible to the visible. The water source is the place of the birth of water and in the *kua* of the women's bodies, the water of birth. To repeat the words of a *dai*. 'You worship the *kua* in your own body.' In all its generative implications, the well both holds and channels finity and infinity, unifying the potential and the active; the yoni-well possesses the capacity to activate the fundamental potential of life.

To speak of a water source means that something exists to symbolise the state before the beginning. There is, then, a notion that even the ultimate paradigm, god, must be drawn into creation. The well, the *yoni-kund*, the spring that opens a gash in the earth from which water becomes immanent, these are the mothers of god. What is ultimate, what is beyond

language, it too has a mother, a symbolic space even beyond what is symbolised as the ultimate, a space surrounding even the all-engulfing symbol of unified opposites.

In the context of these Irula rituals, the homage to Coopa Ma and to the placenta points to the bi-modality of women's bodies and women's water, the blurring of distinctions between the impure and the sacred. Our intention is not to question what is considered impure and what is not, but rather to use Nagamma's words to problematise the concept of pollution/impurity and its usual implications.

BIHARI CHAMAR MIDWIVES' SONG TO THE SEVEN MAYAS

This song was recorded at a workshop with Chamar midwives near Patna, Bihar. An NGO, Adithi, had documented the problem of female infanticide in many districts and was mobilising the *dais* against the practice. During the workshop the *dais* sang and danced, enacted birth in role plays, drew maps of woman's body on chart paper and talked of their lives and work, explaining that this song is sung at *Maya ki puja*, thanking the goddess on any happy occasion.

> *Song to the Sapto Mayas:*
> On a branch of the neem tree,
> The Mayas' jula [swing] is hanging
> The seven sisters are swinging
> and singing a song.
> While singing the sisters feel thirsty
> and say to the malin [woman gardener or
> the gardener's wife].
> Mayas:
> O sleeping malin, please wake up and
> give us a drop of water.
> Malin:
> How can I give water to all of you sisters,
> I have your girl-baby in my lap.
> Mayas:
> O malin, take this golden cradle
> and make your girlchild sleep in this.

Malin:
 O mayas, the golden cradle will break
 and the baby will fall to the floor.
Mayas:
 As your child is falling
 we will catch her.
Malin:
 Mayas, in which bucket
 with which rope
 in which pot
 should I get pure water for you?
Mayas:
 In a golden bucket
 with a silken rope
 in a silver pot
 you will fetch pure water.
 Just as you, malin, have given us this blessing,
 may your daughter and daughter-in-law
 receive our blessings.
Malin:
 My daughter-in-law is in her maike
 My daughter is in her sasural,
 Why are you giving these blessings?
Mayas:
 May your daughter-in-law live well.
 May your daughter live well, wherever they may be.

The activity of the women singing this song mirrors that of the Mayas; both the goddesses and the women are singing. Identities of goddesses and women in creative, expressive activity are collapsed. Identities of both the Sapto Mayas and the *malin* as caretaking mothers are similarly conflated. See Kurtz (1992) for a discussion of the multiple mother-figures in the joint family, childhood development patterns and goddess worship. The *malin* says 'I have your baby in my lap', and not 'my baby', attributing to the Mayas, swinging in the neem tree, the powers of generativity and sustenance.

The Mayas ask the *malin* to 'please wake up', a call for her to shift her consciousness from the mundane to a heightened awareness. As they swing in the *jula* strung from a neem tree,

the Mayas keep a pendulum-like rhythmic time which responds
to the gravitational pull. The pulsations and the tentativeness
of this suspended state is also evoked in the Mayas' golden
cradle for the girl-baby which 'will break and the child will
fall', perhaps a fall into the limits of human corporeality. The
time being negotiated is not historical or even mythic time;
this order of time is marked by the needs of the body.

Our interpretation of this song must be contextualised by
the purpose of the workshop in which it was heard, which
was organising *dais* against female infanticide. Adithi has
documented that the father or the other male relatives make
the decision to kill the female infant usually over the protest-
ations of the mother; the *dai* is pressured by threats of vio-
lence to implement the decision. The report also states that
the customs of giving dowry and occasionally female infanti-
cide were high-caste practices which are now spreading rap-
idly to the other castes (Adithi, 1995). During the workshop,
the mid-wives were visibly distraught by the infanticide and
their role in it, but could see no other options. Both the Adithi
analysis and the lyrics of this song, invoking the Mayas' bless-
ings for the well-being of the daughter and daughter-in-law
suggest that the upward mobility (sanskritisation), commer-
cialisation and the high-caste gender bias are all implicated
in the killing of the female newborns.

In the context of the situation, in which newborn girls are
endangered by the threat of infanticide, this song illustrates,
through the Mayas' seat *(peeth)* on the *jula,* complex and
multivalent notions of human embodiment. This *jula* song
is not of the genre of mourning or lamentation, and yet, as
Sahodri Devi and Phoolmanti's contextualisation reveals,
implicit in the oscillations of the Mayas, of embodied life,
are seeming oppositions: birth and death, well-being and
epidemics, need and satisfaction of that need, and a song
sung in celebration of girl children by the *dais,* some of whom
have been coerced into killing female newborns. And within
the song, the oscillating extremes are not diametrically
opposed; the arc of the *jula*'s swing is triangulated by virtue
of it being suspended from the tree of life. In the Indian
imagination, the tree is an abiding symbol of life and is
directly connected with what Coomaraswamy calls the 'cosmic

waters' rather than any symbol representing the earth (Coomaraswamy, 1993: 97).

The *malin's* girl-baby, within the context of the song, is precious. She is worthy of a golden cradle; she will be caught by the goddesses should she fall. Likewise, we see the value of the containers, the golden cradle, the golden bucket with the silken rope, the silver pot—which hold precious materials, girl babies and water-offerings to the goddess. The Mayas assure the concerned *malin* that while she is busy giving offerings to them, her baby will not be harmed; indeed, she will be kept in a golden cradle guarded by the goddesses themselves.

The dramatic centrality of the life-sustaining waters in the song to the Sapto Mayas points towards another dimension of women's lives and the sacred. The stuff of water gathering (bucket, pot, rope) is mimetic of the stuff of birth (uterus, placenta, umbilical cord), drawing the magical ether of life from another reality into this one. In the song, the central drama is prompted by the Mayas' thirst, their need for water, presumably caused by their activity, i.e., singing. In scholarly literature on the goddess, much has been made of the Devi's need for blood, rather than water. Kinsley (1986) writes of the terrible manifestations of Mahadevi and her need for blood sacrifice. He explains that the world is perceived through the persona of the Devi, as a living organism. As constantly fruitful and nourishing, her energy is consumed by the continuous acts of fertility. But the world-mother herself must be sustained, for her energy is not inexhaustible: thus, the need for blood sacrifice in order to renew her. Kinsley quotes Richard Brubaker on this perception:

> In this view . . . any gain somewhere is a loss somewhere else, every loss a gain. The world is a body, and just as its blood must continually flow both out and back, so at every cell in that body the life-blood must continually both arrive and depart (Kinsley, 1986: 149).

This insight into the goddess' need for replenishment and her interdependence with human beings is similar to the Sapto Mayas' song. But the fluid oblation desired by the Mayas for their creative activity of song (or in association

with quenching the thirst produced by fever) is water and not blood. Gender seems to figure in this distinction that blood sacrifice is routinely performed by men and not by women. Here, the goddess' need is not imaged in terms of the ritual need for blood; but rather, the bodily need for water.

The giving and the withholding of fluids, bodily and otherwise, seem to be gendered activities. The high spiritual currency of withheld bodily fluids (the male retention of seminal fluids) is elaborated in the narratives and medical texts as well as folk imagings, with the consequent valorisation of the yogis and the ascetics. O'Flaherty has noted that according to the texts, 'The breast that feeds itself is symbolic of the evil mother, but the phallus that draws up its seed is symbolic of the perfect man. Women are meant to give, men to receive' (O'Flaherty, 1981: 44). A woman's power, according to these texts, is increased not by withholding her fluid, as would be the case with the male ascetics, but by allowing it to 'flow freely'.

The *malin* is responsive to the bodily desire of the Sapto Mayas, just as the *dai* is responsive to the needs of the woman in labour. The significance of corporeal need and desire is construed differently in orthodox Hinduism from that in women's expressive traditions. In philosophical Hinduism, *maya* has come to mean illusion; the aim of religious practice is to escape 'maho maya ka jal', the trap of affection. But Sircar, in his work on *Shakta Pithas*, states that 'The name *mahamaya* apparently represents the mother-goddess as the spirit guiding the magician-priests of primitive peoples. The name was later given a philosophical interpretation' (Sircar, 1972: 3).

In this song, however, the Sapto Mayas signify mutuality, affectionate concern and responsiveness to bodily need. The contested significance of the word *maya* is obvious from a Hindi–English dictionary definition: '*Maya*—kindness, pity, sympathy; fraud, trick; unreality of worldly existence.' It would seem that the cosmology of the Chamar midwives offers an alternative construction of spirituality, theology and embodiment; one encouraging an empathetic engagement with the cosmic life processes and an attitude which is responsive to the human bodily need.

DAIS AND DEMONS, THE KNOWERS AND KNOWN

Dai, nain, bai, mai, dhobin and ayah all care for bodies and are holders of embodied knowledge and ritual praxis. In the context of their subaltern networks of religio-cultural meaning, the images of the demonic feminine function as diagnostic categories and modalities in the ritual healing of physical, emotional and mental wounds. Matri Masaan, Coopa Ma and the Sapto Mayas are localised and particularised versions of the divine-demonic female personae enacting or narrating complex meanings of embodiment.

However, within the orthodox Hindu texts (excluding the early vedic and the ayurvedic), the demoness' paramount significance is a threat to dharmic ritual purity and in renunciating spiritual ideals. The presence of the demons in popular healing rites opens up symbolic realms of diagnostic categories and causal linkages which allow for the restoration of balance and facilitate healing. The abiding and pervasive presence of the goddess–demoness and her incorporation into the explanatory and symbolic systems points to the need for recouping the demonic within the non-hegemonic cognitive frameworks.

Water figures prominently in the significance of Matri Masaan and the Sapto Mayas and in the ritual to Coopa Ma. Water, in these contexts, not only symbolises a life force, but ontologically partakes in the divinity of that force. Rites and songs enact these sacramental natural ontologies, creating a bodily base for the female experience of sacred procreative power.

In examining women's ritual through the lenses of birth, the body and the midwife, we seek to honour non-patriarchal systems of meaning informing women's spiritual lives. Academic feminism has often seen women's bodies as 'inscribed' with a dominant script which overrides all others, directing and delineating female experience. Our perspective names alternative ontologies (and their ethno-medical and spiritual praxis) as valid and authoritative in their own spheres. We view women not just as bodies being inscribed, but as negotiating among possibilities and inscribing meaning into our own bodies. Many knowledges, 'alternative' and otherwise, are lived in and through

the body, reflect, refer to, and even arise from bodily experience, making the body, the female body in particular, the site where multiple systems of meaning meet.

This attention to the complex meanings of the body and of alternative 'cognitive styles' and ontologies hopefully allows us to hear subaltern feminine voices more fully. Honouring women as knowers and as knowers of their bodies, both individually and collectively challenges the belief that women's bodies are to be known by the male Other. Foregrounding these knowledge systems has implications for women's mental health and emotional well-being, and serves as a call for women to investigate the language of the sacred within traditions rooted in their own histories and bodies (their embodied histories), and for those spiritual voices to be given their due validity.[7]

[7] Deepti Priya Mehrotra and Kishwar Shirali have made such calls. Deepti Priya spoke on 'Bridges between Spirituality and the Women's Movement in India' at the Indian Association of Women's Studies Conference, Jaipur, December 1995 (Reprinted in the *Lokayan Bulletin*, December 1996.) Kishwar Shirali presented a paper, 'Chin-masta to Mira: Female Faces of Consciousness', at the Conference on the 'Two Faces of Consciousness', Dept. of Psychology, Yoga and Parapsychology, Andhra University, Vishakapatnam, 17–19 October 1996.

IX

THE FEMALE BODY OF POSSESSION: A FEMINIST PERSPECTIVE ON RURAL TAMIL WOMEN'S EXPERIENCE[1]

Kalpana Ram

THE PROBLEM OF 'OBJECTIVISM' IN THE STUDY OF POSSESSION

One of the primary features of possession is its capacity to allow more than one voice to emanate from the body. Any model that purports to describe and analyse possession should retain this elementary capacity. I have therefore adopted in this chapter a strategy that is analogous to Freud's

[1] This paper was originally presented at the National Seminar on Indian Women and their Mental Health organised by Anveshi Research Centre for Women's Studies, Osmania University, Hyderabad, 23–24 February 1996. I would like at the outset to thank the organisers for the opportunity to present my work to one of the most responsive and stimulating audiences I have ever experienced. My particular thanks to Bhargavi Davar for the invitation and to Mary John for her thoughtful comments as discussant. I thank the Australian Research Council for providing the funding that made it possible to attend this conference and for funding ongoing field work in this area. The field work for this paper draws on my material gathered in the 80s and towards the end of 1991. I wish to acknowledge the help of my friend Stella in conducting the 1991 interviews. All authorial interpolations are presented in square brackets. The system of transliteration and diacritical marks used for Tamil words follows the system of the Tamil lexicon. Words widely transliterated into English, such as place names and Sanskrit words have been left in their common spelling.

strategies in dream analysis. In re-working previous tradi-
tions of dream exegesis, he deconstructed the superficial
narrative coherence of the dream in order to explore the
workings of not one, but several psychic economies anato-
mised in the now famous trilogy of the id, the ego, and the
superego respectively. Their most salient feature for my pur-
poses is that each of them was theorised as operating on the
basis of radically dissimilar principles even while Freud
sought to show their combined effect on the subject. Posses-
sion can be analysed in an analogous fashion. While pre-
senting a superficial coherence, possession provides ample
scope to explore the workings of radically different explanatory
principles, drawn in this paper from sociology, phenomenol-
ogy and anthropology. This diversity of borrowings is unified
by my purpose, which is to elucidate an understanding of
female experience of possession as specifically conditioned
by the more general experience of living as a woman in a
male-dominated society—even as we increasingly recognise
that there is no unitary version of what it is to be female.

'Objectivism' in social theory presents particular problems
for such an enquiry. The original critique of the fallacies in
objectivism comes from the phenomenology of Merleau-Ponty.
In the first stages of his attempt to develop an embodied
account of human experience and intentionality, Merleau-
Ponty (1986) in *Phenomenology of Perception* elaborates an
insightful critique of behaviourist psychology and biologistic
physiology. Instead of a scientistic account of the body, he
develops a rich account of the minutiae of meanings located
in everyday acts of perception and bodily experience. Merleau-
Ponty's critique has been subsequently generalised into the
category of 'objectivism' by Bourdieu (1972). For Bourdieu,
objectivism characterises all brands of social theory that
break with the categories of the experiencing subject in order
to reveal the laws and rules of the social structure that gen-
erates such experiences.

While Bourdieu argues, in dialectical fashion, for a new
'theory of practice' that will transcend both phenomenology
and objectivism, there are specific reasons why we need to
give priority to a critical stocktaking of existing scholarship
on female possession. As my overview in this chapter elabor-

ates, objectivist accounts of female possession have been developed at the expense of phenomenological accounts. This imbalance has itself created a situation conducive to male-centred perspectives that diminish or bypass the experiences of women. Even a framework like psycho-analysis, with all its rich promise of attention to the body and inter-subjectivity, becomes successfully diverted from attaining its goals by the triumph of objectivist tendencies. Psycho-analytical accounts of spirit possession—tempted, no doubt, by the easy transposibility between spirit possession and psycho-analytical accounts of hysteria—deliver accounts disappointing in their reductionism. The affinity between hysteria and spirit possession was noted, with characteristic insight, by Freud himself in his introduction to 'A Seventeenth-Century Demonological Neurosis':

> The states of possession correspond to our neuroses, for the explanation of which we once more have recourse to psychical powers. In our eyes, the demons are bad and reprehensible wishes, derivatives of instinctual impulses that have been repudiated and repressed. We merely eliminate the projection of these mental entities into the external world which the middle ages carried out; instead, we regard them as having arisen in the patient's internal life, where they have their abode (Freud 1973: 72)

Psycho-analytical constructions of the female hysteric have been regarded by feminist critics as one of the paradigms of modernity's phallocentric construction of woman. In the psycho-analytical cure, argue feminist critics such as Koffman, the woman comes to speak in the language of the psycho-analyst:

> Thus although psychoanalysis may inveigh against the sexual repression to which women are subject, although it may invite them to shed their inhibitions and restore their right to speech, the remedy it offers is at the same time a poison, since it can cure women only by contaminating them, by forcing them to 'collaborate': to espouse the viewpoint of the other, of men, who are supposed to

possess truth. The psychoanalytical solution restores speech to women only the better to rob her of it, the better to subordinate it to that of the master. That is why there is no crime worse than silence (Koffman, 1985: 48)

Accounts of female spirit possession in the social sciences repeat similar moves. The accounts of female spirit possession produced by psycho-analysts (Kakar, 1982) and by psycho-analytically-minded anthropologists (Obeyesekere, 1981) typically narrow down the meanings of the rich material they assemble, to a 'sexuality' that remains at its core, obdurately preconceived. The framework in which participants themselves understand possession, of which religious meaning is an important component, becomes a purely external point of reference, powerless to alter the narrative teleology of the psycho-analytical drive. The female ascetics of Sri Lanka, studied by Obeyesekere, refer to their matted locks in richly varied fashion as their *sakti*, as *dhatu* (relic, essence or life force), as *varama* (boon), as something which hurts badly, and as *prana* and *vāyu* (life force) (Obeyesekere, 1981: 22–32). In Obeyesekere's master narrative, women's language is altered to read as follows:

> . . . psychologically, on the level of unconscious processes, the sublated penis emerges through the head. The matted hair, unlike the shaven head of the monk, does not represent castration for the ascetic, but rather stands for its very opposite: the denial of castration or loss of penis. (Obeyesekere,1981: 33–34.)

Here, the sexual heterogeneity of symbolism in Hindu religious imagery—in which *sakti* is not only *not* reducible to sexuality but is particularly incarnated in the goddess traditions of South Asia—is glossed over in the rush to get to the foregone conclusion, honing in on the male sexual organ. The further question of how female ascetics use the sexual heterogeneity of the tradition in order to signify their experience is marginalised even further. Just as the culture is to be mono-lithically represented by the phallus, so also the ascetic is prototypically male, represented by the general category of

'the Hindu ascetic'. Yet Obeyesekere himself notes that one of the female ascetics gains her boon of divine grace only after her husband releases her from sexual obligations and prays with her for her to be reborn a man (Obeyesekere, 1981: 26). The material calls out for an analysis of how even a sexually plural religion ultimately valorises the phallus. For a woman, asceticism implies not only the codes of celibacy shared by female and male ascetics alike, but also subservience to codes that are gender-specific, and ultimately, aspirations to transcend female embodiment altogether.

Dance, known as *'āttam'* in Tamil Nadu, figures as an important, if not central aspect of possession experiences, particularly among castes classified as 'non-Brahmin' in Tamil Nadu. The importance of dance in possession is a feature shared with the Sri Lankan region. Obeyesekere asks the woman ascetic how she feels when she dances. She answers: 'A shaking, with my body all lifeless.' A few pages later, Obeyesekere picks up only the phrase 'shaking', omitting the paradoxical combining of numbness and lifelessness with the shaking, thereby ruthlessly narrowing the experience of dance itself. He then proceeds to gloss the shaking as 'orgasmic', as a 'religious substitute for what many ecstatics have not experienced in their ordinary sexual lives.' (Obeyesekere, 1981: 34). The very drive to sexualise the body of the possessed woman, to see all her movements as 'orgasmic', or better still, as a substitute for the 'real' orgasm, allows the scientific regime of truth to double its voice at the expense of the woman's.

The integration of the body into social theory is evidently an insufficient move in itself. We need to interrogate the terms on which this integration occurs. In the above accounts, the body has been reduced to the body of sexuality. In turn, we also need to critically examine the presumption that we already know what the category of 'sexuality' means in relation to the group of women who are central to my account of possession—that is, women from south India's rural poor.

Possession and the Voice of the Woman. The Narratives

I have urged the importance of an enquiry into a female-centred phenomenology of possession. But just what does it mean to attempt to 'elicit the voice of the woman' in the case of possession? Possession is quite overtly predicated on the radical splitting of subjectivity. It is this which renders it particularly stimulating as a challenge in developing feminist methodologies. We are seeking to elicit the voice of the woman who experiences possession when she is, by definition, absent during the experience. Therefore, the woman must rely entirely on the narratives constructed for her by previous cultural narratives of what it is to be possessed, and second, on the narratives constructed by significant others in her environment, particularly the families and the therapeutic healers. The methodological contradictions that ensue are not to be simply resolved. Feminist methodologies have inherited the problems that attend Western subject-oriented philosophies. Moreover, these problems are not external but are located at the very core of feminism, which is sustained by the aspiration for a subjecthood hitherto denied to women. I have therefore tried to do justice to the complexity of the situation rather than seeking to resolve the tensions. In a sense, the problem of finding the woman's voice in experiences of possession is not utterly unique, but rather highlights a much more widespread problem for feminism. Women's narratives about their own experience, even in moments of heightened agency, are shaped and structured by the discourses generated by dominant groups. For instance, the women who participated in the peasant movement in Telengana lacked the language that was adequate to their female experience and the language that was available to them was supplied by the communist political leadership of that period (Stree Shakti Sanghatana, 1989).

At the same time, the very fact that no dominant discourse has been fashioned with female experience in mind gives feminist analysis a certain leverage even in this difficult situation. Female experience is always, in some sense, in

excess of the dominant discourse. Although women rely on the possession narratives of others, they seldom simply reproduce a standardised cultural narrative of their possession experiences. Instead, they integrate possession into the particularities of their biographies. Both the women whose narratives I have solicited have experienced possession, not as a singular episode in their lives, but as a recurring pattern that has become woven into their lives and their social networks. In the course of this prolonged evolution, women develop a degree of communication between their conscious subjectivity and the world of spirits, and even some degree of control over the spirits. Some women are able to move in and out of possession states with sufficient control over the process to be able to heal others. Even those who do not achieve this level of control develop enough inter-communication to be able to recount visual sightings of the spirits and even conversations with them. Such developments, of course, ease the intensity of the methodological conundrum.

I have had to radically curtail the number of case studies and the quantity of contextual ethnographic detail due to space limitations. I have chosen two cases, which illustrate the contrasts and common elements linking two subaltern groups of women: Christian fisher women and Paraiyar Hindu agricultural labouring women. They have also been chosen to illustrate the contrast between possession as affliction and possession as the road to healing powers. Readers are referred to my monograph on gender and capitalist transformation among the Mukkuvar coastal communities (Ram, 1992, 1998) for the first case study discussed below. The second case comes from more recent and preliminary work in Chengalpattu (MGR) District in Tamil Nadu. I return to these case studies throughout the paper.

SANTI, 'Pēykari' of Kadalkarai Uru, Kanyakumari District

Santi's possession episodes started almost immediately after her marriage, twenty-five years ago and have abated now. They lasted over a period of ten years, and many of the young

women I spent time with in the village, now in their twenties, remember running behind her as children in order to mimic her antics and shout excitedly: *'Pēykari'* (Demon woman) Santi is now forty years old, and has nine children. Santi was born in the fishing village of Poondurai, in Kerala, near Thiruvananthapuram. Her mother was a fish trader, and her father a fisherman:

> I have four brothers and one sister. I was especially fond of my sister, but she died in childbirth soon after her marriage. I also lost one of my brothers by marriage. My father was a fisherman, and my mother a fish vendor. I had to work hard, but was very loved by my parents. Both were people of Poondurai, and I was very much a child of that village.

Her marriage to a fisherman in Kanyakumari reflects a wider pattern of intense social ties between the borders of Kerala and Kanyakumari in Tamil Nadu. There are Mukkuvar people on both sides of the border (cf. Busby, 1997), facilitating ties based on inter-marriage as in Santi's case, and also based on trade and visits to healers and shrines (Ram, 1992). The relationships continue to re-affirm a historical construction of 'region' that pre-dates the relatively recent division of Travancore into Kerala and Tamil Nadu in 1956. At the same time, the impact of schooling, media, politics, etc., is gradually 'Tamilising' the Mukkuvars of Kanyakumari creating divergences in the culture and political economy of Santi's natal and affinal villages: 'I came to this coastal village of Kadalkarai after my marriage—I had married by choice, I liked the look of my husband. In fact, he wanted to marry elsewhere. But I missed the security and support of my native home.' The official religious regime is that of the Catholic church, whose presence in the coastal villages originates with the Portuguese missions in the sixteenth century. While the church leadership provides a central axis of the identity of fisherpeople as 'Latin Catholics', popular Christianity admits of an intimate, if vexed, relationship with popular spirit cults of the region. The possession episodes describe a fluidity

in the movement of spirits in and out of the bodies of villagers in a manner that belies the official boundaries of religious identities between 'Catholics', 'Muslims' and 'Hindus', identities that have hardened after nearly fifteen years of communalist political activity in the region. The ambivalence and hostility with which these spirits are demarcated as 'Hindu' cannot be attributed entirely to recent communalism. These spirits have acquired, for Mukkuvars, the stamp of missionary characterisations of popular religion, as 'Hindu' demonic beings (cf. Scott, 1994). In the case I am about to describe, the deities possessing Santi are not as overtly malevolent as the local village goddesses. They belong to the grander category of temple dieties such as are seen in the regional Brahminic centres of worship at Thiruvananthapuram and Suchindram. This is attributed by Santi and other villagers to the fact that the house Santi married into is built over the site of an old Hindu temple. She speaks of them in notably distant terms, as 'Hindu' beings whose identificatory marks are known through temple iconography rather than through worship. At the same time, over a period of time, she becomes so familiar with her visiting divinities, whom she often sees in the form of a vision rather than only through possession, that she is able to tell me about them and also reports her chats to them.

My mother's cousin had married into this village before me. She also came from Poondurai. When she was brought to my *māmi*'s [mother-in-law's] home, she experienced possession. The same thing happened to me. Three days after my marriage, I came into one of the rooms in my mother-in-law's home, which was built over the site of an old Hindu *koyil* [Temple]. Everything around here was a forest in the old days. I saw a finely dressed man sitting on an *ural* [mortar]. I felt as if a blow landed on me, and I called out to others as I fell. The spirit demanded a *patukkai* [full ritual], *nērčci* [offerings], *āṭu* [goat sacrifice]. I had the *maṇam* [fragrant odour] of a newly married woman. For the next eight and a half years, that spirit stayed in my body. I would see it as I see you—just there, it would stand. I would see other deities from the Hindu temple, dressed

grandly with conch, flowers and all seven insignia, just like in the temples.

At first there was no *āttam* [dance]. The others [villagers] would take me to the *kurucaṭi* [the base of the Catholic Cross, at the village church], and leave me there without food. Once a policeman came while I was there and gave me medicine.

This place was infested with spirits. There were stories about how urns of water placed on the ground would be swallowed up. While I had the spirit in me, I would beat up anyone who touched me. Others in the house would go out to get some tea, and when they came back, I would be standing on my head. At night, I would suddenly get up and run outside. Things in the house, especially items of jewellery, began to disappear. My *tāli* was lost in this way. The spirit would take them all. The *tāli* was hidden in the walls of the old *koyil* [temple]. No one could find it. Then a *mantiravādi* [Hindu specialists in exorcism and ensorcellment] got the spirit to confess—'the *tāli* is here, the rest of the silver in the west of the temple!'. Sure enough, there it was. We gave it to the *koyil çāmiyār* [lit. church priest] and I wore it again only after he had done a mantra to it. Sometimes I would see jewellery lying on the ground and go to pick it up, and then they would turn into stones.

Then came the *āttam* [dance]. Oh, but it was *nalla āttam* [intense dancing]! In those days I would not have been able to sit and talk to you like this. The whole *ūru* [village, place] would gather and watch. I had gone for an *aḍakkam* [funeral], to a relative's home. My periods started, my clothes were dirtied. I ran down to change my clothes, and to clean my *pāvāṭai* [underskirt], when I saw on the ground, gold bangles, the conch, necklaces, and anklets just scattered there. I was really fated to die that day, but I didn't. Instead, I bent down to pick up the jewels, in my blood stained *pāvāṭai*. When I tried to straighten up again, I could not. I prayed—I said, please forgive me god, I did wrong. I told no one of this incident. They say, that if you talk, the vision will do you no good. The diety's voice said to me: 'This is my sari and my jewels. I had gone for a

wander. This woman has tried to take them away, so now I will not leave her'. It began to beat up on my husband and father-in-law. I saw the beings as a couple, male and female. After seeing them so often, I gradually lost my fear of them.

Two or three months later, they came back. I had stopped to urinate near a Çeṭṭi temple [i.e., temple worshipped at by Çeṭṭiyar caste], when they appeared. I said to them: 'So, you have come back to search for me, helped by my odour [of the urine]!'

My husband decided to take me to give offerings at Mandaikkadu [temple of Bhagavathi Amman near the village, and major site of pilgrimage from Kerala to Kanyakumari]. But my periods came and I could not go. I went to all the shrines of importance—Rāja Ūru, Manavāli-karai, St. Michael of Trivandrum, where I stayed for three days. The āttam in those places would hurl me against the stone walls. We went on pilgrimages to Velānkaṇṇi, Eduttuvai, Kalikkulam, Ovadi, Valiatturai. Finally, at the last one, a medium told me it was a temple spirit that had me, and that it would take its own time to leave. The diety also had some assistant spirits who lived in the çillai tree in our backyard. [I have been told by other villagers that she would run to this tree to ask the spirits to throw money down for her, so she could go and buy 'ice', i.e., sweet ice blocks, with it.]

Once the children began to be born I could no longer go and stay in the shrines like this. I lost my first child to the spirit—the āttam came while I was pregnant, and I lost the baby. Also the spirit would tell me whether it was a girl or boy I had in the womb. I lost two more babies to the spirit, one at four months of pregnancy, the other at two months. The abortions were cured only after a vaittiyar [healer, possibly of the Siddha tradition] gave me a tāyattu [talisman] with medicine in it. I also had trouble urinat-ing. After the last birth, I had a bloody and massive flow, with clots in it, as if I had given birth to ten babies.

Now my periods have stopped—since my last baby was born. But I had mukavāta çanni [facial rheumatism, like a paralysis] and had to go to a special ward of Thiruvanan-

thapuram hospital. At this time, my face and neck were twisted right around.

By the time the spirits left Santi, she had been branded, beaten, her arm was broken and pepper had been repeatedly put in her eyes. As a result of these 'ministrations', she suffers from headaches and backaches. The last episode, for which she uses the term *veṭṭu*, fits into the local category Siddha Vaidya category of *varmam*, which covers the effects of receiving a blow. The effects of *varmam* may be life-long, according to Siddha medicine.

Despite these marks that she retains of her experience, Santi is a relaxed and cheerful woman who describes herself as giving sage counsel to those around her, even if they unappreciatively regard this as taking on more responsibility than is her due.

Muttamma, the Healer and Activist. Village of Porur (Pseudonym), Chengalpattu District

Muttamma is a member of an agricultural labouring community I have only recently begun doing field work with. Muttamma belongs to a Paraiyar community of agricultural labourers in Chengalpattu District near Chennai. I met her through a local, women's NGO which had organised a 'Mātar Cankam' (Sangam in Sanskrit) or Mothers' Union, in a number of dalit communities in the area. Muttamma was an active member of her Sangam, and I have included her case study since it indicates that possession may be experienced not only as affliction, but as a means through which a poor woman can effect a transition into the status of a healer. The extension of her role in the Mātar Cankam as the healer builds on the strong community presence she already enjoys.

Muttamma's community is 'Hindu', although I wish to problematise the meaning of that term for subaltern communities later in the paper. Her father was a spirit medium. As she tells the story, 'before either marriage or wisdom had come on him', the spirit took him wandering far and wide, before it finally revealed itself. Unlike the characteristically

afflictive relationship between Mukkuvars and 'Hindu' spirits, the spirit in this instance undertook to look after the father's village, and asked that a temple be built in its honour. From then on her father stayed at the temple all the time, while his family looked after the little land he owned. There were seven spirits that spoke through him. They were: Muttu Māri Amman, Venkataccalapati, Koṇangi Perumāl, Deva Muni, and Pūvatikāri, literally, it means the spirit of a woman who has died a virgin.

A girl was given to him in marriage expecting that she could survive on the proceeds of the land. When Muttamma was three, she barely survived an illness. They were sure she would die since she had not eaten for days and was in a coma. They had already built the child's bier, which was shaped like a cradle, when her father's possessing spirit spoke through him. It said: 'Give her my name, and I will possess her. Make two eyes for me, and I will open hers. Set the eyes in beaten silver and give it to my temple.' Her name was then changed from Kanakambaram to Muttamma. She was also known as *cetta kaṇṇi* (eyes of the dead) and *cutukāṭu* (burning ground). Muttamma's narration of the story from here:

To appease the spirit, a brick from our home was given to the burning ground after I was saved, and that brick was treated with all the due rituals for the dead, dressed with turmeric and kumkum. [So that the spirits would not feel cheated of her death]. As for me, I had *cōka mayakkam* [giddiness] till I was ten. The sound of the *mōḷam* [drums, traditionally beaten for the temples by the Paraiyar caste] would bring on the *āttam* in me, but there was no *pēcu* [speech] until after I was married.

I was married to my *attai piḷḷai* [father's sister's son] at twelve. He went away while I was still young, and then came and lived with us for a few years. I knew nothing of my marriage, and I wondered why they were making up a feast, and taking me to Chengalpattu [a town]. I kept running away from him. When it came time to be with him [have relations with him], I tied my sari to my aunt, so I would know when she tried to leave me. They had built a small hut for us near my aunt's house, for us to be

together. He went off that evening to see a *kūttu* [rural theatre performance] but his friends told him to go home and get together with his wife. He came home and saw me sleeping in his mother's arms. He lifted my arm, but I rejected him. I kept on rejecting him. Finally, he said he was going off to hang himself, and they tied a *tāyattu* [ensorcelled talisman] to my *tāli* to change my heart. And, somehow, we got by . . .

Today, it is so different—the baby comes along even before the marriage. In our Cankam, we are dealing with two such cases: the girl already has a baby, and the boy is willing to marry her, but his family wants him to marry elsewhere. In the other case, the girl has a baby, but the man is married with two wives! Nor does the girl really want to be with him. What has god given us this for [she points to her clothing]? To cover ourselves, to join our parts.

After marriage I was the victim of *cūniyam* [sorcery]. My husband's cousin called me to him [*kūppiṭṭan*, i.e., made sexual advances]. I was a good looking woman. When I walked, I walked fine and strong. I also had a full set [of jewels] in those days. The man said: 'What I cannot have, will not survive,' and he kept *cūniyam* on me. Three of my children died. A fifteen-year-old son, studying tenth, got *veca kaṭṭi* [poisonous tumour], a daughter of three got whooping cough; and one son who had anaemia, died of fright—his time [*nēram*] had come on him. It was his fate [*viti*]. My husband's brother became sick and went into coma [*mayakkam*]. At this time of trouble, I had a dream in which Muttumari Amman came with *agni* [fire], ti ceṭṭi [fire pot], *katti* [knife] and *cūlam* [the *tiricūlam* or trishul in Sanskrit]. She came to give me *sakti*. The devi placed the *katti* and *cūlam* at my feet, giving me the sign that was to remain with me.

When Muttamma recounts this episode, describing the vision itself is enough for her to go into a trance. She yells, grits her teeth, and her son gives her a turmeric and water drink, which is kept beside her on a tray with kumkum and *vīputi* (sacred ash) on it.

After this vision, I began the *āttam* [dance]. People said: is this a *pēy* or a *sāmi* [demon or deity]? Just then the *sāmi* came on a relative, to let the people know that I had the *sāmi* in me, not a *pēy*. That is how I came to speak and to become a diviner [*kuri collaraṭu*]. But my troubles were not yet over—I had the *cūniyam* set on me, and I had a lot of [menstrual] bleeding. Finally, my *peṇ uṭampu* [womb] has been removed. But the goddess has finally punished my husband's cousin. She chased him and stuck her *cūlam* in the mud in front of him. He begged my forgiveness publicly, and my other children were safe after that.

Muttamma has three spirits speaking through her: Muttumari, Koṇangi Perumāl, and Pūvatikāri who has become their *kula devi* [clan deity]. Muttamma told me that Pūvatikāri was a woman from their family now searching for someone to speak her desires through, and she gets attracted to particular kinds of individuals. It is a kind of love, Muttamma explains. In a curing session by Muttamma, the different deities may take turns to speak. The change of cast is signalled by her son pouring water over Muttamma. The deities respond to particular kinds of complaints: for instance, Koṇanki Perumal comes when the patient is in danger, whereas *pēy* or demonic possessions are dealt with by other deities.

I asked Muttamma about her role in the Cankam. She responded eloquently in the language of the Cankam:

Lourdes [member of the NGO] called on us to organise. She said the politicians were lining their pockets, and we should ask for a road, for light and electricity. Out of the four or five rupees we earn a day, we have to see to children's education, the food. We work all day, and we should ask for greater wages. Since the Cankam we have had a hand pump installed. We went to the current [electricity] office and asked for a *paṭṭa* [title] to our house, a pipe for the street. Our *arivu* [knowledge] was born, and grew. The vote buyer goes and sits in comfort, goes to America and the world. They get our votes and signatures, but my child is still in rags, the money has gone elsewhere. I am a

talaivar [head] in the Cankam, but this has brought me
nothing to feed my child with. Other heads around here
get fat, wear *mancaḷ* and *poṭṭu* [turmeric and kumkum].
We sent a *manu* [petition] to Jayalalitha [the then chief
minister], asking about price rise. How can we survive?
You and your ministers squat around the place. We do not
allow the sale of liquor in our village, for three years now.
But it goes on in other villages, secretly.

I went to witness one of her healing sessions. She deals with
a variety of complaints: from illness to the problems brought
by women about menfolk who are alcoholic or missing to
problems about missing items of jewellery. The healing session
is held in open air, under the margosa tree, which is favoured
by the goddess. In her hands, Muttamma holds a *tiricūlam*,
a clump of margosa leaves, and a long stick. Her son stands
nearby holding a tray with camphor, kumkum and *vīputi*. I
will describe just one case, dealing with *kutumpa kaleccal*
[family discord].

Muttamma exhales noisily, whirls with *tricūlam* in hand.
The woman who has come to see her has lost her husband,
and her eldest son has separated his household, under
the influence of his wife. He now refuses to help his mother
financially. Muttamma henceforth addresses her clients
not as herself, but as the goddess, in characteristically
'goddess-like' imperious tones, chastising and then gra-
ciously consenting to extend help to her supplicants:
Goddess: Where were you for so long? Didn't people let
you know where I was to be found? Will your children
come to me?

Muttamma's son helps to elaborate and translate the god-
dess' questions, and the woman consults an older female
companion, who conveys to the son that there has been no
co-operation from the woman's son.

Goddess: You feel as if you are on fire. For nine long
months, for three hundred days, you carried this boy in
your womb. You spent on him, you raised him, you had

him married. Now, he treats you as if you were dead. He is not happy. You are in agony. But bring me your son. I will make him promise to care for you.

Woman [in tears]: You say all that is in my heart. But no temple of yours gives me solace.

Goddess: Bring your son to me. I will make him come to me.

Woman: He will not come.

Goddess: I will bring him here by next week. Take my lemon [wedged on the *tiriculam* she holds]. Give it to him to eat. It will bring him here. His temerity [*pōkku*] I will subdue [*adakkaren*]. I will get a *vākku* [promise, word] from him.

She throws the margosa leaves in the air, shouts: '*Vho*', exhaling violently, staggers back, and is given a drink of turmeric water. The goddess leaves Muttamma.

SOCIOLOGICAL DISCOURSES ON FEMALE POSSESSION

Social theory has attempted to claim the subject of spirit possession from the province of prior discourses such as theology, comparative religion and religious phenomenology. It has done so by reposing the question to be asked about the state of possession. No longer is it to be a matter of investigating the nature of the experience as articulated by the subjects of that experience, but rather an investigation of the *function* of that experience. Nor is this function to be located in the domain of 'religion'. Instead, it is relocated by social theory in the sphere of political power, in the maintenance and reproduction of leadership and authority. Early work in this area concentrates on the specialised and prestigious figure of the shaman. Eliade's (1951) book *Le chamanisme*, postulates that the sociologist's *proper* concern is 'with the social functions of the shaman, the priest, of the magician: he will study the origin of mystical prestige, its role in the articulation of society, the relations between religious chiefs and political chiefs' (Eliade, 1951: 8). In the 60s and 70s,

the burgeoning of second-wave feminism increased the sensitivity of ethnographers to the prominence of women in spirit possession. However, this prominence is registered initially as a curiosity encountered while pursuing categories of statistical significance: 'What categories of persons most frequently succumb to spirit possession and figure most prominently in possession cults?' (Lewis, 1966: 309). Women emerge as an epidemiological category. 'The literature', notes Lewis, 'is studded with references to the frequent prominence of women in these cults, and some explicit attempts have been made to explain, or at least comment upon, this sexual bias on the parts of the spirits'. (Lewis, 1966: 309). The 'sexual bias of the spirits' weaned the attention of anthropologists away from the specialised figure of the shaman to a study of possession as a symptom of deprivation. Applying the previously evolved framework of functionalism, anthropologists focused on different levels of female exclusion from the participation and exercise of power, studying exclusion as a form of dysfunctionality. Anthropologists such as Lewis (1966), and other anthropologists working specifically on India, such as Harper (1963), and Freed and Freed (1964), pointed usefully and pertinently to the proliferation of the levels of social power from which women are excluded. Women may not participate in the ceremonies and public life of the 'great' traditions—or, as we may now rephrase it, the hegemonic traditions—of religion. Women may not openly express emotional and sexual desires. Women are excluded, in the majority of patrilineal descent systems, from inheriting property and thus securing economic independence for themselves as men do. The concept of role conflict and role stress, which was actively employed by sociologists in the 60s and 70s to analyse gender in Western industrialised societies, was transposed by anthropologists to the asymmetries of gender relations in non-Western societies. Lewis characterises the 'stock epidemiological situation' for female possession in Somali playing with the notion of possession at the disease, gender inequality as the diagnosis and (male) anthropologist as the sympathetic but ironic diagnostician.

In the ethnography of South Asia, the situation of the young bride stands out in particularly sharp relief among

anthropological characterisations of the 'epidemiology' of possession. Anthropologists explore the specific burdens that the kinship system imposes on her at this particular moment of the female life cycle, producing valuable insights into the kin-based nature of female oppression: virilocal patterns of residence, for example, require newly married women to make the difficult transition to a distant village with no networks of social support, while simultaneously occupying the lowest and most vulnerable position in the hierarchy within the household (Grey, 1982; Macintyre, Morpeth and Prendergast, 1981; Sharma, 1980). In following through the consequences for women, of particular forms taken by kinship, anthropologists detail the toll taken by hypergamy and norms of seclusion.

Most of these ethnographies are drawn from the north of India. This is no coincidence. The south not only diverges from the pattern of hypergamy and strict exogamy (that is, the insistence on marrying girls a good distance from their natal village), but positively prefers a pattern of repeated marriages within the same group of kin. If we refer back to Muttamma's narrative, it can be seen that she not only weds her father's sister's son—according to the 'preferred' pattern of cross cousin marriage—but has this cousin living with her for a few years when she is very young. These variations have been shown to have a relatively enhancing consequence for women's status (Kapadia, 1995; Karve, 1994). If we refer once again to Muttamma's case, such practices give someone in her position the socially derived strength to resist her husband's sexual advances even as a newly married bride. They also allow her to seek security as a child-bride in the arms of her mother-in-law. In the north, this would be un-thinkable; but for someone in Muttamma's situation, her mother-in-law is also her aunt. There are limits to this social strength—the aunt does not provide the bulwark against her husband's sexual advances that Muttamma seeks in her; and she, like brides all over India, must learn to 'somehow get by' with the husband she initially rejects.

The Brahmin castes of the south, however, carry through pan-Indian Brahminic kinship values privileging hierarchy (Gough, 1994), although their practices have become coloured

by the south Indian kinship patterns. An analysis of posses-
sion based on the sociology of kinship oppression has there-
fore been extended with relative ease to south Indian Brahmin
women. Harper (1963) finds that 10–20 per cent of the women
in the Havik Brahmin caste of Karnataka experience posses-
sion at some time in their lives, many of them while in the
situation of the newly married woman. He asks what alter-
natives are open to women who do not, unlike the majority
of Brahmin wives, adapt to the restrictions with obedience,
hard work and anticipation of eventual rise in the female
hierarchy. He envisages three options. The first is suicide,
described in clinical terms as a species of 'adjustive behav-
iour'. This stark choice on the part of the woman creates
community feeling against the affines. The second option a
woman has is the refusal of food, which also causes gossip
about the treatment she is receiving at the hands of the
affines. The third option is spirit possession:

> A woman who is ill (*kata*), i.e., periodically 'attacked' by a
> spirit, is shown deference and accorded appropriate spe-
> cial attention—she is indirectly able to influence the behav-
> iour of others towards her. Not only does she temporarily
> gain preferred treatment, but both she and the members
> of her affinal family are given a breathing spell in which
> to reattempt adaptation to the situation A woman who
> is possessed is not only blameless, but the state of posses-
> sion itself is symbolic of her femininity. Women are believed
> to be weak and may be thus easily attacked by spirits.
> Also spirits are said to come on a woman because she is
> beautiful and irresistible. (Harper, 1963: 175)

There are considerable strengths to such analysis, strengths
of the kind that materialist attention to power confers on
any analysis of consciousness. Marx's analysis of conscious-
ness, and in particular his re-articulation of certain forms of
consciousness as class ideology, remains, both the paradig-
matic instance of such analysis and a measure of its power
and scope. We can usefully attend to social relations of un-
equal power to the two case studies I have introduced. Santi
experiences her first episodes when making the transition

into more challenging and difficult life situations. Marriage takes her from the security of her natal home in Kerala to a fishing village in Kanyakumari. The village of Kadalkarai is far more isolated and provincial than the metropolis of Thiruvananthapuram, and thirty years ago would have been relatively small for a coastal village. Muttamma's possession, on the other hand, follows a different trajectory. Her narrative bears all the marks of possession as a divine gift rather than as an affliction and therefore calls for a different treatment. However, I have already indicated that in her case, some of the relative strengths conferred by a more female-centred kinship system can also be elucidated by the use of such anthropological analysis. Both case studies in this paper make it clear that feminist analysis cannot do without careful attention to the larger patterning of social relations of inequality, which largely determine the range of possibilities and life chances open to women. Feminist anthropologists have found sociological analysis valuable in demonstrating not only the victimhood but the agency of women in spirit cults (Boddy, 1989; Constantinides, 1978).

However, certain tendencies in social theory can be positively misleading unless accompanied by a reflexive awareness of the baggage that accompanies each strength. I have referred already to the tendency in the language of the social sciences to turn social relations into reified, thing-like entities. Even this can serve to hit off the intractability of power relations. However—and especially when combined with a functionalist turn of mind—it can dictate a mechanical view of the world we live in, as a 'structure' which must be balanced in respect of its mechanical parts, as a machine endowed with an agency and will of its own which leads it to seek 'safety valves' for the tensions which have built up. One of the problems this mechanical view of society has bequeathed to social theory is an inability to dwell sufficiently on the specificity of the phenomenon under analysis. Rituals—whether of rebellion, of inversion, or of cohesion—all become so many means of reinstating the social norm. Inequality is postulated as a source of stress and tensions, both for the individual and for society, but the reasons for this are not theoretically addressed. Relief for this build-up of stress can

be supplied by any number of responses—illness, ritual, or rebellion. The specificity of both the form of 'stress' and of its 'relieving agent' disappears in this form of analysis. Possession, resistance and suicide all emerge in Harper's analysis as different 'options' available to the stressed individual to be assessed in terms of a rationalistic economic adjudication of the differential costs and benefits accruing to each. No doubt women do, from time to time, consider the choices available to them in patriarchal society. But female subjectivity cannot be adequately accounted for by the specific and narrow form of subjectivity described by rational choice theory. A phenomenon such as possession, predicated as it is on a radical splitting of consciousness, poses a particularly acute problem for an exclusively rationalistic approach to the world. I return to this problem below.

The Female Body of Possession

The gender specific nature of the consciousness which women bring to possession disappears under the weight of rationalism. Although Harper notes that possession may be symbolic of femininity, the significance of this insight is not explored. His rendering of the choices between the three alternatives facing a young bride is redolent of the problems that haunt the subject of Reason in Western philosophy—there is seemingly no body, either male or female, attached to the cogito which reflects and makes choices. Feminist philosophers such as Lloyd (1984) have successfully elicited the body which implicitly structures such philosophical accounts. It is a masculine body, which has rarely had to concern itself with acknowledging the consequences of human embodiment, and therefore, has seldom had to confront the limitations and partialities which necessarily accompany being located in a particular body in a specific time and place. Even less is this masculine rationalist suppression of embodiment able to cope with the specificities of female embodiment, which may be located most spectacularly, though not exclusively, in sexual-cum-reproductive embodiment. Such

feminist deconstructions of Western rationalism have given a substantive meaning to the generalised notion of the 'Man of Reason'.

Despite wishing to account for why women are so prominent in possession cults, the implicit masculinism of the dominant version of reason evacuates the female body which shapes the possession experience of women. We find that despite noting the specific forms of social inequality suffered by women, the sociological accounts of possession hinge on a notion of deprivation which could be generalisable to any underprivileged group.

Such a generalisability is also not without its analytical uses. Too often, women's responses are left unanalysed because they are seen as simple expressions of femininity. In this context, it is important to be able to point to similar responses that men come up with when placed in parallel situations of marginality. Men from castes that have been historically designated as 'untouchables' are prominent in possession cults (Beck, 1981; Kapadia, 1995). At the informal 'court of appeal' presided over by spirit healers, the various categories of the dispossessed meet—not only the women but the men who are poor and low caste. None of these groups expect to find justice in the more formal venues of dispute settlement such as panchayats and state courts (Moore, 1993). Among the Bedouin, young men who are only temporarily placed in the situation of marginality share in the specific performative genres of poetry with which Bedouin women express a lifetime's suffering in poetic code forms that make them publicly acceptable (Abu-Lughod, 1986).

The accounts of the women do not permit the analyst to quite so entirely dissolve their possession experiences into a generalisable sociological notion of inequality. The female body, mediated by cultural constructions of what it is to inhabit such a body, keeps erupting in their narratives. However, it is not exclusively the romantically sanitised body in Harper's account of the beautiful and vulnerable woman. It is equally the female body of smells and odours, of the blood of menstruation, parturition, and miscarriages, the secretions of sexuality and the flows of urine. The spirits make little distinction between the body of reproduction, the body of

sexuality and the body that eliminates wastes. They are avidly interested in all bodily emanations. Santi recounts her first sighting of the deity as one where the deity was attracted by the smells of her newly released sexuality as a newly married woman. The second sighting occurs on a visit to a funeral which requires in Santi a state of purity which is, however, sullied by the arrival of her periods. Her attempt to pick up the jewels strewn by the diety at the stream once again brings together her polluted state with the elevated realm of the diety. The third episode involves the chance coincidence of her urinating at night in an area that is near a Hindu temple. The tensions experienced by women are not only sociological ones, but are also borne by the body of the woman who is valued primarily as fertile but who must keep her reproductive fluids from impinging and disrupting the realm of the sacred. She experiences enormous social pressure to produce babies—preferably male—and exclusively within the bounds of marriage, while at the same time experiencing the body of fertility primarily as a creature of the whims of fate and destiny. Fertility and sexuality come up over and over as the primary areas of contradiction and concern in women's accounts of possession.

Santi progresses, while she is pregnant with her child, from an initial state of possession in which she sees visions to one where the spirit gives her *āttam* or dance. The spirit speaks to her of the sex of the unborn child, but she loses this child due to the spirit dancing her and she goes on to suffer another two abortions as a result of the dance. The spirit, in mischief, also seizes her *tali*, symbol and key instantiater of her married status, and hides it in its own temple.

In Muttamma's case, the narrative is part of a wider cultural narrative about possession as the 'road' to healing (Obeyesekere, 1981). Typical of such cultural narratives is the inheritance of the power to heal. Here Muttamma inherits the gift of divining from her father, and is even visited by many of the same spirits that spoke through him. Muttamma's narrative, however, does not stay at this level of generality. Her narrative gathers up the general ingredients, the elements of spirit genealogy she shares with her father as an inheritance, and integrates the spirit's visitations into a bio-

graphy which is not only about her social circumstances as a woman, but about a sex-specific embodiment as a woman. The sorcery which is placed on her by her husband's cousin is for rejecting his sexual advances to her, a woman who walks—in her own estimation—at the height of her attract-iveness. The effects of the sorcery are felt directly through her maternal and reproductive embodiment in the death of three children, in her greatly swollen outflows of blood and clots after the birth of her last child, in a uterus which is so swollen it must eventually be excised in a medical hysterec-tomy. As a young girl, she rejects her husband's sexual advances, when he attempts to consummate a marriage she has been enjoined to before attaining her puberty. She clings to the last vestige of childhood security, poignantly retold in her story of her tying her sari to her aunt's sari while she sleeps. Muttamma still resists him successfully enough to make him want to hang himself. The family ties a magical charm to her *tāli* to change the course of her desire.

The spirits that possess Muttamma and Santi further tie their biographies to those of other women, who also experi-enced injustice in sexually specific, embodied ways. Local notion of injustice refer us not only to unhappiness born of persecution, but to a life lived incompletely, where desires have not been satisfied. For a woman, these notions refer us typically to a life lived without experiencing marriage and maternity. Muttamma is possessed by the spirit of a young woman who died a virgin, and became a family deity. Santi's possession as a young bride is preceded by a parallel experi-ence of possession that overcame her cousin who came into the same village as a bride. Through possession, women illu-minate the commonness of the horizon of expectations and disappointments that shape the lives of women known to them or near to them.

A PHENOMENOLOGICAL PERSPECTIVE

We may draw on the phenomenological work of Merleau-Ponty (1986) as one of the starting points at which to develop an account in which consciousness is treated as necessarily

embodied, where meaning is located as much in the body as in the mind. Indeed, his account promises to undermine such dualisms, since it is only in and through the body that we can establish any kind of relation to the world. These capacities of the body need not be treated as purely biological or natural attributes, but as products of complex cultural and historical situations into which men and women are born and within which their subjectivity takes shape. His concept of *habit* is a particularly fruitful one for a feminist investigation of possession. Merleau-Ponty distinguishes between the customary body or the body of habit and the body of the moment. At any given moment, the body of the moment utilises as a background, the body of habit. This background is apprehended in the light of an almost impersonal being, but which has some of the momentum of existence and on which we rely for survival. The 'customary body' which we take for granted and draw upon at any given moment performs afresh an act of synthesis between past and present, an act of synthesis performed by and in the body. His ideas on how this customary body is created in the first place, and in particular, his account of the cultivation of habit is crucial in demonstrating how a feminine subjectivity is created and fashioned through the cultural disciplinings of the body.

This is not simply a matter of applying Merleau-Ponty to the female body. It is equally a matter of reading him against the grain. The relationship to the world which Merleau-Ponty describes in his summation: 'Consciousness is in the first place not a matter of "I think" but of "I can" ' represents a remarkable departure from traditional, cogito-based philosophical paradigms of intentionality. Equally, it represents the confident universalisation of a masculine attitude to the world. It provides us with a measure of the degree to which women must be specifically disciplined to suppress this seemingly universal, human orientation in themselves. By contrast, feminist philosophers have described the feminine attitude to the world as a broken, interrupted and self-arresting movement into the world, containing both the impulse to accomplish an act or project and a self-censorship and self-doubt as to one's capability (Young, 1990).

We may usefully draw on Bourdieu at this point since he has taken inspiration from Merleau-Ponty, but has also tried to link the notion of embodied habit to culturally specific contexts. Under the category of bodily habitus, Bourdieu (1977) seeks to describe the production of bodily dispositions which transmit cultural specificity in a mode which is barely accessible to everyday consciousness. In the cultural habitus of south India, puberty represents a crucial time at which this self-arresting splitting of the girl's embodied relation to the world is definitively set in place. The public ritual as well as the ritualistic advice that is given to young girls by older women at the time of first menstruation or menarche is a site that yields rich results on feminist investigation (Ram, 2000). The advice explicitly entails an arrestation of female movement out into the world. The girl is told not to go out of the house too much, to stay indoors as much as possible both to avoid social censure and gossip. The ritual of puberty also encourages the girl to conflate menarche with the sexed identity of a beautiful adorned being imbued with the qualities of modesty and a dawning self-consciousness. All of these qualities, named as 'feminine' and admired in a woman, reinforce the self-censorship, self-doubt and the splitting of the fundamental orientation of 'I can' towards the world.

Over time, we can see these ritually and socially inculcated disciplines and practices becoming incorporated into the female body of habit. Merleau-Ponty describes habit both as a re-arrangement and a renewal of body image. Fresh instruments such as clothing, activities such as using a tool become appropriated and express our power of dilating our being in the world. 'To get to use a hat, a car, or a stick is to be transplanted into them, or conversely, to incorporate them into the bulk of our own body.' (Merleau-Ponty, 1986: 143). We can trace this incorporation in the way we experience our feminine bodies in culturally specific ways. The girl who wears a sari for the first time at the puberty ceremony also comes in time to incorporate it into the bulk of her own body, to the point where it becomes difficult for her to comprehend the questions of a non-sari wearer as to how it is possible to wear a sari while performing complex and vigorous

physical activities. We can see the same habituated integration in the way we come to perform many of the grooming activities of femininity, from plaiting one's long hair to wearing a *poṭṭu* or bindi without a mirror. However, we also integrate into our very body of habit the restrictions and contradictions of living within patriarchy—how to stand in crowded buses in ways that will avoid contact with males, ways of taking on the tasks of self-surveillance that will allow us to avoid censure and the male gaze. We can look back at the work of existential feminists like Simone de Beauvoir (1972) and find there quite a brilliant evocation of the tensions imposed by the splitting that occurs when women have to live their bodies both as agents and as objects within patriarchy. We come to experience our bodies as a thing which is other than it is, a thing like other things in the world. But at the same time, we continue to experience ourselves as a constituting subject, living our bodies as transcendence and intentionality, that is, *not* as a thing like other things in the world.

How does possession relate to this relationship between the body of habit and the body of the moment? At one level, possession seems to offer itself as quite a brilliant metaphoric language with which to express the fundamental splitting that is imposed on women's capacity to move into the world. The ontological distinction between the spirit and the woman's body, the occupation of the woman's body by the agency and desires of a radically different being, the fracturing of the woman's voice by the narratives of others who must fill in the gaps in the woman's narratives about her possession experiences—all these seem nothing more than heightened dramatisations of the existential condition of women in patriarchy. The concentration of the metaphors of possession on the sexual and reproductive embodiment of women seems to illuminate this condition even more effectively, emphasising that it is in these aspects of one's existence that women come to experience, most radically, the splitting of their own subjectivity between objecthood and subjecthood. It is in this area, possession suggests, that we look for what women experience as the most fundamental constitutive features of their own sexed identity.

THE SPECIFICITY OF SUBALTERN RELIGION

The south Indian 'habitus' of communities like Muttamma's and Santi's pose challenges of their own to the Western roots of existentialism and phenomenology. These roots are exposed whenever these philosophies regard splitting as fundamentally pathological. We have seen that these premises, shared with Western humanism, are capable of delivering a profound critique of social conditions, as so many 'deformations' of the integrity are inherent in humanness, but denied to women and other oppressed groups. Nevertheless, they present important limitations when viewed from the perspective of women like Muttamma and Santi. To the extent that feminism itself comes to view the splitting of the self as an index of the fundamental crippling of women in patriarchy, and implicitly posits a unified and continuous self as the aspiration of a feminist sense of subjecthood, we stand the risk which is acute in a country such as India—that of ceasing to be able to apprehend the voices of women who situate their experience within a religious framework. This in turn violates what is equally one of the constitutive features of feminist ethics, which would entail developing the capacity to listen to the voices of women telling of their experiences, however radically differently situated from those of the listener and interlocutor. To the extent that feminist analysis retains its ethical commitment to making its analysis retain an organic link with female experiences rather than simply replacing them with an alien discourse, then we have to investigate the various layers of religious meaning that feed into possession states among women. The narratives of these women recount their histories of possession in a way that does not pathologise their experience. Possession certainly is regarded as a source of considerable affliction and hardship. Nor is it visited on all. But it is not regarded as anything more than the operationalisation of forces and desires that are already in place between humans and supernatural beings.

To speak of 'religion' as a unitary discourse is itself an elite assumption. Rather, possession draws on layers of

religious meaning and sentiment that keep alive in the present the dynamics of marginalisation and incorporation that have characterised elite/subaltern relations in India over centuries.[2] The supernatural beings that possess human bodies—goddesses such as Icakki Amman, Muttumari Amman, as well as beings who are now worshipped as supernatural, but who began their biographies as mortal women who died as virgins or by experiencing an unjust and violent end—take us into some very old sediments of religious emotion and understanding. For us to enter them is to go well beyond the more familiar tensions between Sanskritic forms of religion, and popular bhakti understandings of religion which modelled themselves on more intimate and primary relations of love. Bhakti is often made to stand, particularly in the current political context of mobilisations against 'Hindutva', for the entirety of subaltern religion. The religious cults devoted to goddesses such as Icakki and Muttumari depend centrally, not on expressions of love by the goddess, but on direct possession of their devotees. Unlike Sanskritic deities these goddesses are not characterised by any clear distinction, let alone a polarity, between auspicious power and demonic power. Rather, they represent a view of power as amoral, as efficacy incarnate. They are capable of bringing rains, harvest and plenitude if appeased and propitiated (but even this is no guarantee). Equally, they bring the opposite; diseases of heat, such as the 'pearls' [*muthu*] of small pox, which are the dreaded sign that Muttumari Amman has taken her chosen human.

Regional differences are important here. In the north, the parallel figure of Sitala Devi who brings the pox is the opposite of auspicious Sanskritic goddesses such as Lakshmi. In north India, female supernatural figures such as the *churel* are responsible exclusively for malevolent designs on the lives of infants, driven by unsatisfied desires. In Kanyakumari and erstwhile Travancore, this moral polarisation of good

[2] The literature is particularly rich on this theme. A number of theorists have attempted to view possession as a specific mode of historicity among subaltern groups. See Taussig (1980, 1987), Boddy (1989), Prakash (1990), Seremetakis (1991), Stoller (1995).

and evil is not as salient in local understandings of village goddesses. There are certainly continuities to be remarked on. In Tamil Nadu, as in the north, the powers of the goddess continue to be experienced with particular keenness in the realm of human bodily states such as disease and fertility. Women's inability to conceive, to sustain a pregnancy, to successfully deliver a live birth, and even to successfully nurture children in the critical early years of infancy, may all be taken as evidence of the powers of the goddess. In the Tamil stories of Icakki Amman—lovingly collected by the local folklorists in Kanyakumari such as A.K. Perumal (1990) for the regions of Kanyakumari and adjoining Kerala—the goddess deals out destruction to women, even ripping the foetus out of pregnant women. However, goddesses such as Icakki Amman are capable of attracting great devotion and fervour. For the devotees, these goddesses are complete in their meanings; they are capable of nurturance as well as destruction. These twin but interrelated aspects of the south Indian village goddesses are brought out vividly in the large clay statues of Icakki Amman built outside her temples in Kanyakumari. The icons erected as large clay statues outside her temples show her in two images—one icon beams brightly and nurses a child, the other, with ferocious countenance, has a half-eaten infant dangling from her mouth. Occasionally, these twin aspects of the goddess are represented as siblings with contrastive natures and requiring appropriate forms of devotion—one based on vegetarian offerings and the other on blood sacrifices.

Caste differences between the elite and subaltern shape possession experiences. When Brahmin women in Tamil Nadu worship the goddess and even become possessed by her, it is the sanskritised, exclusively auspicious goddess-as-spouse who enters them. Even in possession, Brahmin women edit out elements that are crucial to the possession experiences of women like Santi and Muttamma—the *āttam* or dance characteristically disappears, along with the goddess' appetite for blood offerings, to be replaced by lemon and curd rice (Hancock, 1995).

While the importance of possession states in the worship of the south Indian goddess is widely attested, (Beck, 1981;

Blackburn, 1988; Kapadia,1995), what has not been as well explored is the particular capacity of fertility—like its better explored counterpart, disease—to provide a highly appropriate medium for the non-elite meanings of the goddess. It is not that Sanskritic religious meanings are entirely absent in her worship. It is simply that human experiences like fertility and disease provide a brilliant medium to demonstrate the limitations of dharmic regulations. The ballads I heard sung at the door of Icakki's temples of Kanyakumari by her Nadar bards repeatedly drove this message home. They tell stories of how even the most powerful of humans—the royal couple—cannot control fertility. These couples follow every conceivable dharmic practice in order to earn better karma and redress their problem of childlessness. They feed pilgrims and the hungry, they behave ethically and so on, but to no avail. The message is that there is little human agency possible in the realm of fertility—here one must throw oneself on the uncertain mercies of the goddess, appease her arbitrary desires, and hope for the best.

Not only are the powers of the goddess, in this sense, beyond the moral binary oppositions of good and evil, but the relations between humans and divines are also far more fluid and amoral than they are in the bhakti cults. Unlike bhakti, which is characterised by the absence of the divine and the devotee's consequent elaboration of the experience of *viraha* or separation, in these subaltern cults, the goddess and her accompanying supernatural beings are only too present. They can be experienced directly in ritual states but they also present themselves in ways that are unlooked for and are even unwanted, randomly possessing individuals who are merely going about their ordinary lives. The goddess is at the apex of a hierarchy of supernatural beings such as demonic warrior guardian figures, demons and spirits who are to be distinguished from the goddess not by any moral distinction, but only by virtue of having lesser powers. All lurk close to human affairs, fascinated and easily drawn by human odours, and bodily outflows of urine and of sexual efflorescence. These outflows are hardly distinguished by the beings—or for that matter by the humans concerned—from the reproductive flows of menstruation,

pregnancy, post-partum and lactation. This fascinated near-
ness of the supernatural world, with its apotheosis in direct
possession, is matched by a complementary cycle of human
beings who turn divine. In a study of what he calls the 'cult
of the dead', Blackburn details the transformation of heroes
and heroines from local castes, low in the Sanskritic hierar-
chy, into deities. These are represented through *pītams*:
obelisk-like statues of clay or brick that are covered with
lime paste and worshipped during goddess festivals with even
greater emotional intensity than even the goddess can com-
mand. Blackburn (1988) stresses that these cults are not to
be confused with the Sanskritic cult of ancestors, whose
spirits need propitiation in order to cross the liminal status
of *pitṛ*. Nor are they malevolent demons. Rather, they are
powerful gods and goddesses who can also be invoked back
into life through possession. Similar cults of the dead are
found not only in other parts of south India and in Sri Lanka,
but also in Rajasthan and Gujarat. However, they are hardly
represented in the literature on religion in South Asia.

What is once again of particular interest to an exploration
of the gender-specificity of possession is the sex-specific route
by which even this transformation of humans into deities
occurs. Men are typically warrior heroes, whose lives are the
epitome of an idealised clan leader—brave and virile. They
are cut down in their prime in violent ends engineered
through treachery and cunning. The women who become
goddesses are beautiful and desired also cut down in their
prime by committing suicide while trying to protect their
chastity, or murdered by the very man who is the object of
their chaste fidelity.[3] The fluidities of the situation are such
that even my earlier attempts to classify the transformation
of humans into demons as distinct from the transformation
of humans into deified objects of worship proved beside the
point. Women who die while giving birth—some understood
to have been killed by the goddess herself—may initially

[3] This particular construction of gender unifies a wide variety of regional
genres, from the ballads to Icakki Amman to the 'high' classic literary
Tamil traditions of the Cankam period (Lakshmi 1990), or the epics of
the Telugu speaking region (Narayana Rao, 1986).

return as *pēy* (demon). However, they are then 'upgraded' fairly easily since in any case appeasing a *pēy* (demon) is not intrinsically so different from rituals of worship. Therefore, in time, a clay mould can become a full-fledged temple. Similarly, Blackburn's distinction between avatar cycles and the cult of the dead breaks down in practice. Some of the stories of the descent of the goddess into human avatar represent only a later stage in a narrative cycle that begins much earlier. It begins with the wrongful murder of a chaste woman, who then ascends to heaven to ask Siva for the boon of returning to earth as a goddess, in order to avenge her murder.

The links between the goddess and women therefore is far more intimate than is allowed by a notion of bhakti devotionalism. Muttamma, speaking as the goddess, enunciates the precise emotional experiences of maternal embodiment to her female devotees: she 'knows' what it is to carry a child in one's womb all those months, to nurture him, only to have him cruelly turn away and deny reciprocal nurturance when he is an adult. The speech brings tears to the eyes of the woman who comes to her as client—the goddess has said all that is in her heart.

The intrinsic ambuigities that occur in this particular stratum of subaltern religion, shifting between demon and diety, human and divine, structure the common understandings of possession itself as a matter of endless speculation and controversy. Initially, in my field work, I assumed possession was controversial only from the perspective of the secular rationalistic modern. But even for those within the religious framework, possession is indeterminate and open-ended. At the very least, it leaves open the question: possession by what? Is it *pēy* or diety? Is it a sign of grace or a sign of ensorcellment? Does it enable curing and healing or does it have to be cured? In addition, there is considerable local scepticism which asks: is it possession or conscious deception? The answers to these questions do not remain fixed either. As an evolving process, the meanings of possession can transform over an individual's life span. An individual can begin his/her possession 'career' as possessed by a demon and then be identified as experiencing possession by a

diety. It can begin as an affliction that the individual has no control over and then transform itself, as with Muttamma the healer, into a state that can be ritually controlled and induced in order to permit healing and divination. The process of identifying the nature of the spirit itself marks various stages of the individual's possession career. The more a spirit begins to communicate its desires and intentions, the more it can be brought under control—either to leave the individual, or else for the individual to be able to control the spirit enough to heal others. The most troublesome phase is therefore the initial one, where the spirit remains mute. The phase where the spirit makes the individual 'dance' is a step up in communication, but it is only when the spirit gives voice through the intervention of another more seasoned medium or healer, that the individual and the community gain some control over the process.

I have suggested in this chapter that we can explore the language of possession within a feminist framework without it requiring us to posit a rationalistic understanding. Nor do we need to consider the splitting of subjectivity in possession as a sign of disease in order to extract something of more general significance for the understanding of how femininity and gender are constituted under specific social relations of patriarchy. The language of possession, and more generally, the language of the particular layer of religious experience that possession belongs to, is already gender-specific. The demons, gods and goddesses, attach themselves, not to disembodied consciousnesses, but to specific smells, odours and flows of human bodies. Within this they are attached even more firmly to female bodies which are constructed primarily in terms of a field in which sexuality and fertility are conjoined. Women in turn follow sexual-cum-reproductive routes to deification and into possession. In my previous analysis of possession among Mukkuvar women (Ram, 1992), I emphasised the relation between the sexually specific disciplining of female movement, of clothing, of language and hair, and the performative engagement and 'play' with these codes by women in states of possession. Subsequent field work on possession has made me confront the prominence of reproductive disorder and irregularity in the women's

recounting of possession experiences. They point to the centrality of reproductive sexuality in the construction of femininity in Tamil Nadu, and possibly more widely in India. Discourses of sexuality which separate sexuality from reproduction—and this includes the psycho-analytical exegeses on female possession in South Asia—fail to comprehend the specificities of this semantic field of meanings.

We can retain the sociological insights that point to the generalised lack of power in women's lives. They only add further insight into the drama that surrounds women's reproductive sexuality. Unsuccessful fertility and an inability to smoothly make the transition from one ritually prescribed phase of womanhood to another carries with it both material and psychic suffering. Modern regimes of reproductive 'planning' have done little to alter this fundamental experience of powerlessness over fertility at the level of the individual woman who must bear the child. Instead, contemporary experience must add further potency to a religious discourse which suggests that fertility and its consequences in human suffering and joy are beyond the control of human agency, but are rather the effects of divine power both in its playful and in its dark, terrorising aspects.

Violence and Mental Health

Violence and Mental Health

X

THE UNSAFE NEST: ANALYSING AND TREATING THE ROOTS AND REACHES OF MARITAL VIOLENCE

Rajalakshmi Sriram and Sudipta Mukherjee

THE CONCEPT OF MARITAL VIOLENCE

I had ordinary looks and was considered very lucky that my parents found me a charming, fair, post-graduate groom. I was 25 and since then, have watched, for each day of my 25 married years, each simple hope and dream of mine being transformed into tales of ugly horror and crashed into a million fragments by this man that I was so lucky to have. He drank alcohol daily and suffered from a psychiatric disease which made him suspicious. I recall only an occasional day or week when I was spared the accusation of having illicit relations with either the milk-man, the newspaper boy, our 60 year old landlord, his 30 year old son. . . .my father, my brother, our adolescent son's friends and even our son!

The fights began with a 'courtroom-styled' inquiry about 'suspected leads' that indicated my flirtatious inclinations. I was constantly put through 'tests' and 'trials', where I would supposedly be caught on the 'wrong foot'. I had to prove my innocence. . . . The accusation became louder followed by the slaps. Then would come the belts or objects like plates, glasses or god's stone idols, hurled at me. I

would cry and keep saying I was innocent, pleading and begging for mercy. But still he would beat to his satisfaction and then end the fight by making me touch his feet and promise not to do 'it' again, or with intercourse. The next day I was expected to continue with life as usual: You know, cook, feed the children, take care of their home-work. . . . My children and I lived in constant terror. We never knew what today had in store or which of our actions would be taken as evidence for my infidelity.

Physically, I was hurt now and then, but emotionally my wounds were much deeper. I felt totally wrecked. I worried about my children's future, felt sorry for him and also des-perately wanted a successful marriage. People believe that I must have been the 'culprit' or else, why would I have taken this torture for so long? I tried to take the help of psychiatrists. . . . Most of the time, he did not agree that he had a problem. When he did, he didn't trust the psy-chiatrist The daily ordeals ended when I finally took courage to run away from home, with our children.

As for myself, I have watched myself change from a confi-dent, decisive person to a person ridden with self-doubts and am unable to take even routine decisions easily. I have learnt to be disorganised and unplanned. I feel guilty all the time for being an unsuccessful wife and a poor mother. All I ended up doing in my married years was to try avoiding his suspicions, being suspected and abused anyway, and then trying to restore normalcy in my crumbling home.

Now, I am trying very hard to get my daughters married, but everyone prefers to keep away from a broken family. I don't have any close friends as most people look at me as a 'freak'—The 54 year old lady with sindoor who doesn't have a husband. Once my daughters are married, I will give up this material life, go to some spiritual ashram and meditate. Only then will I find peace. But of course, I first want to be certain that my husband will be looked after by my children.

This chapter examines the concept, causes, consequences and interventions related to marital violence. Within the con-text of different theoretical and action frameworks to

understand marital violence, our aim is to integrate feminist, socio-developmental and mental health perspectives. Greater emphasis has been given to the latter two.

In everyday language, violence signifies an attack or assault resulting in destructive consequences. The Webster's dictionary sees it as an act of extreme force of passion or fierceness. Another holds that violence is inflicted when people are made the target of coercion or are disciplined to act in a manner required by another individual or group (Chaturvedi, 1988). The dictionary view carries an implication that an act of violence is mainly physical and focuses almost wholly on the intense emotion that incites violence. Chaturvedi's definition, on the other hand, is broader. It implies that violence is not merely physical but takes into account the person(s) inflicting the violence: Violence requires a human medium or media to take place. This view makes tangential reference to the presence of motives in violence and refers to the consequence of violence, by indicating submission. However, the intensity of the phenomenon is not looked at.

Family violence has been described as that which is inflicted on a relative by blood or marriage, individually or collectively, is either contained within the walls of the family or extended to co-laterals for material or psychological gain or ventilation (Kaushik, 1988). The description goes on to specify that it may be a reaction to provocation or an unexplained illogical act, causing physical or psychological injury. This view is comprehensive as it covers the inflictor(s) of violence as well as the victim. It specifies a cause or motive, gives a flexible setting for the act and includes its consequences. While it does not specify the nature of violence, it leaves enough scope to assimilate multiple forms. In the present discussion, the above definition is further limited to the marital couple. Typically, almost all marital violence is targeted at the woman. The multiple dimensions of marital violence are listed below:

1. Violence presumes an actor or inflictor who carries out the violent act. In this case, it is the husband and referred to as the 'batterer'.

2. Violence implies a target, towards whom the act is directed. Here, this is the wife, who will be called the 'victim'.
3. Violence is charged with a strong emotional component which initiates or provokes the act.
4. The direction of this affect is clearly negative.
5. The act of violence is not merely physical.
6. It usually has a material or psychological motive behind it.
7. Finally, its consequences are always detrimental.

Attempts to categorise the forms of family violence (Bhatti, 1990; Kaushik, 1988; Lata, 1990; Parihar, 1990; Sriram, 1991) include physical, verbal, social, intellectual and psychological. Physical violence includes all those acts that may cause bodily harm or bruises. Three kinds of physical violence may occur: (*a*) *Abuse:* Using objects or physical force to hurt the victim; (*b*) *Neglect:* Inadequate physical care which may mean starvation, lack of proper medical attention when needed, not looking after clothing needs, etc.; (*c*) *Sexual abuse*: Using the spouse to satisfy sexual needs without her consent or without looking towards her needs. Psychological violence refers to the intentional withholding of care, concern, affection and sympathy. It also includes emotional apathy and not allowing chances for discussions or confrontations on issues important to the woman. Verbal violence refers to using abusive, insulting language, threats, taunts, excessive sarcasm, etc.

WHY DOES HE DO IT? WHY DOES SHE TAKE IT?

Several analyses have been made (Ahuja, 1988; Kulkarni, 1988; Lata, 1990; Padhye, 1988; Sriram, 1991) on the causes of marital violence. Causal factors may operate at two levels:[1] At a micro-level, where they affect the individuals involved

[1] Causal factors are not the same as 'immediate antecedents', especially in the case of marital violence. Research evidence based on victim and family reports list multiple factors as causes of violence. To illustrate,

in the violent relation (Batterer-battered related factors); at a macro-level, where broader societal mechanisms come into play. The micro-level causal factors have been organised into four broad approaches: the biological, the intra-psychic, the behavioural and the cognitive (see Table 10.1).

However, their differential manifestation leading to the perpetuation of violence needs to be understood. A point of significance is the seemingly contradictory relation between a few of the causes and effects of marital violence. Some causal factors are also implied as effects of marital violence. As a cause, the factor initiates the process of violence or maintains it, while as an effect, the feature is magnified and may result in psycho-pathology. To illustrate, low self-esteem as a cause in the victim creates feelings of helplessness and dependence, allowing her to accept violence, and preventing her from seeking alternatives. As an effect, the victim begins to doubt her adequacy as a wife, mother and person as her self-esteem sinks lower and lower, possibly leading to a full–blown depression. In such cases, the line of demarcation between the cause and effect is one of intensity.

Biological Approaches

Studies have shown a high level of testosterone, a disturbance in the neuro–transmitter serotonin and a greater incidence of learning disabilities in the batterers (Marano, 1993). The general understanding of aggressive behaviour is that it is linked with physiological correlates of autonomic arousal

the wife not taking care of children, or not doing domestic duties to her husband's or in-laws' satisfaction, questioning any of her husband's acts, nagging and accusation by and of family members—all of which may be widely prevalent as normal events in marital life. These events may bear direct temporal relations to the act of violence, but they are definitely not causes. Such events are common occurrences in many homes but do not consistently lead to violence. Individual differences in thresholds are insufficient to universally explain violence. Certain basic processes, in fact, may be able to account for creating the immediate antecedents of violence and to explain its continuation, which will be the focus of discussion herein.

Table 10.1
A Profile of Batterers and Victims. A Congregation of Views

	Biological Determinants	Intra-psychic Determinants	Behaviouristic Positions	Cognitive Approaches
Batterer	• Testosterone • Serotonin disturbance • Disconnected emotions and behaviour • Past head injury • Learning disability	• Low self-esteem • Insecurity • Fear of abandonment • Suspicion • Castration anxiety • Sadism • Male stereotypes	• Social conditioning • Positive reinforcement	• Schemata (lower status to women, sanction for violence and anger) • Faulty processing of social information
Victim	• Progesterone related vulnerability	• Low self-esteem • Dependence and submissiveness • Penis-envy • Masochism • Relational identity	• Social conditioning • Learned helplessness	• Attributing ill intent • Schemata (higher status to men, accepting anger and violence)

(Kaplan, Saddock and Grebb, 1994). But contradictorily, the study of batterers also shows a disconnection between the physiological correlates of affect and their behaviour. That is, while the behavioural display is one of rage or anger, the physiological signs show an internal state of calmness (Marano, 1993). Moreover, biological causes for marital violence have been proposed only from the point of view of the batterer and not that of the victim. Only the testosterone–progesterone theory seems to have implications for the victim. But evidence for validating a cause-effect relationship biologically is not strong enough, giving rise to several doubts. The disconnection between emotion and behaviour may be either related to other variables like motives, or may not have biological linkages at all. Their linkage to other psychological and biological variables however cannot be overruled. Similarly, to establish the importance of learning disabilities in marital violence, it is essential to understand what percentage of the adult population with learning disabilities become batterers. It is also noteworthy that the biological causes have been proposed and researched on mainly by men in the context of marital violence. A further weakness in the biological approach is that it relinquishes batterers of the responsibility for their own behaviours, thus reducing possibilities of constructive intervention in marital violence.

Intra-psychic Approaches

These are postulated psychological mechanisms within individuals which are central to their functioning, such as needs, fears, impulses or feelings working in isolation or as a constellation, sometimes conceptually linked to more basic processes. Some intra-psychic determinants postulated to be common to the batterer and the victim:

1. *Low self-esteem,* a pre-factor in both but manifests differently (Ahuja, 1988): In the batterer, low self-esteem is said to lead to a need for demeaning and exerting power over the victim. In the victim, there is said to be a need to establish self-worth through pleasing the batterer and so, it also becomes difficult for

her to leave the batterer as she lacks confidence in her abilities to survive on her own. In the batterer, feelings of insecurity, a fear of abandonment or rejection, suspiciousness and violence can form a constellation with low self-esteem. Likewise, in the victim, the need for dependence and submission may be an outcome of or related to low self-esteem and serves to maintain the process of violence (Ahuja, 1988; Kulkarni, 1988; Padhye, 1988).

2. *Psycho–analytic positions* posit a weak ego development in the victim (Ahuja, 1988): Freud regarded masculinity and femininity as being synonymous with being active or passive (Mitchell, 1974). The woman is supposed to be plagued by penis-envy, which makes her passively aim at being loved. The passivity is also theoretically linked to masochism, where oedipal love for the father makes the woman wish to submit to castration, copulation or child-birth. She is supposed to derive pleasure from such painful experiences. Extending this view to the present context, the batterer is said to fear castration, which he actively diverts to heterosexual love and sadistically derives pleasure out of giving pain to the victim. On the other hand, the victim is said to passively accept love, deriving pleasure out of being hurt by him.

3. *Identity:* Societal sex role stereotyping ensures that the male identifies himself as having a dominant position in the family and having the licence for outward displays of aggression (Kulkarni, 1998; Padhye, 1988). Women, for the same reasons, particularly in India, do not have independent relationships with others (Bhandari Anand, 1988). Thus the stage is set for the creation of a batterer who makes demands, wields power and is violent. The victim understands herself primarily through her relation with the batterer, which makes her dependent, self-restrained, non-individualistic and ready to accept violence.

These psychological views give only a partial understanding, and have at least two limitations. First, it appears that some

mediating factors are required to link intra-psychic mechanisms to the acts of violence, such as some aspects of behavioural or cognitive processes, which we discuss in the following subsections. Second, these views ignore other significant aspects of the batterer or the victim, and the context of their existence. For example, the psycho-analytic view sees the woman as being a 'deficient male', and ignores the significant aspects of womanhood, that is, women as active givers of love and affection. The concept of identity makes an effort to link it to other basic societal processes by bringing out the importance of stereotyping. However, while it successfully explains gender differences in identity, it fails to explain why some males or females become batterers or victims whereas others do not.

Behavioural Approaches

Researchers have uniformly indicated that many assaultive husbands had been exposed, as children, to models of intra-family violence (Ahuja, 1988; McGarry and McGrath, 1981). Similarly, most women who had observed violence between parents were themselves ultimately victims of violence after marriage (McGarry and McGrath, 1981). Thus, it seems that men and women tend to model the dysfunctional behaviour patterns of their parents. Based on operant conditioning concepts, the behavioural view also highlights the role of positive re-inforcement that the batterer receives in maintaining the cycle of violence. With each episode of battering, the batterer experiences a heightened sense of power seeing the victim helpless and trying harder to please him and this increases the likelihood of future episodes of battering. Conversely, the victim learns that no matter what she does, she is battered. This makes her feel helpless and she learns not to behave autonomously or to exercise control over her life. The concept of 'learned helplessness of the victim' has been developed in another context by Seligman and his colleagues in 1972 (Gombey, 1981) to designate this cycle. Once again, these behavioural views have their limitations: (a) In proposing that positive re-inforcement maintains the batterer's behaviour, we only have an explanation for the continuation

of violence. But the behavioural paradigm does not explain its genesis. (*b*) Coping processes differ in victims. Depending on coping styles and the available social supports, learned helplessness may or may not occur. The learned helplessness theory does not explain the variance in responses. (*c*) Social conditioning poses inter-generational violence as inevitable.

Cognitive Approaches

The cognitive views indicate the importance of cognition as a mediator of behaviour. Based on Beck's theory, they assume that everyone has internal models of aspects of the self and the world that they use in order to perceive, code and recall information. This adaptive schemata is said to develop over the course of numerous experiences, facilitating an information processing system that is biased towards taking in information consistent with itself (Robins and Hayes, 1993). Using this model, we can propose that men and women have a cognitive schemata about their own and each others' status regarding acceptable or non-acceptable emotions and their expression, including behavioural aggression. In the batterer and the victim, these schemata are triggered off in certain situations and determine violence behaviour and its acceptance. The strength and direction of the behaviour varies from person to person. Marano (1993) suggests that batterers are unable to process social information correctly and so perceive the victims' actions as infidel, rejecting or flirtatious. 'The attribution theory' has also been extended to the situation of marital violence. The batterer tends to attribute ill-intent to the victim which makes him violent (Ahuja, 1988). The strength of the cognitive view is that it encapsulates, to some extent, the relationship between the individual and the social situations in explaining behaviour. It is important to integrate these theoretical positions with the social determinants of violence, as explained in the next section.

The Social Context of Violence

Three sets of contextual causes can be identified: Causes related to the marital relationship; familial factors; and situational factors.

Causes Related to the Marital Relationship

The nature of the bond between the batterer and victim plays an important role in marital violence. Both the positive aspect, that is, the caring and love shared by them (Marano, 1993) as well as the negative aspect, that is, the lack of love and caring, and maladjustment between them, have been implicated (Ahuja, 1988). These two views appear contradictory. Perhaps the point of importance is that the marital relationship is essentially ambivalent like most close relationships. There are periods of love and hate which create and maintain the process of violence.

Familial Factors

Bhatti (1990) conducted a study on 120 families with wife-battering and discovered differences in styles of family functioning related to economic status. Violence is more prevalent in low-income families having less regimented family roles and rules, which have not yet emerged as cohesive systems, making them unable to counter internal or external demands. In the middle- and high-income families, poor role allocations, unhealthy communication, lack of complete cohesiveness and disturbed leadership patterns create violence. Other family variables like the number of family members, occupation, educational status of family members and the structure of the family, also determine the presence or the nature of violence.

Situational Factors

The family is influenced tremendously by resource constraints, which is closely related to intra-familial functions.

Figure 10.1
Causative Factors in Marital Violence: An Overview

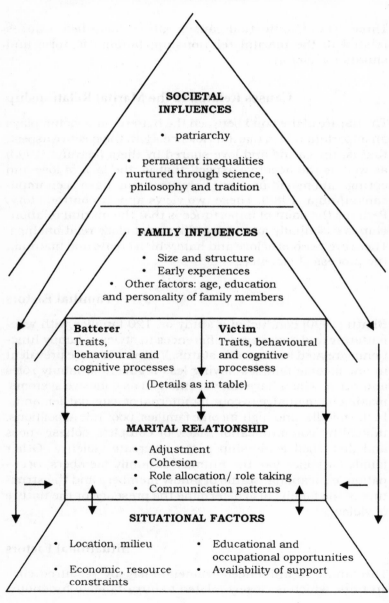

The lack of proper jobs, the lack of job satisfaction, congested living spaces and the lack of material infrastructure, create states of tension and stress in the batterer, leading to feelings of helplessness and powerlessness. These factors form the crux of the 'resource theory', 'frustration-aggression' hypothesis, *anomie* and tension-feedback theories extended by Ahuja (1988) to the context of violence.

FEMINIST VIEWS

The feminist perspective proposes that economic and social processes directly or indirectly operate to support a patriarchal social order. In the ensuing family structure, males hold dominant positions while women remain subordinate. Violence serves as a tool to maintain and reiterate this system. Miller (1976) extends as well as exemplifies this position, proposing that relationships present themselves as two kinds of inequality based on status and power:

Temporal Inequality

In this are included relations like those between parents and children, teachers and students, etc., where there is presumably a 'superior' party with some ability or quality which s/he is supposed to impart to the 'lesser' person. The period of disparity is temporary until the 'lesser' person gains qualities equal to the superior.

Permanent Inequality

Here, groups of people are defined as unequal by ascription (of birth), based on criteria of race, sex, class, caste, religion, nationality, or others. The dominant group is considered 'superior' and labels the subordinate group as inferior or defective. The dominant group usually defines one or more acceptable roles for the subordinates. The subordinates typically provide services that the dominant group does not wish to perform. The preferred roles are not given to the subordinates as they are seen to have innate defects or deficiencies

of mind or body, thereby ensuring that they do not develop further. Forte et al. (1996) point out that the more powerful person with structural sources of status and power can remain imperceptive to the needs of the less powerful person. The dominant person's interactional goals are achieved through brute force rather than through open negotiation. This group includes men and women, where men are the dominant group, while the women are the subordinate group. The subordinate group is further encouraged to develop personal, psychological characteristics that are pleasing to the dominant group, which include the familiar cluster of submissiveness, passivity, docility, dependence, inability to act/think/decide, etc. If they show a potential for or develop characteristics like intelligence, initiative, assertiveness, etc., these are not acknowledged nor allowed to develop, and either subtle or gross means can be used to curb them. The subtle means involve determining a culture's overall philosophy, morality, social theory and science. Blatantly, such subordination may be done through violence.

These underlying societal mechanisms perpetuate patriarchal practices and exert influence through the batterer and the victim. The batterer has an excessive need for power and dominance and ensures the subordination and subjugation of the victim through violence. He treats women as 'objects' of his satisfaction. A woman's defining qualities—like vulnerability, emotionality, capacity to give to others, participating in others' development, doing good for others—which are actually her strengths (Miller, 1976), are considered by society, including women, as her weaknesses. Forte et al. (1996) regard the woman's ability to respond to the other's moods and communications as a defense strategy for survival. As a result of the objectification and subordination, the woman begins to develop the sense that she is bad or evil to warrant such treatment by people whom she values. Hence, her sense of inadequacy and guilt ensures that she remains in the marital situation. The victim's need to maintain silence is further reinforced by the apathy of the members of the social group, who, despite being aware, neither own up nor support her cause, for fear of ostracisation.

THE MULTIPLE EFFECTS OF MARITAL VIOLENCE

Depending on the range and the intensity, the effects of violence may be seen as falling into three categories, namely, emotional, social and psycho-pathological—these may be temporally linked. The emotional effects occur first and over a period of time, they percolate into the social sphere, ultimately compounding into psycho-pathology. This relational sequence must be interpreted with caution, since it is by no means inevitable. Contingent on the amounts of emotional or societal support received from friends, families, neighbours, professionals or other well-wishers at any stage of the sequence, the effects can be minimised.

Discussions with mental health professionals and personal clinical experience have revealed that many reported psychiatric symptoms for which children and adults seek help can be traced to disturbed family relations, one of which is marital violence. In an analysis of intervention strategies for marital violence, Schuler (1992) highlights the need for a data base on the consequences of violence to plan effective interventions. A paucity of research studies, in the Indian context, leads the authors to rely on revealed experiences of victims and clinicians. The conclusions made should not be treated as generalisations, but as a context for follow-up.

Table 10.2 enumerates intra and interpersonal effects for the different persons involved in marital violence. Effects at the personal and social level are not universal, although some may be commonly shared by more than one member. A common emotional effect on the adolescent and the batterer is insecurity linked with mistrust. Similarly, a common social effect is isolation and a psycho-pathological effect is depression (Srinivasan, 1987; UNDPFW, 1992). Marital violence emotionally shakes up the inner being of both the adults directly involved as well as those who are vicariously involved, like their children (who may be very young or even adolescent) and those who are tertiarily involved, i.e., the family, precipitating an overall insecure environment. Insecurity has a bearing on self-concept which may then be linked to isolation and social withdrawal. Withdrawal reduces the

Table 10.2
Nature of Effects and Persons Affected By Marital Violence

Persons	Emotional	Social	Psycho-pathological
Victim	• Shock, disbelief, denial, fear • Insecurity, lowered self-esteem • Shame, guilt • Helplessness • Overinvolved with children	• Isolation, rejection • Desertion/abandonment • Inability to make and sustain relations	• Depression • Anxiety • Psychosomatic illness • Suicide • Post traumatic stress
Child	• Thumbsucking, nail biting • Nightmares, bedwetting • Attachment problems, hypersensitivity • Immaturity, insecurity • Physical problems • Unusual play patterns • Aggression/Academic problems	• Disturbed peer relations • Emotional disorders • Behavioural problems • Conduct disturbances	• Too little concern for others' feelings • School related disturbances
Adolescent	• Mistrustful, insecure • Identity crisis • Learned helplessness • Low self-esteem • Hypersensitivity	• Isolation • Choosing faulty role models • Disturbed relations with opposite sex members • Excess conformity or rebellion	• Depression, suicide • Anxiety • Conduct disturbances • Alcohol or substance abuse.
Family	• Shock or denial • Guilt • Helplessness • Insecurity	• Loss of status • Social isolation or ridicule	• Disturbed family functioning • Burden • Depression • Expressed emotions • Other psychiatric problems

individual's ability to elicit social support which in turn creates a vulnerability for depression.

Victim

The first reactions of the victim are those witnessed usually in crises or traumatic situations (UNDPFW, 1992). For a detailed picture, see Figure 10.2. The children become her source of comfort with whom she may become overinvolved. Strong feelings of inadequacy, guilt and shame over not being a 'good wife' are reinforced when she accepts the disparaging views of the batterer, even though they may go against her self-interest (Forte et al., 1996; UNPDFW, 1992). Concern over physical wounds and a host of other factors ensure secrecy about the battering. The need for secrecy affects her ability to make and sustain relationships out of home, leading to social isolation. If she is deserted by or decides to abandon her husband, she faces further stigmatisation.

The victim is distracted by the constant excuses of the batterer making her believe that the causes lie not in him but in external factors like stress, financial problems, drug or alcohol abuse, or her own behaviour (Wolf-Smith and La Rossa, 1992). As the episodes of battering continue, the victim's coping resources are systematically depleted. Frequent distressful emotions and diminished self-esteem affect the victim's capacity to take constructive action (Forte et al., 1996), and she becomes vulnerable to different kinds of psycho-pathology (Aggrawal, Thatte and Mrinal, 1988; UNDPFW, 1992).

Physical injuries are often severe, requiring either acute or long-term medical attention, sometimes even leading to permanent damage like brain damage, deafness, etc. (UNDPFW, 1992). Following periods of acute battering, the victim is left homeless and penniless for certain periods. If she walks out, and friends or family refuse to shelter her, she may seek help from womens' institutions or shelter homes. However, living in institutions not only demands a major change in lifestyle, it may also be unfriendly/unsuitable for her children, especially the boys.

Children

Children in violent family situations are often the worst hit. First, they do not have any exposure to normal living conditions for fairly long periods of time. Second, they are unclear about why their father behaves the way he does. Third, they live in constant fear and insecurity about their day-to-day living conditions. And last, they are constantly trying to do a 'tight-rope act', making sense of their home and outside (particularly school) environments. Some of these effects are noted in the UNDPFW report (1992: 10).

Emotional turmoil in young children may manifest in one or more physical or psychological ways (Kaplan et al., 1994) (Also see Table 10.2): Display of unusual patterns of play (for example, they may either like only solitary play, avoid physical games, may show bizarre play or even avoid play completely); hypersensitivity and excessive crying, aggression, and several physical symptoms like headaches, tics, skin problems, colds, asthma, etc.; frequently demonstrating academic problems and performing below their actual capacities due to a preoccupation with the situation at home.

In the social sphere, children often are unable to make friends with their contemporaries or become callous to feelings of others, and hence are avoided. Sometimes, they may disregard school rules and become truants. Additional risks include behavioural problems like introversion, attentional problems, over-aggressiveness, or conduct disturbances. With the right kind of intervention and support, the problems may be transient. If not, some effects leave long-lasting scars that may carry on into adulthood resulting in either neurotic conditions, personality disorders, substance abuse and/or a repetition of the violence cycle.

Adolescent

The adolescent in violent family situations may undergo a period of identity crisis where he or she is unable to arrive at a defined self-understanding and may not be able to choose and invest energy into the right careers. At an emotional level, the adolescent may experience problems, often leading

to isolation from peers, unhealthy relations with the opposite sex, identifying with negative role models, or over-dependence on and conformity to peer groups. The rates of adolescent suicides are higher than those for the general population and this is often linked to adolescent depression or substance abuse (Kaplan et al., 1994).

Family

The family of origin of the victim is in a sense only indirectly involved, but as the victim continues to seek various kinds of support from them at different times, they too feel the impact of marital violence. Initially, they also experience shock and attempt to deny the reality of violence. Later, they feel tremendously guilty, especially if it is an arranged marriage. Not wanting to take the responsibility for the victim's life and bound by traditional views, they try to persuade the victim to continue in the relationship while also feeling helpless in supporting her. They may also become tremendously insecure that they have to shoulder the burden of a family member for longer than anticipated and may even worry about their safety if the batterer comes in search of the victim. Socially, the family members feel a loss of status as people get to know about the victim's unhappy marriage and sometimes become socially isolated and ridiculed. Effects may be experienced by the primary care givers, who feel burdened and undergo depression because they have to bear the emotional and financial burden of the victim's family. Sometimes disturbed patterns of functioning may be witnessed, like faulty role allocations in the family, faulty leadership patterns and the development of over-involved subsystems. Expressed emotions in the family can create further dysfunction and other psychiatric problems.

Batterer

Emotionally, the batterer may feel rejected by the victim's abandonment, assign blame to her for hurting him, become increasingly mistrustful of women or repent for his actions, suffering from shame and guilt. Socially, he may be rejected

by people who know about the battering. On the other hand, he may choose to enter another relationship with a woman and repeat the violence cycle. Sometimes, if he has certain personality problems, he may take to criminal behaviour, particularly homicide of the victim. The batterer may psychologically also suffer from depression, which, if severe enough, may lead to suicide. If already an alcoholic or a substance abuser, he may continue these habits as before, or they may become excessive if he is left alone.

Society

Tremendous economic resources are lost as a result of marital violence. Due to the psychological, physical and medical effects of violence, batterers, victims and their families are unable to function optimally. Second, it spurs on the break up of the social institution of the family and increases the number of single parent families (Russianoff, 1981). Third, its long-term consequences on the children reduce the productivity of future generations as well. Finally, violence is linked to symptoms of decay in society, like increased rates of crime and addiction.

TOWARDS LIVING WITHOUT VIOLENCE. CURING THE EFFECTS AND TREATING THE CAUSES

If the WHO's proclaimed goal of the International Year of the Family (1994), that is, 'peace and equality' in the family is to be reached, approaches must not only treat the effects, but also remove the causes of marital violence (Centre for Social Development and Humanitarian Affairs, UN, 1991). As put forth by Mills (1996), interventions planned should be more tolerant of the unpredictability generated by the trauma of intimate violence. There are inherent differences in each battered woman's experience and the survivors' positions often shift. Due to their critical predicaments, they voluntarily return to dangerous situations, withdraw legal charges at the last minute, and choose not to exit from their

marital relationships (Forte et al., 1996). Therefore, empowering the woman may have only temporary and transitional results calling for repeated efforts in its time frames and remedies.

While it is a major achievement for Indian woman activists to have been able to obtain the legal status of a crime for marital violence, an oft lamented fact is that women seldom take recourse to legal action against the batterers. The reasons for this are emotional, cultural and/or financial. The uncertainty, the time factor and the low percentage of convictions have been cited for this reluctance (Ghosh, 1993; Pathak, 1990; Sriram and Bakshi, 1988). The lack of alternatives, concern over family honour and dislike of the idea of subjecting her spouse to arrest or punishment, are some other cultural factors that support the woman's decision to remain in the abusive relationship. Further, women also feel alienated from the criminality oriented legal system. What is needed is a set of multi-pronged humanised approaches focusing action at a personal, familial and community level, as delineated in Figure 10.2.

Combined care from multiple professionals like psychiatrists, clinical psychologists, counsellors, psychiatric or medical social workers, para-professionals like community workers and non-professionals like employees at women's shelters, and friends and relatives could help in intervening with violence. However, it is idealistic to assume the availability of all these facilities and supports. Whether or not the victims and batterers approach and avail of mental health care is determined by three factors: (a) The nature and extent of damage to the psyche and the social self; (b) The availability and continuity of mental health services; and (c) The awareness about and willingness to approach mental health services.

A variety of individual psychotherapeutic or counselling techniques may be applicable for people in situations of marital violence. 'Psycho-dynamic therapy' uses free associations, dream analysis, analysis of transference and counter transference, which may be used with the batterer and the victim to help them gain insight into their psycho-sexual conflicts linked to childhood experiences, which influence their

Figure 10.2
Marital Violence: Approaches to Intervention

Eradicating causes

Preventive educational approaches.
- Curricular changes to ingrate relevant concepts
- Resocialisation: Examples
 - Experimental courses
 - Community melas
 - Prelude to marriage by church.
- Legal awareness and paralegal trainings.

Treating effects

Working with the law
- Sensitisation of enforcement machinery.
 - Police
 - Judiciary
 - Govt. personnel
 - NGOs
- Alternative legal structures
 Eg: Nari Adalat

Supporting the victim
- Crises intervention
- Financial and social support
- Counselling and therapy
 - Individual psychotherapies.
 - Feminist counselling
 - Social skills training
 - Marital therapy
 - Family therapy

Circle of healing (community intervention)

Support to batterer
- Counselling and therapy
 - Problem solving skills
 - Social skills
- Neuro-psychological intervention.

Community Mental Health initiatives
(i) Training to other professionals
(ii) Integration into public health system
(iii) Self-help groups
(iv) Space for mental health professionals in women's organisations

current behaviour. 'Behavioural techniques' may be used with both the batterer and the victim. With the batterer, they help him gain more control over his anger, teach him alternative communication styles and problem-solving skills. The victim can be taught to alter her patterns of behaviour linked with the violence and to help her gain a greater sense of control over her situation through 'assertiveness training' and 'participant modelling'. Special attention is paid to reducing her vulnerability by increasing her confidence and self-esteem. 'Cognitive therapy' can be used with both the batterer and the victim to aid beneficial information processing, to alter their cognitive schemata and to raise their self-esteem. 'Social skills training' involves the identification of deficits or excesses in social behaviour and analysing the context of their occurrence. The batterer has some inherent difficulties in interpreting social behaviour and behaving in a socially desirable manner with his spouse, while the victim apparently loses some of her adaptive social skills due to her unusual life circumstances. Beginning from facial expressions, gestures, postures, interpersonal distance to time and volume of voice, all are taken into account. Through role plays and positive enforcement, socially appropriate behaviours are inculcated (Kaplan et al., 1994). Each episode of violence places the abused woman in a prolonged crisis situation, hence she may require short-term or long-term 'supportive psychotherapy'. Here the victim is given support by helping her to ventilate her feelings, giving reassurance or suggestions and using environmental manipulation until she feels better equipped to carry on with her life. 'Existential approaches' focus on the being of a person and may be used to help the victim find meaning in her existence as well as develop positive values (Spinelli, 1996; Wolberg, 1988). 'Client-centred therapy', developed along Rogerian lines, can be used to heal the victim's self through unconditional positive regard and resolving the conflict between the ideal and the real selves (Wolberg, 1988). 'Family therapy', 'marital therapy' or 'psychotherapy' may be required to restore balance or to treat any family pathology resulting from the violence. Marital therapy can only be undertaken with a therapeutic contract that the violence stops. The couple is then encouraged to

develop healthy patterns of communication and to focus on positive aspects of their relationship. 'Conjoint therapy' involves recognition of the batterer's vulnerability and his dependence on the victim. Independence is encouraged in both the batterer and the victim so that problems related to the dependence are removed (Marano, 1993). If head injury or learning disabilities are involved, the batterer may require special help. 'Neuro-psychological procedures' like cognitive retraining or remedial training may be used. If a serotonin disturbance is present he may require medication for the same (Kaplan et al., 1994).[2] Through 'feminist counselling',

[2] Circle of healing. A unique, humane and holistic framework for healing used primarily for sexual violence by aboriginals from Manitoba, Canada. It has tremendous possibilities for treating the victim, batterer, their families and an effective reintegration for all into society. The 'circle of healing' involves treating the entire community to exorcise the illness of violence through two programmes: (a) A five-day intensive therapy and; (b) A thirteen step process which takes two to five years (MATCH International Centre, 1990). In a special gathering, where members of the community, the victim, abuser and their families are present, the abuser has to acknowledge the crime publicly. Members of the community and the concerned families including the victim speak about their feelings and the community offers their support for healing the abuser. Arrangements are made to protect the victim and the abuser is given a healing contract which involves punishment decided by the community. When the contract expires, a cleansing ceremony takes place to symbolise return of balance to the abuser, the family and the community. At this point the healing is considered complete and the crime is forgotten.

Reincarnation

I used to be alive
till the vermilion was witness
to our footsteps
as we encircled the flames.
It was my body lined with vermilion
that came with you.
But I,
I had walked out of my body.
This empty cage has withered
and now squeaks
under the weight of your abuse.
Mind you, you didn't touch me
Although you thought you did.
Now it was your turn.
You died.

Both body and soul.
My body draped in white
watched the rising flames
without the vermilion.
Would the dried up flood
rise and douse the sparks?
It did not.
And the strange cry you heard
was actually my laughter
filling the air.
Yes, I came alive!
And the vermilion
burned again in my heart
the day you died!

the victim is helped in gaining insight into societal mechanisms leading to her beliefs that she is helpless and that her needs are secondary to those of her family members. She is encouraged to reflect on her own needs and wishes. She is led to believe in herself and to control her own life (Taylor, 1996).

The following steps are suggested to enhance access to treatment, as mental health service delivery in India does not match intervention needs:

1. To integrate mental health services into the public health system so that mental health care is available at most centres for general health.

2. Mental health professionals need to make an active effort to network among themselves and with various organisations providing related services to the community.

3. Women's health workers and women support centres must acknowledge and create space in their organisations for mental health professionals either in full-time, part-time, or visiting capacities. If this is not possible, they need to have an effective referral network so that mental health needs of the batterers and victims are met.

4. Mental health professionals can initiate a second range of services, where, through phased-out training programmes, field workers and other workers devoting full-time to women's causes can be trained to listen effectively, providing initial support and making referrals.

5. Both women activists and mental health professionals must focus on creating self-help groups for women who are facing or have faced marital violence or are facing difficult and traumatic marital situations. This would help to break the pact of secrecy and help experimental sharing without fear of being ridiculed or rejected.

MAKING LEGAL ACTION WOMAN-FRIENDLY

Curative approaches to wife-battering are incomplete without a look at the legal enforcement machinery. The authorities concerned with legal action related to women's issues have had little or no exposure to understanding women or their problems. Women's organisations and departments of women and child development have raised loud voices against their lack of sensitivity, which has resulted in several sensitisation and training courses for police officers, government officials and non-governmental organisations. The courses focus on helping them see events and experiences through 'women's lenses'. In addition, women police cells and vigilance groups have been established to monitor enforcement. A partial change in the quality and time frame of justice has been brought about. Nevertheless, there is still much left to be desired.

The fact that the present legal system proves inadequate for the needs of women is demonstrated by a special initiative undertaken by the Mahila Samakhya, Baroda, which is a Government of India programme for women's equality. In 1994, about 20 km away from Baroda, recognising the widespread violence against women in the area, they set up a Nari Adalat (Dev and Baxi, 1997). The Nari Adalat comprises of tribal women, who along with a group of *sakhis* and *sahyoginis*—working at the grass-root level for the organisation—and other women representatives from the jurisdiction, hold their own positions of power. The purpose of the Adalat is to:

1. Define and view the problems of the women analytically.
2. Bring out latent beliefs and issues to the forefront.
3. Recognise the effects of the problems on women.
4. Find solutions to their own problems, beyond their homes.
5. Give a collective identity and create 'space' for women.

About 40 per cent of the total 325 cases heard in the last two years relate to violence and marital problems. The Adalat

has been fairly successful in finding solutions conducive to the women.

A Case for Prevention

Central to the continuation of marital violence lies the fact that most people tend to treat it in a depersonalised fashion. A variety of notions, such as 'it can never happen to me', 'only alcoholics beat their wives', 'marriage is a solution to irresponsibility and mental illness' or 'that poor woman is suffering for her sins in her past life', make people feel justified in their apathy and indifference. A study conducted on youth and parents in Baroda city showing that less than 30 per cent—only 8 per cent in boys—were aware of the legal provisions against dowry and violence testifies this attitude (Sriram and Mayuri, 1992). The onus of change lies not only on women but more greatly on men. Preventive work, therefore, needs to be targeted at creating awareness, re-educative approaches, and preparation for married life and entry points into the community.

Awareness

The Mahila Samakhya, Baroda organised a paralegal course, using experiential methodologies, in which about fifty women have participated. This course was combined with literacy training. The programme enabled women to understand the following: Women's legal status within the family and society; discrepancies in world views of women and the legal system; discussions on marital violence, rape, sexual abuse—social and legal views on the same; divorce, child custody, property laws and women's rights; attitudes of the enforcement machinery and approaches to setting up alternative models of justice for women. Positive outcomes of the programme have been reflected in three areas: Women's increased awareness about rights and legal issues; increase in the reporting of problems related to violence and greater ease in handling issues with the enforcement machinery. To increase awareness, the role of the university through the Women's Studies

Centres and integrating concerns about violence and legal literacy into university courses may be suggested. The Indian Association of Women's Studies recommended that all universities should implement a foundational course on 'women's issues' for all college students. A sample of university teachers who were part of Sriram and Mayuri's (1992) study responded positively to curricular changes when it was stated that social science disciplines have sufficient scope for integrating concepts of violence and related gender issues. Especially highlighted was the need for interactive activities to facilitate accepting the reality and consequences of violence on the individual.

Re-education

Young people are vulnerable to influences of the television and cinema perpetuating romanticised notions of eternal love and marriage. In a study of personnel in women's organisations and family counselling centres by Bakshi and Sriram (1992–93), a strong need for realistic orientation to adolescents about marriage was emphasised. The study reported that wrong or over-expectations and inadequate coping skills generated violence and maladjustment. Closely linked to this reality is the undue importance given to career or professional achievement, which suggests that family life must always take a back seat. The methodologies used in feminist experiential workshops have proved to be powerful tools to alter mindsets. Extending this methodology to the classroom can yield valuable results.

Preparation for Married Life.
Some Entry Points into the Community

Certain community practices too hold great potential for effective preparation, not only to share expectations but also to promote egalitarian values, moving away from hierarchy and gender stereotyping. For example, the Catholic community in Goa persuade engaged couples to undergo a preparatory course together prior to marriage. Other Indian caste communities (Jain, Marwari and some Marathi communi-

ties) organise socials where group members meet and spend time together. Such forums potentially increase scope for disseminating facts and creating awareness about marital violence.

Attempting to integrate and summarise dynamic facts about marital violence is a challenging task. Some facets have received primary attention and others have only briefly been touched upon. For example, psycho-pathology as a cause of violence, the details of therapeutic procedures, alternative perspectives that have been put forward in relation to effects, legal reforms, etc., have only been listed, and not debated upon sufficiently. We have drawn from activist orientations, but selectively included some perspectives only.

XI

Self-Disclosure in Child Sexual Abuse: Content Analysis of Written Narratives of Disclosure[1]

L. Kavitha Vijayalakshmi and Shekhar Seshadri

Defining Child Sexual Abuse (CSA)

An issue of considerable concern in the large area of women and mental health is the impact of violence against women. While violence and violations occur in many forms, the area of sexual violence is particularly difficult to research. The general area of sexuality as such has never found its crucial location in the dominant public discourse nor in the training and practice discourse in schools/colleges/medicine/the behavioural sciences. Experiences in sexuality, whether positive or negative, are thus processed based on myths, misconceptions, misinformation, social conditioning, pornography and/or skewed media depiction. If one assumes that studying, surveying, understanding and treating sexual abuse relies on DISCLOSURE, the blocks become that much more difficult in the transition from general sexuality to sexual abuse to child sexual abuse. Difficulties in the language of sexuality, knowledge levels, social conditioning and social responses compound the problem for a child. Disclosure cannot occur in the absence of a culture of sexuality discourse and the gender issues that operate therein.

[1] This paper was presented at the National Seminar on Indian Women and their Mental Health, Hyderabad 23–24 February 1996.

Seen in the Indian context, sexuality and sexual abuse are taboo topics. There is widespread discomfort in all sections of society regarding all sexual issues. This attitude prevails across all classes, educational and socio-cultural backgrounds. Even professionals from the behavioural sciences suffer from similar attitudinal inhibitions explaining why this area has remained relatively unexplored so far.

Work in the area of sexual abuse is in its infancy in India. As stated earlier, difficulty in the area of the language for enquiry is a major factor. Furthermore, in a society where even healthy discussion on sexual issues is frowned upon, the knowledge level of children regarding these issues, the nature of certain acts and their social implications can be very skewed. Research so far has concentrated on sexual crimes against women in the reproductive age. A recent survey in Bangalore has revealed a 15 per cent prevalence for sexual abuse, many having occurred at the age of ten years or less. There is hence a need to focus the enquiry on children.

Given the sensitive and 'stigmatised' nature of the problem, disclosure of such experiences becomes central to both identification and formulation of intervention strategies. Disclosure can be as traumatic as the primary event(s). It calls for greater sensitivity on the part of researchers to ensure that a relatively unaffected child does not get affected by the research process and its spin-offs.

This paper represents the initial attempts made by the behavioural sciences to look at the issue of CSA in a systematic way. It also represents the initial but definitive data on the phenomenon. The enquiry itself is located in a larger, networked initiative covering all aspects of CSA. The attempt here is to look at the phenomena of disclosure through the analysis of written narratives collected as part of a workshop series covering sixty college students in Bangalore. The workshop was interactive and hence facilitated discussion and sensitisation on CSA. The qualitative analysis of these narratives has a distinct advantage over quantitative data. It provides insight into the emotional needs as expressed by the women. For the investigator, it provides a strategic location to inculcate the necessary sensitivities in their therapeutic

orientation as well as question their own inhibitions. Overall, such methods provide a window for both respondents and researchers (and similarly clients and therapists, or students and teachers) to then look at the larger and more difficult aspects of CSA.

Definition of what constitutes child sexual abuse vary widely. A general definition of CSA would be that given by Schechter and Roberge:

> [T]he involvement of dependent, developmentally immature children and adolescents in sexual activities that they do not fully comprehend, are unable to give informed consent to, and that violate the social taboos of family role. (Kolvin and Kaplan, 1988)

Sexual abuse is not just a phenomenon by itself but also encompasses the varied psychological disturbances, that range from anxiety to sexual dysfunction to post traumatic stress disorder that follow sexual abuse. Given the complexity of the problem, measures for identification, assessment and treatment of CSA become imperative. For identification of CSA, disclosure of the same by the person victimised becomes crucial.

Self-disclosure is the act of making oneself manifest, showing oneself so that one can be perceived by others. There is probably no experience more terrifying than disclosing any aspect of oneself to significant others whose probable reactions are assumed but not known. This personally terrifying experience becomes all the more so in the context of disclosing sexual abuse, especially in a culture like ours where even a healthy discussion of sexual experiences is frowned upon. Yet, workers in the area of child sexual abuse are left with few alternatives as 'disclosure by the victim' is the crucial stepping stone on which further developments in treating sexual abuse rest. Hence, it becomes very important to study the aspect of 'self-disclosure' and the various factors affecting it in order to facilitate greater understanding of CSA.

CSA is a spectrum phenomenon including exposure, molestation, sexual intercourse and rape (Mrazek and Mrazek, 1985). Estimates of incidences vary according to the definition

used and the population studied. To overcome such variations, Mrazek et al. (1981) screened professional groups in Britain and obtained a figure suggesting that an absolute minimum of three children per thousand could have been abused at some point in their lives. Later studies show that 19 per cent of female and 9 per cent of male college students report having been sexually abused (Finkelhor, 1979), 2 per cent of women raised by biological fathers report sexual abuse by them as against 17 per cent of those raised by stepfathers (Russel, 1984). A recent survey in the UK on prevalence of sexual abuse of adult men and women shows a rate of 27 per cent in women and 16 per cent in men (Finkelhor, 1990). There is a paucity of such information from India which indicates a need for research in this area. The only definitive figures are from the survey of SAMVADA in Bangalore reporting a prevalence of 15 per cent in girls. Though the definitions of CSA and the methodologies used vary amongst these studies, the most striking fact is the high prevalence of CSA.

Inspite of this, the number of cases of sexual abuse brought to the notice of the professionals seems to be low. It is not easy to identify those children who have been abused unless reported by them as there are no witnesses and clear cut physical evidence is not always present. Studies have also shown that there is widespread unwillingness to report abuse (Markowe, 1988). This has probably led to an underestimation of the problem.

It has long been debated as to why there is unwillingness to report abuse, why some children remain silent whereas some do disclose. This aspect of self-disclosure has been extensively studied in the context of psychotherapy. Various factors impeding or facilitating disclosure have been identified. Trusting interpersonal relationships and healthy personalities, amongst other factors, have been shown to facilitate disclosure, whereas fears of rejection, insecurity, etc., have been found to impede disclosure (Derlerga and Berg, 1987). Applying the same theories to disclosure in CSA, various factors like guilt, shame, fear of disbelief, threats from offenders have been implicated in the resistance to disclose (Clark, 1993). Apart from these factors, cultural differences

in the attitudes towards disclosure have also been impli-
cated, for example, virginity being highly valued in girls in
some cultures may actually prevent disclosure, thereby re-
ducing the chances of identification and treatment, but in-
directly helping to increase the morbid sequelae of sexual
abuse. Several methods have been used to facilitate disclo-
sure in clinical and nonclinical situations—like interviewing,
play techniques with dolls, education, etc., whenever there
is a suspicion of sexual abuse. But these methods have met
with limited success.

AIM AND METHODOLOGY OF OUR STUDY

To facilitate the understanding of the vital yet poorly under-
stood phenomenon of disclosure with respect to sexual abuse
and the cultural influences on such a phenomenon, this
study aims to examine the attitude of Indian college women
towards disclosure of sexual abuse and the various factors
that affect disclosure.

The written narratives were collected as part of a series of
workshops and survey conducted by a team working in the
area of CSA. The participants were sixty women students
between the ages of seventeen to twenty-one years, belonging
to various colleges in the city of Bangalore.

The initial part of the workshop consisted of introductory
inputs and discussion about CSA. Following this, the par-
ticipants were asked to write their views on disclosure of
CSA, with assurance of anonymity. The narratives were writ-
ten in response to a priming statement which covered most
aspects of disclosure and was fairly open-ended. The priming
statements were as follows:

- What do you think about disclosure. . .
- Would you disclose. . .
- Would you not. . .
- Why not. . .
- To whom. . . why. . .
- Why do people disclose or not disclose. . .

These written narratives, so collected, were subjected to content analysis and formed the sample of the study.

In this study, the research technique of content analysis (of written narratives from the college women regarding disclosure of SA) was used. Content analysis as a research tool has been used most widely in studying the process of psychotherapy (Marsden, 1971). Schizophrenic communication patterns have also been studied by content analysis and in recent years its influence is spreading to other areas including community psychology. Content analysis is a research technique for the objective, systematic and quantitative description of the manifest content of communication. In other words, it breaks casual communication into more elementary semantic and syntactic structures and calculates frequencies of occurrence.

The sample for analysis may be an audio taped communication which is transcribed and later broken into clauses for analysis or written narratives, for example, suicide notes (Shneidman, 1976). The unit of analysis is often a clause or sentence or even a paragraph but there are no clear-cut guidelines to determine choice of the unit. The categories used for analysis may be predetermined based on theoretical concern or the data may be allowed to generate their own categories by use of statistical measures. In the present study the unit of analysis was the whole narrative and the categories used were 'positive attitudinal', 'negative attitudinal', 'ambivalence', 'facilitative and impeding factors'.

In order to derive the trends in respondents' thinking along the above categories, the whole narrative was analysed by breaking it up into clauses which describe:

1. *Action* : Whether they would or not disclose.
2. *Emotion* : To describe the emotion associated with disclosure. However, on analysing the narratives, it became apparent that some of them described the emotions associated with the act of abuse. Hence this was also included.

3. *Consequence* : To describe the consequence of the abuse and/or disclosure.

4. *Complicating the act (of disclosure)* : Clauses indicating both facilitative and impeding factors were taken.

Having analysed all the sixty narratives under the four categories described above, the results that were obtained are discussed in the following section.

DESCRIPTIVE ANALYSIS

Before discussing the results we have to keep in mind that all sixty students had not covered all the areas in their narratives. The results thus reflect prevailing concerns of the respondents. Significant percentages can, therefore, only be higher.

N = 60

To disclose or not:

Positive attitude	32
Negative attitude	9
Ambivalent	6
Whom to disclose to:	
Friend	19
Mother	9
Sister	2
Cousin	1
Impeding factors:	
Guilt	5
Social threat	12
Rejection	1
Blame	1
Facilitating factor:	
Trust in the person to whom they will disclose:	14

The other facilitating factors coming through the narratives are cells for counselling, education, increasing awareness and increasing parental awareness. Some of them have reported that they would restrict disclosure to either acts of less severe abuse or only to acts of serious abuse like rape. They would also restrict disclosure of abuse only to certain situations and people, for example:

> . . . I would not disclose any incidents to my parents except if it is a major one like rape.
> . . . I disclose only to my friends regarding incidents like eveteasing. . .

Others have reported that they would modify the disclosure for fear of being blamed or fear of social stigma.

Nine out of the sixty respondents made disclosures of their own CSA in the narratives, giving a prevalence rate of 15 per cent. Five of them have reported that they have already disclosed to friends, parents or aunt/cousin. Seven of the nine who made personal disclosures in the narrative had a positive attitude to disclosure, and they report finding relief/ solution to the problem after disclosure. Only one has reported betrayal by the person she had disclosed to. One has not disclosed due to feelings of shame. The narratives do not contain much details regarding abuse. Three of them report to have been abused at a young age. In three narratives, the perpetrator was a family member. In one instance the abuse was by both a family and a non-family person. The abuse episodes appear to be frequent.

DYNAMIC UNDERLYING ABUSE AND DISCLOSURE

The above analysis suggests that the predominant dynamic(s) underlying both abuse and disclosure is stigmatisation—more so in the social context. It appears to be more clear in the context of disclosure. Predominant emotions reported are fear, guilt, shame, frustration and anger. In the narratives, potential behavioural consequences subsequent to the

abuse are suicide, becoming shy and reserved. The emotions of fear, anger, and frustration also reflect the dynamic of powerlessness.

The fear of stigmatisation becomes all the more important in view of the repeated themes of wanting to disclose to '. . . some one you can trust, . . . is understanding . . .'. It seems that this tends to restrict disclosure even to family and friends and also restricts disclosure of serious forms of abuse. It also tends to modify disclosure. Repeated themes of wanting a cell for counselling reflects the need for help (. . . acceptance, . . . and confidentiality. . .). Repeated exclusion of family members or particular family members in the disclosive process suggests the role of the family in stigmatisation (. . . lack of understanding and awareness. . .). These narratives reiterate our prior knowledge on the role of stigma, guilt and shame in the disclosure of abuse and the need to address these issues for facilitating disclosure.

On this basis we propose the following model for the various dynamics involved in abuse and the factors which influence disclosure, as also the various stages at which professionals can intervene and help (see Figure 11.1). From this model, it appears that the feelings of guilt, shame, frustration and anger can influence disclosure adversely. At this stage, both intervention and prevention can be tried to help the abused persons understand and cope with their feelings. This can be attempted through educating children about sexual abuse, what 'good' and 'bad' touches are and sensitising them to such situations. Also, efforts have to be made to enhance their awareness about who potential sexual abuse offenders might be, especially that such abusers might include people whom they may know well and like. Children can also be taught to take action in the event of some such abuse and disclose to someone they trust. Workshops need to be tailored according to the children's changing levels of sophistication, their knowledge of the world and sexual behaviour. Though these are primarily preventive, they can become interventional especially when the groups addressed include some victimised children. In such a situation, these prevention skills could be an excellent vehicle for restoring their sense of power, security and self-esteem.

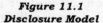

Figure 11.1
Disclosure Model

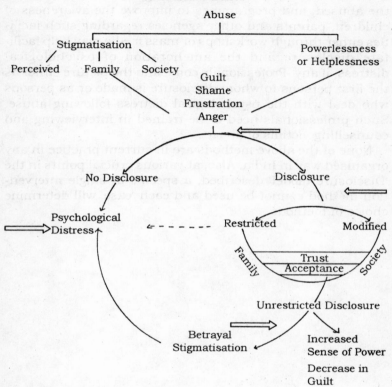

In addition to workshops which increase awareness and impart prevention skills to children, workshops geared towards improving awareness amongst parents, important sections of the society who are likely to be in contact with (abused) children like teachers, physicians, police, etc., are necessary. Such workshops can deal with the issue of stigmatisation, the need for fostering trust, acceptance when a disclosure is made, the need of the abused child for respect and sensitivity from others, and the importance of the above in facilitating disclosure which is the most essential stage

leading to both intervention and/or prevention. Establishment of 'helplines', 'cells', counselling centres especially for the abused, and programmes to improve the awareness of children, parents and other agencies regarding such facilities either through workshops or mass media may help facilitate disclosure and the amelioration of psychological distress, if any. Professionals come into the picture either as the first persons to whom disclosure is made or as persons who deal with the psychological distress following abuse. Such professionals need to be trained in interviewing and counselling victims of abuse.

None of the above methods are in current practice in any organised way in India. Also, at various crucial points in the 'Disclosure model' described, a specific or single intervention method cannot be used and each 'case' will determine choice of methods.

APPENDIX 11-A

Narrative No. 1

You can disclose about the private matters only to the 1
person whom you can trust or can help you to come out from the 2
problem. Disclosure helps a person a lot, i.e., mentally. People 3
keep away from all this as they are scared whether their 4
private matter what they underwent will become a matter for 5
everybody to discuss (backtalk) and look down upon you and, 6
etc. The others won't try to understand your problem instead 7
they'll talk bad about you. But when you don't disclose, it 8
stays in your mind forever and even one would have had full 9
consent in these things but later realise that it was wrong, so 10
conscious pricks your mind that you've done something wrong. 11
Disclosure is helpful only if you trust the person whom you're 12
disclosing it or how he takes the matter or helps you. . . 13

Narrative No. 2

This can not be disclosed sometimes even to our parents, 1
as we feel that a stigma is attached to us, because our society 2
is very crude. Our society is not broad minded and we feel it 3
will never develop. To an extent we do tell our parents, but 4
not very deep into it. Because we feel guilt that they will 5
develop bad impression or negative impression on us . . . 6

Narrative No. 3

Personally speaking, eve teasing or the disclosure of 1
abuse is helpful to a very large extent. The problem lies in 2
to whom do we disclose. I have disclosed my experiences as 3
such with a close cousin and an aunt, who have helped me out of 4
the feeling of 'guilt' so, I really feel that disclosure can be 5
done, if we really have faith in the person. I felt better when 6
I did so. 7

Analysis of the Narratives: No. 1

First-level derivatives:
Action: '. . .can disclose about the private matters. . .' (1)
Emotion: '. . .as they are scared. . .' (4)
Consequences (regarding abuse or disclosure) –
'. . .helps mentally. . .' (3)
'. . .stays in your mind. . .' (8)
'. . .conscious pricks. . .' (10)
Complicating the act:
'. . .only to person whom you trust or can help you
 come out. . .' (2)
'. . .will become a matter for everybody to discuss. . .and (5)
 look down upon you. . .' (6)
Second-level derivatives:
– Positive attitudinal
– Conditional on trust
– Impeding factor of 'social fear'
– Facilitating factor of 'being helped mentally'.

Analysis of Narratives: No. 2

First-level derivatives:
Action: '. . .cannot be disclosed. . .' (1)
 '. . .we do tell our parents. . .' (4)
Emotion: '. . .we feel guilt. . .' (5)
Consequence (regarding abuse or disclosure)
'. . .stigma is attached. . .' (2)
'. . .will develop bad impression or negative impression
 on us. . .' (5, 6)
Complicating the act:
'. . .because our society is very crude. . .' (2, 3)
'. . .is not broad minded. . .' (3)
'. . .we do tell. . .but not very deep into it. . .' (4, 5)
Second-level derivatives:
– Negative attitudinal
– Restrictive disclosure to parents
– Impeding factors of 'social stigma',
 of 'guilt'

Analysis of Narratives: No. 3

First-level derivatives:
Action: '. . .I have disclosed my experiences as such with a close
 cousin and aunt. . .' (3, 4)

Emotion '. . .feeling of guilt. . .' (5)
Consequence: '. . .have helped me out of the feeling. . .' (4, 5)
 '. . .I felt better when I did so. . .' (6, 7)
Complicating the act: '. . .If we really have faith in the
 person. . .' (6)
Second-level derivatives:
– Positive attitudinal
– Has disclosed to aunt and cousin
– Conditional factor trust/faith
– Reason for disclosure—relief

XII

CHILD SEXUAL ABUSE AND SOCIAL FACTORS PREVENTING DISCLOSURE: ADOLESCENT GIRLS' NARRATIVES[1]

Rinchin and Shubhada Maitra

One of the first writings to examine the issue of child sexual abuse (CSA) were from the field of psychiatry. Freudian psycho-analysis explained CSA in terms of the theories of infantile and child sexuality and the theory of the oedipal complex. Thus, cases of CSA were viewed not as cases of sexual violence but as the victims' 'infantile feminine fantasy'. This theory dominated psychiatric thought till recent times, asserting that CSA was very rare, and if it ever really happened, it was at the instigation of the 'highly seductive child' (Waldby et al., 1989). In the available literature on dysfunctional families, CSA is not 'the' problem, but rather something that points towards the more serious problems of broken and unhealthy family relations (Waldby et al., 1989; Renovoize, 1991; Ward, 1991). The humanistic perspective on CSA shows a compassionate understanding of both the offender and the victim. The problem is viewed in the context of unfulfilled needs and deprivation, and the tabooed sexual relation is seen as a search for warmth, comfort and security. Feminism sees CSA as the exploitation of the vulnerable in society, rising out of the existing power inequality (Driver,

[1] *Credits*. This paper is part of an M.A. dissertation (Rinchin, 1997) which would not have happened without the support of the school authorities of Modern High School, Lucknow who permitted the data collection, and above all, the girls who participated in the study.

1989). The feminist literature becomes relevant as it looks beyond the individual and family, and views it in a social context. The moral blame is placed firmly on the offender as well as on the social belief system that fosters sexual violence against women and children. CSA is to be viewed along the same continuum of sexual assault, wife battery and other forms of oppression against women.

OUTLINING A STUDY

This paper has emerged from a study conducted (Rinchin, 1997) among two groups of school going girls in the age group of 12–18. The main objectives of the study were:

1. to explore the adolescent girls' definition of CSA,
2. their understanding of CSA, and
3. the prevalent myths and misconceptions about CSA among them.

The study aimed to examine the adolescent girls' understanding of CSA. It endeavoured to explore the common perceptions, knowledge and values attached to the issue by a group which, by the virtue of their age, is most likely to be affected by it. The respondents were Hindi or English speaking, and belonged to the middle and upper middle class. They were divided into Group A and Group B of twelve girls each. Group A composed of girls between the ages 12 and 14 and Group B composed of girls between 15 and 18 years of age.

The objectives of the study called for data which may not have been easily recalled by the respondents, and as the researcher was unsure of the amount of prior knowledge among all the girls, specific interview questions could not be framed. Also, focus group discussions seemed the most appropriate tool of data collection. It was felt that when the respondents talked in a group, they would take strength from each other about their emotions in relating to a phenomenon which affected all of them. The group work would facilitate a spontaneous association and flow of ideas, bringing up thoughts that probably would not have been brought up without a

discussion. The discussion also gave the researcher an opportunity to feel all that a group feels through the different stages of the discussion. One could see statements being accepted or rejected, new myths being formed and others being shattered.

A series of discussions were conducted through various sessions. Each session dealt with one aspect of the subject in detail. The sessions were meant to be spontaneous, but a group discussion guide was prepared with broad themes and sub-themes. Keeping in mind the sensitivity of the topic and the fact that it was not a topic or issue that the respondents would talk very easily about, the first session had exercises which aimed to make the girls comfortable with issues of sex and sexuality. Being aware that the girls were of an age where they would not be able to maintain long, abstract or theoretical discussions, games and exercises were used to keep the sessions interesting, as well as generate information.

SESSION OUTLINE:
1. Defining one's own self and sexuality
2. Defining abuse
3. Abuser profile
4. 'Vulnerability'
5. Effects of abuse
6. Strategies for intervention (within school/family/society; working with abused children; working with abusers)

The data were collected in the form of recordings of the entire series of discussions in nine, 90-minute tapes. After transcribing the data verbatim, they were divided into broad themes. Though the discussions were planned theme wise, there was a lot of overlap in linking data to various themes.

DEFINING ABUSE

Most of the work being done in India on the issue of CSA is by organisations and people working for the cause of violence

against and oppression of women. The feminist movement looks beyond just women's issues and takes into its purview any kind of exploitation rising out of power inequality. Therefore, it talks of the abuse of both boys and girls. Though both are vulnerable, studies show a gender difference in the phenomenon. A survey of the American Human Rights Association's Children's Division (1969) showed that 92 per cent of sexually abused children were girls and 97 per cent of the abusers were men. The UNICEF 'State of the World's Children Report' (1997) states that girls are more vulnerable than boys. In India, Sakshi's (undated) report states that two out of four girls and one out of six boys are abused sexually. Samvad's study (Ganesh, 1994) revealed that 83 per cent out of a sample of young girls had experienced some kind of sexual harrassment. Sehgal's (1996) study showed that a child becomes more vulnerable with continuous abuse. The abusers were in most cases from the immediate circle or were familiar to the child and her family, and were male. Lack of family support to the child and indifferent or strained family relations were present in most cases. The effects of abuse in these studies ranged from sadness, depression, anger, mistrust towards men, shame, guilt, feelings of low self-worth and esteem to suicidal ideation.

Researchers have operationalised the definition of CSA in different ways. Therefore, the major prevalence studies differ because of the way CSA has been defined in terms of the 'act,' and the ages of the child and the perpetrator. The legal definition of CSA in India is 'the sexual penetration of a child below 16 years'. Such a definition would not include the acts described in the following narratives:

At night on the road a man kicked me on my back. I have always thought of it as a sexual attack. I was kicked by a man because I was a girl walking on the road at night. All my life I have felt it had sexual connotations, how could it not?

Another recalled being made to sit on her uncle's lap where she could feel his erect penis and being asked if it felt good. She defined CSA as a negative sexual experience which has

had a life long impact in terms of her feelings towards men and a difficulty in establishing trusting relationships with adults.

While talking about their negative sexual experiences, the girls spoke of men passing lewd comments, stares, cat calls, dirty phone calls, and abuse through physical contact like feeling, pinching, rubbing their genitalia against them, etc. But when asked to define CSA, the girls used terms like 'molestation,' 'rape,' 'forcible intercourse', etc. This understanding was probably derived from media reports. When spoken about in such objectified terms, CSA seemed like a gross, freak and strange phenomenon which happened to other people, not to them. The girls did not connect CSA to the experiences that they had themselves narrated ('being pinched', 'being given unwanted attention by the bus driver', being touched by a brother's friend', 'being followed on the road', etc.) They talked about being abused all the time, but they did not consider these as abuse.

> These things are so common that we don't think of it as SA, but everytime something like that happens, it leaves us feeling dirty and upset.
> When I tell my mother about being bothered by remarks people make on the road, she tells me to forget it because these things happen.
> What can we do about these things? Nothing can be done. . .

These views bring about a passive acceptance of the so called 'normal' experiences which girls and women go through. By ignoring or trivialising these incidents as 'common place' events without any name, we overlook the fact that women and children get sexually insulted as a part of the power inequality that exists in the society. By identifying only acts like rape and forcible intercourse as sexually abusive, we manage to distance ourselves from the fact that it happens to us all the time in many different ways. This trivialisation has also prevented society from accepting CSA as a rampant phenomenon and from beginning to examine the existing system that allows it to happen.

Most of the literature on CSA also emphasises the intentionality of the act. 'Any sexual act with intention of sexual gratification is termed as sexual abuse' (Sakshi, undated). But the girls characterised the act not only in terms of the intention of the perpetrators, but also in terms of the feelings that the child attached to it. Acts like putting arms around the shoulder, hugging, kissing, etc., are acts accepted by society, but the child might be uncomfortable. The girls talked about not liking a particular touch while not minding another touch.

> If a child says I don't like this hug and the adult had no intention and stops the hug then it is not CSA, but if the person continues the hugging and kissing then it could have a negative impact and the child may feel that there was a sexual intention, that would be abuse.

The narratives show the importance of respecting the child and her control over her own body. Not respecting the child's dislike and continuing with an unwanted hug or kiss violates the child's right over her body and gives the person undergoing the experience an occasion to define for herself what is sexually abusive. The girls also talked about the right to re-examine an incident in the past and define it as sexually exploitative. 'I may not have understood it then, but now I feel dirty, that the person touched me like that, that time I didn't know'. What emerges strongly from the above narratives is that sexual abuse needs to be defined not just in terms of the act, but in terms of the feelings attached to the act by the child. These feelings include both the intention of the perpetrator and how the child perceives the act. Defined in this way, a whole range of other behaviours would have to be included under CSA which are not in the legal definitions.

In the available literature, the age of the abuser is also a parameter to define CSA. In the literature CSA has been operationalised as any sexual act between an adult and a child, where there is an age difference of 10 years or more. This definition excludes abuse by someone who is of the same age or only a little older than the child. The girls talked

about incidents when they were abused or sexually threatened by boys of their own age or a little older. One girl even reported an incident when the perpetrator was a younger boy. 'Boys are physically stronger than us. . .'

The girls talked about not just the power that comes with age, but also about the lopsided gender equation which influences the perception and the threat of abuse.

Defining abuse: Any act that the child perceived as a negative sexual act, done with or without the child's consent. *Forms of abuse*: Unwanted hugging, kissing or petting; Passing comments, cat calls, staring; pinching, feeling or touching private body parts; making crank calls on the phone to talk sexually; sending dirty mail; following the child on the road; talking to the child about sexual acts; viewing pornographic material with the child; exhibiting genetalia or making the child do so; rape, forcible intercourse. [Abstracted from the statements of the girls in the study].

FACTORS INHIBITING DISCLOSURE

In an environment where it is not considered appropriate for girls to have any kind of sexual knowledge and boys are expected to be sexually aware, it becomes extremely difficult for girls to deal with any kind of sexual advance or threat by someone even of their own age because of the scare of being labelled as the 'type' who attracts attention or thinks that 'every boy is after her'. The girls talked about their embarrassment in discussing sexual issues whereas boys did so openly.

Even teachers in schools ticked off girls who were vocal for being 'overfriendly,' 'loose' or 'forward'. This researcher had requested the school authorities to randomly pick girls who fitted the respondents' profile for the study. During the discussions, the researcher found the girls' behaviour and understanding quite appropriate to their age and cultural context. It was only later learnt that the girls had been selected by the teachers on the basis of their being seen as more vocal, 'forward' and 'conscious' of the opposite sex.

Therefore, in the teachers' perceptions, they were more vulnerable to SA! Defining vulnerability in such terms places the onus on the victim rather than on the abuser. Instead of asking 'Why did he do it?' or 'Why do such things happen?', the question becomes 'What is it about her?', 'Why does it happen only to her?', etc., leading to labelling her as 'being *like that*'.

The group defined the 'risk' of abuse as all pervasive and strongly emphasised that the attributes of the child did not play an important role in increasing or decreasing the vulnerability of the child. Though the girls hypothetically agreed that more confident or vocal children were at a lesser risk, it was contradictory to their accounts of their own reactions to any kind of sexual harrassment. 'I was walking and this man pinched me. I froze. . . . Later I felt so bad about it that I did not tell anyone. . .' The group discussed 'vulnerability' at length, and about why girls don't disclose abuse.

Social Hierarchy

The total dependence on adults and a hierarchical culture that demands unquestioning respect for elders prevents disclosure. Even during the discussions, most girls were extremely uneasy about admitting that many close adult relatives were not sensitive in understanding their feelings. There is also the fear of not being believed or appearing ungrateful.

He did bad things, he was very old. . . . I was small, I did not know what to do. . . For all our problems, we go to the grown ups, but if they do this us, who do we go to. . .

Value on Innocence

Innocence is a prized attribute in a girl child. The girls insisted that they knew very little about sexuality. 'We don't know anything. . . .' 'If we tell our parents that we are thinking of all this they will think that our minds are dirty. . .' Children are supposed to be sexually ignorant, and the girls had to pretend that they were even more so. While reacting to anything that was explicitly sexual, the girls had to feign

ignorance while boys were always more open. This prized innocence is yet another fact that prevents disclosure of abuse. The parents preferred not to recognise the girl's sexuality and encouraged a lack of knowledge by suppressing or ignoring any awareness that the girls had about sexual acts. The stigma attached to the 'knowing' child forced her to keep quiet about the abuse, thus allowing the abuse to continue.

Victim-Blaming

The practice of victim-blaming was the main deterrant to disclosure. When sexually harrassed, the primary feelings in the girls were of embarrassment, shame and guilt. They were unsure of the response they would get from their families, leading them to keep quiet. They chose to remain silent because of the fear of being told that 'it's all in your mind'.

> When I am walking with someone like my brother or father and someone says something cheap, I feel embarrassed that because of me they have to hear all this.

Female Submission vs Male Aggression

'The characteristics of a woman are her beauty, smile, care, grace and her silence. We have a certain beauty and physique which is unique and because we are dominated by men, we are quiet.' While, how the girls perceived sexual abuse was important for the study, it was equally important to gain an insight into how they viewed themselves. Being aware of the norms of society, they had adjusted their own behaviour to conform. Any effort to move away from their defined roles was treated as rebellious behaviour and thwarted by disapproval, ridicule or rejection from the parents and other elders. 'When I told my mother that I will not wash my brother's clothes, she said I was selfish I was hurt, it is not that I do not love him or do not want to love him but why hasn't he asked to ever do this for me.' Girls are socialised as caregivers, homemakers, the ones who bear all injustice with silence, 'the essence of sharing and giving',

while men learn to accept love, attention and passive acceptance from women as their right, and when not given all of these, take by force. 'Boys don't realise what they are doing [abuse] is wrong, for them it is just fun.' 'All they care is about their fun and satisfaction, they don't care about the other person's feelings. . .' The perception of feminine characteristics [grace, submissiveness, etc.] were in relation to their perception of masculinity as competitiveness, intelligence and aggression. Though the girls resented this stereotyping, they also seemed resigned to it. Thus, sexual abuse becomes a part of the social framework where male superiority is a part of gender socialisation, aggression is identified with male sexuality and being a man means to be sexually experienced. A passive acceptance in women is built in by the parents and elders, especially the older women, telling them to ignore the incidents of abuse and accept them as part of their lives as women. 'A girl can deal with abuse better than a boy because we can bear and take much more.'

The Social Status of the Abuser

'We cannot judge anyone, one can never make out that this person may have done anything like this [abuse] to someone else.' The experiential literature has shown that most abusers have been 'respectable' members of the society, nice and polite to others, while abusing one or more children. Such qualities make it much more difficult for the child to speak out against the abuse. From the narratives of the girls, it emerged that it was comparatively easier for them to complain about an abuser who was from a lower socio-economic status than them, or when they were not alone in experiencing the abuse and could make a collective complaint.

> The bus driver used to sing dirty songs and look at us, we complained to the principal and he was sacked.
> My brother's friend keeps touching me, hitting me, his hands are all over my back. I've never told him not to do it directly but always removed his hand to show that I don't like it. I've never told my mother or brother about this. They like him. My mother won't understand.

Here the abuser is from the same socio-economic class and
a well-liked friend of the family. In such instances where
disclosure can disrupt family relations with the abuser, the
child is under pressure to maintain silence and tolerate the
advances as there is the fear of being disbelieved.

ABUSER PROFILE. MYTHS AND FACTS

Mostly poor and uneducated people do this [abuse].
These people [abusers] are mostly strangers, who try to
get to know us by asking questions.
Our parents don't allow us to go out alone at night be-
cause it is not safe for us.
Mostly strangers do it, because they can't recognize the
face.

It was more difficult to accept that the perpetrator could be
a close relative. The abuser was usually a neighbour, school
bus driver, skating teacher, classmate or brother's friend.
Stranger abuse was in the forms of periodic pinching, feel-
ing, cat calls and threats. Though some girls admitted that
'people we know' can be abusers, it was not openly accepted.
'My mother never lets me sleep together with all my cousins,
she keeps me with her.' 'In marriages where there are a lot
of people one has to be careful.' While these statements sug-
gested otherwise, the girls talked of their cousins, brothers
and other relatives as their protectors. 'A brother will always
protect his sister.' Tying rakhis and calling boys 'brother',
according to the girls, was a common practice to ensure
immunity to harrassment from them. This was specially
strong among the younger girls while the older ones were a
little sceptical about these 'rakhi' brothers. Overall, there
was a resistance to the thought of abuse by the brother and
some suggested that only a 'mentally retarded' or a 'brother
in bad company' could abuse his sister. The girls admitted
to having read print media reports of fathers abusing their
daughters but said that these were only freak cases and did
not happen often. 'It is a little difficult to believe that for his
own satisfaction a father might do it [abuse sexually] to his

own daughter.' 'A father might do it to his elder daughter if his wife is not there.' These views (the father's unfulfilled sexual needs, wife's absence, etc.) rationalise the act of abuse, while showing acceptance of the father's social power over his daughter for sexual satisfaction. They are in effect saying that a 'normal father' under 'normal circumstances' would not abuse his daughter. (It is important to note that among all the girls, there was only one who stayed alone with her father and she vehemently opposed these rationalisations). Recent findings however show that even men who are 'served by their wives' abuse their children (Bagley and King, 1990). During the course of the discussion, the girls reluctantly admitted that fathers could abuse their daughters, but could not identify these men with any that they knew. In an environment, where the family is considered to be a sacred institution and the child fully depends on it for all her physical and emotional needs, the fact that a relative—particularly a father or brother—could abuse is frightening and discomfiting.

Through the discussions, the girls refuted some myths but held on to some others even though some of their own experiences and prevention strategies suggested otherwise (see Table 11.1). By strongly maintaining that strangers and poor uneducated people abuse more and close relatives do so only rarely, they created a false sense of security for themselves. It would be frightening to believe that people who they meet everyday, depend on, love and trust could abuse. By classifying an unknown set of people of a certain class as abusers, the girls distanced themselves from a scary phenomenon. This can also be seen as an attempt towards maintaining a sense of normality in the society. Openly accepting that abusers could be people close to us would mean accepting that there is something fundamentally wrong with the whole societal framework and belief system.

SUGGESTIONS FOR INTERVENTIONS

Responding to the strategy of surveillance as a method of preventing child abuse, the group felt that to keep someone

Table 12.1
Myths about CSA

Myths Maintained	Myths Refuted
1. Poor people abuse.	1. Child sexual abuse is a rare phenomenon.
2. Child sexual abuse happens more in rural areas.	2. The child invites abuse.
3. Mostly strangers abuse.	3. Only acts like rape and forcible intercourse constitute child sexual abuse.
4. Blood relatives like fathers and brothers rarely abuse.	4. Abuse happens only in dysfunctional homes.
5. A father will abuse his daughter only in the absence of his wife.	5. All child abusers suffer from 'mental illness'

confined to the house and being very strict would only make the child scared, submissive and therefore more vulnerable. Further, confinement would be beside the point if the abuse happens within the house, as is often the case.

How can you keep an eye on her always. . .it is more important to behave as her friend. . .tell her what is right or wrong, to see that she trusts the adults enough to tell them everything. . .also to tell her that if anything happens to her, she should protect herself, not keep it to herself, but tell her parents about it. . .
If they [the parents] show confidence and trust in us, tell us about the dangers and help us cope, but still let us go out we will be more confident.

The narratives highlight the importance of building the child's own resources and encouraging her to speak up, by establishing an open and trusting relationship. Openness, knowledge, information and confidence in the child would help in reducing the 'risk'.

In issues concerning sexual and violent assaults, society has always adopted a stance of confining people (women and children) under threat, undermining their freedom. By making restrictive rules, in cases where the rules are broken by the child, the blame shifts from the perpetrator to the survivor. 'Our parents tell us not to go out, if we insist

and anything happens, they will say, "see, we told you not to go. . .'". The group expressed a need for the parents to make an effort towards creating in the child an awareness and full understanding of issues concerning them, to create an alertness, and encourage her to speak up if she feels uncomfortable or violated. The preventive programmes for CSA should include parents, elder siblings and teachers. They must be made aware of the threat of CSA and be able to pick up and link any telltale signs for the detection of abuse. This, along with an open parental relationship would go a long way in preventing and dealing with abuse.

Some of the suggestions for intervention within the family and the school were:

- A parenting style which was less authoritative and involving the child in the process of forming rules which are based on a rationale.
- Recognising the child's sexuality and satisfying her curiosity on issues related to sex and sexuality.
- Changes in the school education programme.

In order to make the education programme more relevant, it must go beyond giving didactic information about the reproductive system and pubertal changes. There is a need to explore the emotions, feelings, and beliefs attached to these issues intertwined with moral issues, religion and cultural value systems and norms.

There is a need to include teachers and other staff to sensitise them to issues related to sex and sexuality. It is important to bring about a change in their own attitude towards the issue. Maintaining a puritanical stance will only suppress the child's sexuality and isolate her. One of the main drawbacks about the existing programmes was the segregation of boys and girls and targeting most preventive programmes towards girls. Involving boys and girls together in the discussions on these issues would lead to a healthy and open understanding about the opposite sex. There was also a suggestion of focusing on people (men/boys) who abuse or can abuse; educating them about the harmful effects of abuse, projecting it as a violative act which impinges on the

liberty and dignity of another person. A sensitivity to feelings of children and girls needs to be developed. The phenomenon of CSA has its roots in the whole socialisation process and does not exist in a vaccum. As long as those in power continue to believe that the less powerful are commodities to be used, the threat of abuse will remain.

XIII

SEXUAL VIOLENCE AND MENTAL HEALTH: CONFRONTING THE PARADOX OF THE 'GUILTY VICTIM'[1]

Kavita Panjabi

THE GUILTY VICTIM

A central paradox that characterises a woman subject to sexual violence in many cultures including India is that of the 'guilty victim,' both with society declaring her guilty of a moral flaw and with the woman herself feeling guilty of complicity or even provocation. The mechanisms of both, this external imposition of guilt and the internalisation of it become clearer if we see them in the light of a woman's identity. Rose, in her essay 'Femininity and its Discontents,' argues that

> [t]he unconscious constantly reveals the 'failure' of identity. Because there is no continuity of psychic life, so there is no stability of sexual identity, no position for women (or men) which is ever simply achieved. Nor does psychoanalysis see such 'failure' as a special-case inability or an individual deviancy from the norm . . . there is a resistance to identity that lies at the heart of all psychic life. Viewed in this way, psychoanalysis is no longer best understood

[1] An earlier version of this paper was presented at the National Seminar on Indian Women and their Mental Health, Anveshi, Hyderabad, 23–24 February 1996.

as an account of how women are best fitted into place Instead, psychoanalysis becomes one of the few places in culture where it is recognised as more than a fact of individual pathology that most women do not painlessly slip into their roles as women, if indeed they do at all (Rose, 1990: 232).

Rose helps us to open up the space between different notions of identity—'between the idea of a political identity for feminism (what women require) and that of a feminine identity for women (what women should be)' (Rose, 1990: 240). The social demands of the latter, the social construction of what a feminine identity should be, make women vulnerable to internalising guilt, whereas the former, the feminist identity that addresses the needs of women, makes it possible for them to deal with both the superimposed and the internalised guilt. Thus therapy,[2] if it is to be genuinely effective, has to set up a sensitive dialectic between the two forces shaping identity, the social demands on women, and their (women's) internal needs that require fulfilment in order for them to lead a healthy psychic life.

This is however not always the case, because the emphasis within our mental health profession is largely on the normative approach. *Therapy that is founded on the function of normalising in contexts that are dominated by patriarchal norms focuses on the functional integration of women* with a

[2] I would like to clarify here that this analysis is based on years of close interaction with women friends who have experienced sexual violence; my participation in sexual violence workshops in the Indian Women's Movement; and my work in women's studies on gender violence, and in comparative literature on narratives of women in political struggle. I am also grateful for the exposure to Dr Shekhar Seshadri's outstanding work, of which he presented an account at the Seminar and to discussions on therapy with Dr Biswajit Sen. These have to some extent helped me restructure this paper in my efforts to communicate across disciplines to the mental health professionals. My discussion of and suggestions for therapy have been presented here not as comments on the existing state of affairs in the field of professional therapy, which in any case varies from one practitioner to another, but as an articulation, from a gendered perspective, of what women need.

patriarchal society that often deflects the possibility of a genuine healing based on women's reason and values, and their sense of morality, which might be different from the men.[3] Hence, it becomes crucial to address the dialectic of identity, in turn, through a genuine dialectic set-up between the cognitive and the normative approaches in therapy without emphasising the latter.

Further, therapy is usually viewed in terms of treatment or curing rather than healing and empowerment. Here, I would like to emphasise the importance of healing as the goal of therapy rather than treatment or curing; for while curing can also mean (according to Webster's dictionary) 'to free from something objectionable or harmful,' or, 'to restore to normality,' healing goes much deeper. It is more than mere relief from that which is harmful and cuts beyond the restrictions that the demands of normality impose upon character; it is empowerment in the sense that it restores a person to a sense of her integrity and power, and to a sense of wholeness based on the validation of her reason.

One has to also take into account that violence is a sign of a power struggle for the maintenance of a certain kind of social order. And *sexual violence against women is not so much a question of sexuality as it is of political power*, both patriarchal and other, ranging from domestic violence to the violence of state power, that often appropriates the existing patriarchal ideology to control women's minds, bodies, and psyches.

From the testimonies of female political activists too it becomes evident that gender violence is not just about sexuality; it is about patriarchal power and often involves the complexities of other forms of political oppression too. Thus, therapy for women who have been subject to gender violence cannot be based on the deployment of sexuality alone.

[3] It needs to be clarified here that my stress on *women's notions* does not imply any form of essentialism whatsoever. Rather, it emphasises the importance of understanding notions of reason, identity, morality, etc., within the specificity of the context and in this case, the contexts within which women function.

A healing process that can restore to women their sense of wholeness, integrity and power would have to take into account the nature of the nexus between patriarchy, the family, other forms of politics and sexuality in the enactment of gender violence. *Therapy has to address sexuality and its outside, that is, the socio-political contexts within which it is deployed.*

GENDER VIOLENCE. PROBLEMATIC SOCIAL AND PSYCHOLOGICAL APPROACHES

Taking to task psychological theories of violence that are built up as an axiom of human biology and the claim that 'men aggress, and men aggress sexually because they are made that way', Davar asserts:

> This theoretical privileging of aggression and sexuality as the primal instincts gives an important mileage to cultural domination by patriarchy, vindicating the use of violence This view of violence and sexuality as instinctual validates the large scale sexual violence against women (Davar, 1995b: 13).

Violence, which is viewed as instinctual, in fact works at two levels, that of the instinct and that of the idea, and there is no rational or causal connection between the two. This becomes clearer if we take as example the popular perception of rape as 'victory' over the raped woman. It is important to recognise here that bodies in themselves do not give knowledge of victory or defeat, and there is nothing in the biological act of the penetration of the woman's body that designates it as victory. As Freud stated in 'The Unconscious':

> An instinct can never become an object of consciousness—only the idea that represents the instinct can. Even in the unconscious, moreover, an instinct cannot be represented otherwise than by an idea (cited in Mitchell, 1990: 198).

And as Mitchell emphasises, 'There is never a *causal* relationship between the biological urge and its representative' (ibid., my italics). The subjective notion of victory in this case is a social construction of a sexual act, and it is a construction grounded in unreason. And far from being designated as madness, or even abnormal, this construction of unreason i.e.,

raping: victory :: being raped: defeat

unambiguously reveals the systematisation and regulation of sexuality towards patriarchal ends from the very moment in which knowledge begins to take shape.[4]

Three of the common responses that women have towards rape are—guilt, based on the possible complicity or even provocation on her part, a sense of social shame and powerlessness. The sense of social shame is difficult to do away with in therapy because it has as much to do with society's perception of the act, if not more, as with the woman's own perception of it. The sense of guilt and powerlessness, however, can and should be transformed through a self-enabling comprehension of the situation. This comprehension of the situation, the motivation behind the rape and a critique of the patriarchal politics of rape is a crucial factor in helping restore the woman's sense of integrity, self-worth and confidence required for taking the appropriate action as an active agent, or in other words, in helping restore her power of agency.

The notion of the guilty woman derives from the popular perceptions such as 'she desired to be raped' or 'she enjoyed it'. What is dangerous is that instead of working towards erasing this sense of guilt, some analysts too actually evade the issue of violence and power and advocate a 'domestication

[4] c.f. Foucault's *The History of Sexuality* (1980b) for analyses of the ways in which our identity and our subjectivity are intimately linked with our sexuality through representational practices. His *Power/Knowledge* (1980a) addresses the processes through which power and knowledge are produced in language, and institutionalised in the social, cultural and political realms.

of rape' as 'not *that* different from ordinary sex' (Forrester, 1986: 83). Beginning with the token gesture of acknowledging the issue of consent and hence power, Forrester then proceeds to completely wipe it out of his proposal for healing by reducing the act of rape to seduction:

> Wherever there is desire, there will be doubts as to rape . . . we now see why psychoanalysis speaks to seduction and love rather than rape: in the Freudian universe there is no zero state of desire, there is always *some* desire (even if it manifests itself as horror) A rape victim might well wish to take the chance offered by psychoanalysis of thinking her way into the unthinkable But the risk will always be that the rape will turn into seduction as she discovers that, to quote one rape victim trying to come to terms with her experience, 'it's not *that* different from ordinary sex'. The domestication of rape, like the domestication of mourning, may well lead to a healing in which the moment of non-consent is filled in, in a reassertion of omnipotence . . . (Forrester, 1986: 83).

The danger of such a position is that it denies the power play inherent in seduction and then virtually suggests the equating of rape with seduction, hence, circumventing the issue of power altogether. Moreover, in such an approach, rape again becomes an issue of desire, of 'normal sex', rather than that of consent. In fact it goes right back to the suggestion that 'she desired it', thus insidiously placing all responsibility on the woman and completely absolving the rapist of all culpability. Such a process could only reinforce guilt rather than assert omnipotence. Thus, there is a need for establishing not just a gender-sensitive approach, but a fundamental re-orientation which disallows analyses such as Forrester's that twist cognitive responses from a woman's perspective (non-consent) into normative patriarchal stereotypes (a woman's desire to be raped).

In the context of confronting guilt, Davar suggests that Nietzsche's notion of learning 'forgetfulness of guilt' has important therapeutic implications from the perspective of gender 1995b: 19. I would take her argument further to

emphasise that it is not forgetfulness of guilt but the *refusal or the erasure of guilt* that is at stake for the women in therapy. This is because forgetfulness of guilt is predicated on the acceptance and confirmation of guilt, and also that deliberate forgetfulness can only be based on repression causing incomplete healing, if at all. Moreover, since guilt is an issue of morality, and what we have been discussing so far in the context of gender violence is the question of contesting (context-specific) moralities of women versus a patriarchal society, the confirmation of guilt imposed by patriarchal norms could amount to a woman's undermining of her own sense of morality. Hence, what is at stake is the erasure of guilt and a feminist sense of morality, reason and agency that can make this possible.

LEARNING FROM NARRATIVES OF WOMEN IN POLITICAL STRUGGLE

Any genuine healing process would have to cut through the thick layers of established norms to reach that constitutive division between Reason and Madness that Foucault has drawn our attention to in *Madness and Civilisation*.[5] In his radical investigation of the construction of madness, he points out that it is reason's suppression of non-reason that is at the basis of this construction.

An even more fundamental question here is that of the suppression of reason and specially women's reason by an *a priori* notion of a universal Reason. As Mohanty claims,

it would be seriously debilitating for critical analysis to confuse a minimum notion of rationality [reason] as a cognitive and practical human capacity with the grand

[5] I use Michel Foucault as a launching pad for this part of my investigation, and develop the analysis further in the context of gender politics. And while I am conscious of the fact that I initiate this discussion with Western theories about mental health, it is necessary that I do so because these have shaped our mainstream disciplines of mental health in India, irrespective of the ways in which the perception of psychic realities might be different in our contexts.

a-priori foundational structure that has traditionally been called Reason (Mohanty, 1998: 117).

The Enlightenment's privileging of the notion of a universal and given Reason that underlies all human capacities and grounds all human knowledge has already been acknowledged as a failed dream. I would also argue that it is based on eighteenth century eurocentric patriarchal epistemologies. Yet, it still continues to exercise its monolithic tyranny and displace or elide the basic everyday pragmatic sense of reason as an individual's capacity to comprehend and order her life. *Given that all human beings possess a capacity to understand their actions and evaluate them, and that systems of understanding are contextualised forms of life* (Mohanty, 1998:133), *it is crucial that therapy recognise and validate women's context-specific reason rather than imposing the preconceived notion of Reason as norm.*

Further, we need to examine why there is a *selective* subjugation of non-reason by Reason. We need to investigate how and why certain aspects of non-reason are assigned to the category of abnormality or madness while others are not.

In this section, I examine women's responses to gender violence in situations of political crisis as articulated in Indian and Latin American women's political testimonies and fictions. I deliberately focus on extraordinary conditions of crisis because in such times *everyday power relations that normally operate in an implicit and diffuse manner, become explicit and come sharply into focus* with an intensification that elicits, or even demands, responses. Thus, analysing women's responses to incest, forced abortion and rape, I explore their notions of reason, identity and morality that enable them to transform feelings of shame into self-respect, guilt into confidence, and victimhood into protest. Engaging with such responses has important bearings on therapy as it helps us develop an understanding of gender-specific notions of identity, morality and reason, which when validated, would be instrumental in effecting a genuine healing of women subjected to gender violence in everyday situations as well.

Women are often denounced as mad for acts which are grounded in a certain capacity for reason. Jaya Mitra in *Hannaman*,[6] her testimony of her imprisonment during the Naxalite era in Bengal, writes of women who had murdered their daughters to prevent them from being repeatedly raped by their fathers becoming categorised as 'madwomen.' In cases of such women who have no way of surviving beyond the dependence of their husbands, though the murder of their daughters cannot be justified, it can be understood. The 'reason' of such an extreme act lies in the need to protect a daughter from one of the most cruel forms of physical and psychological torture. What is ironic here is that it is the woman who is designated as 'immoral', and the causes of such 'criminal madness' are rarely investigated. This categorising of the *woman* as insane or immoral elides or conveniently deflects from the original immorality of gender violence that the child is subject to by her father.

As Foucault asserts in his *Madness and Civilisation*, this confrontation beneath the language of reason takes us into 'a realm where no doubt what is in question is the *limits* rather than the identity of a culture' (Foucault, 1965: 13, my italics). Our culture, like most others, limits us from acknowledging the reason underlying a woman's murder of her daughter that prevents the latter from leading a life of painful incest; but it allows the non-reason of the equation rape=victory to flourish unquestioned by the rationality test. Hence, gender-sensitive therapy may well have to challenge these patriarchal limits of our culture and push at them in an effort to make genuine healing possible for women.

Bunster-Burotto, exploring the nature of torture in the military state of Argentina in the 70s, asserts that 'We can only describe these patterns of state torture, we cannot make them rational' (Bunster-Burotto, 1985: 307). Examining the military ideology underlying the torture of female political activists, she asserts that: 'One of the essential ideas behind

[6] For a detailed analysis of Jaya Mitra's prison narrative, and of the political torture of women in Argentina including Bunster-Burotto's essay cited here, see my (1997) essay, 'Probing Morality and State Violence'.

the sexual slavery of [a] woman in torture is to teach her that she must retreat into the house and fulfil the traditional role of wife and mother' (Bunster-Burotto, 1985: 307). Bunster-Burroto's research reveals the irrationality of the modes of torturing female political activists who have dared to violate this stereotype, for in 'the method of the "lesson,"' a contradictory logic of inversion 'force[s] a return to the . . . ideal [even as it] simultaneously violates that possibility' (Bunster-Burotto, 1985: 307).

Such torture takes various forms: violating the 'chastity' of a woman through rape; abusing a woman's nurturing role by raping/torturing her in front of her children, causing irreparable damage to both; and attacking a woman's sense of motherhood, by torturing her into aborting, or by appropriating newborn children. Consequently, such torture not only shatters a woman's self-respect, sense of dignity and physical integrity, but also effects what Bunster-Burotto terms a 'cruel double disorientation,' first by forcing upon her a stereotype of 'ideal womanhood', then by making it impossible for her to achieve it.

Hannaman too highlights this 'double disorientation' brought about through the gendered violence of the state under the guise of safeguarding 'morality'. Both cases reveal that such 'morality', privileged by the state and society, far from being an ontological concern, is a socio-political construct designed to legitimate patriarchy and perpetuate control over women's lives and bodies. On the other hand, Gilligan has demonstrated, on the basis of interviews, that women define morality as an ethic of responsibility and care based on interdependence and privileging a relationship of care, whereas men view it in terms of an ethic of rights based on individuation and separation privileging individual achievement. She criticises psychological texts for tending to make independence and separation the goal of development and depicting women's emphasis on relationships as a lack, as an incompleteness of separation (Gilligan, 1982: 155–56).

Thus, political regimes (and sometimes even the woman's own revolutionary party) cruelly take advantage of what psycho-analysis sees as the 'failure of identity' or the tension

in identity between what women require and what 'women ought to be,' to create the paradox of the 'guilty victim' and push her to the borderlines between reason and madness. What is at stake is clearly the safeguarding of patriarchal and political power.

The testimonies of women who fought in the Telengana People's Struggle (Stree Shakti Sanghatana, 1989) articulate their critique of the patriarchal morality of their male comrades within the party who blamed the women when men and women got involved or when women became pregnant. They also frequently forced women into abortions even in the absence of their partners, or impelled them to give away the newborn babies lest the presence of infants hamper the course of political struggle. Highlighting the need for men to shoulder the responsibility of personal attachments equally, the women further enact a powerful critique of the privileging of the political over the personal at the cost of the latter. They emphasise, simply yet critically, that 'the personal is the political' and the shelving of personal responsibilities by the men is a politically regressive act.

Developing the critique of the notion of sacrifice for the greater good, Benjamin (1986) points out that:

> This notion of sacrifice is inextricably associated with the idea that one is responsible only for one's self and that one can consider the web of immediate personal connections as less important than, for example . . . the liberation of the oppressed. It should be obvious that the reason women began to question this conception of struggle and sacrifice, to claim that the personal was also the political, came from their inability to detach themselves from such personal ties, specially from their responsibilities to children (Benjamin, 1986: 78–79).

Thus the assertion that the 'personal is political' refers to the patriarchal politics that control women's personal lives. It also emphasises that personal responsibilities are as political and as important as the ideological ones for the greater good.

In *Sandino's Daughters,* a collection of the testimonies of Nicaraguan women in political struggle (Randall, 1981), there is a narrative of a Sandinista woman who had been raped by an enemy guard, a Somozan, and is faced with the choice of aborting or choosing to deliver that child of this rape. She decides to deliver the child and raise it on her sense of values and her political ideology as a Sandinista, thus gaining a moral victory over the rapist. She denies the 'shame' of this experience by privileging the value of personal attachment and transforms it into an act of political will and an assertion of *her* identity and values. Her example demonstrates how an affirmation of this perspective of the 'personal is political' can help a woman come to terms with the violence and the sense of violation that rape causes.

THERAPY AND THE PROBLEM OF ARTICULATION

Therapy for women subject to gender violence poses some crucial problems that have to be addressed before one can venture to deal with questions of reason, morality, identity and empowerment. The immediate condition of trauma is often accompanied by a resistance to disclosure, specially in the context of the premium on privacy and the taboos associated with the violation of women in our culture. And should the woman be willing to articulate her experience, the equally daunting problem is that of finding a language for it. This is because sexed identity is founded in terms of a verbal language shaped by patriarchy that allows only a selective articulation of sexual experience. And complex aspects of women's experience of sexual violence remain suppressed in the originary realism of verbal language, with no access to verbal articulation. Like certain aspects of women's reason, they too find no place within the limits of culture. As Lovell asserts:

> The bottom line in feminist resistance to Lacanian psychoanalysis is this: if women's oppression is rooted in the very founding of sexed identity in terms which are inescapable for language-speaking human beings, then feminist

demands for the lifting of oppression are deeply compromised (Lovell, 1990: 191).

Since sexed identity is structured through verbal language, and since verbal disclosure often poses a problem initially, the way of dealing with this impasse, I suggest, is to begin with (a) exploring the possibility of engaging with the sexed identity outside the realm of spoken language too; (b) deconstructing the patriarchal structures of this sexed identity either through the same verbal language, or through the actions of non-verbal language.

THERAPY. NON-VERBAL ACTIVITY, COMPREHENSION, DECONSTRUCTION AND RELOCATION[7]

Engaging with Sexual Identity. Non-verbal Activity and Verbal Articulation

After dealing with the immediate trauma of sexual violence (if a woman does come in for therapy at such an early stage), the healing process could continue on the level of individual or group therapy, or involve a combination of both. The workshops on sexual violence designed by some women's organisations within the Indian context, with the help of professionals from various areas such as music, dance, yoga, theatre and mental health could prove to be a useful resource. Many therapists have already begun to use breathing exercises and music in combination with a sympathetic attitude and other techniques to create a calming influence in the initial stages. Then, since many women experience a splitting of the senses of body and self as a consequence of being subject to sexual violence, it becomes important early on to help

[7] For a detailed discussion of Ambai's (C.S.Lakshmi's) 'Black Horse Square' and Mahasweta Devi's 'Draupadi,' see my paper (1996) 'The first syllables of a new language: Responses to sexual violence'. I have used slightly revised versions of the arguments presented there in this section, as they are useful to the concerns of the present discussion.

such a woman re-integrate her sense of body and self. Here, exercises that help create a relaxed state—and then gently urge a woman to begin sensing different parts of her body, from head to toe, and articulate her responses, initially of lightness or heaviness, and then of pleasure, fear, disgust or indifference to each part—are often effective in putting the self back into contact with the body. In the context of the resistance to disclosure and the even more complex problem of the inadequacies of verbal language, some therapists are already encouraging, very creatively, non-verbal forms of expression, such as drawing, painting, creating a collage, miming or dancing. These help release feelings of hurt, depression, anger, fury, horror, entrapment, persecution, shame and of other experiences which the woman is unable to articulate at this or maybe even at a later stage.

All these activities can be conducted at the individual level or in groups of women, depending upon the therapist's discretion in each case. However, another common reaction to sexual violation is one of withdrawal, mental or physical or both, from all people in general, and men, in particular. Thus, connecting with an other/others becomes an important first step in urging a woman back into meaningful interaction with the world. This process is best initiated between pairs of women at the non-physical level, such as that of eye contact, mirroring gestures, etc.; the action can gradually shift to physical contact between the pair such as the holding of hands, and then graduate to the collective level, evolving from holding hands in a circle to the theatre exercises which involve mutual trust building physical exercises within the members of a group. At a later stage such exercises could also be conducted in mixed groups of women and men, if and when the women undergoing therapy are ready for it. Learning to develop non-verbal contact, both non-physical and physical, with others, could become a crucial factor in the healing process, especially because these are the forms of expression one resorts to when language fails.

In Ambai's (1992) narrative, 'Black Horse Square', Abhilasha, a writer for a women's journal, who has come to meet her sister-in-law Rosa after Rosa has been raped in prison, had started her letters to her theoretician husband

Lenin (Rosa's brother) with 'I cannot give you the objective reality.' This was because the experiences she was trying to communicate were located in a realm beyond the reaches of such 'objectivity'. She had said: 'You must make that silence that comes from her [your sister Rosa] your own. And burn in it.' What Abhilasha suggests to Lenin involves both a critique of the male emphasis on individuation and a feminist emphasis on connectedness and care. 'Black Horse Square' posits the importance of non-verbal language that communicates this perspective of care and inter-subjectivity and ultimately helps Rosa to come to terms with her experience of being violated.

The women of 'Black Horse Square' begin pushing through the boundaries of verbal language to communicate and establish their perspectives. Abhilasha finally finds herself on the verge of a new language, one that enables her to reach out to Rosa and in turn forces Rosa to confront the emotions of her own alienated self:

> Rosa had gone inside, behind the partition, to change her clothes. Abhilasha went in after her, suddenly remembering something she had to say. Rosa's clothes lay in heaps at her feet. Upon her breasts were those scattered scars, covered in shrivelled and blackened skin. Without her clothes she was like an arrow not yet fitted to the bow. Abhilasha flew towards Rosa, and putting her arms around her, pressed her face against her stomach. She slid down to the floor cradling her against her breast. The tears began to gather under Rosa's closed eyelids (Ambai, 1992: 136).

It is this body language that finally breaks through the boundaries of the exclusionary semantics of a patriarchal language to set Rosa on the path to comprehension and healing.

Ultimately, however, therapy mostly does require verbal articulation in order to prepare the woman to understand, face and relocate herself within a world in which both community and identity are founded on verbal language. Eliciting verbal expression that is displaced through fictionalisation or distanced through aestheticisation, distanced expression,

as in poems and stories often paves the way towards per-
sonal verbal disclosure. While this too is a mode some thera-
pists use in the mental health profession, less common is
that of preparing the ground for articulation by having a
woman hear other women's narratives of similar experiences,
thus creating a situation, at the individual or the group level,
in which she can feel comfortable narrating her own.[8]

Comprehension, Deconstruction and Relocation

After the articulation of the experience, one of the crucial
factors in helping a woman regain her self-confidence and
power of agency is a comprehension of the situation. A con-
structive approach would be to get the victim to focus on the
possible reasons for the rape within the particular context,
and/or the pathology of rape, to help her erase her sense of
guilt and regain a sense of her own power through some
comprehension of the situation, and the validation of a just
sense of values. As Levi–Strauss has pointed out in his study
of shamanism, the shaman helps the patient enact a psy-
chological healing by facilitating a comprehension of the situ-
ation, and by making available to her a language through
which to order her feelings and emotions.

Regarding the pathology of rape, Sanday offers us, from
the anthropological perspective, one of the ways in which to
comprehend the impetus to rape. Gilligan has shown how
power and separation secure man in an identity achieved
through work, but leave him at a distance from others. Sanday
(1985) locates the origins of male aggression in such psycho-
logical distancing. She argues that the cultural construction

[8] On a collective level, this sharing of personal experiences of sexual vio-
lence could take on the shape of the women's consciousness raising
groups of the 60s and the 70s in the U.S. Such groups enabled women
to build solidarities that helped them deal with personal feelings of shame,
hurt and anger, and sometimes helped develop a collective analysis of
the systemic nature of patriarchal oppression too. They did nevertheless
often fall into the trap of privileging subjective experiences uncritically,
thereby perpetuating an unproductive collectivity of anger and emotion.
This is a pitfall against which therapy groups would have to be con-
sciously safeguarded.

of maleness is based on silencing the 'feminine', i.e., the feelings of dependence and vulnerability, and suggests that rape is a 'form of silencing or concealing male vulnerability and maternal dependency'. According to Sanday, the distancing from others and undermining the emotions plays a crucial part in the psychology of rape. Basing her analysis on Griffin's work she observes that

> . . . pornographic images remake the feminine in a safe image by placing knowledge of the body beyond a man's emotional reach at the same time that the experience of the objectified female body satisfies sexual desire. In the murder of the natural feminine . . . feeling is sacrificed to an image of the self as invulnerable. The male body punishes that which he imagines holds him and entraps him: he punishes the female body (Sanday, 1985: 86).

A comprehension of the act of rape based on such analyses and the violent and debilitating effects of extreme separation and distancing in a man would in turn enable the woman to reassert her own values of connectedness and caring and find a language in which to assert it.

The next critical stage in enabling a woman to take an active stand against the injustice done to her is that of deconstructing patriarchal notions prevalent in society and validating the values of mutual respect and justice from the woman's perspective.

Mahasweta Devi's (1981) story 'Draupadi' deconstructs the established conception of rape-victory, denies the rapist the power over a woman that this equation constructs, and develops a rhetoric for retaliation. What is significant is that this rhetoric stems from the concrete experience of the raped woman, and comprises a *re-presentation* of the very act of rape itself, establishing a feminist perspective based on an alternative knowledge of the act.

Mahasweta Devi shows Draupadi who has been gang-raped deconstructing the very premise of her oppressor, Senanayak, when she approaches him naked and bleeding and he asks his men to clothe her. Her response is, 'You can

strip me, but how can you clothe me again? Are you a man?'
(Devi, 1981: 402). With this move, the story deconstructs
the patriarchal notion of 'man', and reveals the contradictory
reason of any manhood that sexually abuses women and
then demands that they be clothed. Draupadi relocates her-
self conceptually vis-á-vis this meaning system and sets up
an alternate framework. She inverts the equation of being
raped=shame to one of raping=shame: 'Draupadi pushes
Senanayak with her two mangled breasts and for the first
time Senanayak is afraid to stand before an unarmed tar-
get, terribly afraid' (Devi, 1981: 402). Somewhere along the
line, the concept of arms changes.

Further, the politics of identity emerges as strategically
crucial. Draupadi's rejection of Senanayak's value system is
from a point of relocation. She recognises the fact that his
power over her was almost effective because of her insertion
into a triply 'inferior' location at the intersection of the pol-
itical class/caste axis and the equally political gender axis,
as a peasant, a Santhal, and a woman. It is her rejection of
the very framework of hierarchy associated with these axes,
and her relocation outside of it that makes him powerless
over her, and that instead gives her the power to deconstruct
the notions of his manhood.

A woman needs a sense of connectedness with a commu-
nity of shared beliefs that validates her sense of herself vis-
á-vis patriarchal power when she is subject to any form of
gender violence, especially sexual violence. The fundamental
source of Draupadi's strength, first, to refuse to betray her
people, and then to retaliate, stems from her sense of belong-
ing and loyalty to her community of Santhal tribals. The
sense of connectedness with her community and its values
of solidarity that give her this courage is represented by the
echo in her head 'Crow would eat crow's flesh before Santhal
would eat Santhal'. Thus rootedness and pride in her tribal
identity provides the stable base from which she challenges
Senanayak's patriarchal oppression and establishes her
humanitarian perspectives of 'manhood.' Similarly, the
Sandinista woman's rootedness in her political community
and its political beliefs provided the base for the confidence
with which she deconstructed the semantics of rape by the

enemy and replaced it with her privileging of personal attachment for the child within her.

An emphasis on her ethnic or communal identity, however, could prove to be either fruitless in the context of patriarchal communities or dangerous in terms of intensifying strife between communities. Neither would this help deal with situations such as those of everyday domestic violence when the oppressor is not just a person of the same community, but of the same family.

What is needed therefore—whether a woman continues to inhabit her original family and community physically or not—is an anti-patriarchal community of shared beliefs in human rights and egalitarian principles *that a woman can belong to, and relocate herself within, conceptually.* Such a community could be that of a progressive workplace, a community action group or even a therapy group that continues— transformed post-therapy—into a citizen's community action organisation or a human rights cell. Only then will therapy be able to address sexuality and its outside, that is, the socio-political contexts within which it is deployed, and effect a genuine healing.

XIV

Inscribing Madness: Another Reading of *The Yellow Wallpaper* and *The Bell Jar*[1]

Jayasree Kalathil

What is a paper attempting yet another reading of two Western novels doing in a book on women and mental health in India? The question has been at the forefront as this paper went through a considerable number of revisions. The paper attempts to examine the nexus created by the three nodes: women, madness and writing. At the outset I claim that literature can give us useful insights into the phenomenological experience of being mad in a way that psychiatry never can. The texts that I am concerned with are not just representations of madness; they are works written by women who have experienced some kind of mental illness and have written about it in an autobiographical mode. What then interests me is the act of writing itself, what it means to write about an experience which has resounding sociocultural implications in the ways in which female subjectivity itself is defined. The primary objective of this paper is to pose questions related to women and madness, to explore the connection, or the lack of it, between femininity and insanity.

[1] I thank Bhargavi Davar and Susie Tharu for their comments on an earlier draft of this paper, which was presented at the National Seminar on Indian Women and their Mental Health, Hyderabad, 1996. I am deeply indebted to my friends at Sihaya Samooh, Pune, for sharing their experiences with me, and for clarifying many of my reluctant and hazy ideas.

One way in which literature can provide insight into the understanding of madness is by de-pathologising it. Literature, especially the kind of texts that I am analysing in this paper, looks at the experience of being mad, raises questions of social and cultural significance about the state of being 'mad' as defined in terms oppositional to accepted definitions of 'normalcy'. Apart from the male scientific discourse on normalcy and madness, what do women have to say about the experience of being mad in a 'normal' society? There is a vast body of literature written by women on the theme of madness. These works come across as powerful readings of the creation of female madness as an institution. More than trying to cope with the pain of being mad in a normal society, they read madness and the process of being institutionalised in terms of violation of human rights, making a critique of hospitals and mental asylums, the masculine character of these institutions, the role of psychiatrists and doctors, social reception of the mentally ill persons and so on. More interestingly, they attempt to arrive at a way in which madness can be relieved of its relation with femininity so that women can live in a society having complete claim over their right to creativity and individual existence.

In contrast to the abundance of women-authored texts on madness in Western and European literature, there seems to be very little work done in the Indian context. During my research—admittedly limited—I have not come across many works which make a critique of madness as an institution in an autobiographical mode. There are a few works available which deal with the theme of madness, of which the works of the Telugu writer Vasundhara Devi, Malayalam writers Sara Joseph and B.M. Zuhra and Triveni's *The Mad Woman* and Santha Gokhale's *Rita Velinkar* are worth mentioning. I do not believe that this silence is due to Indian women's lack of awareness or sensitivity towards the state of being mad. Personal experience, experiences of friends and the discussions that came up in the seminar on Women and Mental Health held in Hyderabad—all tend to bring out the increasing interest in women's mental health and the issues that are involved. Then what makes our women remain silent about the topic? Is it something inherent in the Indian women's

movement itself that has brought about this silence? My hunch is that the conflict between 'the personal' and 'the collective', which marks the Indian women's movement would provide the answer to this. The Indian women's movement, over the past two decades, has dealt with a wide range of issues arising from the societal oppression of women. Literacy, sexual and familial violence, harassment in the workplace, economic status, legal equality, etc., are a few examples of the issues that the Indian women's movement has taken up. These are all of a collective nature. Mental health or issues of madness do not figure on the agenda perhaps because they are seen as individual problems rather than collective ones. Most women are oppressed but not all of them go mad. Moreover, the pathologising of mental illness makes it easier to confine it to the realm of the personal rather than the collective. Feminism, which is based on collective change, and psychology, which is aimed at individual change, do not, at the first glance, go hand in hand.

Perhaps then, one must look elsewhere for 'disclosures' of madness. I think, apart from the fictional works falling under what is called feminist writing, one might have to explore diaries, journals, personal correspondence, prison accounts and so on to break the false silence that now seems to pervade women's accounts of madness. I was partially successful in tracing down some such private accounts but will not be able to use them for this paper as the writers were not comfortable with the idea of making their writings public. Instead I shall draw from the insights that these writings have given me in my readings of the two texts, *The Yellow Wallpaper* by Charlotte Perkins Gilman (1973) and *The Bell Jar* (1963) by Sylvia Plath (hereafter referred to as *YWP* and *BJ* respectively).

Both Gilman and Plath had been treated for mental illness and the novels are based on the experiences that they had. Written from a feminist point of view, *YWP* which when it was published for the first time in 1920 was received as a story to 'freeze our . . . blood,' heralded a new way of thinking about madness (Howels, 1920). Sylvia Plath (1981) has until recently been treated as a myth, a haunting figure whose poetry was more often read, especially by men critics, with a

mixture of love and hate. *BJ* was first published in 1963 and is the story of a woman caught up in what has been called the 'feminine mystique' of the 50s (Friedan, 1971). Friedan, talking about the idealisation of femininity, calls it a mystique by which American women are trapped into 'the old image: "Occupation: Housewife"'. According to Friedan, the idealised femininity or the feminine mystique 'simply makes certain concrete, finite, domestic aspects of feminine existence . . . into a religion, a pattern by which all women must now live or deny their femininity' (Friedan, 1971: 38).

The two novelists, Gilman and Plath, have one thing in common which is dealt with in the novels in a very significant way and that is their existence as 'women' writers. Writing has always been considered as a male art—the pen, a metaphoric penis, and the male author an all-powerful patriarch. Writing, attempting the pen, is in itself seen as deviation from femininity, hence unnatural, abnormal. This tension was more for Gilman as compared to Plath. For Plath, it was not so much as her right to write that had to be asserted, but to prove herself 'successful' in terms of the male standards of success. The two novels raise important questions in connection with women, making links with the social, political and cultural worlds within which each protagonist is placed.

RE-READING MADNESS: AN OVERVIEW

It would be worthwhile to look at some of the critiques that feminist theory has brought into the understanding of madness. The interdisciplinary scrutiny of madness has placed reason and knowledge within quotes, that is, it has caused a questioning of these concepts which are usually taken for granted. What does it mean to know? What is reason and what is non-reason? How does one know where reason ends and madness begins? The main object of Michel Foucault's study *Madness and Civilization* is to contend that knowledge systems are built upon a radical misunderstanding of the phenomenon of madness and a misapprehension, even

an appropriation, of its language (Foucault, 1965). The acknowledgment of a universal reason that characterised Enlightenment led to a subjugation of certain kinds of non-reason which were then termed as 'diseased'. This is where questions pertaining to women and madness become significant. Often, women's understanding of values which went contrary to what was accepted as norm could be dealt with only by terming it as madness.

What would be the gender specificity of normalcy? Living under a patriarchal system of oppressions where preconceived notions of femininity, sexuality and 'women's role' rule each of her action and behaviour, how would women experience madness defined as any deviance from 'normal' 'feminine' behaviour? These questions are important because an intrinsic link between femininity and madness has always been posited. The term 'hysteria', as is well known, was derived from the Greek word for the uterus and was understood as an exclusively feminine disease. Even today, statistics establishes a definite relation between women and madness. Numbers tell us that more women are involved in, to borrow a phrase from Phyllis Chesler, 'careers as psychiatric patients' than men (Chesler, 1972). Even if one does not want to question the degree of 'fact' in these data (though Chesler remarks pointedly that around 1964 there were significantly more women being 'helped' than their existence in the population would allow us to predict), how would one go about analysing them? If one is to break the notion of an innate link between femininity and insanity, one will have to look at madness as the product of the social conditions in which women live, confined to the roles of daughters, wives and mothers, and examine the male-centredness of the psychiatric profession as a whole. Chesler's work *Women and Madness* sees the women confined to the mental asylums, who are the subjects of her study, as failed but heroic rebels, whose insanity is a punishment for '*being* "female" as well as for desiring or daring *not* to be' (Chesler, 1972: 279). The masculine ethic of mental health requires her to keep failing. Chesler argues that it is this 'double standard of sexual mental health, which exists side by side with a single and masculine standard of *human* mental health' that is being

enforced by both society and the clinicians (Chesler, 1972: 68–69).

The concept of madness as rebellion is pushed forward by the French feminists Cixous and Clement (1986). According to them, madness is the historical label applied to female protests and rebellion at any given point in history. They celebrate the 'admirable hysterics' as champions of a plot of subverting the linear logic of male rationality, choosing 'to suffer spectacularly before an audience of men' (Cixous and Clement, 1986: 10). But this view of seeing madness as rebellion is considered to be dangerous by critics like Soshanna Felman and Elaine Showalter. For madness, Felman notes, is 'quite the opposite of rebellion. Madness is the impasse confronting those whom cultural conditioning has deprived of the very means of protest or self-affirmation' (Felman, 1975: 2). Showalter argues that such claims as Cixous and Clement are making come 'dangerously close to romanticizing and endorsing madness as a desirable form of rebellion rather than seeing it as the desperate communication of the powerless' (Showalter, 1987: 5). Any serious study of the 'female malady' should, instead of romanticising it, investigate how in a particular context notions of gender influence the definition and, consequently, the treatment of mental disorder.

Showalter's critique of the concept of madness as the 'female malady' needs a little attention here. In an attempt to comprehend the origin of the link between femininity and insanity, Showalter points out that women, within our dualistic systems of language and representation are constantly situated on the side of irrationality while men on the side of reason. Thus, woman *is* madness and the female body is used to represent irrationality in general. To quote Showalter,

> [w]hile the name of the symbolic female disorder may change from one historical period to the next, the gender asymmetry of the representational tradition remains constant. Thus madness, even when experienced by men, is metaphorically and symbolically represented as feminine: a female malady (Showalter 1987: 4).

Re-writing Madness. From Malady to Therapy

As mentioned earlier, the act of writing was conceived as primarily a male privilege. For women then, the act of writing represented a fall from the norm of femininity, a madness. It is in this context that writing about madness becomes interesting. Sandra Gilbert and Susan Gubar (1979) were among the first to explore the link between madness and women's writing. The fictional character of the mad woman who haunts Victorian literature is, for Gilbert and Gubar, the symbolic representation of the female author's anger against a patriarchal tradition. The mad woman is the author's double through whom 'the female author enacts her own raging desires to escape male houses and male texts' (Gilbert and Gubar, 1979: 85). For Gilbert and Gubar, every woman writer becomes the mad woman in her attic, playing out her madness.

It is possible to see writing as therapy. It provides a textual space to confront the experience. Writing gives language to madness. The act of writing is a public confession, an open protest. It makes one wonder that perhaps what women could not find in the confessional mode of psycho-analytic treatment they are trying to find in the confessional mode of autobiographic writing. The re-inscribing of madness in the textual space of literature would perhaps be, I want to suggest, an attempt at self-cure, for writing is also in a sense an admission, a facing of facts, and a self-evaluation. Writing about one's experience of madness then is a journey from malady to cure. I shall be dealing with some of these ideas in my analysis of the two texts.

The Yellow Wallpaper. Madness and Survival

Charlotte Perkins Gilman was born in 1860. By late teens Gilman had begun to ponder upon 'the injustices under which women suffered' (Gilman, 1935: 61). She was aware of the changes that were slowly becoming visible in the lives of women; she herself was beginning to write poems and pursue her own independent thinking. The most disturbing

question for her was the one involving marriage and career. She believed and argued that a woman 'should be able to have marriage and motherhood, and do her work in the world also', but was, like many nineteenth century women, without a model to emulate (Gilman, 1935: 83). She soon began to experience periods of depression when she felt that a 'sort of green fog drifted across [her] mind, a cloud that grew and darkened' (Gilman, 1935: 87–88). She gave birth to a daughter and within a month was, as she puts it, a mental wreck.

Gilman was sent to the most eminent 'nerve specialist' of her time, Dr Weir Mitchell. It seems that what ultimately forced Gilman to write *YWP* is Dr Mitchell's treatment of her. Dr Mitchell had only one prescription for her illness and that was to devote herself completely to her domestic life, looking after the husband and child and confining herself to, at the most, two hours of intellectual work and he exhorted her to 'never touch pen, brush, or pencil as long as you live' (Gilman, 1935: 96). For three months she tried to follow this advice and came so close to complete mental ruin that she considered herself lucky to have survived. In 1887, Gilman left her husband and fought a lonely battle to overcome periods of severe depression and lethargy, writing, travelling and lecturing, seemingly with a full store of energy. In 1890, she began lecturing on the status of women, struggling for economic independence, and at the same time fighting a society hostile to the ideas that she propagated. It is in the midst of this difficult time that she wrote *YWP*.

The narrator of the story is a woman who has been brought to the country for 'the rest cure' prescribed for her postpartum depression by her doctor-husband. The most powerful critique that the novel makes is of this assumption of complete rest as remedy for the woman's illness. She is housed in a nursery and throughout the novel, the narrator tries to bring out the contrast between what is needed of her, being a comfort to her husband and child, and what she thinks she needs, intellectual stimulation and the time, space and energy to write. So here is a woman who, emblematic of the female insane character in nineteenth century psychiatric imagination, is treated like a child, irrational,

constantly made aware of her 'duties' and imprisoned by a loving and caring husband in a nursery.

In a way, the novel questions the premise of madness as the other of rational behaviour, and for a woman rational behaviour means adhering to norms of femininity and domesticity, which do not include artistic pursuit. Hence, the protagonist of the story has to be 'taught' to go back to her essential femininity. All through the narrative, there are admissions of guilt for not being able to fulfill her duty towards her husband and child. But this sense of guilt is interspersed with acts of rebellion. The narrator is throughout the novel *making* stories, the very act a defiance of her attributed irrationality. She is all the time writing her stories, trying to hide them from her husband and his sister. Her apparent acceptance of her husband's love and concern, her admission of a sense of failure as a mother and wife, her acceptance of her husband's position and power over her as a doctor who knows better—all these are at one point or the other underscored by subtle sarcasm or direct statement of the feeling of the persona 'I' in her story-writing mode. And the yellow wallpaper in the nursery, with its intrinsic patterns that escape definition, becomes the major theme of her creative imagination.

The wallpaper at first revolts her. Slowly it captures her attention. Inside the intrinsic patterns of the wallpaper, which looks to her like bars of a cage, she sees a sub-pattern—'a strange, provoking, formless sort of figure, that seems to skulk about behind that silly and conspicuous front design' (Gilman, 1935: 17–18)—a figure which eventually becomes a woman in the narrator's private discourse. Caged as she is within the actual bars of the nursery and the metaphorical bars of her marriage, she projects her own feeling of being trapped onto the woman she sees behind the bars of the wallpaper. The last section of the novel, where the narrator 'frees' the woman behind the bars of the wallpaper is the culmination of her authorial autonomy. At first, the narrator imagines that the woman behind the wallpaper manages to escape during daytime. She sees her outside, creeping around:

It is the same woman, I know for she is always creeping, and most women do not creep by daylight.

I see her on that long road under the trees, creeping along, and when a carriage comes she hides under the blackberry vines.

I don't blame her a bit. It must be very humiliating to be caught creeping by daylight!

I always lock the door when I creep by daylight [Gilman, 1935: 30–31].

The narrator identifies with the woman when she reveals that she too creeps. In the last move, she identifies totally with the woman and destroys the wallpaper in an attempt to 'free' her, even as she locks herself in, denying the opportunity to be free and starts to creep around the room and right over the husband who has fainted and fallen across her path.

Figuratively, the movement in the novel is from oppression to a self-chosen form of freedom. But it is significant that, as Linda Wagner-Martin has pointed out, Gilman chooses the image of creeping and not skipping or flying which are the more common images of freedom. Creeping in public, outside in daylight, is humiliating. It is also in another sense the culmination of the childlike stage in which she is closed in. Like an infant, she now learns to creep, and to creep as she pleases and where she pleases. Perhaps it is this image of creeping on all fours, reminiscent of Bertha Mason as Jane sees her for the first time in Charlotte Bronte's *Jane Eyre*, that has led to a long debate as to whether Gilman's protagonist succeeds or fails in the end. The question, according to me, is not about succeeding or failing. Gilman, I would like to suggest, is accepting the 'fact' of mental illness and at the same time, underlining the mentally ill person's right to individuality. She is doing this by making her protagonist set free her creation (the woman behind the bars of the wallpaper) even as Gilman herself assigns her creation (the protagonist of the story) into a world of total madness.

The Bell Jar. **Madness and Conformity**

BJ captures the dilemma of an educated middle class woman in the 50s America. It is a fictionalised autobiography and the protagonist of the novel, Esther Greenwood, is in many ways Sylvia Plath herself. I am not stating this to raise questions about fact and fiction in the novel. My agenda is to examine how Plath re-inscribes her madness in Esther Greenwood and what it does to her own understanding of the experience. Esther's story is the story of the struggle for conformity to societal norms and a testimony of how this conformity defines the subjectivity of a woman. The story begins with Esther in New York, one of the twelve guest editors of 'the magazine', a fictionalised counterpart of *Mlle.*—'the magazine for Smart Young Women'. Being selected as a guest editor for this magazine is one of the greatest achievements that any college-going American girl can aspire for, but all Esther can feel is 'the way the eye of a tornado must feel', very still and empty. It is the summer when the Rosenbergs were executed. Esther's sense of personal inadequacy is linked with the political inadequacy of the Rosenbergs. The Rosenbergs were pronounced guilty for giving away the secret of the atom bomb to the Russians. They were guilty not only of being spies, but of being Jewish, of being communists, and Ethel Rosenberg, of her strong womanhood. Put in one word their crime is 'dissent'. By juxtaposing the Rosenberg case with Esther's own struggle, Plath is looking at the controlling, policing, collective gaze of the political and the legal with that of the societal and the cultural.

The novel is in one sense a lengthy examination of the various crimes of Esther Greenwood and, like the Rosenbergs, she will also be punished for the crime of non-conformity.

After having been the best student for years, always winning scholarships and other prizes, Esther identifies her 'failures' one by one. Her time at the magazine whose business it is to fashion femininity through image is, interestingly, what makes Esther question the standards that have been set for her. Her return home after having relinquished those standards also heralds her slow descent into insanity.

Esther is first referred to a male psychiatrist, Dr Gordon. She starts hating him from the moment she walks into his hushed beige office, with the family photograph of his wife, two blond children and a dog. His first question is 'Suppose you try and tell me what you think is wrong' (Plath, 1963: 137). Esther reflects that the statement 'made it sound as if nothing was *really* wrong, I only *thought* it was wrong.' Dr Gordon as the therapist and Esther as the patient is another version of the depressive wife and the doctor husband in *YWP*. The visit to Dr Gordon, which will continue over the next few weeks, is interspersed with Esther's attempts at committing suicide. Finally, Esther is given shock treatment:

> something bent down and took hold of me and shook me like the end of the world. Whee-ee-ee-ee-ee, it shrilled through as air crackling with blue light, and with each flash a great jolt drubbed me till I thought my bones would break and the sap fly out of me like a split plant.
> I wondered what terrible thing it was that I had done (Plath, 1963: 151–152).

The electroshock treatment takes us right back to the Rosenbergs. Dissent, be it political or personal, will be punished by electricity.

Esther's crime was also Plath's crime. The novel here is a record of the events that happened to Plath in the summer after she tried to commit suicide. She spent some time in a private mental hospital where she was treated with insulin and electro convulsive therapy (ECT). For many years, she did not talk about this episode and it was looked at, especially by her mother, as shameful and something to be kept secretive. Later, in her poetry, Plath looked at the shock treatments as a kind of ritual and rebirth. In The Hanging Man', Plath refers to ECT: 'By the roots of my hair some god got hold of me. I sizzled in his blue volts like a desert prophet' (Plath, 1981: 141). Here, electricity associated with man is a frightening experience. There is no sign of redemption. But later in the novel, Esther goes to a woman therapist, Dr Nolan who tells her that electroshock therapy is like going to sleep. For her next ECT session, Dr Nolan accompanies her and she is

surrounded by women who keep talking to her until 'darkness wiped me out like chalk on a blackboard' (Plath, 1963: 226). And she wakes up feeling 'surprisingly at peace. The bell jar hung, suspended, a few feet above my head. I was open to the circulating air' (Plath, 1963: 227). If not completely recovered, Esther is now onto the path of recovery.

Throughout the novel, Plath examines Esther's relation with various other women characters. Her mother, the magazine editor Jay Cee, the wealthy benefactress who helps her through college and through her mental crisis, her boyfriend Buddy Willard's mother, her New York friend Doreen and Joan Gilling, her friend and another lover of Buddy Willard— all these women are various aspects of the life that Esther is trying to conform to. Recovering under the care of Dr Nolan, Esther should now purge herself of all these stifling female presence, and Plath does this by the ritual killing of Joan Gilling, Esther's alter ego.

> Sometimes I wondered if I had made Joan up. Other times I wondered if she would continue to pop in at every crisis of my life to remind me of what I had been, and what I had been through, and carry on her own separate but similar crisis under my nose (Plath, 1963: 231).

The ritual of killing the mad double is not new in literature, the most famous example being that of Bertha Mason's death by leaping into the fire in *Jane Eyre*. In her attempt to claim authority over her body, Esther decides to 'lose her virginity' and is in the process hurt and bleeding. It is Joan who nurses her and takes her to the doctor. Finally, when Esther is recovering from the post-coital haemorrhage, Joan commits suicide by hanging herself. Joan has most of Esther's dangerous, seditious, unacceptable ideas and her death symbolically purges Esther of them.

The killing of the mad double does not in itself allow for recovery. For this, Esther must admit the situation in which she is. In the asylum Esther asks herself:

> What was there about us, in Belsize, so different from the girls playing bridge and gossiping and studying in the

college to which I would return? Those girls too sat under bell jars of sorts.

The life inside the bell jar is to be forgotten as her mother put it, like 'a bad dream.' But to the person in the bell jar, bland and stopped as a dead baby, the world itself is the bad dream (Plath, 1963: 250).

The way Plath deals with Esther's madness stops us from privileging either the pathological and physiological aspects of madness or the socio-cultural aspects. For the person under the bell jar, madness is a reality. She acknowledges that there is 'something wrong' with her. At the same time, she is aware of the pressures working on her—the pressures of conforming to accepted notions of femininity, of being a 'woman,' of being policed into the roles of ideal daughter, wife and mother. For Plath, who was the wife of a 'successful' poet and who in her own right was a poet, these pressures were actually felt. Engaged in an 'unfeminine' act, writing, she has to secure her position in terms of standards set by a male world of literature. Success then is in being a superwoman—a super-wife, super-mother and super-poet.

Plath leaves us with Esther—patched, retreaded and waiting to be approved for the road—asking herself this question: 'How did I know that someday...the bell jar, with its stifling distortions, wouldn't descend again?' (Plath, 1963: 254).

For Plath, the bell jar did descend again, when she placed her head in the gas oven, accepting her 'failure' in not being able to be a superwoman.

Women, Society and Mental Illness

Women, Society and Mental Illness

XV

LAY AND MEDICAL DIAGNOSES OF PSYCHIATRIC DISORDER AND THE NORMATIVE CONSTRUCTION OF FEMININITY

Renu Addlakha

SOCIOLOGY OF MENTAL ILLNESS

Gender stereotypes, reflecting societal norms of appropriate characteristics and behaviour for each sex, underlie both popular understanding of health and illness and their configurations in professional medical practice. Feminist analysis shows that the theoretical constructs of major psychological paradigms are themselves based on 'male nature as the norm' (Hole and Levine, 1971: 177): generalisations from male experience and development is common. Furthermore, where the emotional, psychological and the intellectual differences between the sexes are asserted, the distinguishing criterion is a biological difference deriving from a natural determinism rather than a social system that insidiously but systematically oppresses and degrades women in all spheres of life. The apparently objective process of clinical judgment is itself permeated by gender politics (Broverman et al., 1970).

There is a vast sociological literature which shows higher rates of mental illness in women in comparison to men. This literature has been treated more elaborately in other chapters in this book. Looking at the issue of sex and social role from another perspective, Bart attributes depression in middle-aged women to their over-conformity to the feminine role, whose destruction due to children leaving home precipitates

psychiatric problems because they feel a sense of emptiness and a loss of meaning (Bart, 1971). On the other hand, according to Phillips and Segal, ill health is less stigmatising for women, who also report it more because the ethics of health is masculine (Phillips and Segal, 1969). In addition to hysteria, depression has been singled out as the disorder most congruent with the traditional feminine role, confirmed by many studies reflecting its higher incidence in women than men (Weissman and Klerman, 1977). But the most well-known study linking gender and psychiatric illness is a collaborative survey undertaken by a sociologist and a psychiatrist of South London (Brown and Harris, 1979). They found much higher rates of depression among working class women in comparison to middle class women, which the authors explained in terms of the greater vulnerability of the former arising out of a higher exposure to stressful life events. They found that 23 per cent of the working class women in the community compared to 6 per cent of the middle class women were clinically depressed in the three month period prior to the interview. They attributed this to several conditions characterising the lives of their working class sample, such as the experience of the more severe life events especially in relation to the household, like notice of eviction, husband losing his job or a son getting in trouble with the police, and early loss of mother and the lack of a confiding intimate relationship. Furthermore, their vulnerability to depression was enhanced by the drudgery of caring for young children at home and the lack of employment (Brown and Harris, 1979).

Sociological approaches to the relationship between gender and psychiatry can be broadly grouped under two headings, those that regard mental illness as a product and those that regard it as a social construct (Busfield, 1989). The former focus on the empirical differences between the sexes in prevalence rates, treatment modalities and outcome of various disorders. Thus Gove's (1972) findings on the higher rates of mental illness among women, their over-representation in patient populations especially in disorders of emotion like depression and their under-representation in the medical profession at the consultant level, have been incorporated

into psychiatric epidemiology by giving formal recognition to the importance of the role of gender at least in theory by practitioners. However, this perspective does not question the definitions of mental illness and health put forward by the psychiatric establishment. This issue is dealt with by the proponents of the social constructivist approach which emerged contemporaneously to the anti-psychiatry movement in the 60s. Chesler noted: 'What we consider "madness" whether it appears in women or men, is either the acting out of the devalued female role or the total or partial rejection of one's sex role stereotype' (Chesler, 1972: 56). This is a paradox for any definition of women's mental health because conformity and deviation from sex roles is liable to generate definitions of psychiatric ill health.

Goffman's theoretical analysis of stigma provides the frame within which the above may be substantiated because stigma '. . . is really a special kind of relationship between attribute and stereotype' (Goffman, 1968: 14). The stereotype refers to the person's virtual social identity which is the sort of person s/he is expected to be in the given circumstance and the attribute points to what s/he actually is, i.e., his or her actual identity—a case of discrepancy between the two gives rise to a stigmatised self. All phenomena including pathology are embodied in a multi-faceted context which relativises their manifestation. One such standard of relativisation is gender and the aim of the present chapter is to show how the notion of virtual gender identity with its attendant patriarchal conceptualisation of women's social roles and the configuration of female sexuality, permeate ideas of psycho-pathology in both the professional discourse of Indian psychiatrists and the lay discourses of families and patients.

Thus, in the following case illustration, I make an attempt to show how patriarchal standards of femininity condition the illness experience, perception, articulation and behaviour of both an individual patient and her significant others. Furthermore, her plight, and the reaction that it provokes in her natal and conjugal families as well as in the representatives of the medical profession is itself embedded within a politics of the family in which her position renders her socially,

economically and emotionally disadvantaged. While not making a case for or against the existence of schizophrenia as an objective disease entity, the aim of the analysis in Laingian terminology is to validate the view that the behaviour of this patient is '. . . socially intelligible in the light of the praxis and process of the family nexus' (Laing and Esterton, 1964). Furthermore, the sex role stereotypes that condition the evaluation of all the participants in this 'nexus' also underlie the inner conflicts and contradictions about personal identity and selfhood of the patient herself.

My interest in the sociology of mental illness and treatment dates back to my postgraduation in social work. As a part of the compulsory assignments for this degree, I was given a fieldwork placement during the first year in the rehabilitation department of a hospital and during the second year in a child guidance clinic. This initial exposure to the social dimensions of illness and care stimulated my interest in perceptions of disease and healing practices in non-literate societies from a cross-cultural perspective (Addlakha, 1989). This work exposed me to a vast literature on the interface between shamanism, psycho-pathology and psychotherapy, which suggested the need for a thorough examination of psychiatric practice in a hospital setting. Consequently, for a doctorate degree, I was able to conduct sixteen months of intensive fieldwork between 1990 and 1992 in the psychiatry department of a public hospital in Delhi. The concern with issues of gender in the diagnostic and treatment processes crystallised in the course of my observations during this time, which are partly presented in this chapter.

As the case material was collected as part of this larger study of psychiatric practice in a general hospital setting, it is necessary to describe in detail the methodological stance that underlies this research. In my fieldwork, I relied on the method of participant observation and ethnographic interviewing. Participant observation essentially means observing a situation while simultaneously participating in it. My training in social work helped me to participate in the routine activities of the psychiatry department. In a sense I became one of the staff, which gave me the opportunity to contribute to clinical work in addition to carrying out my own research.

I accompanied the doctors on their ward rounds, participated in the regular case conferences and seminars, which enabled me to gain a thorough understanding of the actual practice of psychiatry. I also had the privilege of sitting in on consultations and observe the triadic interaction between patients, their families and the doctors. Tape recording in such a set-up was out of the question. Under these circumstances, I was left with no alternative but to make points while the exchange was going on and then to reproduce it later on in long hand. This approach became very arduous in the case of interviews with patients and their families both in the hospital ward and in their homes. It meant that immediately after the interview, I had to find a secluded spot and reproduce it relying on the faculty of immediate recall.

The anthropological approach of ethnographic fieldwork is an open and fluid method of research in comparison to the more structured questionnaire and formal interview methods. By being part of a social setting over an extended period of time, the researcher is in a better position to understand his/her subjects because of the familiarity that s/he attains with their lives arising out of prolonged interaction. The possibility of generating more authentic insights is greater because of the researcher's in-depth contact and participation in the research field. Furthermore, by taking on the role of a non-professional but concerned 'insider' vis-à-vis patients and their families, the same informal approach of natural interaction allowed me at times to be more aware of their situation than their doctors because of the lack of apparent structure to our interchange.

However, this very fluidity of the anthropological method limits its universal generalisability. The inferences that emerge derive from a specific social setting, but as one of the fundamental characteristics of social life is its repeatability, both over time and space, they carry relevance of varying degrees for all such social settings. Even when the focus is on one particular narrative as in the present study, the unique experiences and events can be slotted into patterns that emerge in the case of other similar narratives. For example, the ontological notion of mental illness that emerges in the course of the analysis of the present case study

configures it neither as a purely medical category nor as entirely a social construct. The fact of the matter is that chronic mental illness from the point of the view of the sufferers is just that: an inchoate conglomeration of thoughts, perceptions, emotions and events that get classified differently depending on the social context of the person. In the hospital situation it is pathology, while in the home situation it may be labeled as moral turpitude. For the patient it may be an unending and indescribable struggle for self-definition in a seemingly hostile world.

I must admit that I did not commence fieldwork with a feminist orientation. My choice of women patients over their male counterparts arose more out of the conditions of the field. The hospital in which I did my work primarily caters to a female patient population in the city. However, content analysis of the data revealed that issues of patriarchy could not be overlooked in the women's experiences of psychopathology both within their homes and in their diagnosis and treatment in professional psychiatric settings.

Pushpa's Story

Pushpa[1] is a 34-year-old married woman living with her husband and widowed mother-in-law in a suburban middle class residential locality of west Delhi. Despite being married for the past 12 years, the couple is childless, a factor which, as will become evident soon, plays a crucial (if not overriding) role in the genesis and sustenance of her psycho-pathology. Her only sibling is a 32-year-old brother who lives with his wife and two children in the neighbouring state of Haryana, bordering the capital. Her parents had died and she has studied till B.A. (II Year) in addition to having done a year's course in beauty culture. Prior to her marriage in 1979, she successfully ran a salon at her home for a year. The patient's

[1] For the purpose of confidentiality, the names of all the persons in this case have been changed. However, names of places and dates of events have not been altered to maintain the authenticity of the narrative.

case record lists a principal diagnosis of an undifferentiated type chronic schizophrenia with all the typical symptoms of the syndrome. A differential diagnosis of schizoaffective disorder was also made because there was some excessive talking and singing and evidence of grandiosity. The speech sample from the case sheet in support of this is 'I can do anything!' Since the past one month and a half, she was reported to have said, 'I can do the make-up of big people'. A point crucial to my analysis is that it is almost exclusively the husband's version of the situation which forms the backbone of the clinical interpretation as he is the 'chief informant'. The patient's brother, although physically present, served, for reasons which will soon become evident, more as a sounding board for his brother-in-law than anything else— at least in the latter's presence.

The presenting problems as listed in the case sheet are: not doing housework and not maintaining personal hygiene and grooming since the past 6 years. During the preceding month and a half, she was reported to have stopped bathing daily and changing her clothes. In addition to this, she had also torn up her husband's clothes, had thrown household articles out of the house, had gone out alone without informing anyone and returning several hours later. These actions were classified in the case sheet as instances of violent, abusive and aggressive behaviour. Two to three days prior to coming to the hospital, she had stopped sleeping altogether. It is interesting to note how the family's tolerance is inversely proportionate to the level of disruption of the patient's mental pathology.

Pushpa was brought to the Psychiatry OPD on a bright sunny October morning by her husband and her brother. A postgraduation examination was scheduled on that day and Pushpa was instantly chosen by the senior doctors as the 'long case' for the viva voce examination primarily because of her florid psycho-pathology. However, this resulted in her being left unattended for several hours, waiting for her turn to be presented before the 'big doctors' (*bade doctor*). She presented a visual paradox which under the medical gaze was immediately transformed into an acute episode of psychiatric disorder. She was dressed in a pair of gray-coloured

men's kurta pajamas below which a glimpse of a sari blouse could be caught. On her feet, she wore a pair of ladies' sandals. Her pale face was framed by an uneven crewcut of graying locks, and on her upper lip and chin was a thin, but very distinct growth of the same gray hair. To complement this striking appearance was a high pitched voice and incessant stream of commentary delivered in a forceful self-assertive manner that drew the attention of all within hearing distance. In this manner, she kept the occupants of the OPD engaged while her husband and brother cowered sheepishly in different corners of the room. 'My father died yesterday on 25 October 1985 . . . Sona Rupa Janpath, I'm a commercial artist . . . S.N. Depot, Lakshmi Bai Nagar In 10th class, I studied nutrition, hygiene and animal husbandry I want to be an actress . . .' After making a cursory tour of the ward in the course of waiting in the OPD, she returned and loudly announced:

The sisters in this hospital are the worst. In Holy Family Hospital the sisters are so good. My mother was admitted there for diarrhoea and the nurses changed the sheets everytime they got dirty. They made no distinction between patients. Work is worship!

Upon seeing one of the female senior residents sitting at the social worker's desk, she began quizzing her in English.

P: Madame, how many medical colleges are there in India?
Dr (curtly): 144.
P: And how many states are there in India?
Dr: 28.

When I drew near her and my sandal accidentally brushed against her leg, she said to me sharply again in English, 'Please put your *chappal* down madam. Don't you know how to sit properly?' This self-assertive and brusque manner only serves to heighten the deep sense of pathos and pain that permeates her illness narrative. However, in the course of my first conversation with her husband a few days after her ward admission, the image that he painted of his wife is that

of a vicious, idle, physically unkempt, sterile and sexually inadequate woman of a suspicious temperament. According to him, instead of doing the housework, she would spend the whole day sleeping, reading novels or watching films. She would only wash her own clothes:

Husband: My mother had to wash my clothes.
Renu: And what about the cooking?
H: My mother also did the cooking.
R: You don't have any children?
H: No, her fallopian tubes are blocked. 3–4 years after marriage we started having the gynecological investigations. Before that, whenever the matter was mentioned she would say 'Not now, I won't be able to look after it.'
R: Please, don't mind my asking, but how have your sexual relations been?
H: She was always cold, 'like a dead girl'. After the first 2–3 years of marriage, I began spending more time out of the house. When a man doesn't get the response from his wife, what can he do? Then it would just happen automatically when one was asleep.
R: What do you know about her life before marriage?
H: Her father had died when she was very young. She didn't get along with her brother and *bhabi*. She comes from a conservative family. She was not allowed, for example, to go to the market alone. Our family is 'advanced.'
R: How is her relationship with your mother?
H: Initially she got along with her, but then she started fighting over little things. She has this habit of arguing (*Choti choti cheesoin pe behas karne ki aadath*).
R: What little things?
H: I can't really say. I am out of the house from 7.30 in the morning to 7.30 in the evening.
R: Then what began happening 6 years ago?
H: Her mind began going in one direction. She became suspicious, saying that I was meeting other women out of the house, that I was seeing the colleagues' wives. In front of them she would say that their own husbands were not good. Then she stopped looking after herself. She didn't wear proper clothes. She would dress the way she was

dressed on the day she was brought here. She also began spending on useless items (*fazul ki cheesain*).

R: Like what?

H: She would buy make-up spending 300 to 400 rupees on a foundation and then not use it. I often go abroad but the things I bought for her she would not use, exchanging them for cheaper items. We gave her 50 *tolas* of gold and she has just wasted it.

R: Anything else?

H: In between, for two months she became very violent (*wohi haatha pai thordh pordh*). I was constructing my house and she refused to give tea to the workers saying, 'It is not my house, why should I give them tea?'

R: Then what happened on the 20th of this month?

H: She started talking a lot and stopped sleeping. Our sleep was also ruined. Then that evening she began to throw things out of the house. She hit my mother with a stick. She was awake when the earthquake[2] came, standing on the balcony and saying loudly that it was because the people had not plastered the house properly. She has this habit of making speeches in the *gali* (*bhashan dena*). She threatened to hit the neighbours with a brick. No one could go in front of her so I rang up her brother in Faridabad and we brought her to the OPD on Monday.

In a subsequent interview he said that he felt much more 'relaxed' at home, now that she was not there.

The description of Pushpa given by her husband reveals her to be not only someone who is selfish and self-assertive, but also someone who is repudiating her role within the family system by not conforming to the expectations associated therewith. She is expected to be fertile, for barrenness is the worst curse that can befall a married woman. A housewife in a middle class urban family is required to perform household tasks including washing her husband's clothes and cooking regularly. Her household duties and unquestioning

[2] An earthquake of moderate intensity rocked Delhi in the early hours of 21 October 1991.

devotion to her husband and his family should constitute the raison d'être of her existence. In addition to this, she is supposed to be thrifty, reserved in speech or unobtrusive in manner. Finally, these feminine virtues should be complemented by those physical attributes and emotional qualities that ensure sexual gratification exclusively for her husband. But Pushpa is said to hit and argue with her mother-in-law, to speak in public, to spend on useless items and otherwise indulge herself without giving primacy to her husband's needs and her duties towards promoting the welfare of the conjugal home, and furthermore, leaving the house without informing the relevant authority figures, i.e., her mother-in-law or her husband. She shows herself to be wilful and obstinate, contributing to further eroding her essential feminine nature which is already in question. Her lack of a standardised physical comeliness further exacerbates her status of wife and daughter-in-law in her affinal home. By these behavioural and characterological deviations which go against the standard norm of what a woman in her social situation should be, Pushpa opens herself up to the charge of being grossly and dangerously different constituting a threat to the orderly functioning of the family. Her wilful refusal to perform her designated role as an average housewife is re-labelled, reclassified as 'abnormal', 'ill' or 'mad', and her past narratively reconstituted to give elaborative credence to these imputations. However, could her refusal to wash her husband's clothes and cook, and her unwillingness to make tea for the construction workers not be reflective of her perceived disaffiliation from her conjugal family both emotionally and materially?

In fact, the juxtaposition of her own narrative with the above account reveals that it is not only her husband who perceives her lacking in basic feminine attributes, her own assessment of herself is highly, if not exclusively, colored by gender-based evaluative standards appropriate to her social milieu. She regards her deviations not so much in terms of mental or even physical pathology but more as failures to meet a certain ideal of womanhood arising out of external circumstances beyond her control. This view is expressed in no uncertain terms in 'I am a victim of Fate!'

So, although there might be significant differences in assigning cause or motive to the behaviour in question, nonetheless, there is an underlying agreement in evaluating it derogatively by both oneself and others giving credence to Goffman's assertion that at a basic level

> The stigmatised individual tends to hold the same beliefs about identity that we do: . . . His deepest feelings about what he is may be his sense of being a 'normal person', a human being like anyone else, a person therefore, who deserves a fair chance and a fair break (Goffman, 1968: 17).

However, this discrepancy between what one appears to be and what one actually is may be expressed differently resulting in a differential perception of the resulting stigmatisation by self and others. So while Pushpa's husband regards her shortcomings as more or less wilful arising out of basic deficiencies in her nature, disabling her from performing the female roles of wife, home maker, daughter-in-law and mother with their attendant normative expectations, Pushpa herself offers a concrete explanatory model. She believes in the idea that she is not directly responsible for her failing and like any other normal woman she had tried to actualise a feminine ideal, an ideal that she holds more or less in common with her husband, and that her inability to do so is not due to any lack on her part but the direct outcome of her unfortunate circumstances. An acute sense of personal injustice and helplessness permeates her description of her life, especially after her marriage, an account that I have culled together from several long interviews that I held with her in the ward.

From the outset it becomes apparent that Pushpa's domestic life is full of woes. One of the speech samples in her case sheet quoted her as saying in the course of the initial MSE, 'My mother-in-law beats me. She wants me to get raped (*who chahathi hain ke mera rape ho jaye*). My husband wants to prove me mad (*who mere ko pagal ghoshith karna chahatha hai*). He wants to remarry.' When her husband visited her in the ward on the morning following her admission, she pointed

to him and said loudly in the presence of the other patients, their attendants and myself:

He is married to Miss Mona Sharma. He married 3 years ago without my permission. She lives in Hari Nagar. She knows all about it. She is a widow with two children— Gita and Sakshi. There is a murder charge against him. He wants to kill me. He has 'ego sperm.'

When I asked her what was 'ego sperm', she replied, 'That is an illness (*bimari*), if one has sexual relations in childhood.' Continuing in English she said to him, 'You are not my husband, Mr. Rajindra Suri. I am your ex-wife. Get out of my room!' In the grand ward round, she told the doctors, 'His *mataji* said to me on the staircase, "Bitch (*kuthi*), leave my dog (*kutha*) alone!"' The head of the department said to his colleagues, 'What about the hair on her face?' Before anyone else could say anything she responded:

P: Yes, yes, I have hair on my face. My gynecological tests have been done at St. Stephen's Hospital and Medical (All India Institute of Medical Sciences) Testosterone has been done.
Dr: What is testosterone?
P: It's the man's sperms which are weak. There is nothing wrong with me. I'm 100 per cent fit, medically fit. His sperm count is less. That is our personal matter (*gharelu mamla*). No problem . . . police case . . . anti-dowry cell.

However, it was in the course of our acquaintanceship when she came to trust me more that she spoke of her domestic troubles in a succinct, direct fashion, quivering at times with a deep sense of anguish.

P: When there is fighting (*kalesh*) at home, then I can't sleep. My mother-in-law is a cruel lady. I am being 'tortured' by them. I had 'depression' from 30 November 1990 to 31 July 1991.

R: What happened then?

P: In depression I was afraid of water. I felt I shouldn't eat. I would hug and kiss my *saas* (mother-in-law), Mrs. Rajrani Suri. She says to me 'You are inauspicious (*munhoos*). You are a *hijra*. No woman has hair on her face'. My husband says it's because I have 'gents ki qualities'. Anyone can have hair on the face. They beat me. They are mad (*pagal*). He tore up my poems. Then I told him I would have no 'relations' with him.

R: You say that he is having relations with other women?

P: My husband is too sexy (*bhoth jada sexy hain*). I found out about it from Miss Sneh Lata Diwan 6 months after my marriage. Manpreet Kaur was a receptionist in his office: she used to come to the house and my *saas* (mother-in-law) would send me to see what they were doing, she would say to me, 'Make food for these harlots (*in kunjarion ke liyae khana banao*)'. There was also another divorcee Rani Dogra. The girls came to the house. They would hold hands and kiss. He said to me, 'You are old. It's modern times'. (With tears in her eyes) My mother died. My brother was alone. Then he became modern. He didn't like me from the beginning. I don't have friends. They didn't get enough dowry.

R: He said that you didn't cook, nor wash his clothes.

P: He doesn't let me wash his clothes. He doesn't eat food cooked by me. It's a self-made story.

R: How did you respond to this treatment? Did you get angry?

P: These people 'irritate' me. I use to retort back (*jawaab dethi thi*). Sometimes I used to abuse them also (*gali bukthi thi*), but I didn't hit anyone (*haath kabhi nahin utaya*). My nature is 'artistic'. I make dolls, write poems, I tear clothes when I'm angry.

If a woman is socialised into believing that marriage is the goal of her existence and that her identity is dependent upon her relationship to a man, it is easy to understand Pushpa's sense of disillusionment and frustration with her life situation in which she is deprived of both conjugal love and maternal happiness. It is in the light of these circumstances

that she put forward the following solution to resolve her dilemmas, which she voiced to me in the presence of her husband:

> I and Mona Sharma are both *pagal* because of our love for him. I have decided that he will marry her (*Jab mian bibi razi to kya karega kazi*). She will come and live on the second floor, and I will live on the ground floor. Our *saas* Rani will live on the top floor. He will control both of us by being in the middle. In return, I will get the two girls— Gita and Sakshi. Let's not talk about it anymore. The matter is settled.

Goffman tells us that the stigmatised are not passive sufferers who submit quietly to their fate. On the contrary, they devise management strategies in which they try to conceal or underplay as far as possible their failings in order to approximate to the best of their ability the societal standards of normality from which their stigma excludes them. Like most ward patients finding themselves in a discredited position (their failing being known to all those interacting with them in the department), Pushpa did not openly or directly speak of the attribution of insanity, which becomes the sole criterion for immediate admission into the psychiatry ward. Apart from speaking of her 'depression' in the past sense, she only rarely referred to the state of her mind. Towards the end of her stay in the hospital, in response to a doctor's query asking her why she thought she had been brought there in the first place, she said shortly, 'I don't know why I was brought here. I think because I had "mental tension." What illness do I have?' The discredited develop techniques of passing, through which they attempt to control crucial information about themselves in face to face encounters, so as to mitigate the impact of their shortcomings. Pushpa developed several ingenious compensatory techniques. By projecting herself in the light of a wronged wife and victimised daughter-in-law, she was able to shift the onus of responsibility for her plight onto her conjugal family and thus gain the sympathy of the hospital staff especially lower level hospital staff and the attendants of other ward patients. In a

conversation between an ayah and a staff nurse I overheard the latter say, 'No woman can tolerate her husband seeing other women. In Pushpa's place even I would have had a mental breakdown'. The ayah said, 'He is not a good man. One can see it from his eyes.' This goodwill towards her is further enhanced by the infrequent visits of her husband who came once every two or three days. Thus, she was seen in the ward by many as someone who is to be pitied for her tragic plight and her abnormal behaviour is explainable and consequently vindicated in that light.

In her interactions with the doctors, this image of the underdog is further crystallised by her articulate rendering of her situation. Her precise memory for dates, her frequent and correct use of medical terms in addition to the internal coherence and consistency of her account made it very difficult to disbelieve her. Her intelligence rendered her situation even more poignant in the eyes of professional caregivers, and her husband's lackadaisical manner contributed to her gaining their sympathy. In a separate interview her brother had more or less corroborated his sister's account:

Rajindraji threatened to remarry. He told Mona Sharma's parents that he was divorced, but now I think he has realised his mistake. Pushpa is ambitious. She lives in a fantasy world (*kalpana ki duniya*). She wants her husband to behave with her like they do in films.

In the joint situation with both her male kin, the underlying family politics of the situation surfaced, for when the brother timidly answered in response to the doctors inquiries that his sister had told him how she was being physically ill-treated by her husband, the latter burst forth angrily, 'And how long have you kept her? How long did your wife treat her properly? When she came back, she said, 'My brother and *babhi* hit me with a broom. They threw my bag out of the house and told me to leave'. It is not only chronically ill patients who find themselves in double binds vis-à-vis their families and the institution of medicine, practitioners can also find themselves similarly placed as is illustrated by the

young doctor attending on Pushpa. He spelt out his dilemma in the case conference as follows:

> The patient's account is quite genuine. I think her husband is involved with other women. He says that he did file for divorce but he is ready to keep her if she becomes alright. The brother is not willing to keep her.

The doctor is in the impossible position of helping her to cope with an impossible situation which has insidiously contributed to her falling ill in the first place. He neither has the legitimate power nor the requisite resources to alter it or remove her from it.

Another way in which Pushpa tries to pass is by emphasising physical ailments in her interactions with the doctors. When her turn came in the ward round, she would take charge of the situation in a dramatic manner by saying something like, 'Have my urine reports come? Give them to me. My BP has come down to 120/80. You have done your work. Let me be discharged (*Meri chutti kar do*)'. Or 'My eyes ache, my menses have not come. I have difficulty passing stools. I have hair on my face. Why? Send me to Gyne OPD'. Her case sheet was full of referrals to other departments like gynecology, medicine, ENT. Thus, she was effectively able to divert some of the psychiatrists' attention from her mental problems to her physical problems taking advantage of her accessibility to a multidisciplinary medical regime.

With regard to the other more overtly psychotic ward patients she would maintain a clear distance. When her bed had been shifted in her absence and she found a new admission showing signs of florid psycho-pathology sitting on her bed, she rushed into the OPD and said loudly, 'I went to ENT department with Radha (the ayah hired to look after her) and now my bed has been shifted. There is a mad girl (*pagal ladkhi*) on my bed.'

However, as time went on she took on the role of a wise person among her own. She took a special interest in the welfare of an illiterate young woman who was in the same cubicle as herself. The latter had a diagnosis of catatonic schizophrenia. As she had stopped eating for several days,

she had been put on the drip. Pushpa explained to her mother in simple terms what she overheard the doctors say about her daughter during the ward rounds, adjusted her riles tube, and talked to her with great affection. She performed a similar role for several other patients and hence came to serve as an effective mediator in the ward between doctors, patients and their attendants.

Most patients' desire to be discharged from the ward is in direct proportion to the extent to which they begin to view themselves as approximating the normative expectations of their social milieu. In the process of trying to assert their normality, they purposefully engage in those behaviours which testify to the idea that whatever they may have been shown to be in the past, they are presently as normal as anyone else. This involves on their part subtle techniques of impression management consisting of the manifestations of those behaviours and verbal utterances which question the imputations of an identity of insanity. This enactment is made with a watchful eye upon the perspective of what constitutes normality for the members of the family and the hospital establishment, for the collation of both attendants' verbal reports and doctors' mental status examination constitute an accepted measure of the patients' level of normality and fitness for discharge. The patients' own presentation is a tertiary phenomenon in this configuration. However, the fact that mental illness, unlike physical disability, does not implicate standard stigma symbols like a club foot or an unsightly skin lesion, allows the latter more scope for passing in back places like hospital wards and for covering in the outside world.

After one or two weeks in the ward, Pushpa began the process of presenting herself in a manner to demonstrate that she was ready to be discharged. In addition to pleading with the doctors and nurses, social workers and even me for discharge, she asked me: 'Do you see any "abnormality" in me?' And when I answered in the negative, she said: 'Then, get me *chutti* [leave]. Today I'm fine (*bilkul teek hun*), perfectly normal.' She also began paying special attention to her appearance, discarding her husband's clothes (which she had earlier referred to as her night suit, evoking that she

perceived their relationship only limited to a sexual one), and switched to dressing in matching salwar kameez and begging her husband to bring saris from home for her to wear. Furthermore, she borrowed bindi and nail polish from the attendant of one of the patients in addition to wearing some oxidised jewellery which her sister-in-law had brought for her. She also began putting on vermilion everyday. Instead of walking barefoot around the ward, she wouldn't leave her bed without donning her bathroom slippers. Earlier, she had bathed in the ward bathroom with all her clothes on and then changing into clean dry clothes. Now she began bathing normally in the nude. She also stopped moving around the ward aimlessly but began confining herself more and more to her crucible. In addition to modifying her appearance in a socially desirable direction, she also began voicing those desires and aspirations that give the impression that she wished to be a devoted wife, an efficient housekeeper and aspired for motherhood like any other normal woman. She made strategic use of the agreement between the family and the doctors that health for women is defined in terms of their feminine role, a point of view she herself espouses, as seen by her desire to gain her husband's love, to make her marriage work and to bear children. 'I'm not *pagal*. I'll adjust in that house. I'll go home, maintain myself, cook good food. I don't want him to drink and beat me (*maar peet karna*). He'll realise his mistake and then he'll give me *izzat.*' And on another occasion when she was being told to return to her bed during the course of the weekly grand ward round, she burst forth

> Why do I have anxiety (*bechayani*)? Why do my hands tremble? It's due to tension. My husband has told Dr Kumar that he wants me to get well. Will I have to stay here all my life? He says he's changing. Even my *bhabhi* said that his attitude is changing. I'll get adjusted.

And when she was further pressed to leave, she said in a sharp voice, 'I even told him that he could remarry. Honesty is the best policy. Examinations are not a test of ability, I'll gain my health'.

When one of the patients' 2-year-old child was brought to see its mother in the ward, Pushpa lifted the child with utmost care and carried it to the OPD and told the social worker and a group of doctors sitting with her during lunch, 'See I can carry a child. I only want children now.'

And when after three months in the ward, she was informed that she would be discharged, her joy writ large on her face, she hugged me and said excitedly, 'Now each second is difficult for me to pass here. How do I look? I don't even know what happened to me. What illness do I have?' But I wonder what she would have said if she had been told that she was being discharged because she had over-stepped the maximum time period of stay in the ward and that her husband had been told that he could have her admitted in Shahdara Mental Hospital through police certification if she deteriorated further and became unmanageable at home. Obviously, she had failed to reach a satisfactory level of normal functioning from the point of view of the psychiatrists despite her frantic efforts to demonstrate the contrary.

Considerations of stigmatisation and its management centre primarily on the sickness dimension of pathology focusing as it does on the individual's social identity, how others view him/her, i.e., his/her idea of him/herself reflecting how he/she appears to others. Personal narrativisation of experiences of suffering despite its highly subjective nature cannot be rendered meaningful without reference to the social context, being embedded as they are in a network of interpersonal relationships, social institutions and normative expectations. That is why it is so difficult to disentangle the interconnected dimensions and more fruitful to envisage them within an intersubjective universe (Schutz, 1970).

The underlying theme of this narrative of suffering is the overriding role of gender-based evaluations in the evaluation of abnormality both within the family and medical discourses. The fact that the patient herself appropriates these notions in her own assessment and presentation of herself underscores the role of intersubjectivity in the perception of the self. If gender politics impacts so deeply on medical judgments, then the first step in effective therapy lies in the recognition of this dimension in conceptualisations and

practice of medical personnel. This involves at the first level an incorporation of feminist themes in medical pedagogy, a concomitant modification in diagnostic procedures like the mental status examination and a therapeutic orientation that questions the position of women in patriarchal familial institutions in relation to issues of their mental health and well-being.

In this chapter, my attempt has been to present a descriptive account of psychiatric treatment in a concrete medical setting and to show how in its present form, it systematically goes against the interests of the female patients. The most striking feature of this situation is that it almost goes unrecognised in the professional discourse of practitioners and researchers in the area. Mental health personnel have to be made more aware of the class and gender-based biases into which they have been socialised and which they also carry, albeit not always consciously, into their practice.

XVI

WOMEN AND THE LAW ON UNSOUNDNESS OF MIND

Amita Dhanda

The provocation for this article is Davar (1994a, c, 1995) who interrogates the bio-medical thrust of the National Mental Health Programme: Due to its aetiological predilection, the programme concentrates on the severe mental disorders and neglects the common mental disorders. Davar finds this gender discriminatory as women are the major sufferers of the common mental disorders. She therefore demands that the NMHP should shift its focus from the severe mental disorders to the common mental disorders. Instead of relying on the medical establishment alone for relief, other psycho-social support measures should be explored. A mental health policy, she contends, cannot be a footnote to the health policy.

Reacting to Davar's proposal, I had cautioned[1] that seeking a public space for the common mental disorders will only be a mixed blessing. It could cause the common mental disorders to be clubbed with the severe mental disorders and result in persons with the common mental disorders to lose the capacity to control their own lives. This could occur by reason of the all-encompassing legal regime of disqualification. Such a result could occur primarily because mental disorder is seen to render legal capacity questionable. A legal transaction has both a physical and a mental element. The transaction would be enforced in law when both the physical and the

[1] An earlier version of this paper was presented at the National Seminar on Indian Women and their Mental Health, organised by Anveshi, Research Centre for Women's Studies, Hyderabad, 23–24 February 1996.

mental elements are fulfilled. Illustratively, to make the gift of a car, not only must the keys of the car be handed over to the donee but the keys have to be handed over with the intention of permanently giving away the car. If the keys have been handed over but the intention is that the person receiving the keys take a trial run in an automobile of a recent model, the transaction is not a valid gift. This is because the object has been handed over without the necessary intention. Mental disorder, it is believed, could vitiate the mental element of legal transactions. To that end, the state of mind of the doer becomes relevant for assessing the legal validity of a transaction. The presence of mental capacity along with a condition of mental disorder is only marginally accepted. The only place where such simultaneity has been accepted in the Indian law is the provision in the Mental Health Act (S. 20) which allows a person with mental disorder to voluntarily seek treatment.

Davar's response to my apprehension was to say that her suggestions were premised on foundational changes in every discipline interfacing with mental disorder. In the discipline of law this would mean a re-examination of the disqualifying regime as also an analysis of the Indian law for persons with mental disorder from the perspective of women.

In my recent works (1993, 1998, 2000) I have analysed the laws relating to persons with mental disorder. The analysis shows that mental illness has received legal recognition in India for three purposes:

1. To determine the effect of insanity on legal capacity;
2. To contain the disruptive and dangerous manifestations of the condition; and
3. to provide protection to the person with mental illness.

The study finds that these purposes are fulfilled in such manner that the interests of persons with mental illness are continually subordinated to those of society. Even provisions aimed to protect the interests of persons with mental illness provide the protection in such manner that it results in their real or symbolic exclusion from the social fabric. Real exclusion is undertaken by the confinement of the person of

unsound mind, whilst symbolic ouster is achieved by denying legal recognition to the transactions entered into by such persons.

Table 16.1 depicts the various legal contexts where unsoundness of mind could be of relevance. The aforesaid study has examined how unsoundness of mind has been legislatively enunciated, judicially interpreted and litigatively activated in each of these contexts. The study was gender-sensitive but not gender-centric. The laws for persons with mental illness have not been examined from the perspective of women. And yet for any Davar-prompted foundational reordering of the law to be attempted, it is essential that the manner in which women interact with the law for persons with mental illness be mapped out. It is such mapping that this chapter aims to carry out.

Legislations, executive orders and judicial decisions are encompassed within the term 'law'. Legislations and subordinate legislations (except where containing a special provision for women) construct a similar legal order for men and women. Gender variations occur primarily in the implementation of these general norms. Individuation of the general norm of legislation occurs through judicial decisions and to some extent by administrative ones. This chapter therefore, whilst describing legislations, focuses more on adjudication. The chapter does not confine itself to examining how women with mental illness relate with the law, the purpose of the analysis being to gain insights on the direction of law reform. It also records how the laws for persons with mental illness impact on women.

LAWS RELATING TO CARE AND TREATMENT

On the first of April 1993, the Mental Health Act of 1987 replaced the Lunacy Act of 1912 as the legislation regulating care and treatment. The new legislation came on the statute book amidst hectic debate before the parliamentary committee on whether legal regulation of mental health care and treatment was at all required (Committee Report, 1984a).

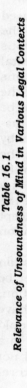

Table 16.1
Relevance of Unsoundness of Mind in Various Legal Contexts

Personal Liberty
- Criminal Law
 - At the time of offence, altered norms of culpability and discharge
 - At trial, postponement of trial
 - On cure, prisoner of unsound mind released
- Institutionalisation
 - Limited duration
 - For treatment up to 90 days
 - For observation up to 30 days
 - Unlimited duration
 - Health and safety
 - Protection of self and others
 - Treatment of mental disorder

Family Life
- Adoption
 - Incapacity to adopt child
- Marriage
 - Incapacity to marry
 - Ground of dissolution

Economic Life
- Contractual capacity
- Management of property
- Probate of will
- Dissolution of partnership
- Practice of profession
- Incapacity to litigate
- Incapacity to hold public office

Political Status
- Exercise of franchise
- To stand for elections
- To retain elected office

This was because presence of a law both stigmatised and delayed treatment for mental illnesses. The mental health needs of this vulnerable populace, thus, would be better met without a law. The debate was concluded by opting for legislative intervention (Committee Report, 1984b). The result of the digression was that valuable committee time was used in discussing the need for a law instead of deliberating on the substantive content of the law.

In view of the disproportionate interest that it generated, it may be apposite to consider whether or not institutionalised mental health care and treatment can be provided in the absence of legislative intervention. Even the most vociferous proponents of the similarity between physical and mental illness have had to concede that there would be situations when a person suffering from mental illness would lack the insight to seek treatment for herself. There would also be instances (howsoever few) when a person with mental disorder may turn socially disruptive, violent or dangerous by reasons of his condition. In both sets of circumstances, the afflicted person may have to be institutionalised compulsorily. Such compulsory and involuntary institutionalisation is a deprivation of her liberty. By the terms of Article 21 of the Indian Constitution, this deprivation cannot take place except by a legislatively provided procedure. Legislative intervention thus is a constitutional necessity.

In the face of this constitutional imperative, the question is only of the nature of the intervention. It could either be minimalist or maximalist. In the minimalist intervention, the law regulates only those matters which mandatorily have to be regulated by it. Article 21 restrictively interpreted would only require a legislation on involuntary commitment.[2] In a maximalist intervention however the legislation would not only be restricted to hospital procedures, it would also re-

2 In *A.K. Gopalan v. Union of India* 1950 SCR 88, the Supreme Court of India laid down that Article 21 prohibited deprivation of personal liberty by executive fiat. If any person was deprived of her liberty then a legislation allowing for such deprivation has to be promulgated. Subsequently in *Maneka Gandhi v. Union of India* 1978 1 SCC 248 the Court has found just a procedure in a legislation to be insufficient. It further requires the procedure to be just, fair and reasonable.

flect and reinforce mental health policy. Community care and institutionalised treatment then are not viewed as discrete services but as integral parts of the mental health system (Curran and Harding, 1978). Needless to point out that such a legislation provides a more positive platform for persons with mental disorder than a minimalist law which reinforces the stereotype of the 'dangerous incurable lunatic.'

This issue of appropriate legislative intervention could be reconsidered after describing how women figure in this legal context. To bring to the fore the various issues surrounding women and institutionalisation, this section starts with a narration of the history of an inmate at the Shahdara Mental Hospital, Delhi, whose case resulted in the apex court being moved in public interest.[3]

S was admitted into the hospital in 1975.[4] Two months after treatment at the hospital, she was married without informing her in-laws about her mental illness problem. After marriage when her in-laws came to know of the mental disorder, she was first driven out and later divorced by her husband.

Subsequent to the divorce, S gave birth to a male child at her parent's house. After the death of her father, she was turned out of her parents' house along with her child in 1978. In a state of wander, she was apprehended along with her child by the police. The child was sent to a children's home and S was admitted to the mental hospital. After treatment for two years she was declared fit to be discharged. Upon both her parents and in-laws refusing to take her back she was sent to the Nari Niketan. Following relapse at the Nari Niketan she was readmitted to the mental hospital this time as a voluntary boarder under section 4 of the Lunacy Act.

[3] The apex court was moved in *PUCL v. Union of India*, W.P. (Criminal) No. 2848 of 1983 to seek redress for certain specific cases of sexual abuse, to address the problem of inmates who continued to reside in the hospital after being declared fit to be discharged and to seek enforcement of minimum living and therapeutic standards in the hospital.

[4] This narration has been extracted from the report of the Deputy Commissioner, Mr R.S. Sethi who was required to investigate the case.

On 15.2.1981 morning S had to be administered ECT but could not be found in her own ward or any of the other wards. She could not be administered ECT and was reported missing. On the evening of the same day S was again in her ward. No medical examination of S was conducted on return. No police report of her being missing was lodged. Instead, the doctor in charged opined that disciplinary action should be taken against the staff for raising a false alarm.

Seven months later S was sent for a medical check-up to an adjoining hospital with a diagnosis of abdominal tumour by the senior medical officer at the mental hospital. The hospital informed that S was seven months pregnant and should be regularly sent to the hospital for ante-natal check ups. S was however not sent for any check-ups. Instead efforts were made to transfer her back to the Nari Niketan. Her voluntary status[5] provided the authorities a legal reason to seriously act on her perennial requests for discharge.

S was in the hospital because she had nowhere else to go, a condition that she shared with a large number of other inmates in mental hospitals around the country.

Another typical example is that of P, a widow whose commitment was ordered by a metropolitan magistrate at Delhi on request of her married daughter, the reason being that the mother lived alone and the married daughter could not provide the constant care and attention that she required. So convinced was the magistrate of her need for institutionalisation that not only was commitment ordered but the hospital authorities were required to obtain the permission of the magistrate before ordering discharge.

The reasons for the abandonment of S were also typical. Daughters even if suffering from mental disorder have to be married off, is the social imperative, an imperative strengthened by the folk belief that marriage could cure the mental disorder. After the ailment was discovered, if her husband

[5] Section 4 of the Lunacy Act 1912 provided that a voluntary patient had to be discharged within twenty-four hours of her making a request for discharge.

decided to divorce her, well, that was her fate. And yet, having performed the marriage the natal family had fulfilled their obligations. In the case of S, her marriage took place even before she had recovered from her illness. The same result could have occurred even with recovery. There are a number of cases where a decree of nullity has been granted upon the respondent's failure to disclose a past history of mental illness. Such suppression, courts have held, was suppression of a material fact which, if disclosed, would have significantly influenced the petitioner's consent to the marriage.[6]

Despite this social scenario, institutional practice is such that even women declared fit to be discharged cannot leave the hospital unless either their families come to claim them or they are escorted back to their families.

Even with regard to rape and sexual exploitation, the case of S seems representative. The People's Union for Civil Liberties (PUCL) report mentioned other cases of sexual exploitation. Many a case was explained away as sexual hyperactivity by the medical superintendent. In the case of the Thiruvananthapuram mental hospital also, it was the collapse of the wall between the hospital and the adjacent police station resulting in the sexual abuse of a number of women patients which had caused the public interest petition on the hospital to be filed in the Kerala High Court. Instances of sexual abuse were brought to focus by the in-service doctor in the case of the Hyderabad Institute of Mental Health.

The non-representative aspect of S's case was the fact that it could not be suppressed. Otherwise, with the noting of 'false alarm' on the case files and the issue of rupees twenty to the sweeper to dispose off the body of the infant, the matter would have been closed. The case of sexual abuse saw the light of day because of the PUCL investigative report

[6] This is how courts have ruled on the matter in *Asha Srivastava v. R.K. Srivastava* AIR 1981 Del 253; *Kiran Bala v. Bhaira Prasad Srivastava* (1982) 1 DMC 327; *Tarlochan Singh v. Jit Kaur* AIR 1986 P&H 379; and *Alka Sharma v. Abhinesh Sharma* AIR 1991 MP 205. Justice Poti in *Daniel v. Sarla* 1976(2) ILR (Ker.) 357 however took the view that 'non disclosure of such circumstances could not be considered active concealment'. It was unrealistic to expect parents to mention such facts at the time of the marriage settlement.

and the subsequent magisterial enquiry. In the absence of such an enquiry, the inmate of a closed institution would have been hard put to even file a complaint of rape or sexual exploitation, let alone, establish it. This is a practical difficulty which is only half addressed by making sexual exploitation not amounting to rape by the head or staff of an institution or hospital, a criminal offence.[7] When charged of raping a person of unsound mind the accused cannot plead consent as a defence. If the case is one of those freak ones where witnesses were present, prosecution on the basis of the prosecutrix testimony could occur if the victim fulfils the testimony standards laid down by Section 118 of the Evidence Act. The Section holds all persons competent to testify unless the court considers that they are prevented from understanding the questions put to them or from giving rational answers to those questions by tender years, extreme old age, disease whether of body or mind, or any other cause of the same kind. Clarifying on the capacity of a lunatic to be a witness, the explanation to the Section provides that, 'a lunatic is not incompetent to testify, unless he is prevented by his lunacy from understanding the questions put to him and giving rational answers to them'. These testimonial inadequacies did not significantly influence S's case because the inquisitorial mode of prosecution was adopted. The magistrate was required to enquire where and how S became pregnant. He put forth the following hypotheses to explain the pregnancy: One, that S went outside and was raped by an outsider. Two, S hid in one of the wards and was raped by a visitor/labourer. Three, she hid in the gardens and was raped by an outsider. And four, she was raped within the hospital premises by the staff of the hospital.

[7] By Section 376-C of the Indian Penal Code 1860 any superintendent or manager of a jail, remand home or other place of custody, who takes advantage of his official position to induce or seduce any female inmate of such institution to have sexual intercourse with him, can be punished for such act with imprisonment upto five years, or fine, or both. A similar provision with regard to members of the management or staff has been made by Section 376-D of the Code. Importantly, this provision does not punish the aforesaid personnel if they use their official position to force the inmate to have sexual intercourse with any other.

He discounted the first hypothesis on the ground that it would have attracted attention. And more importantly, no outsider would have taken the risk of returning her to the hospital. The rape-in-ward theory he discarded because the wards had been thoroughly searched. The rape in gardens possibility was ruled out due to the bald conditions of the lawns. Such may have occurred if there was tall grass as in the monsoon. The magistrate settled on the last explanation that S was raped within the hospital premises by the staff of the hospital. He was confirmed in his belief by the fact that three employees had seen S going to the house of the superintendent along with an ayah. And one other was asked to procure liquor and supply it at the crucial time at the superintendent's house. The subsequent effort to shift out S from the hospital as also the medical neglect to which she was subjected caused the magistrate to state: ' I am of the firm conviction that (S) was raped within the hospital premises.'

However, the name of the actual accused could not be ascertained due to the circumstantial nature of the evidence. To establish individual culpability the magistrate suggested a CBI enquiry. He thought this was necessary because

> the truth must come out and the guilty should be punished. The conduct and action of officials who are supposed to run an important and sensitive institution like the mental hospital should be above doubt. This does not appear to be so in the instant case.

Although demands for a CBI enquiry were bandied about and even the apex court issued orders for disclosure of an already held CBI enquiry,[8] only a joint disciplinary enquiry against the superintendent, deputy superintendent and the chief medical officer was held at the end of the day.[9] All the three officers were found guilty of misconduct whilst the

[8] This order was passed by the court in the PUCL case on 29 April 1987. And yet again on 8 February 1988.
[9] This report was filed by the Delhi Administration in its affidavit dated 2 March 1989.

enquiry officer recommended that the pensionary benefits of the retired superintendent may be withdrawn permanently. The government, subsequent to the employees representation, came to the conclusion that the ends of justice would be met if 10 per cent of the monthly pension otherwise admissible be withheld for a period of three years. Reduction by two stages in the present scale of pay for a period of two years, with further stipulation that he would not earn increments of pay during the aforesaid period of reduction, was the penalty imposed on the deputy superintendent. Demotion to the next lower post for a period of three years was the order against the chief medical officer. Thus, after a long crusade of nearly eight years, other than the ignominy of the enquiry, all that did happen was that the recalcitrant officers suffered some monetary losses. Even this happened because the matter was under the scrutiny of the apex court.

Problem of Wrongful Commitment

One of the classic reasons for legal regulation of institutionalised treatment has been the need to guard against wrongful commitment or 'railroading'. A concern which significantly enough was unequivocally voiced by a woman who had been institutionalised in a state of sanity by her husband. This was because the then prevailing 'lunacy laws' in America allowed a husband to bind over his wife to an asylum without providing her with a right of say or an independent medical examination (Chesler, 1972).

Power of commitment under the Lunacy Act 1912 had to be exercised by magistrates. These orders of magistrates are not reportable nor is access to them easily available. Studies on the functioning of magistrates (Dutta, 1989) have shown the authorities to exercise their powers mechanically and without due application of mind, in many an instance, the clerk of the magistrate using the seal of the magistrate to sanction commitment. Dutta's finding has been endorsed by the Supreme Court Commissions of Enquiry investigating the commitment of persons with mental illness into jails (Supreme Court Commission Reports: 1993 and 1994). These enquiries show the use of confinement for ulterior purposes.

Other than through reports of Commissions of Enquiry, information on wrongful commitment also comes to the fore in petitions activating appellate courts to quash the orders of detention. It is significant that of the five *habeas corpus* petitions filed in the 90s, four have been filed by women. In each of these four cases of wrongful detention, the committed woman was found to be not suffering from mental disorder. The psychiatric detention was procured to oust an inconvenient occupant (*Meera Nireshwalia* 1991 Cri L J 2395); to silence a crusading employee (*P. C. Kakar* 1994 Cri L J 1025); to tame a querulous neighbour (*Ezlinda Fernandes* 1997 AIHC 144); or to curb an effort at independent living (*Anamika Chawla* 1997 3 SCALE 761). The question however is: did these psychiatric detentions take place due to inadequate safeguards in the law? A valid conjecture, considering that in an earlier analysis (Dhanda, 1984) of the Lunacy Act and the Mental Health Bill, I had found the legislations short of fair procedure safeguards. A closer examination however showed that the detentions took place because even the safeguards provided within the law were not observed. In *Meera Nireshwalia*, the commitment was ordered under the aegis of Section 13(2) of the ILA which makes it mandatory on the incharge of a police station to take into custody any person who is *dangerous by reason of Lunacy*. In the absence of any demonstrable proof of dangerousness, the provision cannot be used. And yet, an allegedly dangerous lunatic was summoned by the officer-in-charge to the police station and taken into custody under this provision. It was the adoption of this procedure which caused the High Court to question the claim of dangerousness.

In *Anamika Chawla*, the metropolitan magistrate contrary to the requirement of the Lunacy Act ordered her psychiatric detention on the basis of two verbatim medical certificates without personally examining the alleged mentally ill person. This was done even when Section 18 of the Lunacy Act required the medical practitioners to issue their certificates independent of each other after an independent examination of the 'alleged lunatic'. The verbatim medical certificates were issued by the psychiatrists concerned without any proper medical examination. In fact one of them had not even seen

the supposed patient and the other (by his own affidavit) had only fleetingly met her.

An American study had found (Roth and Lerner, 1974) that when the person to be committed was a woman, both psychiatrists and judicial officers gave greater credence to the version of the male family members. The functioning of the various authorities in the case provides an Indian confirmation of this finding. *Ezlinda Fernandes* demonstrates how a label of mental illness doubly discriminates a woman. In this case, the alleged mentally ill person was sent to the mental hospital for purposes of observation upon the complaint of her neighbours that she was a danger to society. The medical board found that she was of sound mind and not in need of institutionalisation. Her actual discharge from the hospital was at first delayed because the days following the decision of the medical board happened to be holidays. Despite the board finding her sane, the doctor-in-charge considered it better that she should be discharged along with an escort which further delayed her release. Breach of safeguards usually evoke reactions on their futility. It is however important to comprehend that infringement of standards can be remedied only in their presence. When such standards are not provided, to even raise a contention of infringement becomes that much more difficult.

The report of the Supreme Court Commission on the Mental Hospital, Shahdara (1984) found that male inmates received more visitors than female inmates, the visitors being the women relatives, be it wife, mother or sister. Female relatives have been more often found to perform support and care taking roles in hospitals. This allows for less restrictive conditions within the institutions for their wards. The care providing role does not occur only within the institutional set-up. This is evident from their disproportionate presence as victims of crimes committed in a state of insanity, and their scarce use of the ground of insanity to seek a dissolution of marriage.

The above scenario shows that mental hospitals should function as live communities and not as closed institutions. This requires not only procedures for entry and discharge but also policies which both facilitate exit and make it possi-

ble. The reports of sexual abuse and wrongful commitment all the more underline the need for the open functioning of institutions. Institutions which function as supportive communities are needed not just for persons with mental illness but also their carers. Insofar as the role of carers is primarily performed by women, a proactive policy and law on care and treatment is needed for all women and not just women with mental illness. Such an institutional structure would not come into being by merely transferring the authority of making admissions from magistrates to psychiatrists, as was the demand before the Parliamentary Committee. This demand has been conceded to a great extent by the induction of Section 18, 19 and 20 of the Mental Health Act.[10]

The above narrative does show that fewer therapeutic decisions than required are made, merely because the decisions are taken by doctors. For mental hospitals to function as supportive communities, recognition would have to be accorded to every actor of the mental health team, i.e., the psychiatrist, counsellor, the social worker, the family and most importantly, the person with mental illness herself. Such recognition is necessary not just to establish a system of checks and balances but also to facilitate the forging of genuine therapeutic relationships. As things stand, there are procedures in the Mental Health Act which allow for a consensual relationship to be converted into a nonconsensual one. The reverse is however not possible. It is this lack of choice which has been most resented by persons

[10] By Sub-section 3 of Section 18, the medical officer of a psychiatric hospital has been authorised to retain a voluntary patient even after she has been asked to be discharged, provided that within seventy-two hours a medical board of two medical officers agree that such retention is necessary in the best interest of the voluntary patient.
Section 19 authorises a medical officer in charge of a psychiatric hospital or nursing home to admit on the application of friend or relative any person with mental illness who does not or is unable to express her willingness for admission as a voluntary patient.
By clause (a) of Sub-section 1 of Section 20, the medical officer of a psychiatric hospital or nursing home has been authorised to seek from a magistrate long term admission for a mentally ill person for social defence or therapeutic reasons.

with problems of mental illness in their narratives (Porter, 1987). The ground level realities do seem to indicate that deliberations on legal intervention are better addressed around a maximal than a minimal model.

Criminal Responsibility

The criminal trial of an accused who is unable to defend herself due to unsoundness of mind has to be postponed by the adjudicators. In order to make a determination of insanity the adjudicator has been authorised by the criminal procedure code to seek a medical opinion from the civil surgeon or other government designated medical officer.[11] The provision is aimed to promote the norms of fair trial as only the accused can instruct counsel for her defence.

During the period of postponement the accused can either be discharged on surety of safe conduct to a friend or relative, or be kept in safe custody in the jail or mental hospital.[12] The Section provides no time limit for which the trial is postponed. Nor does it in any way facilitate the early resumption of the trial by a right of treatment for the accused.

In the fifty appellate decisions from 1898–1997 interpreting the provision, only three cases involved women-accused. In all the three cases, the women were charged with murder. In two of these cases, assertions of the personal liberty rights of insane undertrials were made. The third only stressed, as in the other judicial decisions within this context, that the procedure under the Section had to be followed when the accused by reason of unsound mind was unable to instruct her counsel (*Satya Devi v. State* AIR 1969 P and H 387).

In *Ambujam v. State of Kerala* (1973 KLT 23), the magistrate ordered the commitment of the accused to a mental hospital

[11] Sections 328 and 329 of the Code of Criminal Procedure 1973 (Cr. P.C.). Substantially similar provisions were included in the code of Criminal Procedure 1898.
[12] Section 330 of the Code of Criminal Procedure 1973.

for medical observation. The Kerala HC struck down the order as it violated the statutorily prescribed procedure and infringed the personal liberty rights of the accused.

In *Daljit Kaur v. State* (AIR 1968 Ori 125) an effort was made to alter the disposition consequences. The accused, it was contended, was of unsound mind not just at the time of the trial but also at the time of the occurrence. Therefore, the magistrate should not frame a charge against her. Instead, as is the case when the right of *privataea* defence is made out, the accused should be discharged. The argument was raised on the strength of the SC decision in *Vadilal Panchal v. Dattatraya* (AIR 1960 SC 1113) where the court had held that when a report of an enquiry under Section 202 of the Criminal Procedure Code 1898 finds that the plea of self-defence made by the accused was correct, the magistrate should not issue process; instead the accused should be discharged. This contention was however not accepted for the defence of insanity.

Public interest actions on the plight of undertrials brought to light the indefinite incarceration of insane undertrials.[13] The petitions also brought to light the practice of keeping women who needed protective custody in jails. The SC decried the practice. Widespread recourse to this practice was again confirmed by the SC Commission (1993) on persons with mental illness in West Bengal jails.

Section 84 of the IPC 1860 making insanity a general defence against criminal culpability provides that

> nothing is an offence which is done by a person who at the time of doing it, by reason of unsoundness of mind, is incapable of knowing the nature of the act or that he is doing what is either wrong or contrary to law.

This provision, since it's inception, till about the 60s has been judicially interpreted in a strict and legalistic manner. From the 60s, however, a medicalised-liberal view has also been propounded by some courts. The strict legalistic

[13] *Hussainara Khatoon v. State of Bihar* (1980) 1 SCC 93 and *Veena Sethi v. State of Bihar* AIR 1983 SC 339.

interpretation stressed that the presence of mental disorder alone did not exempt a person from criminal liability. It was necessary that the disorder should be present at the time of the act. It should have so affected the cognitive faculties of the afflicted person, that he was able to neither understand the nature of the act nor that it was wrong and contrary to the law. To establish unsoundness of mind at the time of the offence, proof of mental disorder both before and after the occurrence was considered necessary. Thus, a diagnosis of insanity a couple of hours after the occurrence was considered insufficient to fulfil the requirement of Section 84. Even evidence of insanity before and after the occurrence was discarded if some action by the accused at the time of the offence showed that he knew the wrongfulness of his actions, such as cleaning the weapon of offence, washing blood stained clothes or fleeing from the scene of crime.

The medicalised-liberal interpretation however discounted the difference between legal and medical insanity. The compartmentalised construction of the mind was not accepted. Thus, once mental disorder was found proved, the impairment of cognitive faculties was presumed. Greater significance was attached to the fact of disorder than to acts committed at the time of the offence.

Out of 237 appellate court decisions studied from 1860–1997, the defence was claimed by women-accused only in eight cases.[14] It was granted in four cases.[15] Of the remaining four cases where it was not granted, in one, the court recommended clemency[16] and in another, the defence resulted in the death sentence being reduced to life.[17] Except for one

[14] *Anandi v. Emperor* AIR 1923 All 327; *Mahajjan Bibi v. Emperor* AIR 1932 Cal 658; *Mt. Sukhni Chamain v. Emperor* AIR 1936 Pat 245; In *re Pappathi Ammal* AIR 1959 Mad 239; *Shanti Devi v. State* AIR 1968 Del 177; *Phulabai Sadhu v. State of Maharashtra* 1976 Cri LJ 1519, *Basanti v. State* 1989 Cri LJ 415 and *Bai Ramilaben v. State of Gujarat* 1991 Cri LJ 2219.

[15] *Anandi; Shantidevi; Phulabai* and *Bai Ramilaben supra* note 14.

[16] In *re Pappathi Ammal supra* note 14 in what the court considered to be a case of puerperal insanity.

[17] *Mt Sukhni Chamain supra* note 14. These offences have been rendered punishable by the Sections 498 A and 304 B respectively of the Indian Penal Code 1880.

case where the woman had killed her husband, in all other cases, the victims of women's crime were children. Only in two cases was any medical evidence of mental disorder produced and in both the cases the defence was accepted. If the percentage of acceptance of the insanity defence for female-accused are compared with those of male-accused, it can be said that the defence has been more often granted when pleaded by women.

One of the problematic aspects of the defence of insanity has been the disposition of the insane-accused. Acquittal does not mean discharge. The court can either discharge the acquittee on a safe custody bond to a friend or relative, or has to ask for the accused to be kept in safe custody in the jail or the mental hospital. The period of safe custody detention is not fixed, and reports of the insane-acquittee being kept in jail for periods longer than for which they could have been punished have surfaced. It is due to this indefinite incarceration that I have contended that the focus of law reform in criminal responsibility needs to shift from the substantive defence to disposition of the insane acquittees. As things stand, whilst the defence does not in fact gain liberty for the insane acquittee, it is commonly believed that insanity has allowed her to escape the consequences of her wrongful acts. A person who cannot be held responsible for her wrongs should therefore not be given responsibility.

Of the four cases where the defence was accepted, in one, the acquittee was ordered to be kept in jail or the mental hospital. In another, no order as to disposition was made. In the remaining two cases, contrary to the terms of the law, the court ordered that the accused be set at liberty.

The procedure for disposition has been constructed as a social defence measure. It has been found problematic because it accords no recognition to the personal liberty rights of the insane acquittee. The reform effort would also need to take note of the fact that in a majority of cases where unsoundness of mind has been pleaded, close relatives have been victims of the crime. Thus, of the 237 cases, in as many as 134, close relatives were the victims of violence, with the wife being the victim in 66 cases.

Cruelty and Dowry Death

The other criminal law context where a woman's state of mind has assumed importance are cases deciding on the criminal offence of cruelty and dowry death.[18] In these cases, the accused-husband has been held nonculpable; in the face of the mental instability, hypersensitivity and mental disorder of the victim-wife, one or two incidents of assault are not likely to drive a wife to commit suicide, hence a conviction for cruelty is not proper. If such a result does occur, it is only because the deceased was unable to adjust herself in the family of the accused. Thus, if after a mild beating by the husband for some domestic quarrel on the morning in question, the wife committed suicide out of disgust as she had a temperament diametrically opposite to that of the accused, the husband cannot be held guilty (*Nilakantha Pati v. State of Orissa*, 1995 Cri L J 2472).

Where evidence of two letters and a prescription was produced to show that the deceased was suffering from some mental illness, the court held that

(p)erhaps she had an unstable personality with a low threshold of tolerance for even domestic friction as is displayed by her beating of children which actually made her end her life. The possibility of such an occurrence creates a doubt, the benefit of which has to be given to the accused.

In *State of Haryana v. Shivnath Rai* (1997 Cri L J 404), the complaint of the father of the deceased was not believed because it was filed after due deliberation and as an afterthought. The version of the defence that the deceased had developed psychiatric depression because she had given birth to three daughters was believed because documentary evidence of the illness was produced.

[18] *Roshan Lal v. Kadembari* 1978 Curr L J (P and H) 579; *V. Balakrishnan v. Lalitha* AIR 1984 AP 225; *Praveen Kumari v. Manmohan Kumar* AIR 1984 Del 139 and *Raj Rishi v. Sudesh Kumari* 1985 Pun LR 334.

In *State of Karnataka v. H. A. Ramaswamy*, Justice Venkatraman of the Karnataka High Court, after a close reading of the diary of a young woman who committed suicide within four years of her marriage reversed a sessions court decision which found her husband, mother-in-law and father-in-law guilty of cruelty. Along with several outpourings of grief, anger and frustration, the young woman's diary also narrated a story of humiliation pursuant to economic dependence. Thus, she says at different points in her diary:

> After marriage what I learnt was that my husband loved not me but my money (the money that was given to me).
> In his opinion I and my daughter are unnecessary expenditure.
> In this house I do not have the authority to feed the guests even once. If anyone from my parental house comes they consider it appropriate to humiliate them or not talk to them. . .
> If I do this it is wrong if I do that it is wrong—listening to radio is wrong seeing TV or cinema is wrong. If I talk to anyone it is wrong, talking or writing in Hindi is wrong. All my talks appeared to be wrong to him. If I say something he would say unnecessary expenditure.
> Even after five years of marriage even on one occasion he has not brought any article sought for by Anu.

Along with the above entries were others where she riles against the callousness of her husband:

> I have become a riddle for myself. I do not mind if no one understands me—but if my husband himself does not understand me then what is the use of living.
> My every dream is shattered into pieces. Possibly his heart has become of stone.
> After marriage I have not spent a day without shedding tears. His special quality is that though he sees me shedding tears he behaves as if he has not seen it.
> He only wants my body but not my mind.

And still other places she worries for her own mental health:

> Slowly my mind is being spoilt—I am losing my ability to think or know—If the situation continues like this it may not require much time for me to become insane. Probably I am suffering from a mental ailment. If he talks to me with love, I feel he has some work to be done and as such he is enacting a drama.

On the strength of the entries in the diary the judge describes K as 'an idealistic girl, highly sensitive and emotional'. The husband he opines, 'appears to be most unromantic and calculative . . . who does not seem to know how to conduct himself with his wife and as to how to win the heart of his spouse'. The judge, thus having explained the personalities, notes that K could not continue with her hobby of painting and embroidery because her husband considered it unnecessary expenditure. On the question of economic dependency, the judge is quick to point out that the first accused had just started his private practice in a rural area; and 'appears to have devoted himself more to the profession possibly because he wanted to build up his career and the deceased has felt that she is neglected'. The problem, the judge holds, was one of incompatibility which was exacerbated by K's mental depression. The conduct of the accused husband might not be that of an ideal husband and he might have failed in his duty to provide love and mental security to his wife, yet, on the basis of the material on record, he could not be held guilty of such wilful cruelty as to drive an ordinary woman in an Indian set-up to commit suicide. Section 498-A is ' not intended to punish those husbands whose wives undergo mental suffering and unhappiness largely due to incompatibility of temperament and attitude'. The issue in *H.A. Ramaswamy* may have been one of incompatibility, but it was also one about the social role allotted to men and women. K's problem was one of the limited female role, whereby the woman is required to obtain all her happiness, from her marriage, from being, in K's words, 'a skilled housewife, a good life partner and an ideal mother'. Inability to perform that role can only mean curtains.

In both *Shivnath Rai* and *Ramaswamy*, the victims of suicide have also been presented as on the borderlines of psychiatric illness. The judgements do not utilise the label of psychiatric illness to explain all the behaviours of these dead women. The diagnosis is however quite unquestioningly relied upon as providing one of the explanations for the suicides.

In *Sunkoji Laxman Chary v. State of A.P.* (1995 Cri L J 2562), the accused was acquitted of the charge of dowry death not just because the deceased was suffering from mental illness, but also because the judge was impressed by the fact that though the deceased 'had mental illness the accused was treating her well and was giving her treatment' (Id at 2564). The above decisions underscore that the criminal law may not be the most appropriate vehicle for the redefinition of social norms of interaction and interpersonal relations. Subjective standards of appropriate behaviour cannot be upheld by the criminal law. At the same time, the cases record the agony, trauma and distress that sex role stereotypes inflict on individual women, who in the absence of relief, found death as the only remedy. The alternative of divorce on the ground of cruelty was possibly not even considered.

MARRIAGE AND DIVORCE

Every religious community has it's own personal law. The Tables 16.2 and 16.3 depict how unsoundness of mind affects the capacity to marry and the continuance of marriage. The tables also show how the scope of the ground has been expanding over the years in Hindu, Parsi and the civil law. The Muslim and Christian laws remain unchanged due to a curious interplay of political and religious factors.

According to the statement of objects and reasons, the scope of the ground was being expanded to keep pace with the growth of medical science. It is presumed that the science of medicine has not only discovered diseases, but also their treatment. For this treatment to be accessed without

Table 16.2
Unsoundness of Mind as Affecting the Capacity to Marry

Hindu Marriage Act (HMA) 1955	Indian Divorce Act 1869
Before 1976	A Christian marriage is voidable if either party was a lunatic or idiot
Neither party is an idiot or a lunatic at the time of marriage	
After 1976	**Parsi Marriage and Divorce Act (PMDA) 1936**
1. is incapable of giving a valid consent as a consequence of unsoundness of mind, or	Unsoundness of mind is not a ground for annulment
2. though capable of giving a valid consent has been suffering from mental disorder of such a kind or to such an extent as to be unfit for marriage and the procreation of children	**Muslim Law** A person of unsound mind cannot contract a marriage and such a marriage, if contracted, is void. However, if the guardian of the person of unsound mind considers such marriage to be in his interest and in the interest of society and is willing to take up all the monetary obligations of the marriage then such a marriage can be performed.
3. has been subject to recurrent attacks of insanity or epilepsy	
The *Special Marriage Act (SMA) 1954* applicable to persons from any religion undergoing a civil marriage has provisions similar to the HMA except that a marriage under the SMA is void	

hesitation, it is essential that the disease should be acknowledged without shame or stigma. The expanding contours of unsoundness of mind in the marriage law impedes this process. The inclusion of epilepsy as a ground of nullity and the induction of the psychiatric classification of disease in the definition of mental disorder are obvious examples. The law has evidently been constructed keeping the interests of the sane spouse in view. It is therefore necessary to examine the gender division of insanity in this context.

A compilation of sixty appellate court decisions till 1997 was made. Of the sixty cases fifty-seven were filed against women. With the liberalisation of the law the number of petitions filed has increased and thus, of the sixty cases, fifty were filed under the Hindu Marriage Act and thirty-four after the 1976 amendment.

Table 16.3
Unsoundness of Mind as a Ground for Divorce

Hindu Marriage Act and Special Marriage Act (Before 1976)	*Hindu Marriage Act and Special Marriage Act* (After 1976) and *Parsi Marriage and Divorce Act* (After 1988)
Respondent has been incurably of unsound mind for a continuous period of not less than three years immediately preceding the presentation of the petition	Respondent has been incurably of unsound mind or has been suffering continuously or intermittently from mental disorder of such a kind and to such an extent that the petitioner cannot reasonably be expected to live with him.
Dissolution of *Muslim Marriages Act* (1939) A muslim woman can seek divorce on the ground that her husband has been insane for a period of two years.	*Parsi Marriage and Divorce Act (1936)* (Before and after 1988) That the defendant was of unsound mind at the time of marriage and has been habitually so up to the date of the suit.

All the petitions for dissolution on ground of epilepsy have been filed against women. The rigour of the ground has been that much increased by judicial interpretation. In *Balakrishna v. Lalitha* (AIR 1984 AP 225), it was argued that a nullity decree should not be granted because epilepsy was a curable disease. With the aid of drugs, the ailment of the defendant was well within control. The court ruled the question of curability or manageable degree of the disorder to be of no relevance in the context of a nullity petition. Hence, once the fact of the disorder was proved, relief had to be granted.

The inclusion of epilepsy and the psychiatric classification of mental disorder does show that the ground has been constructed in medical terms in the legislation. Litigants attempting to establish the ground do not rely on medical evidence alone. Behaviour departing from sex role stereotype has often been put forth as evidence of insanity. The respondent wife's inability to cook,[19] her refusal to allow consummation of marriage on the first night,[20] crying in front

[19] *Jagdish Prasad Sharma v. Shashi Bala* FAO 179/75 decided on 5.8.1977.
[20] *Anima v. Mohan Roy* AIR 1969 Cal 304.

of guests at the wedding reception,[21] rude treatment of the husband's relatives,[22] poor house management,[23] and disobedience of elders[24] have been contended to show mental disorder. In some cases allegations such as these have been the basis of obtaining relief from original courts.[25] In a few cases original courts have granted divorce merely on the affidavit of the husband alleging unsoundness of mind.[26] Even where the court conceded that the alleged abnormal behaviour may not signify unsoundness of mind, it simultaneously insisted that such behaviour constituted legal cruelty (*Uma Wanti v. Arjan Dev*, AIR 1995 P and H 312). In contrast, when women in defence of the allegation of unsoundness of mind have contended that their mental condition was precipitated by spousal torture, courts have not refused relief on the grounds that the petitioner cannot take advantage of his own wrong. And yet, in *Shanker Prasad Pal v. Sabita Pal* (1995 AIHC 2707), a husband whose mental condition was suspect sought divorce on the grounds of cruelty. Relief was refused on the rationale that he could not take advantage of his own wrong. This decision makes one wonder whether relief would have been granted to the women in the dowry death cases if they had sought divorce on grounds of cruelty.

In view of its disproportionate and inappropriate use against women, should the deletion of mental illness on the grounds for divorce be recommended? Abandonment of women by reason of insanity will not cease with just this blanket withdrawal (Dhanda, 1992). The law needs to be reformed in such a manner that it improves the negotiating spaces for women with mental illness. Taking the issue out of the aegis of the law would mean that the empowerment which could be obtained from it is being relinquished, a situ-

[21] *Pronab v. Krishna* AIR 1975 Cal 109.
[22] *Supra* note 20.
[23] *Santosh v. Nandan Singh* 1980 HLR 528.
[24] *Alka Sharma v. Abhinesh Sharma* AIR 1991 MP 205.
[25] See for e.g. the original court decision in *supra* note 23.
[26] *Asha Rani v. Amratlal* AIR 1977 P&H 28; *Durga Bai v. Kedarmal* 1980 HLR 166 and *Meena Deshpande v. Prakash Deshpande* AIR 1983 Bom 409.

ation which persons with mental illness, and more particularly women with mental illness, can ill afford. Consequently, the following suggestions for change are being made.

To prevent a colourable use of the law and to grant relief to unworkable marriages, it is suggested that the process of liberalisation should be reversed. Extrapolating from Section 19(b) of the PMDA, the petitioner should be allowed to seek annulment of marriage if the respondent was of unsound mind at the time of marriage and continues to be so till the filing of the petition. The limitation for filing of the petition should not be one year from the discovery of ailment but one year from marriage. By virtue of this formulation the consent component of marriage may be diluted as some marriages contracted without capacity to consent may be validated. In a country where both the contracting and continuance of marriages is more a family than an individual decision, such dilution should be culturally acceptable (Derett, 1970).

Law should not discourage persons from seeking mental health treatment, rather it should perform a promotive and facilitative role. The judicial decisions on past mental illness and treatment could discourage persons with mental illness from seeking succour. It is therefore suggested that an express legislative provision should be incorporated which states that a past history of mental illness will be no bar to marriage; failure to disclose such past history or the fact of treatment would not amount to suppression of a material fact. The NMHP (National Mental Health Programme) states that epilepsy is a curable condition manageable within the community. In order that the marriage provisions do not discourage people from seeking treatment for this ailment, the epilepsy clause should be repealed.

The *liberalised* legislative principles accord greater protection to the interests of the sane spouse. Legislative norms which would further the interests of the mentally ill spouse are not articulated. Unsoundness of mind is not a matrimonial fault. Allowing divorce on the grounds of unsoundness of mind accords recognition to a breakdown situation. However, in order that this provision should protect the interests of both spouses, it is essential that two provisions should be legislatively incorporated.

One, it should be provided that the petitioner can seek matrimonial relief only after full medical treatment is obtained for the respondent. However, if the respondent refuses treatment, the petitioner should be allowed to move the court immediately. And the court should be legislatively empowered to seek expert advice before arriving at a decision.

Two, even after the requirement of the law is satisfied, divorce should be granted only if a full-fledged maintenance arrangement for the spouse with mental illness is made. The need for such an arrangement was clearly evident in *Gnanambal* (1970 MLJR 430) where the respondent, after five children and years of marriage, was afflicted by schizophrenia which even after continuous treatment could not be cured. The requirements of law were satisfied, divorce was granted, and the ill spouse was left totally in the lurch. Arrangements for financial compensation, therefore, seems eminently necessary, especially in view of the fact that a majority of the divorced spouses are women. Also the requirement of financial compensation should discourage the use of this provision for ulterior purposes.

ECONOMIC LAWS

In this context stand included the laws regulating capacity to contract management of property, capacity to litigate and testamentary capacity. A fit mental state is an integral component of each of these capacities. There are differences in the scales of capacity required for each transaction. Accordingly, there are variations in the degree of mental disorder which would displace the presumption of capacity.

Capacity to Contract

A person possesses the capacity to contract if at the time when she makes it, she is capable of understanding it and of forming a rational judgement as to its effect upon her interests. A person who is generally of sound mind may not enter into a contract when of unsound mind. And a person gener-

ally of unsound mind, even an inmate of a mental hospital, may enter into a contract during a lucid interval. By a process of judicial interpretation the contract of a person of unsound mind has been declared to be void *ab initio.*[27] The consequence of such absolute incapacity is that a person of unsound mind cannot even enter into a contract which is beneficial to her interests.

The number of cases where women figure as makers of contracts which are questioned on ground of their mental disorder are few and far between. In these few cases the matter is in court because the economic interest of someone else is in jeopardy. In *U. Aung Ya v. Ma E Mai* (AIR 1932 Rang 24), an old woman who suffered from xenophobia executed a mortgage deed in favour of her son. The deed was challenged by her daughter on the grounds that her mother lacked mental capacity. In *Mahendra Pratap Singh v. Padam Kumari Devi* (AIR 1993 All 143), the power of attorney granted by a seventy-year-old lady to her grand-son-in-law was being challenged by her son and daughter. In this battle for the management of the property between her close relatives, the old lady emerges as a paralysed player, a player whose interests come to be protected due to some vigilant and innovative adjudication. The court through unceasing persistence first found out that the mental faculties of the old lady were impaired due to age. Consequently, the power of attorney issued by her no longer remained valid. It appointed the district collector as the guardian of the old lady till her children obtained court authorisation. Arrangements for necessary medical services were also made by the court.

Women figure in greater proportion as litigants. Either as oustees impugning contracts or as beneficiaries upholding them. Thus, in *Govindswami Naicker* (AIR 1940 Mad 73), a

[27] In English law the contract of a person of unsound mind is not void but voidable at the option of the person of unsound mind, and this, if the other party had notice of her incapacity at the time of making of the contract. This position prevailed in India before the decision of *Mohoree Bibi.v. Dharmodas Ghosh* (30 I.A. 114) when the Privy Council held the contract of a minor to be void *ab initio.* In *Kamola Ram v. Kaura Khan* [(1912) 15 I.C. 404] without a full consideration of its effect extended the same to contracts of persons of unsound mind.

settlement made by the father in favour of the daughter was at issue. It was challenged after the death of the father on ground of the mental incapacity of the father. The daughter however defended it claiming that the father was sane. In *John Eric* (Civil Appeals 3332 and 3333 of 1982 decided on 3.3.1989), the mother of the person alleged to be of unsound mind sold property owned by her son. The transaction was challenged by the sister on grounds of her brother's insanity. And in *Amina Bibi v. Saiyid Yusuf* (AIR 1922 All 449), the validity of a lease was contested between the son of a lessor and the wife of the lessor's manager after the death of the lessor, the son contending that his father was of unsound mind when he granted the lease.

Capacity to Litigate

The code of Civil Procedure 1908 (Order XXXII) provides that if a person due to mental infirmity or unsoundness of mind is unable to file a petition herself then the same may be filed on her behalf by a next friend. Similarly if a petition is filed against her and she is unable to defend her case due to mental incapacity then a litigation guardian may be appointed for her. Allowing a petition to be filed by a next friend as well as the appointment of a litigation guardian has to be undertaken by the court after necessary enquiry.

In the litigational incapacity context, no special findings emerge for the women litigants. There are no special presumptions of incapacity because the litigant filing the case or defending it is a woman. Cases where allegations of insanity are made against the defendant to obtain forensic advantage are practised against women litigants as much as it is done with other litigants. Thus, for example in *K.C. Sivasankar Panicker v. P. Ravindranath* (1988 2 Ker LJ), the husband who was seeking a divorce on grounds of unsoundness of mind wanted that the petition should be defended by the father of the wife. The one gender imbued decision in this context was the ruling in *Markoo v. State of U.P.* (AIR 1978 All 551) where the eviction suit against an incompetent tenant was proceeded with after appointing his wife as *guardian ad litem*. The suit resulted in an order of eviction being passed.

The tenant, subsequent to regaining capacity, contended that a guardian capable of protecting his interests had not been appointed. The court accepted this contention, set aside the eviction order and directed a fresh trial.

Testamentary Capacity

Section 59 of the Succession Act 1925 lays down that every person of sound mind not being a minor may dispose of her property by will. In making a positive demand of a sound mind and not just the absence of an unsound mind the requirements of Section 59 are similar to those of Section 12 of the Contract Act. However, contractual capacity has been adjudicatively negated only if the party is, due to mental illness, unable to understand the terms of the contract and its effect on her interests. But for the negation of testamentary capacity, factors other than actual mental illness have also been found relevant. The notion of sound mind is more holistically construed in this context.

Again here, as in the contractual capacity context, not too many cases were found where wills made by women were the subject of challenge.[28] There are three significant cases, however, where women who were disinherited by the testament challenged its validity on the ground that the testator lacked soundness of mind.

Thus in *Suradhani Debya Choudharani v. Raja Jagat Kishore Acharya* (AIR 1939 Cal 379), the testator made a will whereby he bequeathed his property in favour of a distant collateral whilst excluding his mother and younger brother. The mother challenged the will on the ground that her son had an irrational delusion that the property belonged to the collateral and was wrongfully usurped by his branch of the family. The deluded feelings also extended towards her as without any factual basis he had a strong aversion for her.

The court found that the mother and son had continuously wrangled over the management of the property of the testator and the mother had even initiated inquisition proceedings against the testator and his brother. Further, there

[28] *Brahmpal Singh v. Ram Dulari* AIR 1981 NOC 32 is one such case.

were strong rumours that the mother had been unfaithful to her husband and the testator had found her in a compro- . mising position, which caused his strong dislike towards his mother. It was held that the exclusion of the mother was not based on delusion as the feeling of aversion towards the mother had a basis in fact. The brother was not made a beneficiary because he would not get married and the property was given to the collateral so that it would remain within the family, Also, with a codicil, the testator made provision for the maintenance of the mother. In these circumstances the contention of lack of testamentary capacity was not upheld.

In *Rajeswhare Rani v. Nirja Guleri* (AIR 1977 P and H 123), the wife challenged a will from which she had been disinherited on the grounds that the husband was a schizophrenic who had made the will in a state of mental disorder. The court, however, found that the relations between the spouses were very acrimonious, consequently the exclusion of the wife was justified. In *Kamla Devi v. Kishorilal*, the issue was which of the two wills executed by the testator was valid. The earlier will excluded the wife because he doubted her fidelity but made provision for the daughters. The later will excluded both the wife and the daughters. The second will which was executed after long illness and near the time of death was held invalid as the exclusion of the minor daughters was unnatural and suggested lack of mental capacity. The first will which excluded the wife was however found valid. It was held that even if the suspicions against the wife were the result of an extremely jealous disposition, it did not negate testamentary capacity. It is interesting to note that an extremely jealous disposition was not considered abnormal by the court.

Appointment of Guardians for Management of Person and Property

The Lunacy Act till 1993 and now the Mental Health Act 1987 contain a procedure whereby if a person who owns property is unable to manage herself or her property due to

unsoundness of mind, then a guardian for the person and a manager for the property can be appointed. Application for such an appointment can be made by any relative before the District Court. Once such an appointment is made, a person with mental illness cannot act for herself even during a lucid interval. Under the Lunacy Act legal heirs were not to be appointed as guardians of mentally ill persons. The Mental Health Act discourages the appointment of such persons, both as guardians of mentally ill persons and as managers of property. The statute contains elaborate instructions on how the property of the incapacitated owner is to be managed. Decisions with regard to the person, even major intrusive ones, have been left entirely to the discretion of the guardian. Thus, Section 81 of the Mental Health Act provides that a person with mental illness may be used as a subject of experimental research which may not directly benefit her, provided that the consent of her guardian has been obtained.

Possibly because the procedure has been made available for owners of property, not very many appellate decisions could be found where guardianship arrangements were being required for an incapacitated woman owner. Here again women figure in a major way as seekers of guardianship arrangements. Thus, of the forty-nine cases compiled between 1869–1990 in as many as eighteen of them, whether in the capacity of mother, sister, aunt, wife, niece, sister-in-law or concubine, women were seeking guardianship arrangements.[29] In one case, primarily on the criterion of the best

[29] *Manohar Lal v. Gouri Shankar* (1877) 1 ILR (All) 476; In re *Joga Koer* (1903) ILR Cal 973; *Amir Kazim v. Musi Imran* (1916) ILR All 158; *Anilbala v. Dhirendernath* AIR 1921 Cal 309; *Dada v. Chandra Bhaga Bai* AIR 1929 Nag 93; *Teka Devi v. Gopal Das* AIR 1930 Lah 289; *E.M. Dawood v. Ma Khatoon* AIR 1934 Rang 164; *Mahipati v. Mt Changana* AIR 1934 Nag 27; *Sesha Ammal v. Venkatnarsimha* AIR 1935 Mad 91; *Lalitha Devi v. Nathuji* AIR 1939 All 333; *Joshi Ram Krishna v. Rukmani Bai* AIR 1949 All 449; *Ganga Bhavanamma v. Somairaju* AIR 1957 AP 938; *Rambhabai v. Rukminibai* AIR 1957 M.B. 96; *Sarjug v. Gulab Koer* AIR 1969 Pat 33; *Kesava Pillai v. Kamalammal* AIR 1972 Mad 1; *Lingaraj v. Parvathi* AIR 1975 Mad 285; *Thiruvalluramal v. Kullachiammal* 1977 (1) MLJ 306 and *Peter Thompson v. Tresa* AIR 1984 Ker 35.

interest of the person with mental illness, the concubine of the person of unsound mind was appointed as his guardian in preference to his children from his first wife (*Kesava Pillai v. Kamalammal* AIR 1972 Mad 1). In *Sesha Ammal v. Venkatanarsimha* (AIR 1935 Pat 423), the woman who had been gifted property by the 'alleged lunatic' objected when the father of the donor sought a declaration of unsoundness of mind and permanent guardianship arrangements.

The utilisation pattern again brings to the fore the fact of marriage being used as a means of obtaining caretaking arrangements for men of weak intellect.

POLITICAL STATUS LAWS

Unsoundness of mind when declared by a competent court can deprive a person of the right to vote, to stand for election and to hold public office. Uncertainty persists as to which court is competent to grant a declaration by which a person of unsound mind stands deprived of the right of franchise (Dhanda, 1993). There is no record of persons being deprived of the right to vote because of unsoundness of mind. Persons staying in mental hospitals including persons fit to be discharged lose their franchise rights, not because of unsoundness of mind but because their stay in the mental hospital does not make them residents of the hospital. Therefore, they will not be registered in the electoral roll of the constituency where the hospital is situated. And without such registration, franchise rights cannot be exercised. Consequently, the political leverage which inmates of mental hospitals can exercise is denied to them, a matter of special significance to women because a large number of them are in mental hospitals because they have nowhere else to go.

Just the fact of obtaining psychiatric treatment does not result in a person losing the right to hold public office. Here again a declaration of unsoundness of mind by a competent court is required. In *O.P. Saxena v. State,* an abortive attempt was made to use this ground to unseat Prime Minister

V.P. Singh.[30] The case shows the universal vulnerability to the ascription of insanity, a matter which could be of political relevance to women, if the 33 per cent reservations law comes through.

This survey of how women figure in the law on unsoundness of mind provides insights on the future direction of law reform. It also yields some data on the status of women and the mental distress faced by them. The analysis brings to the fore the fact that in a number of contexts the law operates on the logic of sameness. The consequences which have been documented in relation to incapacity to stand trial or incapacity to litigate differed in no way when the accused or the litigant was a woman or a man. Thus, in *Ambujam v. State of Kerala*, the woman undertrial was sent to a mental hospital for a medical examination. The same procedure was followed in *Dhani Ram V. State* (1982 Cri LJ 661) for a male undertrial of unsound mind. And all this happened without any questions on the infringement of personal liberty even being raised.

My earlier analysis of the law on the insanity defence has found the disposition procedure highly problematic insofar as it made the person of unsound mind pay the costs without the benefits of a responsibility-oriented criminal justice system. A special focus on the victims of these wrongful acts in this survey has brought home the fact that the social defence compulsions cannot be ignored in any law reform effort.

The care and treatment context underscores that it is social needs rather than psychological ones which dictate recourse to institutional facilities. For these social needs to be addressed in a manner less extreme than detention in a closed institution, it is essential to diversify the services options and to dismantle the closed door. On the legal front, such

[30] Lunacy Petition No. 6 of 1990 was filed by the president of a civil rights group alleging that Mr V.P. Singh, the then Prime Minister of India, had been found to be of unsound mind subsequent to an inquisition in 1952. The certification order had not been revoked. In the absence of decertification, the order determining unsoundness of mind subsisted and this disqualified Mr Singh from holding public office.

opening up would require a closer look at the norms regu-
lating access of the community to the hospitals.[31] Do these
have to be constructed on a presumption of mistrust and
suspicion? For such procedures do successfully isolate the
inmates of institutions whether or not they safeguard them.

The rules of discharge by which institutions see themselves
only as custodians of families also merit a re-examination.
In the face of family rejection, institutional organisation and
provision of care and treatment has to be so undertaken
that it facilitates exit. Such a result cannot be achieved just
by allowing persons with mental illness to seek their own
discharge if certified as cured by a psychiatrist, as has been
done under the Mental Health Act. Conditions which facili-
tate exercise of the choice of exit need to be created.

The substantial presence of women in the cases where
guardianship arrangements are being desired shows the extent
to which women acquire economic status as surrogates for
men. Economic dependence emerges as a source of distress
both in the cruelty cases and the marriage decisions. The
need to access institutions of whatever kind as places of
refuge again highlights this dependent status. The narration
of trauma and unhappiness in the cruelty, dowry death and
divorce cases show the life threatening proportions mental
distress assumes in the matrimonial context. The case for
psycho-social interventions answering to these distress calls
is thus further strengthened.

My study on the laws relating to the mentally ill (Dhanda,
1993, 2000) has shown that the legal order in this area has
been constructed purely to protect society from the dangerous
and dysfunctional consequences of mental disorder. The
effect of these arrangements on the life and liberty of the
person with mental disorder have not been considered. The
study emphasised that such legal ordering of mental disor-
der reinforced negative attitudes and enhanced the stigma
of the condition, a factor which significantly affected both
the accessing and the negotiation for mental health services.

[31] For example in Delhi special permission from the Secretary (Health) is
required before any member of the public can visit mentally ill persons
in mental hospitals.

Strategies of destigmatisation were required. Whilst these strategies need not be law-exclusive or even law-centric, law should constitute an integral component. To that end, the existing laws relating to mentally ill persons need to be recast from a rights perspective. A legal recognition of the basic human rights of persons with mental illness would enhance their status whilst promoting the destigmatising effort.

The above gender-based survey of the laws on unsoundness of mind has reinforced the necessity of this law reform exercise. Further, as the study concerned all women and not just women with mental illness, the interests of society have also received representation. Insofar as women emerge as the major carers of persons with mental illness, the society that they represent is a caring one. The perceptions of a caring society could more usefully assist in the construction of an equitable law for persons of unsound mind. Such a law is needed by all persons with mental illness, and women are in need of such law, both as sufferers of mental illness as well as carers of mentally ill persons.

XVII
THE MEDIA AND WOMEN'S MENTAL HEALTH

Ammu Joseph

> Mental health is the capacity of the individual, the group
> and the environment to interact with one another in ways
> that promote subjective well-being, the optimal develop-
> ment and use of mental abilities (cognitive, affective and
> relational), the achievement of individual and collective
> goals consistent with justice, and the attainment and pre-
> servation of conditions of fundamental equality (Canadian
> Report, 1988: 2).

If that is the case, it is not surprising that mental health
eludes a large number of women worldwide. The inter-
national mental health establishment has moved a long way
towards a greater understanding of the gender dimensions
of mental health. The WHO acknowledges that the distribu-
tion of power among individuals, groups and their environ-
ments is a crucial determinant of mental health. Recognising
the links between mental disorders, on the one hand, and
alienation, powerlessness and poverty, on the other, the WHO
points out that the latter conditions are most frequently ex-
perienced by women. According to the WHO:

> The last decades have seen increasing recognition of the
> pervasive and destructive effects of gender inequalities and
> the stresses that differentially affect women by virtue of
> their unequal social status, especially in their family roles
> (Dennerstein, Astbury and Morse, 1993: 3).

As a result of such insights, the social, economic and, to some extent, cultural origins of psychological distress in women have received legitimate attention in recent times. However, the role of the mass media in promoting or endangering the mental health of women has been inadequately explored.

Yet, the mass media have assumed an extremely powerful role in human society. They are possibly the most pervasive and potent purveyors of culture in the modern world. They are also major agents of socialisation. Today the media are increasingly playing the role once played by family, community, religion and formal education in shaping values and norms, attitudes and behaviour and in influencing the very process of living.

The Indian Readership Survey 1998 provides a glimpse of the extent to which the modern mass media, particularly television, have penetrated Indian society. According to a report on the findings of the survey,

Television has the largest reach among the various media available in urban and rural India. As many as 45.5 per cent of the people have access to TV as compared to 33.3 per cent to print media, 19.7 per cent to the radio and a mere 19 per cent to cinema. In urban India, 75.4 per cent watch television, 58.1 per cent read newspapers and magazines, 29.5 per cent go for cinema and a dismal 21.1 per cent listen to the radio. In the rural areas, 32.8 per cent watch television, 24 per cent depend on the print media, 19.2 per cent have access to radio and 15.1 per cent are exposed to cinema (*The Hindu*, 19 October 1998: 14).

In this paper I make a tentative effort to highlight the possible ways in which the media can have an impact on women's mental health. In addition, I briefly present some preliminary impressions about the manner in which the media tend to handle issues relating to women's mental health. My reflections here are based on my experience as a journalist and media watcher.

There is, today, a growing recognition of the fact that one of the several sources of the stress experienced by women in

their daily lives is gender-based stereotyping. According to the WHO, sex role stereotyping limits the roles for women, requiring greater role adjustments from them than men. That stereotyping adversely affects women's health, both physical and mental, is now widely acknowledged. The media have always purveyed and continue to perpetuate gender-determined roles and stereotypes. While the specific characteristics of these roles and stereotypes naturally undergo some change over the years, they continue by and large to be rigid, limiting, unreal and, to that extent, potentially damaging to women's mental well-being.

Many media messages not only reinforce traditional sex role stereotypes but create new ones. For example, product advertisements were once dominated by images of women as mother, housewife, wife or girlfriend, decorative item and sex symbol. Today, while some of these images persist, others have undergone superficial modifications, ostensibly in keeping with the changing times. New avatars of the housewife image reveal this trend. While the majority of ads in India continue with the traditional image of a full-time housewife, a newly popular image is that of a 'career' woman cheerfully, single-handedly and efficiently shouldering the double-burden of gainful employment and housework—with a little help from a growing range of domestic appliances, of course. In both types of ads, gadgets tend to be glorified as symbols of love. They promote two forms of love: love between the husband and the wife—symbolised by the presentation by the former to the latter of these 'labour savers'—and love between the woman and her 'kitchen companions', i.e., gadgets. An example of the former is contained in a print ad which used to appear a few years ago. The visual showed a harried housewife struggling with her household duties while the copy asked: 'Is this what you promised your wife on your wedding day? Now let the real women's lib start in your home . . . (with X wet grinder).' More recently, a new brand of 'world class home appliances' was advertised in magazines with a copy that offered 'Five ways to romance a woman: Lexus heating appliances. Just one of the ways to melt the coldest of hearts Five sure ways to show her you care . . .' Similarly, a luxury brand of wall paint was

promoted with a man spouting the lines, 'Because you're the pearl in my life, what else can I give you but pearls?' The copy continued: 'Velvet Touch creates the most luxurious finish on your walls: the glow of pearls. Special as the love you share.' The concept of an actual relationship between woman and gadget is unveiled in a series of print ads for a washing machine. In one, the copy said: 'Clean. Quiet. Tangle free. Are you ready for the relationship?' In another, the visual of a man and a woman was accompanied by copy which proclaimed:

> Finally, a strong, silent type you can take home. Finally, a perfect partner for your home. One that fits right in and makes living a joy. An LG Chaos Punch Washing Machine—for the cleanest, quietest, tangle free wash. Don't wait too long. Strong, silent types aren't easy to find.

The reference to 'women's lib' in the wet grinder ad is just one example of an ongoing tendency to subvert the struggle for women's empowerment to serve commercial ends. It goes without saying that ads such as those described above have the potential to create false expectations and feelings of dissatisfaction and frustration. They also promote bankrupt notions about love and its manifestations. None of this is conducive to mental well-being.

But what is even more worrisome is the fact that they distort reality by suggesting that a wide range of home appliances will keep a woman happy, that all a woman needs to run a comfortable, happy and efficient home are these domestic devices, that gadgets 'liberate' women from housework, and so on. Many women in the West, who have had a longer history of being seduced by such ads, hold that what these appliances actually do is to increase the range of tasks in individual kitchens and, therefore, increase the volume and variety of work to be done by individual housewives. The relevance of this debate in the present Indian context may be questioned, particularly in view of the continuing availability of paid domestic help. Still, a great deal more seems to be expected of housewives here now that they are

equipped with multi-channel television sets as well as so-called labour saving devices.

For example, going by the cookery programmes on satellite TV channels—even indigenous ones—it is clearly not enough any more to be proficient in traditional cuisine. To win recognition as a good cook (which is, of course, seen as an essential part of being a good housewife, mother and wife), a woman now has to learn how to make exotic and not-so-exotic dishes from around the country and the world. This usually necessitates the extensive use of kitchen appliances and unfamiliar ingredients, including packaged food products. It is clear whose commercial interests are being served by this globalisation of cuisine.

From the mental health point of view, such expectations are likely to place additional pressures on women already suffering from the multiple burden of work and responsibility. This can lead to anxiety and feelings of inadequacy, especially in those women whose self-esteem is in any case fragile. Besides, it is a matter of concern that these ads propagate the false notion that machines can relieve women of all the tedium of housework and, what's worse, absolve men of their domestic responsibilities.

In addition, the idea of the woman as a loving, sacrificing, selfless caregiver—with no identity or needs of her own—is encouraged by a number of press ads. 'Does your refrigerator care as much about your children's health as you do?' asked one. 'You care deeply about keeping your family healthy . . . LG Refrigerators work as hard as you, to take care of your family's health.' There was, of course, no mention of the woman's own health. 'Why let a bodyache prevent you from caring for all those you love?' queried another ad. The visual showed a daughter tending to the ailing mother as the copy went on to suggest, 'Soothe away bodyaches with Zandu balm. Get her back in action—fast!'

Certain new themes in ads place a different set of pressures on the new, improved, modern version of the Indian woman. One is the importance of preserving youth or, atleast, youthful looks. As the print ad for the Senorita Miss World Collection of sandals put it, 'Hey Woman! Stay Girl'. Another is the undermining of the notion of freedom. For example, an ad for

a brand of disposable contact lenses in a glossy magazine exulted: 'Talk about the freedom to do what I want to. When I want to.' And exhorted: 'Pick it up. It sets you free.'

The pseudo freedom and liberation themes extend to the sexual arena too. With many ads now advocating sexual abandon, the modern Indian woman is called upon to free herself of sexual inhibitions, if nothing else. The controversial ads for condoms (Kama Sutra et al.) are not the only vehicles for such messages. For instance, a recent press ad for bathroom fittings featured a steamy visual of a couple in a clinch and the question: 'Where is it written that you can't use a bathroom for some other purpose?' 'Hindware'; it continued, 'Elegant, evocative, stirring, sensuous. But why are you blushing?' Some ads even project the idea of the woman as sexual aggressor. A recent series of print ads for jeans—'552 Tight Jeans = dan*ger-ous'—promoted this fantasy. The visual had a clearly vulnerable, distressed and disheveled young man cowering at the feet of a predatory woman standing, in a faintly menacing pose, over him and between his legs. The copy went thus:

> MIND: The urge to devour partner can be traced to behaviour of the Black Widow Spider (a creature that, after mating, consumes male). BODY: Notice how tight fit of 552 jeans accentuates female curves, sending out dangerous sexual signal to male of species; male is then lured into tight situation by female's bold display of abdomen, exposed by the sexy low-rise out of 552 jeans. Male is rendered helpless. JEANS: look for lethal curves of indigo denim; protruding rivets on hips: distinctive Red Tab mark on right buttock.

And the final message was:
'Levi's. The original body language.'

A recent press ad by a multinational bank exemplified many of the often contradictory messages sent out to women through advertisements today. Its theme: 'Time management. Diplomacy. Mathematics. Even juggling skills to run a home. Now, a little help from a credit card exclusively for you. Citibank presents the first ever card designed specially for

women'. The copy went on to valorise the traditional, gender-based division of domestic labour and trivialise the tasks and decisions involved in housework and home management:

> Only you know what it takes to run a home. Tackling what seems like a million jobs in 24 hours. Diplomatic skills (telling your mother-in-law tactfully why you can't come over for the weekend). A head for numbers (after all, the monthly budget demands it). And, of course, amazing juggling skills (should you buy that table lamp or a pair of sports shoes for your little one?)

At the same time, acknowledging that the woman could be working outside the home and reflecting recent debates about sexual harassment at work, the bank offered a side-benefit for card-holders: 'reimbursement if you take legal action for a work-related harassment.' What is more, the bank has and promotes a social conscience: The ad promised to make contributions on the card-holder's behalf to certain 'associations for underprivileged women—so each time you use your card you will be helping needy women'.

Despite these recent innovations, however, the bulk of Indian advertisements today continue to reinforce women's traditional roles. In their 1997 study of television commercials, Gupta and Jain (reported in *Media Asia*, 1998: 33–36) found that women are most often portrayed in their conventional roles as housewives and mothers. Even when women in ads seem to be involved in activities outside the domestic sphere, they are invariably shown to be preoccupied with their primary tasks: managing the household and looking after the family. Also, say the researchers, when working women are depicted in ads, they are usually shown as secretaries or middle level executives in supportive, advisory or sympathetic roles vis-á-vis male characters. They are rarely shown in unconventional careers or in positions of power and authority. Further, Gupta and Jain point out that the man-woman relationships projected in TV commercials are not based on equality and mutual respect. The woman usually occupies the role of the provider of services, while the man is shown as the consumer of these services. For example,

while the whole family enjoys a meal, the wife/mother is often shown hovering around the table, waiting on them. As the researchers point out, 'Whether the man is in bed, needing his first cup of tea, or has just arrived home and needs an energetic drink, his woman is ready (all dressed up) to serve him'.

In addition, television commercials reinforce traditional patterns of authority within the family which subordinate the woman not only to her husband but to other structures of power in the domestic sphere. The daughter-in-law/mother-in-law theme, showing the former to be constantly under the critical and suspicious scrutiny of the latter, additionally encourages the concept that women are their own worst enemies.

According to Gupta and Jain, the imbalance in the power relations between the genders extends beyond personal and family relationships. For example, they found that most commercials suggest that men are well-informed, aware, alert, rational and technically competent, while women are usually just the opposite.

When women in advertisements are not shown in their domestic and family roles, they are depicted as glamourised objects conforming to rigidly defined concepts of beauty and femininity. The modern woman in TV commercials is defined by her outward smartness, beauty, glamour, sensuality and sex appeal. As the researchers put it, woman's image 'travels easily' from an object of beauty to a sex object, the objectification taking place in an explicit as well as implicit manner. Their study revealed that about 75 per cent of the advertisements on television depict stereotyped images of women and show them in stereotypical roles. They point out that these commercials are telecast at least 4 to 5 times daily, making a deep impression on audiences and perpetuating the dominant values of society, including the subordination of women. Clearly this has implications for women's mental health.

The belittling and stereotyping of women have characterised practically all forms of the media over the years. For example, Pogrebin (1980: 393–458) has discussed at length the 'sexist-vision' to which children are exposed through

television, as well as the press, films, books, and the visual and performing arts. Even seemingly innocuous and harmless forms of childhood entertainment, such as cartoons, are guilty of sexist-vision (not to mention purveyance of violence). According to Pogrebin, males not only outnumber females in cartoons, sometimes by as much as four to one, but 'cartoon daddies are ambitious, aggressive, adventurous and employed, while cartoon mommies are passive, timid, emotional and almost exclusively domestic.'

Rated on a forty-point personality chart, she says, both sexes make a strong showing in all categories of stereotypes, from boy-is-brave to female-is-fragile.

Although a few, sophisticated cartoon strips for adults have begun to reflect the changing gender roles and perceptions in today's world, few of the cartoon films which children love watching reveal increased gender-sensitivity. As a result, children still tend to grow up on a diet of stereotypical images and roles which can adversely affect the self-image and self-esteem of girls as well as relationships between growing children of both sexes. Together these can have an impact on the mental health of women and girls.

In 1983, an official committee on the portrayal of women in the media found that the media then projected certain values related to ideal gender roles, attitudes and behaviour. As Ninan (1995: 176–186) puts it in her book, these suggested that

> a woman's place was in her home, her most important asset was physical beauty, her energies and intellect must be directed at finding the right man and keeping him; that women were dependent, coy and submissive, masochistic in their response to indignities, humiliation and physical violence inflicted on them, and that the good woman was the traditional housewife, long-suffering, pious and submissive. Also, that women are women's worst enemies.

Ninan reports that a full decade later, in 1992–93, a limited monitoring exercise undertaken in different parts of the

country at the instance of the National Commission on Women showed that the teleserials transmitted by Doordarshan (the national television network) 'were still largely anti-women, reinforcing notions of the good wife, the bad daughter-in-law, the vamp, the scheming woman, and the seductress.'

According to Ninan, by 1995, Doordarshan as well as its commercial satellite rivals were purveying equally problematic new images of women. For example, several serials featured exaggerated characterisations of the 'modern' woman: 'liberated to the point of being home-wreckers'. Teleserials sprouted on both Doordarshan and Zee TV, says Ninan, depicting women sailing through romance and pregnancies, extramarital affairs and becoming accomplices in 'sprawling' family intrigues.

As Ninan points out, in this way even public television tends to compound the very real problems and dilemmas faced by many women across classes today by presenting or depicting them but choosing to titillate rather than educate or sensitise audiences. The superficial treatment of serious and complex situations suggesting simplistic and seemingly easy solutions render many teleserials useless, if not dangerous.

On the other hand, Doordarshan has used both public service advertisements as well as a crop of serials (several of them aired in the mid-80s) to create awareness about gender-based discrimination and exploitation as well as about the need, ways and means to avoid and/or overcome them. But the net result is, as Ninan puts it, that while the aim has been to create awareness, 'television has actually degraded Indian women . . . through mindless and retrograde depictions which reinforce stereotypes'.

In recent years the Indian media as a whole and some publications in particular have been aggressively and obsessively promoting beauty as a passport to fame, wealth, freedom, self-confidence and even self-determination through the unprecedented coverage given to beauty contests and those who win them. It is obviously not a coincidence that the cosmetics industry and the practice of cosmetic surgery in India have grown in leaps and bounds in the same period

(report in *India Today*, 1996). This is a significant development
in the context of women's mental health. If nothing else, it
could signal the advent and aggravation here of eating dis-
orders, a problem which hardly affected Indian women until
recently. At the beginning of the decade, as the *India Today*
report notes, NIMHANS (Bangalore) 'had just one or two re-
ferrals of such cases every year'. In contrast, today, it's about
five a month, with girls in their teens or early 20s being the
most affected group.

Eating disorders, such as anoxeria and bulimia, are es-
sentially female maladies, with girls and women making up
at least 90 per cent of those afflicted with the diseases world-
wide. Unfortunately, these are not minor or trivial ailments
but constitute a major health problem in many countries.
For example, the American Anorexia and Bulimia Associa-
tion reported several years ago that the two related diseases
annually struck one million women and resulted in 1,50,000
deaths a year. Feminist research suggest that these prob-
lems occur in societies which have limiting sex stereotypes
and which promote a body image ideal that is impossible for
most women to achieve. Significantly, many studies have
demonstrated the role played by media-defined images of
beauty in the spread of eating disorders.

According to Naomi Wolf (1991: 10–11), images of female
beauty come to weigh even more cruelly and heavily on
women as they break through legal and material hindrances.
According to her, the beauty myth is part of a violent back-
lash against feminism and all that it has achieved for women.
It uses images of female beauty as a political weapon against
women's advancement:

> The ideology of beauty is the last one remaining of the old
> feminine ideologies that still has the power to control those
> women whom second wave feminism would have other-
> wise made relatively uncontrollable: It has grown stronger
> to take over the work of social coercion that myths about
> motherhood, domesticity, chastity and passivity, no longer
> can manage. It is seeking right now to undo psychologic-
> ally and covertly all the good things that feminism did for
> women materially and overtly.

The beauty myth puts pressure on women to conform to its exacting standards, often at the cost of their physical and mental health, if not their lives. According to Wolf, dieting and thinness began to be female preoccupations when Western women received the vote around 1920. Later, she says, 'when women came en masse into male spheres, that pleasure had to be overridden by an urgent social expedient that would make women's bodies into the prisons that their homes no longer were'. She reports that during the 80s, when women in the West began to breach the power structure as never before, eating disorders among women rose exponentially and cosmetic surgery became the fastest-growing medical speciality in the U.S. A decade later, India seems to be witnessing a similar trend.

If media-promoted stereotypes can endanger women's mental well-being, so can their poor representation in serious media discourse, which tends to call into question their very existence as active citizens. Studies in various parts of the world including India have found that news is often reported as if it affects only men. For instance, the media rarely show women as active participants in social, economic and political life, or as experts and decision-makers. The relative absence of women from the news pages is what American media analyst Tuchman terms 'symbolic annihilation'—a combination of condemnation, trivialisation and erasure (Tuchman, 1978).

One reason why women seldom come across as active agents in society is that the media still rely on traditional sources of news, usually persons in positions of power. As American media analyst Molotch has pointed out,

> Women are not in control of society's institutions. Traditional dependence by the media for spokesmen (literally) from the top of such institutions means that the sexism which blocks women's mobility in other realms accumulates to block women from even knowing that they exist as a public phenomenon (quoted in Joseph and Sharma, 1994: 18).

Besides this, the unquestioning acceptance of traditional definitions of news by the mainstream press often affects

the coverage of women and their concerns directly and adversely. Most issues of special concern to women, for example, do not fit into professional concepts of news.

Events that would be given historical weight if men, rather than women, were the subjects tend to be under-valued and, therefore, under-reported. For example, the continuing abuse of women's bodies through population control research and programmes receives little sustained media attention, whereas the 'excesses' of the Indian government when the national family planning programme subjected large numbers of men to compulsory vasectomies in 1975–1976 created a public outrage. When events and issues relating to women are reported, there is a tendency towards sensationalisation and/or trivialisation. Much of the media coverage of the 1995 Fourth World Conference on Women and the NGO Forum in Beijing provides a case in point. Even issues in which women are central are often covered in such a manner that the gender dimension is marginalised; press coverage of the Shah Bano controversy (over Indian Muslim women's right to maintenance after divorce), which erupted in the 80s, exemplifies this trend.

Films, too, often contribute to the silencing of women in all but their roles as mothers and lovers. One of the many disturbing aspects of Mani Ratnam's popular Tamil and Hindi film, 'Bombay', for instance, was the treatment of its female characters. They were just not acknowledged as complete human beings with at least a minimal degree of autonomy—in terms of feelings and relationships, if not other aspects of their lives.

For example, the mothers of the hero and the heroine were almost totally silent throughout the film, mute spectators to the drama played out by their children and husbands. There was no indication of what they thought of their children's love affair or of their husbands' hostile reactions to it, how they felt about being out of touch with the runaway pair for six long years (even after the arrival of grandchildren) and whether they had or would have liked to have had any say in all of this. The women were shown as lifeless cut-outs when they could have been shown as living, breathing and, above all, credible characters.

The invisibility and inaudibility of women in society is thus further perpetuated, enhanced and even exaggerated by the media. This clearly has a bearing on women's self-perceptions and self-confidence. The cumulative effect of such silencing and erasure cannot but have a negative impact on women's sense of self-worth, their self-esteem and, by extension, their mental well-being.

To make matters worse, when women are visible—if not audible—in the media, they usually appear as victims. Often, though not always, their presentation as victims is done in good faith, in order to raise public consciousness about the problems that women face and to bring about positive social change. Nevertheless, the preponderance of images of the woman as victim can have a negative impact on women's mental well-being, especially in the relative absence of more empowering images.

For example, in the 80s, Doordarshan telecast a number of prime-time serials that were supposedly 'woman-oriented'. However well-meaning the programmes were and however moving the stories were in themselves, the presentation of one weepy after another, night after night, was quite depressing. Similarly, at a weekend workshop on film appreciation from a women's perspective, organised by the Women and Media Group, Bombay, participants noticed that at least one important female character, often the heroine, died under tragic circumstances in virtually all the films viewed. Similarly, in the press, news about women tends to be concentrated in the crimes section, where reports of gender-specific crimes such as rape, dowry-related harassment and murders, female suicides, and so on, tend to predominate. Women in the audience already experiencing unhappiness and despair could be plunged into further depression by watching or reading about the unadulterated suffering and the seemingly inevitable and invariably violent death of large numbers of women in the media.

On the rare occasions when the media do show women asserting themselves as active agents, they tend to heroise them and individualise their achievements. This was the case in the more positive of the women-oriented television serials mentioned earlier. In several films made over the past decade

384 ★ *Ammu Joseph*

or so, the heroine has been depicted as an avenging angel. The press, too, regularly celebrates women achievers, particularly those in glamorous and/or high-profile fields of activity.

The media seem to prefer to highlight individual success stories that imply that personal initiative or courage is all that is required to overcome gender-based oppression and discrimination. The underlying message is that anyone who cannot rise above her circumstances has no one to blame but herself for being a loser. The structural nature of women's oppression and the importance of collective action to tackle it are thereby conveniently bypassed.

This individualising approach to women's problems is, of course, mirrored in the approach of popular psychological theory and practice to the question of women's mental health. Such an approach does not serve to empower the thousands of women trapped in oppressive situations (including abuse within the family) or facing discrimination or harassment of various kinds at work. In fact, it may well disempower them by making them feel individually inadequate and hopeless, and thereby increase the risk of mental distress.

Two other issues that merit attention in relation to media images and women's mental health are violence and poverty. It is now recognised that women's mental health is severely strained by their experience of physical, psychological and/or sexual violence, both inside and outside the home. Even the constant threat and consequent fear of violence, as well as the perceived need to consciously try to avoid situations that might bring on violence add ongoing stress to the lives of every woman and girl.

In this context, the preponderance of violence in the media can be viewed as psychological violence, which can have an adverse impact on the mental well-being of all women, whether or not they have direct experience of violence in their lives. If scenes depicting the sexual and/or physical abuse of women are titillating to sections of the male audience, they tend to generate feelings of horror, fear, sadness, vulnerability and/or helplessness among women and girls. The manner in which these scenes are generally shot serve

to affirm and accentuate women's sense of helplessness and hopelessness in the face of male violence. This is surely not conducive to women's mental health.

Poverty is often cited as an important determinant of mental health. The expanding reach of the media, particularly television, in India has been accompanied by the liberalisation of the economy and the rise of aggressive consumerism in the country. The mental health consequences of the images of wealth and conspicuous consumption beamed across the country via television for the poor in general and poor women in particular cannot be ignored. The poor and their children continue to have minimal access to even basic needs like adequate food and water, decent shelter, education and healthcare services. But thanks to the media, they now have

• rising aspirations fed by the affluent lifestyles peddled on the screen. At the same time, they have little hope of fulfilling these desires by honest means. This cannot but have a major impact on their mental well-being.

An important point to be noted here is that mental health professionals are also consumers of the media and, like other members of society, likely to be influenced by media messages. The perpetuation of gender-based stereotypes, the trivialisation and silencing of women, the glossing over of the structural nature of women's oppression and the promotion of individual success stories as model solutions to women's problems—in and by the media—can affect the way these professionals view, understand and approach the mental health needs of female patients/clients. This, in turn, can have repercussions on the women who turn to them for help.

While the images purveyed by the media may contribute to increasing women's vulnerability to mental ill health, media coverage of mental health remains minimal, sporadic and, by and large, superficial. For example, coverage in the press, when it occurs, falls into three main categories:

1. Horror stories and atrocities—e.g., occasional exposes on conditions in mental hospitals and the controversy over the hysterectomies performed on mentally handicapped girls in Maharastra.

2. Articles based on popular psychology—particularly on issues of interest and concern to the urban elite, such as executive stress and interpersonal issues from the perspective of this class (although, in recent times, more informative pieces on problems such as learning disabilities, drug addiction and alcoholism have been appearing, along with a few in-depth ones on serious mental illnesses such as depression and schizophrenia.)

3. Advice columns featuring agony aunts (and now the occasional uncle), which serve as interesting indicators of the range of psychological and interpersonal problems faced by a large number of media consumers, for which they seem to have no other recourse to help; significantly, the advice offered often reveals sexist biases and stereotypes.

Apart from this, there does not seem to be any serious, sustained effort on the part of the media to spread public awareness and deepen public understanding of mental health. Neither common psychological problems nor chronic mental ailments receive the attention they deserve, especially in view of their prevalence and their implications for the sufferer, his/her family and society as a whole. Nor does there seem to be any ongoing attempt by the media to focus attention on the mental health implications of socio-economic and/or cultural discrimination and oppression (experienced, for example, by women, dalits, tribals, child workers, etc.) Further, although the media routinely cover conflicts and disasters of various kinds, the psychological trauma caused by these is rarely focussed upon.

To make matters worse, the mentally ill are often portrayed in demeaning ways in the media, particularly in commercial films. In addition, many media products, including some whose claim to fame is their focus on psychological issues, reveal appalling ignorance and understanding of mental illness. For example, in Mani Ratnam's widely acclaimed Tamil film, 'Anjali', it was difficult to figure out whether the child heroine was mentally disturbed or disabled.

In many films with psychological themes, the source of the problem is, predictably, a woman. In 'Anjali', for example, the child's life was ostensibly made miserable by an unsympathetic female caregiver; there was little attempt to examine the possible cause of the woman's seeming hostility towards the child. In 'Kadina Benki', a Kannada film directed by Suresh Heblikar, the hero's perverse sexual behaviour (he could only have sex with his wife after watching her have forced sex with another man) was sought to be explained, even justified, by his supposedly oedipal relationship with his mother. The latter, expectedly, emerged as the villain of the piece. To make matters worse, the consultant psychiatrist in the film used an injection of 'truth serum' to help him in his diagnosis.

The media's neglect of mental health issues and media practitioners' lack of exposure to debates in this area often result in missed opportunities to examine issues in terms of their impact on mental health in general, let alone the mental health of women. This seems to happen even when this aspect of an event or issue is rather obvious. For example, an interesting and well-written feature by a woman journalist some years ago on the process of exorcism at a temple known for 'curing' people possessed by devils or spirits (or what you will) totally failed to investigate the question of why the majority of those who had gone there for help were women.

In conclusion, the following three points could serve as starting points for initiatives to improve the situation with regard to both the impact of the media on women's mental health and media coverage of issues relating to women's mental health.

First, it is important to understand that the poor coverage of mental health issues, including those of particular relevance to women, is not unique. Almost as inadequate is the coverage given to several other vital issues, such as health, education and development as a whole. The reason for this is that dominant perceptions within the profession of what constitutes news determines coverage to a great extent. Issues such as health in general and mental health in particular do not always fit into the media's hierarchy of news values.

According to generally accepted definitions of news, events rather than processes make news. A violent episode merits frontpage coverage while a peaceful state of affairs is hardly worth reporting. The magnitude and/or extraordinary nature of an event also affects its newsworthiness. By conventional standards, people can also make news—but not all people. The activities, preoccupations and opinions of the wealthy and the powerful usually rate higher in the media's scheme of things than those of the poor and the marginalised, including women and of course, the mentally ill.

Consequently, mental health issues, and certainly those that affect women in particular, are not priority issues for the media. As Joseph and Sharma point out, the media's orientation towards events rather than processes necessarily results in the neglect of issues concerning women because many of these are linked to the latter.

> A number of serious women's issues are not overtly violent or dramatic and, though they often involve large numbers, the affected persons are not necessarily part of a readily identifiable group or concentrated in a particular geographical area. Further, many aspects of women's oppression are so commonplace and widely accepted that they are not considered sufficiently extraordinary to merit coverage (Joseph and Sharma, 1994: 18–21).

This argument can be convincingly extended to mental health issues, including those affecting women. Interestingly, the WHO acknowledges that 'circumstances and conditions that society accepts as normal or ordinary often lead to mental health problems in women' (Dennerstein, Astbury and Morse, 1993: 3).

The above explanation for the media's poor coverage of mental health issues is not meant to justify current media practices. In fact, there is a strong case for a professional re-examination of current definitions of news and hierarchies of news values, which are increasingly outdated, inappropriate and limiting. However, under the present circumstances, it is important to recognise that these biases do

exist and to plan intervention strategies that can work around them.

Second, if the media's coverage of mental health in general and women's mental health in particular is to improve, concerned mental health professionals need to be pro-active. The media depend on experts in the field to point the way to deeper understanding and, thereby, improved coverage. More interaction between mental health and media professionals would help move this process along.

Third, a healthy and satisfactory relationship between professionals from the media and other fields, including mental health, depends on a sound understanding of the priorities, compulsions and limitations of each profession. Media women and women activists interested in better coverage of women's issues (as a whole) have dialogued over the years on how to improve the situation. While some hurdles remain, more meaningful and fruitful co-operation and collaboration have been made possible through ongoing interaction. The forging of similar links between mental health professionals and media persons interested in mental health issues would not only help generate better coverage of mental health issues but also perhaps discourage the stereotypes and other mental health hazards that currently abound in the media.

REFERENCES

Abu–Lughod, L. (1986). *Veiled sentiments. Honor and poetry in a Bedouin society.* Berkeley: University of California Press.

Achterberg, J. (1990). *Woman as healer.* Boston: Shambhala.

Adcock, C. and **Newbigging, K.** (1990). Women in the shadows. Women, feminism and clinical psychology. In E. Burman (Ed.). *Feminists and psychological practice.* (pp. 172–88). London: Sage.

Addlakha, R. (1989). Possession, mediation and healing. M. Phil. diss., Dept. of Sociology, University of Delhi.

Adithi (1995). Female infanticide in Bihar. Report prepared by V. Srinivasan, Parinita, Vijay, Shankar, Alice, Mukul, Medha and Anita Kumari. New Delhi.

Agarwal, P., Bhatia, M.S. and **Malik, S.C.** (1990). Post–partum psychosis: A study of indoor cases in a general hospital psychiatric clinic. *Acta Psychiatrica Scandinavia, 81*: 571–75.

Agarwal, P., Khastgir, U., Bhatia, M.S., Bohra, N. and **Malik, S.C.** (1996). Psychological profile of females with chronic pelvic pain. *Indian Journal of Psychiatry, 39*(4): 212–16.

Ahuja, R. (1988). *Crime against women.* Jaipur: Rawat.

Almeido–Filho, N., Mari, J. and **Coutinho, E.** (1995). The process of urbanisation and mental health. In T. Harpham and I. Blue (Eds.). *Urbanisation and mental health in developing countries.* (pp. 41–60). England: Ashgate Publishing Company.

Alves, P.C., Rabelo, M.C., Almeido–Filho, N., Harpham, T. and **Atkinson, S.** (1992). Women's experience of social risk factors for mental ill health in Salvador, Brazil. Research proposal, CESAME, Brazil and LSHTM, London.

Alvin, Y.S. (1990). *Social change and development. Modernization, dependency and world system-theories,* New Delhi: Sage.

Ambai (C.S. Lakshmi). (1992). Black horse square. In Lakshmi Holmstrom (Trans). *A purple sea. Short stories by Ambai.* (pp. 109–36). New Delhi: Affiliated East-West Press Pvt. Ltd.

Ansari, S.A. (1969). Symptomatology of Indian depressives. Transaction 9, *Transactions of All India Institute of Mental Health,* Bangalore.

Araya, R.I., Wynn, R. and **Lewis, G.** (1992). Comparison of two self-administered psychiatric questionnaires (GHQ–12 and SRQ–20) in primary care in Chile. *Social Psychiatry and Psychiatric Epidemiology, 27*: 168–73.

Bachrach, L.L. (1992). The urban environment and mental health. *The International Journal of Social Psychiatry, 38*(1): 5–15.

Bagadia, V.N., Jeste, D.V., Dave, K.P., Doshi, S.V. and **Shah, L.P.** (1973). Depression: A study of demographic factors. *Indian Journal of Psychiatry, 15*: 209–16.

Bagedahl-Strindlund, M. and **Monsen-Borjesson, K.** (1996). Post-natal depression. Still a hidden problem. Paper presented at the 10th World Congress of Psychiatry, at the women's mental health section of the WPA, Madrid.

Bagley, C. and **King** (1990), *Child sexual abuse. A search for healing.* London: Routledge.

Bakshi, A. and **Sriram, R.** (1992–93). Action to combat violence against women in the family. An overview of some efforts in Gujarat. *Journal of the MS University of Baroda (Social Science), 41–42*(2): 117–27.

Bang, R. and **Bang, A.** (1994). Women's perceptions of white vaginal discharge. Ethnographic data from rural Maharashtra. In Gittelsohn, J. et al. (Eds.). *Listening to women talk about their health. Issues and evidence from India.* (pp. 79–94). New Delhi: Har-Anand Publications.

Bang, R.A., Bang, A.T., Baitule, M., Choudhary, Y., Sarmukaddams and **Tale, O.T.** (1989). High prevalence of gynaecological diseases in rural Indian women. *The Lancet, 14* (January): 85–88.

Barnet, S.A. and **Gotlib, I.H.** (1988). Psychological functioning and depression. Distinguishing among antecedents, concomitants and consequences. *Psychological Bulletin, 104*: 97–126.

Barstow, A.L. (1995). *Witchcraze. A new history of the European witch hunts.* San Francisco: Pandora, Harper-Collins.

Bart, P. (1971). Depression in middle-aged women. In V. Gornick and B. K. Moran (Eds.). *Women in sexist society.* (pp. 99–117). New York: Basic Books.

Beach, S.R.H. and **O'Leary, K.D.** (1986). The treatment of depression occurring in the context of marital discord. *Behaviour Therapy, 17*: 43–49.

Beck, B. (1981). The goddess and the demon. A local south Indian festival and its wider context. In M. Biardeau (Ed.). *Autour de la Deese Hindoue.* (pp. 83–136). Paris: Edition de l'Ecole des Hautes Ediudes en Sciences Sociales.

Bem, S.L. (1975). Sex-role adaptability. One consequence of psychological androgyny. *Journal of Personality and Social Psychology, 31*: 634–43.

Bem, S.L., Martyna, W. and **Watson, C.** (1976). Sex typing and androgyny. Further explorations of the expressive domain. *Journal of Personality and Social Psychology, 34*: 1016–23.

Benjamin, J. (1986). A desire of one's own. Psychoanalytic feminism and intersubjective space. In Teresa de Lauretis (Ed.). *Feminist Studies/Critical Studies.* (pp. 297–324). Bloomington: Indiana University Press.

Bentley, M.E., Gittelsohn, J.G., Nag, M., Pelto, P.J. and **Russ, J.** (1990). Use of qualitative research methodologies for women's reproductive health data in India. Paper presented at the International Conference on Rapid Assessment Methodologies for Planning and Evaluation of Health Related Programs, Washington DC. November 12–15.

Bhandari Anand, S. (1988). Caveats of women's emancipation. In R. Ahuja (Ed.). *Crime against women.* (pp. 127–43). Jaipur: Rawat.

Bharti, A. (1985). The self in Hindu thought and action. In A. J. Marsella, G. DeVos and F.L.K. Hsu (Eds.). *Culture and self.* (pp. 185–230). New York/London: Tavistock.

Bhatia, J.C. and **Cleland, J.** (1995). Symptoms of gynaecological morbidity and their treatment in southern India. Results from a community based study. *Studies in Family Planning,* 26-4, July–August.

Bhattacharya, Deborah (1986). *Pagalami. Ethnopsychiatric knowledge in Bengal.* Syracuse: Maxwell School of Citizenship and Public Affairs. Syracuse University.

Bhattacharya, M. (1989/1990). Women's studies and some preliminary notes. *Samya Sakti, IV and V.* (pp. 274–78).

Bhattacharya, S. (1991). A pilot study on prevalence and perception of gynaecological morbidities among rural women of West Bengal. Draft paper presented at a manuscript writing workshop for Qualitative Research on Women's Reproductive Health. Organised by the Ford Foundation and John Hopkins University, Baroda. April 22–26.

Bhatti, R.S. (1990). Socio-cultural dynamics of wife-battering. In S. Sood (Ed.). *Violence against women.* (pp. 45–56). Jaipur: Arihant Publishers.

Blackburn, S. (1998). *Singing of birth and death. Texts in performance.* Philadelphia: University of Pennsylvania Press.

Blue, I. and **Harpham, T.** (1994). *The World Bank Development Report 1993: Investing in health.* Reveals the burden of common mental disorders, but ignores its implications. Editorial. *British Journal of Psychiatry, 165:* 9–12.

Blue, I., Ducci, M., Jaswal, S., Ludermir, A. and **Harpham, T.** (1995). The mental health of low-income urban women. Case studies from Bombay, India; Olinda, Brazil; and Santiago, Chile. In T. Harpham, and I. Blue (Eds.). *Urbanisation and mental health in developing countries.* England: Ashgate Publishing Company.

Boddy, J. (1989). *Wombs and alien spirits. Women, men, and the Zar cult in northern Sudan.* Madison, Wisconsin: University of Wisconsin Press.

Bograd, M. (1988). Feminist perspectives on wife abuse. An introduction. In K. Yllo and M. Bograd (Eds.). *Feminist perspectives on wife abuse.* (pp. 11–27). Newbury Park: Sage.

Bolles, A.L. (1985). Economic crises and female headed households in urban Jamaica. In Nash and Sefledo (Eds.). *Women and change in Latin America.* Massachusetts: Bergim and Gravy.

Bourdieu, P. (1990). *The logic of practice.* (Trans.) R. Nice. Stanford: Stanford University Press.

Bourdieu, P. (1972). *Outline of a Theory of Practice.* London: Cambridge University Press.

Brabin, I. Kemp, J., Orikomaba, K.O., Ikimalo, J., Dollimore, N., Odu, N.N., Hart, C.A. and **Briggs, N.D.** (1995). Reproductive tract infections and abortion among adolescent girls in rural Nigeria. *The Lancet, 345:* 300–04.

Brabin, L. (1992). Prevention of PID: A challenge for the health services. *Annals of Tropical Medicine and Paristology, 86*(1): 25–33.

Brockington, I. and **Cox-Roper, A.** (1988). The nosology of puerperal mental illness. In R. Kumar and I.F. Brockington (Eds.). *Motherhood and mental illness*. Vol II. *Causes and consequences*. (pp. 1–16). London: Wright.

Brockington, I. (1996). A portfolio of postpartum disorders. In I. Brockington (Ed.). *Motherhood and mental health.* (pp. 135–38). Oxford: Oxford University Press.

Broverman, I.K., Broverman, D.M., Clarkson, F.E., Rosenkrantz, P.S. and **Vogel, S.R.** (1970). Sex-role stereotypes and clinical judgements of mental health. *Journal of Consulting and Clinical Psychology, 34*: 1–7.

Brown, G.W. (1979). A three-factor causal model of depression. In J.E. Barret (Ed.). *Stress and mental disorder*. New York: Raven Press.

Brown, G.W. and **Harris, T.** (1978). *Social origins of depression. A study of psychiatric disorder in women*. London: Tavistock.

Brown, S.C. (Ed.) (1979). *Philosophical disputes in the social sciences*. Sussex: Harvester Press.

Bunster-Burotto, X. (1985). Surviving beyond fear. Women and torture in Latin America. In J. Nash and H. Safa. (Eds.). *Women and change in Latin America. New directions in sex and class*. (pp. 297–324). Greenwood Press.

Busby, C. (1997). Of marriage and marriageability. Gender and Dravidian kinship. *Journal of the Royal Anthropological Institute, 3*(1): 21–42.

Busfield, J. (1989). Mental illness as social product or social construct: A contribution in feminists' arguments. *Sociology of Health and Illness, 10*: 521–42.

Buss, D.M. (1995). Psychological sex differences. Origins through sexual selection. *American Psychologist, 50*: 164–68.

Canadian Report (1988). *Mental health for all Canadians. Striking a balance*. Minister of National Health and Welfare, Canada.

Canguilhem, G. (1995). Georges Canguilhem on Michel Foucault's *Histoire de la folie. Critical Inquiry, 21*: 277–89.

Caplan, P.J. and **Hall-McCorquodale, I.** (1985). Mother-blaming in major clinical journals. *American Journal of Orthopsychiatry, 55*: 345–53.

Carta, M.G., Carpiniello, B., Cicone, V., Sannais, C., Paulis, M. and **Rudas, N.** (1993). Standardization of a psychiatric test for use by general practitioners in Sardina, preliminary results. *Acta Psychiatrica Scandinavica, 87*: 342–44.

Centre for Social Development and Humanitarian Affairs, United Nations (1991). *International year of the family. Building the smallest democracy at the heart of society*. Vienna: United Nations.

Chakraborty, A. (1971). Cargo cult in Calcutta: Reappearance of a myth. A phenomenological interpretation of myths. *Indian Journal of Psychiatry, 13*: 222–28.

——— (1990). *Social stress and mental health. A social psychiatric field study of Calcutta*. New Delhi: Sage.

Chakraborty, A. and **Banerji, G.** (1975). Ritual, a culture specific neurosis and obsessional states in Bengali culture. Part I and II. *Indian Journal of Psychiatry, 17*(3): 211–16; *17*(4): 273–283.

Chakraborty, A. and **Bhattacharya, D.** (1985). Witchcraft beliefs and persecutory ideas in Bengali culture. *Indian Journal of Social Psychiatry, 1:* 231–43.

Chakraborty, A. and **Sandel, B.** (1985). Somatic complaint syndrome in India. Field study. In P. Pichot, P. Berner, R. Wold and K. Thau (Eds.). *Psychiatry. The state of the art.* Vol. 8. *History of Psychiatry, National Schools, Education, and Transcultural Psychiatry.* (pp. 641–46). New York: Plenum Press.

Chakravarty, U. (1993). Conceptualising Brahmanical patriarchy in early India. Gender, caste, class and state. *Economic and Political Weekly,* 3 April: 579–85.

Chamberlain, G. and **Brown, J.C.** (Eds.) (1978). Gynaecological laproscopy. Report of the working party of the confidential enquiry into gynaecological laproscopy. London: Royal College of Obstetricians and Gynecologists.

Chandra, P.S. and **Chaturvedi, S.K.** (1989). Cultural variations of pre-menstrual experience. *International Journal of Social Psychiatry, 35:* 343–49.

————— (1995). Pre-menstrual experiences, explanatory models and help seeking in Indian women. *Indian Journal of Social Psychiatry, 11*(1): 73–77.

Chandra, P.S., Chaturvedi, S.K., Issac, M.K., Chitra, H., Sudarshan, C.Y. and **Beena, M.B.** (1991). Marital life among infertile spouses. The wife's perspective and its implications in therapy. *Family Therapy, 18*(2): 145–54.

Chatterjee, M. (1994). Occupational health of self-employed women—some experiences. *FRCH Newsletter,* Jan–Feb., *VIII*(1): 6–9.

Chaturvedi, G. (1988). Violence committed by husband on wife and by in-laws on daughter-in-law. Paper presented at the National Conference on Family Violence Against Females, NIPCCD, New Delhi. February.

Chaturvedi, S.K., Chandra, P.S. and **Issac, M.K.** (1993). Pre-menstrual experiences. The four profiles and factorial patterns. *Journal of psychosomatic obstetrics and gynaecology, 14:* 223–35.

Chaturvedi, S.K., Chandra, P.S., Isaac, M.K., Sudarshan, C.Y. and **Rao, S.** (1993). Is there a female dhat syndrome. *NIMHANS Journal, 11*(2): 89–93.

Chawla, J. (1993). Gendered representations of seed, earth and grain. A woman-centered perspective on the conflation of woman and earth. *Journal of Dharma,* July–September, *XVIII* (3): 237–57.

————— (1994). The mythic origins of the menstrual taboo in the *Rig Veda. Economic and Political Weekly,* October 22, *XXIX* (43): 2817–27.

————— (1995). A woman activist theologizes. *Vidyajyoti Journal of Theological Reflection,* August, *59*(8): 528–38.

Cheng, A.T.A., Soong, W.T., Chong, M.Y. and **Tsung, Y.L.** (1995). Urbanisation, psychosocial stress, and minor mental illness in Taiwan. In T. Harpham and I. Blue (Eds.). *Urbanisation and mental health in developing countries.* England: Ashgate Publishing Company.

Chesler, P. (1972). *Women and madness.* New York: Double Day.

Chodorow, N. (1974). Family structure and feminine personality. In M. Z.

Rosaldo, L. Lamphere (Eds.). *Woman, Culture and Society.* Stanford: Stanford University Press.

Cixous, H. and **Clement, C**. (1986). *The newly born woman.* (Trans.) B. Wing. Manchester: Manchester University Press.

Clare, A.W. (1985). Hormones, behaviour and the menstrual cycle. *Journal of Psychosomatic Research, 29*(3): 225–33.

Clark, C.S. (1993). Child sexual abuse. *CQ Researcher, 3*(2): 27–47.

Climent, C.E., Diop, B.S.M. Harding, T.W., Ibrahim, H.H.A., Ladrido-Ignacio, L. and **Wig, N.N.** (1980). Mental health in primary care. *WHO Chronicle, 34*: 231–36.

CMDA Report (1983). Report of the health and socio-economic survey in Calcutta Metropolitan Area. Vols. I and II. Calcutta Metropolitan Development Authority.

Comaroff, J. and **Comaroff, J.** (1992). *Ethnography and the historical imagination.* San Francisco: Westview Press.

Committee Report (1984). Report of the evidence before the Joint Parliamentary Committee on the Mental Health Bill, 1981. New Delhi: Rajya Sabha Secretariat.

Conklin, G.H. (1968). The family formation process in India. *Journal of Family Welfare, 14*: 28–37.

Conrad, P. and **Schneider, J.W.** (1980). *Deviance and medicalization: From badness to sickness.* St. Louis, Mo. : C.V. Mosby.

Constantinides, P. (1978). Women's spirit possession and urban adaptation. In P. Caplan and J.M. Bujra (Eds.). *Women united, women divided. Cross-cultural perspectives on female solidarity.* (pp. 259–82). London: Tavistock.

Coomaraswamy, A.K. (1993). *Yakshas: Essays in the water cosmology.* New Delhi: Indira Gandhi National Centre for the Arts.

Cooper, D., Pick, W., Myers, J., Hoffman, M. and **Klopper, J.** (1991a). Urbanisation and women's health in Khayelitsha. Part I. Demographic and socio-economic profile. *SAMJ, 79*: 423–27.

——— (1991b). Urbanisation and women's health in Khayelitsha. Part II. Health status and use of health services. *SAMJ, 79*: 428–32.

Cox, A.D. (1993). Befriending young mothers. *British Journal of Psychiatry, 163*: 6–18.

Cox, J.L. (1983). Clinical and research aspects of post-natal depression. *Journal of Psycho-somatic obstetrics and gynaecology, 2*: 46–53.

——— (1988). The life event of childbirth. Social cultural aspects of post-natal depression. In R. Kumar and I.F. Brockington (Eds.). *Motherhood and mental illness.* Vol. II. *Causes and consequences.* (pp. 32–38). London: Wright.

Csordas, T. (Ed.) (1994). *Embodiment and experience.* Cambridge: Cambridge University Press.

Culbertson, F.M. (1997). Depression and gender: An international review. *American Psychologist, 52*: 25–31.

Curran, W.J. and **Harding, T.W.** (1978). *The law and mental health harmonizing objectives. A comparative survey of existing legislations together*

with guidelines for its assessment and alternative approaches to its improvement. Geneva: World Health Organisation.

Dalton, K. (1964). *The pre-menstrual syndrome.* London: Heinemann.

————— (1977). *The pre-menstrual syndrome and progesterone therapy.* London: Heinemann.

Das Gupta, M., Chen, L.C. and **Krishnan, T.N.** (Eds.) (1995). *Women's health in India. Risk and vulnerability.* Bombay: Oxford University Press.

Davar, B.V. (1995a). Mental illness among Indian women. *Economic and Political Weekly, 30*(45): pp. 2879–86.

————— (1995b). The mental health aspects of socialisation from the gender perspective. Paper presented at the Symposium on socialisation. Theory and Research. Dept. of HDFS, MS University of Baroda, Baroda. December.

————— (1995c). Gender politics in mental health care in India. *Radical Journal of Health, 1*(3): 183–207.

————— (1999). Mental health of Indian women: A feminist agenda. New Delhi: Sage.

Davar, B.V. and **Bhat, P.R.** (1995). *Psychoanalysis as a human science Beyond foundationalism.* New Delhi: Sage.

de Beauvoir, S. (1972, orig. 1949). *The Second Sex.* Middlesex: Penguin.

Dean, C. and **Kendell, R.E.** (1981). The symptomatology of puerperal illnesses. *British Journal of Psychiatry, 139*: 128–33.

Deaux, K. (1984). From individual differences to social categories. Analysis of a decade's research on gender. *American Psychologist, 39*:105–16.

Denmark, F., Russo, N.F., Frieze, I.H. and **Sechzer, J.A.** (1988). Guidelines for avoiding sexism in psychological research. A report of the adhoc committee on non-sexist research. *American Psychologist, 43*: 582–85.

Dennerstein, L., Astbury, J. and **Morse, C.** (1993). Psychosocial and mental health aspects of women's health. WHO/FHE/MNH/9.3. WHO: Geneva.

Dennerstein, L., Burrows, G.D. and **Hyman, G.J.** (1979). Hormone therapy and affect. *Maturitas, 1*: 247–59.

Dennerstein, L., Morse, C. and **Vamavides, K.** (1988). Pre-menstrual tension and depression—Is there a relationship? *Journal of Psychosomatic Obstetrics and Gynaecology, 8*: 45–52.

Dennerstein, L. and **Pepperell, R.** (1989). Psychological aspects of hysterectomy. A prospective study. *British Journal of Psychiatry, 154*: 516–22.

Derlerga, J. and **Berg, H.** (1987). *Self-disclosure. Theory, research and therapy.* New York and London: Plenum Press.

Derrett, J.D. (1970). *A critique of modern Hindu law.* Bombay: N.M. Tripathi.

Derrida, J. (1978). Cogito and the history of madness. In *Writing and difference.* (pp. 31–63). Chicago: University of Chicago Press.

Deschner, J.P. (1984). *The hitting habit. Anger control for battering couples.* New York: Free Press.

Deshpande, S.N., Sundaram, K.R. and **Wig, N.N.** (1989). Psychiatric disorders among medical in-patients in an Indian hospital. *British Journal of Psychiatry, 154*: 504–9.

Desjarlais, R., Eisenberg, L., Good, B. and **Kleinman, A.** (1995). *World mental health.* New York: Oxford University Press.

Dev, A. and **Baxi, M.** (1997). *A working paper on nari adalat: Baroda district, Gujarat.* Baroda: Mahila Samakhya.

Devi, M. (1981). Draupadi. (Trans.) Gayatri Chakravorty Spivak. *Critical Inquiry, 8*(2): 393–402.

Dbadphale, M., Ellison, R.H. and **Griffin, L.** (1982). Frequency of mental disorders among outpatients at a rural district hospital in Kenya. *The Central African Journal of Medicine, 28*(4): 85–89.

Dhanda, A. (1984). The mental health bill of 1981. A new deal for the mentally ill. *Supreme Court Cases, 2*: 8–19.

——— (1992). Should mental illness be a bar to marriage or a ground for divorce? Paper presented at the Conference on Strategies for Professional Collaboration to Promote the Rights of the Mentally Ill. Madras: SCARF–Law Asia.

——— (1993). A critical appraisal of the laws relating to the mentally ill. Ph. D. Thesis Submitted to the Faculty of Law, University of Delhi, Delhi.

——— (1995). Insanity, gender and the law. *Contributions to Indian Sociology,* (n. s.) *29*: 348–67.

——— (1998). Insanity in law. Dissent, deviance, disorder. In S. Saberwal and H. Sievers (Eds.). *Rules, laws, constitutions.* (pp. 151–71). New Delhi: Sage.

——— (2000). *Legal order and mental disorder.* New Delhi: Sage.

Dixon-Mueller, R. and **Wasserheit, J.N.** (1991). The culture of silence—reproductive tract infections among women in the Third World. In Selected readings in womens' reproductive health. Prepared for Ford Foundation Training Workshop on Women's Reproductive Health, Baroda. April 22–26.

Driver, E. (1989). *Child sexual abuse. Feminist perspectives.* London: Macmillan Education Ltd.

DSM-IV (1994). *Diagnostic and statistical manual of mental disorders.* 4th revision. Washington, D.C.: American Psychiatric Association.

Dutta, A.B. (1989). Mental Health Act, 1987. A critical appraisal. In A.K. Agarwal et al. (Eds.). *Proceedings of the Workshop on Ethics in Psychiatry.* (pp. 117–47) Lucknow: Dept. of Psychiatry, KG's Medical College.

Dutta, D., Phukan, R. and **Das, P.D.** (1982). The *koro* epidemic in lower Assam. *Indian Journal of Psychiatry, 24*: 370–74.

Eagly, A.H. (1995). The science and politics of comparing women and men. *American Psychologist, 50*: 145–58.

Eliade, M. (1951). *Le chamanisme.* Paris: Payot.

Elliot, S., Sanjack, M. and **Leverton, T.J.** (1988). Parent groups in pregnancy. A preventive intervention for post-natal depression? In B.H. Gottlieb (Ed.). *Marshalling social support.* (pp. 87–110). London: Sage.

Faulk, M. (1977). Men who assault their wives. In M. Roy (Ed.). *Battered women. Psychosociological study of domestic violence.* New York: Van Nostrand Reinhold.

Felman, S. (1975). Woman and madness: the critical phallacy. *Diacritics,* 5.

Finkelhor, D. (1979). *Sexually victimized children*. New York: Free Press.
────── (1990). Sexual abuse in a national survey of adult men and women. Prevalence, characteristics and risk factors. *Child Abuse and Neglect*, *14*: 19–28.
Finney, J.C. (1970). (Ed.). *Culture change, mental health and poverty*. New York: Simon and Schuster.
Ford Foundation (1994). *Listening to women talk about their health. Issues and evidence from India*. New Delhi: Har Anand Publications.
Forrester, J. (1986). Rape, seduction and psychoanalysis. In Sylvana Tomaselli and Roy Porter (Eds.). *Rape. An historical and social enquiry*. (pp. 57–83). Oxford: Basil Blackwell.
Forte, J.A., Franks, D.D., Forte, J.A. and **Rigsby, D.** (1996). A symmetrical roletaking. Comparing battered and non-battered women. *Social Work*, *41*(1): 59–72.
Foucault, M. (1965). *Madness and civilisation. A history of insanity in the age of reason*. New York: Random House.
────── (1975). *Discipline and punish. The birth of the prison*. London: Harvester Press.
────── (1980a). Lecture One, 7 January 1977. In *Power/Knowledge: Selected interviews and other writings, 1972–1977*. New York: Pantheon Books.
────── (1980b). *History of sexuality*. Vol. 1. New York: Vintage Books.
────── (1980c). *Power/Knowledge. Selected interviews and other writings, 1972–1977*. New York: Pantheon Books.
────── (1988). *Politics, philosophy, culture. Interviews and other writings, 1977–1984*. London: Routledge.
Freed, S.A. and **Freed, R.S.** (1964). Spirit possession as illness in a north Indian village. *Ethnology*, *2*(2): 152–71.
Freud, S. (1973, orig. 1923). A Seventeenth-century demonological neurosis. In *The standard edition of the complete psychological works of Sigmund Freud*, (XIX: 72–121). London: Hogarth Press.
Friedan, B. (1971). *The feminine mystique*. Harmondworth: Penguin.
Friedman, R.J. and **Katz, M.M.** (Eds) (1974). *The psychology of depression. Contemporary theory and research*. Washington D.C. : John Wiley and Sons.
Fry, R.P.W., Crisp, A.H. and **Beard, R.W.** (1997). Sociopsychological factors in chronic pelvic pain. A review. *Journal of Psychosomatic Research*, *42*: 1–15.
Ganesh, A.R. (1994). Preliminary report of a workshop series and survey on child sexual abuse. Bangalore: Samvada.
Ganesh, K. (1990). Mother who is not a mother. In search of the great Indian goddess. *Economic and Political Weekly*, October 20–27: WS 58–WS 63.
Gaonkar, M. (1995). Relationship attributions and marital quality in couples with depressed wives. M. Phil diss. Bangalore University, Bangalore.
Gaur, S.M. (1996). A comparative study of attributions and marital quality

in women with depression and family pathology. M. Phil, diss. NIMHANS (Deemed University), Bangalore.

Gautam, S., Nijhawan, M. and **Gehlot, P.S.** (1982). Post-partum psychiatric syndromes—An analysis of 100 consecutive cases. *Indian Journal of Psychiatry, 24*: 383–86.

Gautama, (1991). *The sacred laws of the Aryas, Part I.* Vol. 2. From *The sacred books of the East.* (Ed.) F. Max Muller. (Trans.) G. Buhler. Delhi: Motilal Banarsidass.

Geetha, V. (1996). On bodily love and hurt. Paper presented at the 26th Inter-disciplinary Research Methodology Workshop. Madras Institute of Development Studies, on Rethinking Indian Modernity. The Political Economy of Indian Sexuality, Chennai. August 1–3.

Ghosh, S.K. (1993). *Women and crime.* New Delhi: Ashish.

Gilbert, S. and **Gubar, S.** (1979). *The mad woman in the attic. The woman writer and the nineteenth century literary imagination.* New York: Yale University Press.

Gilligan, C. (1982). *In a different voice psychological theory and women's development.* Cambridge: Harvard University Press.

Gilman, C.P. (1935). *The living of Charlotte Perkins Gilman. An autobiography.* New York: Appleton-Century.

Gilman, C.P. (1973). *The yellow wallpaper.* New York: Feminist Press.

Gitlin, M.J. and **Pasnau, R.O.** (1989). Psychiatric syndromes linked to reproductive function in women. A review of current knowledge. *American Journal of Psychiatry, 146*: 1413–22.

Gittelsohn, J., Bentley, M.E., Pelto, P.J., Nag, M., Pachauri, S., Harrison, A.D. and **Landman, L.T.** (Eds.) (1994). *Listening to women talk about their health—issues and evidence from India.* New Delhi: Har Anand Publications.

Gittelsohn, J., Pelto, P.J., Bentley, M.E., Nag, M. and **Oomman, N.** (1994). Qualitative methodological approaches for investigating women's health in India. In J. Gittelsohn et al. (Eds). *Listening to women talk about their health—Issues and evidence from India.* (pp. 40–54). New Delhi: Har Anand Publications.

Goffman, E. (1968). *Stigma: Notes on the management of spoilt identity.* Harmonsworth, England: Penguin.

Goldberg, D.P. and **Blackwell, B.** (1970). Psychiatric illness in general practice: a detailed study using new methods of identification. *British Journal of Psychiatry, 129*: 61–67.

Gombey. L. (1981). Learned helplessness, depression and alcohol problems of women. In P. Rusianoff (Ed.). *Women in crisis.* (pp. 38–43). New York: Women's Science Press.

Good, B.J. (1996). Mental health consequences of displacement and re-settlement. *Economic and Political Weekly,* June 15, *31* (24): 1504–8.

Gough, K.E. (1994, orig. 1956). Brahman Kinship in a Tamil village. Reprinted in P. Uberoi (Ed.) *Family, kinship and marriage in India.* (pp. 146–75). Delhi: Oxford University Press.

Gove, W.R. (1972) The relationship between sex roles, marital status and mental illness. *Social Forces, 51*: 34–44.

Gove, W.R. and **Geerken, M.D.** (1977). The effects of children and employment on the mental health of married men and women. *Social Forces*, *56*: 66–76.

Gove, W.R. and **Tudor, J.F.** (1973). Adult sex roles and mental illness. *American Journal of Sociology*, *78*: 50–73.

Grey, J. (1982). Chetri women in domestic groups and rituals. In M. Allen and S. Mukherjee (Eds.). *Women in India and Nepal.* (pp. 211–41). Canberra: Australian National University Monographs, No. 8.

Guha, R. (1987). Chandra's death. In R. Guha (Ed.). *Subaltern studies V: Writings on South Asian history and society*. New Delhi: Oxford University Press.

Gyatso, J. (1989). Down with the demoness: Reflections on feminine ground in Tibet. In J. Willis (Ed.). *Feminine ground: Essays on women and Tibet*. Ithaca: Snow Lion Publications.

Hacking, I. (1995). *Rewriting the soul. Multiple personality and the sciences of memory*. Princeton, N.J. : Princeton University Press.

Halbreich, V., Endicott, J., Scachet, S. and **Nee, J.** (1982). The diversity of pre-menstrual experiences as reflected in the pre-menstrual assessment form. *Acta Psychiatrica Scandinavica*, *65*: 46–65.

Hancock, M.E. (1995). The dilemmas of domesticity. Possession and devotional experience among urban Smarta women. In L. Harlan and P.B. Courtright (Eds.). *From the margins of Hindu marriage. Essays on gender, religion and culture.* (pp. 60–92). Oxford and N.Y.: Oxford University Press.

Harding, T.W., De Arango, M.V., Baltazar, J., Climent, C.E., Ibrahim, H.H.A., Ladrido-Ignacio, L., Srinivasa Murthy, R. and **Wig, N.N.** (1980). Mental disorders in primary health care. A study of their frequency and diagnosis in four developing countries. *Psychological Medicine*, *10*: 231–41.

Hare-Mustin, R.T. (1983). An appraisal of the relationship between women and psychotherapy: 80 years after the case of Dora. *American Psychologist*, *38*: 593–601.

————— (1987). The problem of gender in family therapy theory. *Family process*, *26*: 115–28.

Hare-Mustin, R.T. and **Marecek, J.** (1988). The meaning of difference. Gender theory, postmodernism and psychology. *American Psychologist*, *43*: 455–64.

Harper, E.B. (1963). Spirit possession and social structure. In B. Ratnam (Ed.). *Anthropology on the march.* (pp. 165–77). Delhi: Social Science Association.

Harpham, T. (1992). Urbanisation and mental disorder. In D. Bhugra and J. Leff (Eds.). *Principles of social psychiatry*. Oxford: Blackwell Scientific Publications.

————— (1995). Future directions in urbanisation and mental health in developing countries. In T. Harpham and I. Blue (Eds.). *Urbanisation and mental health in developing countries*. England: Ashgate Publishing Company.

Harpham, T. and **Blue, I.** (Eds.) (1995). *Urbanisation and mental health in developing countries*. England: Ashgate Publishing Company.

Harrop-Griffiths, J., Katon, W. and **Walker, E.** (1988). The association between chronic pelvic pain, psychiatric diagnosis and childhood sexual abuse. *Obstetrics and Gynaecology, 71*: 589–94.

Harsh, K. (1989). Lifestyles, sex-role orientation and depression in women. *Journal of Personality and Clinical Studies, 5*: 19–22.

Hegde, S. (1994). Pathways through method. An essay in review. *Social Scientist, 22*: 83–100.

Henderson, S. (1980). A development in social psychiatry. A systematic study of social bonds. *Journal of Nervous and Mental Disease, 168*: 63–69.

Henley, N. (1985). Psychology and gender. *Signs, 11*: 101–19.

Hoch, E. (1993). *Sources and resources. A Western psychiatrist's search for meaning in the ancient Indian scriptures.* Delhi: Book Faith India.

Hole, H. and **Levine, E.** (1971). *Rebirth of feminism.* New York: Quadrangle Books.

Howels, W.D. (Ed.) (1920). *The great modern American short stories.* New York: Boni and Liveright.

Hsu, F.L.K. (1985). The self in cross-cultural perspective. In A.J. Marsella, G. DeVos and F.L.K. Hsu (Eds.). *Culture and Self.* (pp. 24–55). New York/London: Tavistock.

Hunter, M. Battersby, R. and **Whitehead, M.** (1986). Relationships between psychological symptoms, somatic complaints and menopausal status. *Maturitas, 8*: 217–88.

Hyde, J.S. and **Plant, E.A.** (1995). Magnitude of psychological gender differences. Another side of the story. *American Psychologist, 50*: 159–61.

ICD-10 (1992). *International classification of diseases. Classification of mental and behavioural disorder.* 10th revision. Geneva: World Health Organisation.

India Today (1996). The beauty craze. Cover story. November 15. (pp. 44–55).

Jablensky, A., Sartorius, N. and **Ernberg, G.** (1992). Schizophrenia. Manifestations, incidence and course in different cultures. A World Health Organisation's ten country study. *Psychological Medicine Monograph.* Supplement 20. Cambridge: Cambridge University Press.

Jacoby, R. (1975). *Social amnesia.* Boston: Beacon.

Jaswal, S.K.P. (1995). Gynaecological and mental health of low-income urban women in India. Ph.D. thesis. Public Health and Policy, Health Policy Unit, London School of Hygiene and Tropical Medicine, London University.

Joseph, A. and **Sharma, K.** (Eds.) (1994). *Whose news? The media and women's issues.* New Delhi: Sage.

Kakar, S. (1982). *Shamans, mystics and doctors. A psychological inquiry into India and its healing traditions.* Delhi: Oxford University Press.

Kakar, S. (1997). *Culture and psyche.* New Delhi: Oxford University Press.

Kannani, S. (1991). Application of ethnographic research to understand perceptions of health and disease in slums of Baroda. Draft paper presented at a manuscript writing workshop for qualitative research on women's reproductive health. Organised by the Ford Foundation and John Hopkins University, Baroda, India. April 22–26.

Kapadia, K. (1995). *Siva and her sisters. Gender, caste and class in rural south India.* Boulder: Westview Press.

Kaplan, H.I., Saddock, B.J. and **Grebb, J.A.** (1994). *Synopsis of psychiatry. Behavioural sciences, clinical psychiatry.* Seventh Edn. New Delhi: Waverly.

Kapur, R.L. and **Shah, A.** (1992). Psycho-social perspective of women's mental health. In *Women in Development III: Gender Trainers Manual.* SAKTI : Bangalore.

Karve, I. (1994, orig. 1953). The kinship map of India. In P. Uberoi (Ed.). *Family, kinship and marriage in India.* (pp. 50–73). Delhi: Oxford University Press.

Kaushik, S. (1988). Strategies of professional intervention in family violence against women. A study of cases reported in Maharashtra. Paper presented at the National Conference on Family Violence against Females, NIPCCD, New Delhi. February.

Kendell, R.E. (1983). Hysteria. In G.F.M. Russell and L. Hersov (Eds.). *Handbook of psychiatry. The neuroses and personality disorders.* 4: 232–46. Cambridge: Cambridge University Press.

Kerns, D.L. (1981). Medical assessment of child sexual abuse. In P.B. Mrazek and C.H. Kempe (Eds.). *Sexually abused children and their families.* Oxford: Pergamon.

Kinsley, D. (1986). *Hindu goddesses, visions of the divine feminine in the Hindu religious tradition.* Delhi: Motilal Banarsidass.

Kirmayer, L.J. (1992). The body's insistence on meaning: Metaphor as presentation and representation in illness experience. *Medical Anthropology Quarterly, 6*(4): 323–46.

——— (1994). Pacing the void. Social and cultural dimension of dissociation. In D. Spiegel (Ed.). *Dissociation: Culture, mind and body.* (91–122). Washington, D.C.: American Psychiatric Press.

Kitzinger, C. (1990). Resisting the discipline. In E. Burman (Ed.). *Feminists and psychological practice.* (pp. 119–36). London: Sage.

Klonoff, E.A. and **Landrine, H.** (1997). *Preventing misdiagnosis of women. A guide to physical disorders that have psychiatric symptoms.* Thousand Oaks: Sage.

Kolvin and **Kaplan, C.A.** (1988). Sexual abuse in childhood. In K. Granville-Grossman (Ed.). Recent advances in clinical psychiatry. No. 6. London, Edinburgh, Melbourne and New York: Churchill Livingstone.

Koffman, S. (1985). *The enigma of woman. Woman in Freud's writings.* Ithaca: Cornell University Press.

Kortmann, F. and **Ten Horn, S.** (1988). Comprehension and motivation in responses to a psychiatric screening instrument: Validity of the SRQ in Ethiopia. *British Journal of Psychiatry, 153*: 95–101.

Koss, M.P. (1990). The women's mental health research agenda: Violence against women. *American Psychologist, 45*(3): 374–80.

Kulkarni, R. (1988). A study of family violence against married women in Nagpur city during 1987. Paper presented at the National Conference on Family Violence against Females, NIPCCD, New Delhi. February.

Kumar, R. and **Brockington, I.F.** (Eds.). (1988). *Motherhood and mental illness. 2. Causes and consequences.* London: Wright.

Kurtz, S.M. (1992). *All the mothers are one. Hindu India and the cultural reshaping of psychoanalysis.* New York: Columbia University Press.

Laing, R.D. and **Esterson, A.** (1964). *Sanity, madness and the family.* London: Tavistock.

Lakshmi, C.S. (1990). Mother, mother-community and mother-politics in Tamil Nadu. in *Economic and Political Weekly, XXV*(42 and 43), WS-72-WS-83.

Lata, P.M. (1990). Violence within the family. Experiences of a feminist support group. In S. Sood (Ed.). *Violence against women.* (pp. 223–26). Jaipur: Arihant Publishers.

Latha, K., Shah, M. and **Kannani, S.** (1991). The ethnographic approach to understand perceptions of health practitioners and women regarding reproductive health morbidity in slums of Baroda. Draft paper presented at a manuscript writing workshop for Qualitative Research on Women's Reproductive Health. Organised by the Ford Foundation and John Hopkins University, Baroda, India. April 22–26.

Lee, S. (1996). Book review of A. Kleinman (*Writing at the margin. Discourse between anthropology and psychiatry.* Berkeley: University of California Press, 1995). *British Journal of Psychiatry,* 169.

Lerner, G. (1979). *The majority finds its past. Placing women in society.* New York: Oxford.

Leslie, J. (1989). The inherent nature of women. In *The perfect wife, the orthodox Hindu woman according to the Stridharmapaddhati of Tryambakayajvan.* Delhi: Oxford University Press.

Lewis, I.M. (1966). Spirit possession and deprivation cults, *Man,* (n.s) *1*(3): 306–27.

Lion, J.R. (1977). Clinical aspects of wife battering. In M. Roy (Ed.). *Battered women. Psychosociological study of domestic violence.* New York: Van Nostrand Reinhold.

Littlewood, R. (1994). From demoniac possession to multiple personality and back again. An inaugural lecture. (ISBN. No. 0902137352). London: University College of London.

Lloyd, G. (1984). *The man of reason. 'Male' and 'female' in Western philosophy.* London: Methuen and Co.

Lott, B. (1985). The potential enrichment of social/personality psychology through feminist research and vice versa. *American Psychologist, 40*: 155–64.

Lovell, T. (Ed.) (1990). Introduction. In *British feminist thought. A reader.* (pp. 188–95). Oxford/Cambridge: Basil Blackwell Ltd.

Luthra, U., Mehta, S., Bhargava, N.C., Ramachandran, P., Murthy, N.S., Sehgal, A. and **Saxena, B.N.** (1992). Reproductive tract infections in India. The need for comprehensive reproductive healthy policy and programs. In A. Germain, K. Holmes, P. Piot and J.N. Wasserheit, (Eds.). (pp. 317–41). *Reproductive tract infections—Global impact and priorties for women's health.* New York: Plenum Press.

Macintyre, M., Morpeth, R. and **Prendergast, S.** (1981). A daughter. a thing to be given away. In The Cambridge Women's Studies Group (Eds.). *Women in Society. Interdisciplinary Essays.* (pp. 127–45). London: Virago.

Marano, H.E. (1993). Inside the heart of marital violence. *Psychology Today*, Nov./Dec., (pp. 48–53), (pp. 76–78, 91).

Marecek, J. (1995). Gender, politics and psychology's ways of knowing. *American Psychologist, 50*: 162–63.

Mari, J.J. (1986). Minor psychiatric morbidity in three primary medical care clinics in the city of Sao Paulo. Ph.D thesis. Institute of Psychiatry, University of London.

Mari, J.J. and **Williams, P.** (1985). A comparison of the validity of two psychiatric screening questionnaires (GHQ-12 and SRQ-20) in Brazil, using relative operating characteristic (ROC) analysis. *Psychological Medicine, 15*: 651–59.

Markowe, H.L.J. (1988). The frequency of childhood sexual abuse in the UK. *Health Trends, 20*: 2–6.

Marsden, G. (1971). Content analysis studies of psychotherapy, 1954 through 1968. In A.E. Bergin and S.L. Garfield (Eds.). *Handbook of psychotherapy and behaviour change.* (pp. 345–407). New York: John Wiley and Sons.

Martin, R.L. et al. (1980). Psychiatric status after hysterectomy. *Journal of the American Medical Association, 244*: 350–53.

MATCH International Centre (1990). *Linking women's global struggles to end violence.* Canada: Author.

Mayamma, M.C. and **Sathyavathi, K.** (1985). Disturbances in communication and marital disharmony in neurotics. *Indian Journal of Psychiatry, 27*: 315–19.

————— (1988a). Affection and domination. Submission conflicts in neurotics. *Journal of Psychological Research, 35*: 59–62.

————— (1988b). Marital disharmony in neurotics. *Indian Journal of Psychiatry, 30*: 389–93.

McGarry, P.A. and **McGrath, D.** (1981). Breaking cycles of victimisation. The shelter as an affirmative in situation. In P. Rusianoff (Ed.). *Women in crisis.* (pp. 133–44). New York: Women's Science Press.

McDermott, J., Bangser, M., Ngugi, E. and **Sandvold, I.** (1990). Infection: Social and medical realities. In M. Koblinsky, J. Timyan and J. Gay (Eds.). *The health of women—A global perspective.* Boulder: Westview Press.

McDowell, J. (1994). *Mind and world.* Cambridge, Mass.: Harvard University Press.

McHugh, M., Koeske, R.D. and **Frieze, I.M.** (1986). Issues to consider in conducting non-sexist psychological research: A guide for researchers. *American Psychologist, 41*: 879–90.

Media Asia (1998). Mass media and social change. A case study of TV commercials. Review of A.K. Gupta and N. Jain. *Media Asia, 25*(1): 33–36.

Merleau-Ponty, M. (1986, orig. transl. 1962). *Phenomenology of perception.* London: Routledge and Kegan Paul.

Merskey, H. (1992). The manufacture of personalities. *British Journal of Psychiatry, 160*: 327–40.

Miller, J.B. (1976). *Towards a new psychology of women.* London: A Ven Lans.

Mills, L. (1996). Empowering battered women transationally. The case for postmodern interventions. *Social Work, 41*(3): 241–336.

Mitchell, J. (1974). *Psychoanalysis and feminism.* New York: Penguin Books.
———— (1990). Feminine sexuality. ·Jacques Lacan and the Ecole Freudienne. In T. Lovell (Ed.). *British feminist thought. A reader.* (pp. 196–210). Oxford/Cambridge: Basil Blackwell.

Mitra, J. (1989). *Hannaman.* Calcutta: Anyadhara.

Mohanty, S.P. (1998). *Literary theory and the claims of history. Postmodernism, objectivity, multicultural politics.* New Delhi: Oxford.

Moore, M. (1984) *Law and psychiatry. Rethinking the relationship.* Cambridge: Cambridge University Press.

Moore, R. (1993). Gender, power and legal pluralism. Rajasthan, India. In *American Ethnologist, 20*(3): 543–63.

Mrazek, P.B. et al. (1981). Recognition of child sexual abuse in the United Kingdom. In P.B. Mrazek and C.H. Kempe (Eds.). *Sexually abused children and their families.* (pp. 35–50) Oxford: Pergamon.

Mrazek, D. and **Mrazek, P.B.** (1985). Child maltreatment. In M. Rutter and L. Hersor (Eds.). *Child and Adolescent Psychiatry. Modern Approaches.* (pp. 679–97). Oxford: Blackwell Scientific Publications.

Mulgaonkar, V.B. (1991). Non-utilization of gynaecological health services—perceptions of Bombay urban slum women. Draft paper presented at a manuscript writing workshop for Qualitative Research on Women's Reproductive Health. Organised by the Ford Foundation and John Hopkins University, Baroda, India, April 22–26.

Murphy, H.B.M. (1982). *Comparative psychiatry. An international and intercultural distribution of mental illness.* Berlin/New York: Springer-Verlag.

Murphy, J.M. (1986). Trends in depression and anxiety. men and women. *Acta Psychiatrica Scandinavica, 71*: 113–27.

Murray, J. (1983). Sex bias in psychotherapy. A historical perspective. In J. Murray, and P.R. Abramson (Eds.). *Bias in Psychotherapy.* NY: Praeger.

Nahem, J. (1981). *Psychology and psychiatry today.* New York: International Publishers.

Nandi, D.N. (1988). Status of women in our society and their mental health. *Indian Journal of Social Psychiatry, 4*: 2–9.

Nandy, A. (1983). *The intimate enemy. Loss and recovery of self under colonialism.* New Delhi: Oxford University Press.

Narayana Rao, V. (1986). Epics and ideologies: Six Telugu folk epics. In S. Blackburn and A.K Ramanujan (Eds.). *Another harmony. New essays on the folklore of India.* (pp. 131–64). Delhi: Oxford University Press.

Nathanson, C.A. (1980). Social roles and health status among women. The significance of employment. *Social Science and Medicine, 14*: 463–73.

Nichter, M. (1981). Idioms of distress. Alternatives in the expression of psychosocial distress. A case from south India. *Culture, Medicine and Psychiatry, 5*: 379–408.

Ninan, S. (1995). *Through the magic window. Television and change in India.* London: Penguin.

Nolen-Hoeksema, S. (1987). Sex differences in unipolar depression. Evidence and theory. *Psychological Bulletin, 101*: 259–82.

O'Flaherty, W.D. (1981). *Sexual metaphors and animal symbols in Indian mythology.* Delhi: Motilal Banarsidass.

O'Flaherty, W.D. (1988). *The origins of evil in Hindu mythology.* Delhi: Motilal Banarsidass.

Obeyesekere, G. (1981). *Medusa's Hair. An essay on personal symbols and religious experience.* Chicago and London: University of Chicago.

Padhye, M. (1988). Violence committed by the husband on the wife, by in-laws on daughter-in-law and on widows and on separated and divorced women. Paper presented at the National Conference on Family Violence against Females, NIPCCD, New Delhi. February.

Paltiel, F.L. (1993). Mental health of women in the Americas. In E. Gomez (Ed.). *Gender, women and health in the Americas.* (Scientific publication; 541). Washington D.C.: PAHO.

————— (1987). Women's mental health. A global perspective. In M. Koblinsky, J. Timyan and J. Gay (Eds.). *The health of women—A global perspective.* (pp. 197–216). Boulder: Westview Press.

Panjabi, K. (1996). The first syllables of a new language. Responses to sexual violence. (*Indian Journal of Gender Studies, 1995, 2*(1): 87–100.) In (Ed.). Shefali Mitra. *Women, heritage and violence.* (pp. 55–71). Calcutta: Papyrus.

————— (1997). Probing morality and state violence. Feminist values and communicative interaction in prison testimonies in India and Argentina. In Jacqui Alexander and Chandra Talpade Mohanty (Eds.). *Feminist genealogies, colonial legacies, democratic futures.* (pp. 151–69). New York and London: Routledge.

Parihar, L. (1990). Battered wife syndrome. Some socio-legal aspects. In S. Sood (Ed.). *Violence against women.* (pp. 35–44). Jaipur: Arihant Publishers.

Paris, J. (1996). Dissociative symptoms, dissociative disorders and cultural psychiatry. Review essay. *Transcultural Psychiatry Research Review, 33*(1): 55–59.

Parlee, M.B. (1979). Psychology and women. *Signs, 5*(1): 121–33.

Patel, P. (1994). Illness beliefs and health-seeking behaviour of the Bhil women of Panchamahal district, Gujarat state. In Gittelsohn et al. (Eds). *Listening to women talk about their health–issues and evidence from India.* (pp. 55–66). New Delhi : Har Anand Publications.

Pathak, I. (1990). Women's responses to familial violence in Gujarat. In

S. Sood (Ed.). *Violence against women.* (pp. 259–68). Jaipur: Arihant Publishers.

Pearce, J., Hawton, K. and **Blake, F.** (1995). Psychological and sexual symptoms associated with the menopause and the effects of hormone replacement therapy. *British Journal of Psychiatry, 167*: 163–73.

Penayo, U., Kullgren, G. and **Caldera, M.** (1990). Mental disorders among primary health care patients in Nicaragua. *Acta Psychiatrica Scandinavica, 82*(1): 82–85.

Perumal, A.K. (1990). *Tolpalam Samaya Kurukal.* (Tales of Ancient Times). Chennai: Pioneer Book Services.

Phillips, D.L. and **Segal, B.E.** (1969). Sexual status and psychiatric symptoms. *American Sociological Review, 34*(1): 58–72.

Pilowsky, I. (1991). Editor's Introduction. *British Journal of Psychiatry, 158*: 7–8.

Plath, S. (1963). *The bell jar.* London: Faber.

———— (1981). *Collected poems.* London: Faber.

Pogrebin, L.C. (1980). *Growing up free. Raising your child in the 80s.* London: McGraw-Hill.

Porter, R. (1987). *A social history of madness. Stories of the insane.* London: Phoenix Giant.

Prabhu, G.G., John, A., Daniel, E. and **Elizabeth, C.K.** (1985). Retardation in India. 7th World Congress of IASSMD, New Delhi. January.

Prakash, G. (1990). *Bonded histories. Genealogies of labor servitude in colonial India.* Cambridge: Cambridge University Press.

Priya, D. (1996). Bridges between spirituality and the women's movement in India. *Lokayan Bulletin, 13*(1): 1–15.

Ptacek, J. (1988). Why do men batter their wives? In K. Yllo and M. Bograd (Eds.). *Feminist perspectives on wife abuse.* (pp. 133–57). Newbury Park: Sage.

Rabelo, M.C.M., Alves, P.C.B. and **Almeida Souza, M.** (1995). The many meanings of mental illness among the urban poor in Brazil. In T. Harpham, and I. Blue (Eds.). *Urbanisation and mental health in developing countries.* (pp. 167–92). England: Ashgate Publishing Company.

Raheja, G.G. and **Gold, A.G.** (1996). *Listen to the heron's words, reimagining gender and kinship in North India.* Delhi: Oxford University Press.

Ram, K. (1992). *Mukkuvar women. Gender, hegemony and capitalist transformation in a south Indian fishing community.* New Delhi: Kali for Women.

———— (1998). Maternity and the story of enlightenment in the colonies: Tamil coastal women, south India. In K. Ram and M. Jolly (Eds.). *Maternities and modernities. colonial and postcolonial experiences in Asia and the Pacific.* (pp. 114–43). Cambridge: Cambridge University Press.

———— (2000). Uneven Modernities and Ambivalent Sexualities. Women's Constructions of Puberty in coastal Kanyakumari, Tamil Nadu. In M. John and J. Nair (Eds.). *A Question of silence? The sexual economies of modern India.* Kali for Women.

Randall, M. (1981). *Sandino's daughters. Testimonies of Nicaraguan women in struggle.* Lyna Yanz (Ed.). Toronto: New Star Books.

Reichenheim, M.E. and **Harpham, T.** (1991). Maternal mental health in a squatter settlement in Rio de Janeiro. *British Journal of Social Psychiatry, 159*: 683–90.

Reismann, C.K. (1983). Women and medicalization. A new perspective. *Social Policy,* Summer: 3–18.

Renovoize, J. (1993). *Innocence destroyed. A study of child sexual abuse.* London: Routledge.

Rinchin (1997). A study of the adolescent girls' perception of child sexual abuse. M.A. Thesis. Dept of Medical and Psychiatric Social Work, Tata Institute of Social Sciences, Mumbai.

Roberts, J.M. (1991). Sugar and spice, toads and mice—General issues in family therapy training. *Journal of Marital and Family therapy, 17*: 121–32.

Robins, C.J. and **Hayes, A.L.** (1993). An appraisal of cognitive therapy. *Journal of Counselling and Clinical Psychology, 61*(2): 205–14.

Roland, A. (1988). *In search of self in India and Japan. Towards a cross-cultural psychiatry.* Princeton: Princeton University Press.

Rose, J. (1990). Femininity and its discontents. In Terry Lovell (Ed.). *British feminist thought. A reader.* (pp. 227–43). Oxford/Cambridge: Basil Blackwell Ltd.

Roth, T. and **Lerner, J.** (1974). Sex-based discrimination in the mental institutionalisation of women. *California Law Review, 62*: 789–815.

Roy, M. (Ed.). (1977). *Battered women. Psychosociological study of domestic violence.* New York: Van Nostrand Reinhold.

Russell, D.E.H. (1984). *Sexual exploitation. Rape, child sexual abuse and workplace harrassment.* California: Sage.

Russianoff, P. (1981). Learned helplessness. In P. Rusianoff (Ed.). *Women in crisis.* (pp. 33–37). New York: Women's Science Press.

Russo, N.F. (1990). Overview. Forging research priorities for women's mental health. *American Psychologist, 45*(3): 368–73.

Sakshi (undated). Child sexual abuse. Beyond fear, secrecy and shame. New Delhi: Sakshi.

Salleh, M.R. (1990). Psychiatric morbidity in schizophrenic relatives—Use of self-reporting questionnaires (SRQ). *Singapore Medical Journal, 31*(5): 457–62.

Sanday, P.R. (1985). Rape and the silencing of the feminine. In S. Tomaselli and R. Porter (Eds.). *Rape: An historical and social inquiry.* (pp. 84–101). New York: Basil Blackwell.

Sandel, B. (1982). A comparative study of neurotic symptom patterns, life stresses and demographic features in women of a local neighbourhood and women attending a psychiatric outpatients clinic. M.D. diss. Department of Psychological Medicine, University of Calcutta, India.

————— (1990). An in-depth study of neurosis among women in Calcutta, with special reference to life-events. In A. Chakraborty (Ed.). *Social stress and mental health. A social psychiatric field study of Calcutta.* Addendum. (pp. 147–78). New Delhi: Sage.

Sarason, S.B. (1981). An asocial psychology and a misdirected clinical psychology. *American Psychologist, 36*: 827–36.

Sax, W. (1994). Gender and politics in Garhwal. In N. Kumar (Ed.). *Women as subjects: South Asian histories.* (pp. 172–210). New Delhi: Stree.

Scharfetter, C. (1995). *The self-experience of schizophrenics. Empirical studies of the ego/ self in schizophrenia, borderline disorders and depression.* ISBN No. 3 9520932 1 6. Zurich: Private publication.

Scheper-Hughes, N. and **Lock, M.M.** (1987). The mindful body: A prolegomenon to future work in medical anthropology. *Medical Anthropology Quarterly, 1*: 6–41.

Schmunis, G.A. (1993). Infectious diseases of women: Tropical diseases and reproductive tract infections. In E.G. Gomez (Ed.). *Gender, women and health in the Americas.* Washington D.C.: PAHO.

Schuler, M. (1992). Violence against women. An international perspective. In M. Schuler (Ed.). *Freedom from violence. Women's strategies around the world.* New York: UNIFEM.

Schutz, A. (1970). *On phenomenology and social relations. Selected writings.* H.R. Wagner (Ed.). Chicago: University of Chicago Press.

Schwab, J.J. and **Schwab, M.E.** (1978). *Socio-cultural roots of mental illness. An epidemiologic survey.* New York: Plenum Press.

Scott, David. (1994). *Formations of ritual. Colonial and anthropological discourses on the Sinhala Yaktovil.* Minneapolis, London: University of Minnesota Press.

Sehgal, A. (1996). The sexually abused girl child. A hermeneutic approach. M.A. thesis. Department of Medical and Psychiatric Social Work, Tata Institute of Social Sciences, Mumbai.

Sellars, W. (1963). *Science, perception and reality.* London: Routledge and Kegan Paul.

Sen, A. (1987). Gender and co-operative conflicts. Discussion paper No. 1342. Harvard: Harvard Institute of Economic Research.

———— (1990). More than 100 million women are missing. *New York Review of Books, 37*(25): 51–67.

Sen, B. (1987). An analysis of the nature of depressive phenomena in primary health care utilising multivariate statistical techniques. *Acta Psychiatrica Scandinavica, 76*(1): 28–32.

Seremetakis, N.C. (1991). *The last word. Women, death and divinaton in Inner Mani.* Chicago: University of Chicago Press.

Sethi, B.B., Gupta, S.C., Mahendru, R.K. and **Kumari, P.** (1974). Mental health and urban life. A study of 850 families. *British Journal of Psychiatry, 124*: 243–46.

Shah, A. (1995). Clinical validity of marital quality scale. *NIMHANS Journal, 13*: 23–31.

———— (1997). Interpersonal relationship in the family and mental health. Paper presented at Seminar on Developments in Clinical Psychology, NIMHANS, Bangalore. 20–21 January.

Shah, A.V., Goswami, U.A. and **Sinha, B.K.** (1980). Prevalence of psychiatric disorders in Ahmedabad. An epidemiological study. *Indian Journal of Psychiatry, 22*: 384–89.

Sharma, U. (1980). *Women, work and property in north-west India.* London: Tavistock.

Shatrugna, V. (1999). Foreword. In B.V. Davar. *Mental health of Indian women. A feminist agenda.* (pp. 11–17). New Delhi: Sage publications.

Shatrugna, V., Vidyasagar, P. and **Sujata, T.** (1993). Women's work and reproductive health. *Medico friend circle bulletin.* August–December: 1–4.

Sheinberg, M. and **Penn, P.** (1991). Gender dilemmas, gender questions and the gender mantra. *Journal of Marital and Family Therapy, 17:* 33–34.

Shepherd, M., Cooper, B., Brown, A.C. and **Kalton, G.** (1981). *Psychiatric illness in general practice.* 2nd Edn. London Oxford University Press.

Shneidman, S. (1976). Suicide notes reconsidered. In S. Shneidman (Ed.). *Suicidology. Contemporary developments.* New York: Grune and Stratton.

Showalter, E. (1987). The *female malady. Women, madness and the English culture. 1830–1980.* London: Virago.

Sircar, D.C. (1972). *The Shakta Pithas.* Delhi: Motilal Banarsidass.

Skorupski, J. (1979). Pangolin power. In S.C. Brown (Ed.). *Philosophical disputes in the social sciences.* (pp. 151–76). Sussex: Harvester Press.

Sniderman, M.S. (1983). Self-esteem in psychotherapy. *Canadian Journal of Psychiatry, 28.*

Special Issue, (1995). Violation of innocence, child sexual abuse and the law. *Lawyers' Collective, 10*(10 and 11).

Spence, J.T. (1985). Achievement American style. *American Psychologist, 40:* 1285–95.

Spinelli, E. (1989). *The interpreted world. An introduction to phenomenological psychology.* London: Sage.

Spinelli, E. (1996). The existential-phenomenological paradigm. In R. Woolfe and W. Dryden (Eds.). *Handbook of counselling psychology.* (pp. 180–200). London: Sage.

Srinivasan, V. (1987). Deserted wives in the slums of Madras city. Pilot study. *The Indian Journal of Social Work, 48*(3): 287–96.

Sriram, R. (1991). Research on marital violence. Some trends, implications and emerging issues. In M. Desai (Ed.). *Research on families with problems in India.* (pp. 483–95). Bombay: Tata Institute of Social Sciences.

Sriram, R. and **Bakshi, A.** (1988). Family violence against married women. *Social Change, 18*(3): 45–58.

Sriram, R. and **Mayuri, K.** (1992). Can we alter the male prerogative? Opinions on dowry. Unpublished manuscript. Department of Human Development and Family Studies, M.S. University of Baroda, Vadodara, Gujarat.

Stansfeld, S., Feeney, A., Head, J., Canner, R., North, F. and **Marmot, M.** (1995). Sickness absence for psychiatric illness: The Whitehall study. *Social Science and Medicine, 40*(2): 189–97.

Stoller, P. (1995). *Embodying colonial memories. Spirit possession, power, and the Huaka in West Africa.* London: Routledge and Kegan Paul.

Storm, C.L. (1991). Planning gender in the heart of MFT masters grams: Teaching a gender-sensitive systemic view. *Journal of Marital and Family Therapy, 17*: 45–52.

Stree Shakti Sanghatana. (1989). *'We Were Making History.' Life stories of women in the Telangana People's Struggle.* New Delhi: Kali for Women.

Stricker, G. and **Shafran, R.** (1983). Gender and psychotherapy. In J. Murray and P.R. Abramson. (Eds.). *Bias in psychotherapy.* NY: Praeger.

Sugar, J.A., Kleinman, A. and **Heggenhougen, K.** (1991). Development's 'downside': Social and psychological pathology in countries undergoing social change. *Health Transition Review, 1*(2): 211–20.

Sullivan, J. (1989). A partial review of the Indian literature on health producing behaviour. Unpublished manuscript produced for the Ford Foundation (India).

Supreme Court Commission Reports (1984). Supreme Court enquiry report on hospital for mental diseases. Shahdara. Parts I and II, GOI.

———— (1993). Unlocking the padlock. Mental health care in West Bengal. Report of the Supreme Court Commission on the jails of West Bengal, GOI.

———— (1994). *Justitia Virtutum Regina.* Report of the commission on the mentally ill in Assam.

Taussig, M. (1980). *The devil and commodity fetishism in South America.* Chapel Hill: University of North Carolina Press.

———— (1987). *Shamanism, colonialism, and the wild Man. A study in terror and healing.* Chicago: University of Chicago Press.

Taylor, C. (1986). Foucault on freedom and truth. In D.C. Hoy (Ed.). *Foucault. A critical reader.* (pp. 69–102). Oxford: Basil Blackwell.

———— (1989). *Sources of the self. The making of the modern identity.* Cambridge Mass: Harvard University Press.

Taylor, M. (1996). The feminist paradigm. In R. Woolfe and W. Dryden (Eds.). *Handbook of counselling psychology.* (pp. 201–18). London: Sage. Publications.

Tinker, I. and **Bramsen, B.** (1977). *Women and world development.* Overseas Development Council, Washington DC.

Tuchman, G. (1978). (Ed.). *Home and health. Images of women in the mass media.* Oxford: Oxford University Press.

Tully, J. (Ed.). (1994). *Philosophy in an age of pluralism. The philosophy of Charles Taylor in question.* Cambridge: Cambridge University Press.

Turner, R.P. (1989). *Medical power and social knowledge.* Newbury Park: Sage.

Turner, V. (1974). Metaphors of anti-structure in religious culture. In *Drama, fields, and metaphors: Symbolic action in human society.* Ithaca: Cornell University Press.

UNICEF (1997). State of the World's Children Report. Geneva: UNICEF.

United Nations Development Fund for Women (1992). *Battered dreams. Violence against women as an obstacle to development.* New York: Author.

Ussher, J. (1990). Choosing psychology or not throwing the baby out with the bathwater. In E. Burman (Ed.). *Feminists and psychological practice.* (pp. 47–61). London: Sage.

Ustun, T,B. and **Sartorius, N.** (Eds.). (1995). Mental illness in general health care. An international study. London: John Wiley & Sons (for WHO).

Varma, V.K., Avesthi, S.K., Mattoo, S.K. and **Jain, A.K.** (1992). Diagnostic and sociodemographic data of psychiatric patients at the national level. *Indian Journal of Psychiatry, 8*(3 and 4): 22–34.

Vashishta. (1991). *The sacred laws of the Aryas, Part II.* Volume 14. In F. Max Muller. (Trans.) G. Buhler (Ed.). *The sacred books of the East.* Delhi: Motilal Banarsidass.

Vaughter, R.M. (1976). Review essay: Psychology. *Signs, 2:* 120–46.

Venkoba Rao, A. (1994). Depressive disorder. Editorial. *Social Science and Medicine, 38*(9): v–viii

Verghese, A., Beig, A., Senseman, L.A., SunderRao, S.S. and **Benjamin, V.** (1973). A social and psychiatric study of a representative group of families in Vellore town. *Indian Journal of Medical Research, 61:* 608–20.

Waldby, C., Clancy, A., Emtchi, J. and **Summerfield, C.** (1989). Theoretical perspective on father daughter incest. In E. Driver and A. Droisen (Eds.). *Child sexual abuse. Feminist perspective.* London: Macmillan Education Ltd.

Walker, L.E. (1989). Psychology and violence against women. *American Psychologist, 44:* 695–702.

Walters, V. (1993). Stress, anxiety and depression: Women's accounts of their health problems. *Social Science and Medicine, 36*(4): 493-502.

Ward, E. (1984). *Father–daughter rape.* London: Women's Press.

Wasserheit, J.N. and **Holmes, K.H.** (1992). Reproductive tract infections. Challenges for international health policy, programs and research. In A. Germain, K., Holmes, P. Piot and J.N. Wasserheit (Eds.). *Reproductive tract infections—Global impact and priorities for women's reproductive health.* (pp. 7–34). New York: Plenum Press.

Weissman, M.M. and **Klerman, G.L.** (1977). Sex differences and the epidemiology of depression. *Archives of General Psychiatry, 34*(1): 98–111.

Weisstein, N. (1970). Kinder, kirche, kuche, as scientific law. Psychology constructs the female. In R. Morgan (Ed.). *Sisterhood is powerful.* (pp. 228–44). New York: Random House.

Wilkinson, S. (1990). Women organizing withing psychology. Two accounts. In E. Burman (Ed.). *Feminists and psychological practice.* (pp. 140–62). London: Sage.

Williams, B. (1985). *Ethics and the limits of philosophy.* Cambridge, Mass.: Harvard University Press.

Williams, S.R. (1992). *Riding the nightmare. Women and witchcraft from the old world to colonial salem.* New York: Harper Perennial.

Wing, J.K., Cooper, J.E. and **Sartorius, N.** (1974). *The measurement and classification of psychiatric symptoms.* Cambridge: Cambridge University Press.

Wittgenstein, L. (1967). *Remarks on the foundations of mathematics.* Oxford: Basil Blackwell.

———— (1969). *On Certainty.* Oxford: Basil Blackwell.

Wolberg, L.R. (1988). *The technique of psychotherapy. Part II.* New York: Grune and Stratton.

Wolf, N. (1991). *The beauty myth. How images of beauty are used against women.* London: Vintage.

Wolf-Smith, J.H. and **La Rossa, R.** (1992). After he hits her. *Family Relations, 41*(3): 324–29.

Woolfolk, R. and **Richardson, F.C.** (1984). Behaviour therapy and the ideology of modernity. *American Psychologist, 39,* 777–86.

World Bank (1993). *World Development Report 1993—Investing in Health.* New York: Oxford University Press.

World Health Organisation (1991). *Health trends and emerging issues in the 1990s and the twenty-first century. Monitoring, evaluation and projection.* Methodology Unit, WHO, Geneva.

———— (1994). *A user's guide to the self reporting questionnaire* (SRQ). Division of mental health, Geneva: WHO.

———— (1978). The application of advances in neurosciences for neurological disorders. Technological Report Series. WHO, N. 629. New Delhi: SEARO.

Yogananda, B.H. (1997). A study of phenomenology and quality of marital life in major post-partum psychiatric disorders. M.D. Thesis. Dept. of Psychiatry, NIMHANS, Bangalore, India.

Young, I.M. (1990). Throwing like a girl. A phenomenology of feminine body comportment, motility, and spatiality. In I.M. Young (Ed.). *Throwing like a girl and other essays in feminist philosophy and social theory.* (pp. 141–60). Bloomington and Indianapolis: Indiana University Press.

Younis, N., Khattab, H., Zurayk, H., El-Mouelhy, M., Amin, M.F. and **Farag, A.M.** (1992). A community study of gynaecological and related morbidities in rural Egypt. *Regional papers,* No. *38,* West Asia and North Africa: The Population Council.

Zurayk, H., Khattab, H., Younis, N., Kamal, O. and **El-Mouelhy. M.** (1995). Comparing women's reports with medical diagnosis of reproductive morbidity conditions in rural Egypt. *Studies in Family Planning, 26*(1): 14–21.

ABOUT THE EDITOR AND CONTRIBUTORS

ABOUT THE EDITOR

Bhargavi V. Davar is a freelance researcher based in Pune and is presently on a Homi Bhabha Fellowship to study community mental health in India. She has been actively involved with women's group in creating a context of discussion and research on women and mental health in India. Her other research interests include the social and political bases of psychiatry in India, especially as it pertains to gender, culture and mental illness. Besides contributing articles to journals and edited volumes, Bhargavi Davar has previously published *Psychoanalysis as a Human Science: Beyond Foundationalism* (co-author) and *Mental Health of Indian Women: A Feminist Agenda.*

ABOUT THE CONTRIBUTORS

Renu Addlakha is a Ph.D. in the sociology of psychiatry. Her doctoral dissertation was on an ethnographic study of psychiatric practice in India. She was a Research Associate at the Centre for Development Economics, Delhi School of Economics. She has been attached to various health related projects in Delhi.

Ajita Chakraborty is a consultant psychiatrist based in Calcutta. She obtained her DPM in the UK and later became a Fellow of the Royal College of Physicians, Edinburgh, of the Royal College of Psychiatrists, London and of the American Psychiatrists Association. Chakraborty has held various senior administrative posts in psychiatry and has published in the area of culture and mental illness.

Prabha S. Chandra is the Associate Professor of Psychiatry, NIMHANS, Bangalore. She is a member of a group in the World Psychiatric Association which works on women's mental health. She is also a member of the International Society of Psychosomatic Obstetrics and Gynecology. She has published widely in the area of reproductive health and mental health.

Janet Chawla from New Delhi is interested in women's health, traditional midwives, ethno-medicine and religio-cultural imaginings of the female body. She is currently the Project Director of MATRIKA, a three year documentation effort focussing on *dais*.

Amita Dhanda has done a Ph.D. in Law from the University of Delhi and is the author of *Legal order and mental disorder* (Sage, 2000). She has been on various consultations and commissions for the rights of the mentally ill and disabled and has published widely on mental health advocacy, particularly the Mental Health Act. She is also part of the faculty at the Indian Law Institute, New Delhi. Presently she is Professor at the University of Law, Hyderabad.

Sasheej Hegde is a Ph.D. and presently Reader in the Sociology Department, University of Hyderabad. He was also in the Faculty of Sociology, University of Goa. His work straddles various disciplines and ethico-political questions, and is presently occupied with issues of an 'Indian Sociology'.

Surinder K.P. Jaswal has an M.A. in Medical and Psychiatric Social Work (Tata Institute of Social Sciences) and a Ph.D. from the School of Hygiene and Tropical Medicine, London. Currently, she is Reader at the Tata Institute of Social Sciences, Mumbai, India. She has been a principal investigator on studies in understanding sexuality, an ethnographic study of poor women in Mumbai, communication needs assessment, and the role of ICDs workers and health correlates of violence.

Ammu Joseph is a freelance journalist, media analyst and editorial consultant based in Bangalore, India. She has taught journalism to post-graduate students in Bombay. She writes a fortnightly column for children in *The Hindu*. She is co-author and editor of *Whose news? The media and women's issues* from Sage, and author of a (forthcoming) book on Indian women in journalism.

Jayasree Kalathil is a Research Fellow at CIEFL, Hyderabad. She is an active member of Anveshi, Research Centre for Women's Studies, Hyderabad, a feminist organisation devoted to research on women's studies. Her research interests include gender, domesticity, violence and media.

Shubhada Maitra is in the faculty of the Department of Medical and Psychiatric Social Work, Tata Institute of Social Sciences, Mumbai. She is also the faculty-in-charge of the Child Guidance Clinic of TISS. Her areas of interest are women's health, child and adolescent mental health, sexuality and sexual health.

Sudipta Mukherjee is an M.Phil in medical and social psychology from NIMHANS, Bangalore. She is a lecturer in the Department of Human Development and Family Studies, MS University of Baroda, where she teaches courses related to children with special needs. She is a consulting honorary clinical psychologist.

Kavita Panjabi is a Ph.D. from Cornell University and is currently a Senior Lecturer in the Department of Comparative Literature, Jadavpur University, Calcutta. Closely associated with the School of Women's Studies at JU, she is currently working on oral narratives of women in the Tebhaga Movement. She has published on women's response to sexual violence and narratives of women in political struggle and Latin American Literature.

Sarah Pinto is a Ph.D. in socio-cultural anthropology from Princeton University. She has researched Tibetan childbirth practices and rituals in Dharamsala, India, and menopause

and the use of HRT in Philadelphia, USA. She has also published in these areas.

Kalpana Ram is a Research Fellow of the Australian Research Council in the Department of Anthropology of Macquarie University, Sydney. Her previous publications include *Mukkuvar Women, Maternities and Modernities: Colonial and Postcolonial Experiences in Asia and the Pacific* (edited), *Migrating Feminisms,* and also the special issue of Women's Studies International Forum.

Rinchin is currently working with MASUM, an NGO in Pune. She completed her MA dissertation at TISS in 1997. She is interested in gender and mental health, particularly as they pertain to the area of child sexual abuse.

Shekhar Seshadri is Additional Professor at the Child and Adolescent Psychiatry Services, Department of Psychiatry, NIMHANS. His areas of work and interest are: Child and adolescent mental health; adolescence; psychotherapy and psychotherapy training; gender, sexuality, sexual abuse; school programmes; consultation psychiatry; qualitative research methods; action research; special populations (street children, child sexual abuse); and theatre in education.

Anisha Shah is a Ph.D. and currently works as Assistant Professor of Clinical Psychology, Department of Clinical Psychology, NIMHANS, Bangalore. She is a clinical psychology consultant with one of the adult psychiatry units, and with the Family Psychiatry Unit at NIMHANS. Her interests are in the psycho-social aspects of human behaviour, family/marital relationships and gender, psychotherapies and depression.

Rajalakshmi Sriram is Reader in the Department of Human Development and Family Studies, MS University of Baroda. Her area of special interest is family and women's studies. She has been actively involved in research, designing interventions, training and writing in relation to childcare issues interfacing with women's empowerment.

L. Kavitha Vijayalakshmi is an MBBS, MD, DPM and was, until recently, working as Senior Resident at the Child and Adolescent Psychiatry Services, NIMHANS. Her areas of interest include developmental disorders, dyslexia, sexual abuse, women and mental health.

U. Vindhya is in the Faculty of Psychology, Andhra University, Visakapatnam. Her research concerns include the areas of women's mental health, domestic violence and the psychology of women's political activism. She has completed an ICSSR-sponsored study on domestic violence in Andhra Pradesh and an analysis of judicial outcome of cases. She has also been involved with the human rights and women's movement in Andhra.

A.K. Gopalan v. Union of India,
 1950 SCR 88, 338n
ability, 75–76
abnormality, 42, 47, 84, 284, 332
abuse and abuser, 222, 271–74
acquaintanceship, 325
acquired immuno-deficiency syn-
 drome (AIDS), 138
adaption, 43
adaptive schemata, 228
Adithi, 162n, 174, 176
adjustment, 43, 54, 83, 94
adolescent, effect of marital vio-
 lence on, 236–37
advertisement and women images,
 372–77
aetiology, 34, 62, 89, 106, 129,
 131
affective disorders, 129
age and common disorders, 47
ageing, 43, 134
aggression, 75, 226, 231, 236, 280
agony, 355
agrophobia, 146
AIDS *see* acquired immuno-defi-
 ciency syndrome
alexithymia, 45, 59
alienation, 370
Alka Sharma v. Abhivesh Sharma
 AIR 1991, MP 205, 341n
ambivalence, 189
Ambujam v. State of Kerala, 348,
 367
ameliorating psychological symp-
 toms, 134
American Anorexia and Bulimia
 Association, 380
American Human Association, 265
Amina Bibi v. Saiyid Yusuf (AIR
 1922 All 449), 362

androgyny, 65
anger and depression, 43, 59, 71,
 255–56, 290
Anjali, 386–87
anomie, 231
anorexia, 89, 380
anti-psychiatry, 34, 38
Anveshi, 13, 181n
anxiety, 44–45, 54, 56, 59, 85–86,
 96–97, 124, 127–28, 132, 146,
 164, 250, 331, 374
Argentina: female political activ-
 ists, 285–86
asceticism, 185
Asha Srivastava v. R.K. Srivastava
 AIR 1981 Del 253, 341n
assertiveness, 241
attam, 185, 190–91, 193
autonomy, 114, 382

backwardness, 36
Balakrishnan v. Lalitha (AIR 1984
 AP 285), 356–57
Bangalore, sexual abuse of chil-
 dren in, 249
batterer, 221, 226–28, 231–33,
 235, 237–38, 241–42
battering, 87, 94, 244, 263
Bayen, 16
beauty, ideology of, 377–81
Befriending Young Mothers, 125
behaviours, 21, 36, 62, 69, 79, 83–
 86, 94, 132, 223, 225, 227–28,
 304, 313, 319, 355–57, 371,
 378; disturbed, 62; therapy, 64;
 unfeminine, 96
behavioural: consequences, 255;
 techniques, 241
behaviourist psychology, 182
bhakti and possession, 210, 214

Black Horse Square, 290–91
Bombay, 382
Bourdieu, P., 161; on objectivism, 182–83; on possession, 207
Brahmpal Singh v. RamDulari AIR 1981 NOC 32, 363n
brutalisation, 95
bulimia, 89, 129, 380
Bunster-Burreto, X., on political women activist, 285–86

Calcutta: women, common disorders, 47–54, 56;- neuroses, 37–39;- possessions, 56;- psychoses, 41;- somatic complaints, 45
Canguilhem, G., 109–11, 113–15, 119
cardiovascular diseases, 134
care and treatment, 293; laws, 336–44
casteism, 157, 199
cause–effect relationship, 225
change, collective and individual, 83, 90–94, 96, 298
chauvinism, 23
Chawla, Anamika, 345
child, abuse prevention, 273–76; marital violence, impact, 236; mortality, 107; rearing, 66, 69, 82
chronic pelvic pain (CPP), 134–36
Chugtai, Ismat, 16
Civil Procedure Code (CPC), 1908, 362
class ideology, 200
clinical judgement process, 76–77, 313
cognitive abilities, 74–77
cognitive symptoms, 127, 134
commitment, 340, 344–48
common mental disorders, 103, 105, 144–47; and gynaecological morbidity, 147–52
community support, 93, 103, 105
conduct disorders, 41
confidence, lack of, 226
confinement, 340–45

conformity, 84–85, 313
conjoint therapy, 242
connectedness, 293–94
consciousness, 200, 202, 206–07, 215
Constitution of India, 338
consumerism, 385
consummation, 357
Contract Act, 363
conversion disorder. *See* hysteria
Coomaraswamy, A.K., 176
Coopa Ma, 171–74
coping, 54, 59, 68, 228, 246, 256
cost-effectiveness, 105
Criminal Procedure Code (Cr.PC), 1973, 348n, 349
criminal responsibility, 348–51
cross-cultural psychiatry and mental disorder, 54–60
cruelty and dowry deaths, 352–55

dais, see midwives
Daljit Kaur v. State (AIR 1968 Ori 125), 349
de Beauvoir, Simone, 208
deficiency, 92
dementia, 43
dependency and neuroses, 50–54, 92, 96, 293
depression, 19, 43–45, 49, 55, 59, 63, 65, 68–74, 85–86, 95–97, 106, 124–25, 127, 132, 135–36, 223, 233–34, 290, 303, 313–14, 327, 353–54, 386; and witchcraft, 42
desacralisation, 170
Dhanda, A., 119
Dhani Ram v. State (1982 Cri LJ661), 367
Dharmashastras, 157
diagnostic reality, 112–14
disclosure, resistance to, 288, 290
disembodiment, 58
disillusionment, 326
disposition, 351
dissociation, 56–59
distress, 31, 43–47, 49–50, 52, 59, 90–91, 94–96, 98, 130, 258,

355; subjective, 37–38. *See also* mental distress
diversity, 98, 182
divorce, mental illness and, 355–60, 368
dominant assumptions. *See* male dominance
Doordarshan, 379
dowry deaths, 352–55, 368
Draupadi by Mahashweta Devi, 289n, 293–94
dream analysis, 182
dysfunctionality, 59, 90–91, 137, 198
dysthymic disorder, 45

Eagly, A.H., 76
eating disorders, 380–81
economic dependency. *See* dependency
education and mental disorders, 50
electroconvulsive therapy, 15
embarrassment, 270
emotions, 92, 94, 233, 236
employment and depression, relationship, 73–74
empowerment, 14, 279, 288, 358, 373
enlightenment, 117, 300
epidemiology of possession, 199
epilepsy, 41, 355–57, 359
epistemology, 106, 164, 166, 198
equality, 298, 370
esotericism, 20
ethno-medical systems, 163–69
ethnography, 198
Evidence Act, 342
excitement, 63
exclusion, 172–73
exogamy, 199
exorcism, 387
expression, permissibility, 59

family relationship, role, 70, 73, 143–44, 233, 262, 315–16, 322–33; and child sexual abuse, 265; and neuroses, 50–54;

therapy, 65–68; and violence, 82, 237
fear, 255–56
female foeticide and infanticide, 40n–41, 174
female submission v. male aggression, 270–71
femininity, 58, 85, 89, 200, 202–03, 208, 216, 277, 296–97, 299–300, 302, 304, 309, 377
feminism, 14–18, 20–21, 29, 83, 90, 95, 186, 198, 262, 278, 298
feminist activism, 17, 22
Fernandes, Ezlinda, 345–46
fertility, 177, 204, 212, 215
Foucault, Michel, 108–15, 119, 160, 283, 299
freedom, 305, 374–75
Freud, S., 181–82; on child abuse, 262; frustration, 92, 231, 255–56, 326; on masculinity and femininity, 226; on neurosis, 183; on rape victims, 282

gender: discrimination and bias; 14, 36, 56, 61–68, 72, 74–80, 82, 90, 92–93, 98, 104–07, 120, 176, 178, 198, 227, 246, 248, 265, 268, 282, 301, 332, 336, 356, 378–79, 383–84; hierarchy, 157–58; polarity, 67; politics, 16, 105, 313, 332; and psychiatric illness, 314–15; sensitivity, 63, 67–68; socialisation, 271; stereotypes, 246, 313, 315, 372, 377, 379, 385; violence, 279–80, 284, 286, 288;—social and psychological approaches, 280–83
generalisability, 203, 317
generativity, 170–71, 175
Gilligan, C., 64
Gilman, Charlotte Perkins, 31, 298–99, 302–05
Gnanambal (1970 MLJR 430), 360
Gokhale, Santha, 297
Govindaswami Naicker (AIR 1940 Mad 73), 361

guilt, 86, 91–92, 237, 255–256, 270, 283, 292, 304
gynaecological pathology, 132
gynaecological somatisation, 134–36

HIV. *See* human immunodeficiency virus
harassment, 82, 292
Hare-Mustin, R.T., 64–66, 76
Harper, E.B., 202–03
healing, 279–80, 290, 292, 295
Heblikar, Suresh, 387
hegemony, 167, 198
helplessness, 43, 69, 223, 227–28, 231, 384–85
hermeneutics, 38
hierarchy, 65, 160, 199–200, 212, 246
Hindu Marriage Act, 356
Hindus, 189, 193, 210
Hinduism, 171, 178; sexual heterogeneity of symbolism, 184–85
Hindutva, 210
hopelessness, 43, 52, 59
hormone replacement therapy and menopause, 133–34
housework, unappreciativeness, 65–66
human immunodeficiency virus (HIV), 138
human rights violation, 297
humanism, 84, 209
humiliation, 97
Hussainara Khatoon v. State of Bihar (1980) ISCC93, 349n
hyperactivity, 41
hypergamy, 199
hypersensitivity, 236, 352
hypothesis, 231
hypothyroidism, 125
hysterectomy, 134, 205
hysteria, 36, 46, 55, 183, 300, 314

identification, knowledge of, 111, 113–14, 119

identity, 98, 226–27, 278–79, 284–89, 294
impulse control, 86–87, 100
impurity, notion of, 171–74
inadequacy, 43, 59, 91–92, 98, 108, 232, 306, 374
incompatibility, 354
Indian Association of Women's Studies, 246
Indian Penal Code 1860, 342n
Indian Readership Survey 1998, 371
indifference, 59
individual experience, 83–86, 90
individualism, 66, 84, 98
individuality, right of, 305
individuation, 118–19, 291
inequality, 22, 66, 82, 231–32, 262, 265–66. *See also* gender discrimination
infection, 138–40
inferiority complex, 96
infertility, 132, 139–40, 145
insanity, 87, 296, 300, 306, 327, 350–51, 356–58, 362, 367
insecurity, 233, 236
institutionalisation, 338–40, 344, 346
integrity, 279–81, 286
interpersonal behaviour, 75, 386
interpersonal relations, 53, 71, 73, 251, 355
intersubjectivity, 183, 291, 332
irritability, 123, 127–28
isolation, 233, 235
intrusiveness, 63
Irula community, rite honouring, 169–74
Irula Women's Tribal Welfare Association, 162n, 169n

jaljogini, 168
Jane Eyre by Charlotte Bronte, 305, 308
Jaunpur, Uttar Pradesh: *Matri Masaan ki puja*, 162–69
John Eric (Civil Appeals 3332 and 3333, 1982), 362

Joseph, Sara, 297
justice, 86, 106, 293, 270

K.C. Sivasankar Panicker v. P. Ravindranath (1988 2 Ker LJ), 362
Kachra Ma, 170–72, 179
Kandina Benki, 387
Kamala Devi v. Kishorilal, 364
Kamola Ram v. Kaura Khan (1912) 151.C.404, 361n
Kesava Pillai v. Kamalammal (AIR 1972 Mad. 1), 366
kinship, 58, 110, 199–201
Kiran Bala v. Bhaira Prasad Srivastava 1982, 1DM 327, 341n
kua (the well) and embodiment, 161, 167–69

law and psychiatry, 108, 110, 114
legal: action against martial violence, 244–45; discrimination, 98
lesbianism, 85
lethargy, 127
leucorrhoea, 134
litigation capacity, 362–63
loneliness, 52, 92, 96
Lunacy Act, 1912, 336, 340n, 344, 364–65

Mad Women by Triveni, 297
madness, 108–10, 114, 283–85, 287, 315
Madness and Civilization, 299
Mahashweta Devi, 16, 289n, 293
Mahendra Pratap Singh v. Padam Kumari Devi (AIR 1993 All 143), 361
Mahila Samakhya, Baroda, 244–45
male: aggression, 270–71, 292; dominance, 84–86, 98, 231–32, 271, 293
Maneka Gandhi v, Union of India 1978 ISCC 248, 338
Mani Ratnam, 382, 386

mania, 129
manjal thanni uthharadu, 172
Marecek, J., 64–66, 76
marginalisation, 73, 82, 210
marital status: and common disorders, 47–48, 53, 82; and distress, 70–73, 91–92, 125–26, 318–33, 353–54
Markoo v. State of U.P. (AIR 1978 All 551), 362
marriage and divorce, 355–60
Marx, Karl, 200
masochism, 78, 86, 226
Matri Masaan, 162–69, 179
mathematical reasoning ability, 74–75
medico–psychological practice, 102, 108–16, 119
menarcheal experience, 130–31, 137, 207
menopause, 123–24, 137; hormone replacement therapy and, 133–34; and mental health, 132–33
menstrual cycle and psychiatric problems, 88–89, 126–37, 212
mental distress, 20, 35, 46, 93, 95, 367–68, 371
mental disorders, 34–37, 42, 54–60, 76, 82, 86, 103–04, 146, 148, 339, 350, 352, 356, 370; instability, 352; minor, 43–47; psychiatric classification, 356–57; severe, 40–43, 85, 334
Mental Health Act, 1987, 115, 335–36, 345, 347, 364–65, 368
Mental Hospital, Shahdara, Delhi, 339, 346
mental illness, 20, 62, 82–83, 92, 94–95, 103–06, 110, 116, 119, 313, 338, 386; and human rights, 369; as an individual experience, 83–86, 90
Merleau-Ponty, M., 206–07
midwives (*dais*), 156, 159–62, 173–74; Bihari *Chamar*, 174–78
mild retardation, 40–41
mistrust, 233

Mitchell, Weir, 303
Mitra, Jaya, 285
mobility, 63
modernity, 117–18
Mohoree Bibi v. Dharmodas Ghosh (301 A. 114), 361n
moral reasoning, 75
morality, 279, 283–84, 286–88
morbidity, 125–26, 129, 132, 137
multiple personality disorders (MPD), 36, 112–13

NMHP. *see* National Mental Health Programme
Nagamma, 169, 171–74
Nari Adalat, 244–45
Nari Niketan, 339–40
National Commission on Women (NCW), 379
National Council for International Health (NCIH), Conference, Washington D.C., 1991, 138
National Institute of Mental Health and Neurosciences (NIMHANS), Bangalore, 39, 380
National Mental Health Programme (NMHP), 334, 359
Naye Kahani, 16
neglect, 222
neutrality, 77, 86
neurasthenia, 130
neurosis, 39, 85, 47–48, 50–54, 85, 183
neurotic disorders, 85, 91, 106, 146, 236
neurotransmitter changes, 125
news values, 388–89
Nietzsche on guilt, 282
NIMHANS. *See* National Institute of Mental Health and Neurosciences, Bangalore
normalcy, 297, 300
normality, 84, 111, 142, 279, 330
normative therapy, 279
norms individuation, 336

O.P. Saxena v. State, 366
objectivity, 77, 84

objectivisation, 232
obsessive compulsive state, 46–47, 55
oedipal complex, 262
oopherectomy, 134
openness, 274
oppression, 60,90, 98, 200, 263, 265, 279, 287–89, 294–95, 298, 300, 384, 386
osteoporosis, 134
ostracisation, 232
oversensitivity, 46

PUCL v. Union of India, W.P. (criminal) No. 2848, 1983, 339n
paranoia, 42–43, 55, 85–86
parental awareness, 255
pathology, 110, 315, 318, 323
patriarchal, patriarchy, 23, 30, 58–59, 90–91, 104, 155, 167, 202, 208–09, 215, 286, 291, 293–94, 300, 302, 315, 318, 333; epistemologies, 284; and family, 280; limits, 285; norms, 278, 281; power, 279, 287, 294–95; social order, 59, 231–32, 279, 283, 293–94; stereotypes, 282
pelvic congestion syndrome, 135
People's Union for Civil Liberties (PUCL), 341
perception, 182
perfection, lack of, 92–93
person and property management, guardian for, 364–66
personal: change, 90–95, 98; identity, 316; integrity, 94
personality, 74–75
personality disorders, 37, 236
personality traits theories, 86–87
phenomenology, 38, 182–83, 186, 197, 209
Phenomenology of Perception by Merleau-Ponty, 182
phobias, 96
Phoolmanti, 176
physical assault, 86–87
placenta, 170–71, 173–74

Plath, Sylvia, 298–99, 306–09
political, politics, 279–80; activity, 83; ideals, 95; identity, 278; power, 287; status laws, 366–69; unity, 98
Politics, Philosophy and Culture (1988) by Michel Foucault, 111
polarisation, 90, 100, 103, 210
pollution–purity notion, 46, 55, 157–58, 160, 173–74
post-hysterectomy syndrome, 132
psychomatic disturbances, 146
post-partum psychiatric problems, 124–26
poverty and common disorders, 48, 95, 370, 384–85
power relations, 36, 56, 59–60, 65–66, 86–87, 89, 91, 155, 157, 160, 200–01, 276, 279–81, 284, 292, 381; inequality, 265–66, 377; male control, 57; redistribution, gender-based, 68
powerlessness, 92, 216, 231, 281, 370
praxis, 156, 160–61
pregnancy, 123, 162–66, 171
premenstrual psychiatric syndrome (PMS), 89, 126–29; cultural issues in, 130–32
progesterone, 225
psychiatric disorders, psychiatry, 34–35, 45, 53, 60, 83, 90, 95, 100, 110, 112, 115, 119, 129, 262, 314; depression, 352; detention, 345; epidemiology, 315
psycho-analytic positions, 226
psycho-neuroses, 43–47
psycho-pathology, 74, 76, 83, 85–87, 94–95, 112, 223, 233, 235, 315, 318–19, 329
psycho-social aetiology, 106
psycho-social factors, 41, 68, 98, 124, 135
psychological gender difference, 74–77
psychology, 83–85, 90–91, 95, 98, 100, 108

psychotherapy, 62, 241, 251; gender in, 63–68
psychosis, 35, 37, 42, 47–48, 50, 55, 124–25, 129
psychotic, 43, 50
puberty ceremony, 207
purity *see* pollution–purity notion

Rai, Shivnath, 354
Rajeshware Rani v. Nirja Guleri (AIR 1977 P and H 123), 364
Ramaswamy, H.A., 354
rape, 94, 282–83, 286, 292–94; pathology of, 292
rationalism, rationality, 23, 29, 160, 162, 202, 285
realism and anti-realism, 19–26, 103, 106
reason, 117, 202–03, 279, 282–85, 287–88, 299–300
rebirth, 58
relationship, 66, 72
relativisation, 315
relegation power, 111, 113–14, 119
religion and disorders, 56, 189, 198, 209–16
reproduction-related events, 68, 88–90
reproductive health, 82, 107
Reproductive Tract Infections (RTIs), 138–39, 141–42, 145
research gender, 77–78
resentment, 43, 59, 96
responsibility, 86, 97, 374
rights perspective, 86, 369
Rita Velinkar, 297
rituals, 6, 201–02

safety needs, 86
Sahodari Devi, 176
Sakshi, 265
SAMVADA, Bangalore, 251, 265
Sadino's Daughters, 288
Santi: possession, 187–92, 209
Sapto Mayas, 174–79
schemata, 228, 241

schizophrenia, 35, 37, 41, 55, 85–
86, 125, 129, 316, 319, 329,
360, 386
schizophrenic communication pat-
tern, 253
seclusion, 199
self, 57–58, 70, 92, 105, 155, 228,
256, 289–90; affirmation, 301;
consciousness, 57; esteem, 92–
93, 223, 225–26, 256; evalua-
tion, 302; perception, 332;
respect, 284, 286
self-disclosure, problems, 71, 73,
126
self-help groups, 243
selfhood, 316
Seligman on violence cycle, 227
semen loss syndrome, 130
senile psychosis, 43
sensationalisation, 382
sensitisation, 244
serrotonin disturbance, 242
*Shesha Ammal v. Venkata-
narasimha* (AIR 1935 Pat 423),
366
Sethi, R.S., 339n
severe mental disorder *see* mental
disorders severe
sex, role, 275, 315–16; stereo-
types, 355, 357, 380–81
sexual: abuse, 222; assault, 86;
behaviour, 75–76; heterogene-
ity, 184–85; labour division, 90;
violence, 82, 248, 263, 289,
294, sexuality, 123, 142, 165,
184–85, 203–04, 248–49, 264,
271, 275, 279–81, 295, 300
sexually transmitted diseases
(STDs), 138–39, 149
sexism, 38, 96–97
Shah Bano, 382
shame, 281, 284, 290
shamanism, 292
Shankar Prasad Pal v. Sabita Pal
(1995 AIHC 2707), 358
Sharapanjara, 16
silencing, 382–83, 385
Singh, V.P., 367

Skorupski, John, 103n
social: aetiology, 89; ambience, 37;
behaviour, 75–76; causes, 90,
94, 98; change, 383; classes,
48–49, 74; coercion, 380; con-
ditions, 91, 95, 228, 248, 300;
hegemony, 66, 167; hierarchy
and disclosure, 269; identity,
315; inequity, 47; injustice,
201, 203, 302; isolation, 105;
mobility, 152; norms, and eth-
ics, 52, 55, 92, 108, 228, 263,
270, 273, 313, 355; oppression,
23, 82–83, 95; ostracism, 139;
possession theory, 197–202;
power, 198; reality, 68, 162;
relationship, 73, 93, 144, 201,
215; roles, 89, 154; support,
54, 69, 74, 199, 235; system,
78, 80, 90–91, 156, 279; val-
ues, 65
socialisation process, 84, 276
society, impact of marital violence,
238
somatisation, somatic disorders,
45, 58–59, 124, 134–36, 146,
178
spatial ability, 74, 77
State of Haryana v. Shivnath Rai,
352, 354
*State of Karnataka v. H.A.
Ramaswamy*, 353–54
status quo ideology, 84, 96
sterilisation, 152
stigma, stigmatisation, 144, 161,
235, 249, 256, 270, 327, 338,
355, 368
stress(es), 51, 54, 68–69, 92–94,
96, 202, 386
subjectivity, 117, 183, 186–87,
202, 208, 215, 296
subjugation, 300
Succession Act 1925, 363
suchibai, 46, 48
sufferings, 105, 332; private, 94,
96; social causes of, 90
*Sunkoji Laxman Chary v. State of
A.P.* (1955 cri L J 2562), 355

superstitions, 36
Supreme Court Commissions of Enquiry, 344–46
Suradhani Debya Choudharani v. Raja Jagat Kishore Acharya (AIR 1939 Cal 379), 363
suspiciousness, 326

Tarlochan Singh v. Jit Kaur AIR 1986 P&H 379, 341*n*
Tehri Lakhir, 16
Telengana People's Struggle, 186, 287
television, impact on women's mental health, 371, 378
testamentary capacity, 363–64
testosterone, 223, 225
Thakur-bhar, 57
therapy, 288–95
tolerance, 319
torture, 286
tradition and women, 30
transformation, 58
trauma, 86, 164, 238, 288–89, 355, 386; and unhappiness, 368
treatment, laws relating to, 336–44
Triveni, 16, 297
trivialisation, 124, 137
truism, 84
trust, 73, 103, 106–07, 126, 257, 274
'truth conditions', 102–03, 106–08

U. Aung Ya v. Ma E. Mai (AIR 1932 Rang 24), 361
Uma Bharati v. Arjan Dev AIR 1995 Pand H 312, 358
unemployment and depression, 49, 73
unhappiness, 59, 368, 383
untouchability, 157
urbanisation and mental health, 142–44

Vadilal Panchal v. Dattatraya, 349

vaginal discharge, non-pathological, 136, 139, 142
value-neutrality, 84, 90
values and norms, 241, 279, 292–94, 300; role of media, 371, 377
Vasundhara Devi, 297
Veena Sethi v. State of Bihar AIR 1983 SC 339, 349n
Venkataraman, Justice, 353
victim, 232, 235, 241–43, 262
victim-blaming, 86–88, 270
victimisation, 87, 95, 104, 327
vimroti, 43
violence, 30, 86–88, 94–95, 97, 104–05, 233, 236, 246, 248, 264, 294–95, 298, 384–85; social context, 228–29
vulnerability, 54, 92–93, 100, 102, 154, 235, 242, 246, 264–65, 269, 274, 293, 384–85

water retention syndrome, 128
well and embodiment. *See Kua*
white discharge per vagina (WDPV), 136
widowhood, 107
women: activists, 243; consciousness, 292n; epilepsy, 41; group, 82–83, 94–98; invisibility and inaudibility, 383; movement, 82–83, 297–98; occupation and common disorders, 48–49; organisations, 83, 94–98; in political struggle, 284–88; self-representation, 36, 66; working,—depression, 314;—sexual harassment at work, 376
Women and Madness, by P. Chesler, 300
Women and Media Group, Bombay, 383
World Bank, 143
World Health Organisation (WHO), 138, 370, 372, 388

Xenophobia, 361

Zuhra, B.M., 297